PUB YARNS
The pub, the whole pub and nothing but the pub

Best Wishes — good reading, safe travels & tumma — good prada! top

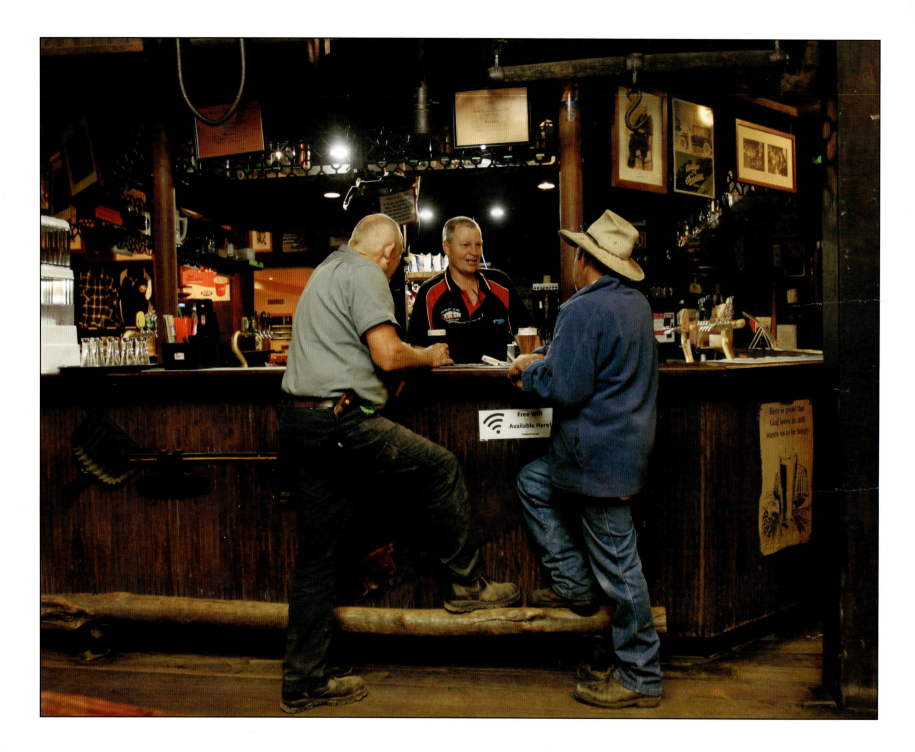

PUB YARNS

The pub, the whole pub and nothing but the pub

Colin Whelan

A solivagant's encounters with some of Australia's best bush and outback pubs

CONTENTS

INTRODUCTION 7

PART ONE: NOTHING BUT THE PUB 11
TATTERSALLS HOTEL 15
BARRINGUN, NEW SOUTH WALES
THE TOOMPINE PUB 21
QUILPIE AREA, QUEENSLAND
THE GENERAL GORDON HOTEL 27
HOMEBUSH, QUEENSLAND
THE MAJORS CREEK HOTEL 31
MAJORS CREEK, NEW SOUTH WALES
MIDDLETON HOTEL 35
MIDDLETON, QUEENSLAND
HEBEL HOTEL 41
HEBEL, QUEENSLAND
THE BLUE DUCK INN 47
ANGLERS REST, VICTORIA
PRAIRIE HOTEL 51
PRAIRIE, QUEENSLAND

PART TWO: PUB ROYALTY 55
ROYAL HOTEL 61
PORTLAND, VICTORIA
ROYAL HOTEL 67
SNAKE VALLEY, VICTORIA
CRAIG'S ROYAL HOTEL 71
BALLARAT, VICTORIA
PLEB PUB: SWISS MOUNTAIN HOTEL 75
BLAMPIED, VICTORIA
ROYAL HOTEL 79
BERRIGAN, NEW SOUTH WALES
ROYAL HOTEL 85
GRONG GRONG, NEW SOUTH WALES
ROYAL HOTEL 89
MIRROOL, NEW SOUTH WALES
PLEB PUB: THE BLYTH HOTEL 105
BLYTH, SOUTH AUSTRALIA
ROYAL HOTEL 109
CONDOBOLIN, NEW SOUTH WALES
PLEB PUB: THE FIFIELD HOTEL 113
FIFIELD, NEW SOUTH WALES
ROYAL HOTEL 115
MENDOORAN, NEW SOUTH WALES
ROYAL HOTEL 121
BINNAWAY, NEW SOUTH WALES
IMPERIAL HOTEL 129
WEE WAA, NEW SOUTH WALES
ROYAL HOTEL 135
MOREE, NEW SOUTH WALES
ROYAL HOTEL 139
GOONDIWINDI, QUEENSLAND
STOCKMAN HOTEL (EX ROYAL) 147
TEXAS, QUEENSLAND
ROYAL HOTEL 153
LEYBURN, QUEENSLAND
PLEB PUB: THE QUINALOW HOTEL 159
QUINALOW, QUEENSLAND
PLEB PUB: THE COOYAR HOTEL 163
COOYAR, QUEENSLAND
ROYAL HOTEL 167
YARRAMAN, QUEENSLAND
PLEB PUB: THE MULGILDIE HOTEL 173
MULGILDIE, QUEENSLAND

THE NEW ROYAL HOTEL RUBYVALE, QUEENSLAND	**181**
ROYAL PRIVATE HOTEL CHARTERS TOWERS, QUEENSLAND	**189**
RAILWAY HOTEL RAVENSWOOD, QUEENSLAND	**193**
IMPERIAL HOTEL RAVENSWOOD, QUEENSLAND	**195**
ROYAL HOTEL TOWNSVILLE, QUEENSLAND	**199**
ROYAL HOTEL INGHAM, QUEENSLAND	**207**
ROYAL HOTEL HERBERTON, QUEENSLAND	**213**

PART THREE: THE POETS — 217

BEEHIVE HOTEL COOLAC, NEW SOUTH WALES	**221**
ROYAL MAIL HOTEL HUNGERFORD, QUEENSLAND	**227**
RICE BOWL HOTEL WHITTON, NEW SOUTH WALES	**235**
BLUE HEELER HOTEL KYNUNA, QUEENSLAND	**241**
ELLANGOWAN HOTEL AUGATHELLA, QUEENSLAND	**247**
BREDBO HOTEL BREDBO, NEW SOUTH WALES	**255**
WARREGO HOTEL FORDS BRIDGE, NEW SOUTH WALES	**261**
YARAKA HOTEL YARAKA, QUEENSLAND	**267**
THE PALACE HOTEL BROKEN HILL, NEW SOUTH WALES	**275**
ROYAL HOTEL HILL END, NEW SOUTH WALES	**281**
PUB WITH NO BEER TAYLORS ARM, NEW SOUTH WALES	**285**
ROYAL HOTEL YEOVAL, NEW SOUTH WALES	**289**
IRON BARK INN STUART TOWN, NEW SOUTH WALES	**293**
NORTH GREGORY HOTEL WINTON, QUEENSLAND	**297**

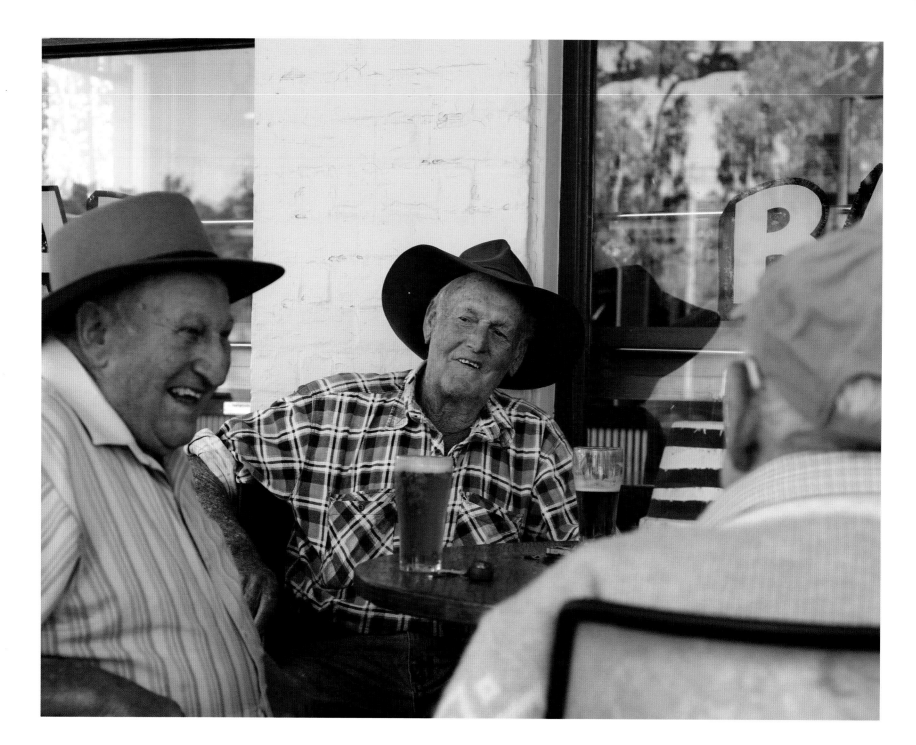

INTRODUCTION

Of course, the subtitle of this book is a lie. A book about pubs cannot, *ever,* be about nothing but the pub because good pubs themselves are never about nothing but the pub. They're about their history, their story, about their current owners and their publicans past. They are about their surroundings, their neighbours, about the customers both regular and occasional.

Pubs are about their community, and they almost always have been. The only exception to this was in the four decades of six o'clock closing, when 90 per cent of a pub's turnover was taken in the frantic 60 minutes of swill after 5pm.

The wowsers who'd pressed for the restricted hours in 1916 as a 'war measure' but who then fought to maintain it for the next 40 years were not so much upset by drinking, they were threatened by the pub's central role in the community.

Pubs were places where women congregated to socialise and get support as they shelled peas and peeled spuds. They were places where politicians would do business; meet constituents after arriving by train. They were the venue for meetings of the town's sporting, cultural and service clubs. They doubled as the town's post office, general store, fuel station and it was this service role, this hub of the village wheel, that the temperance movement sought to stop.

The six o'clock swill resulted in bar rooms being cleared of all tables and chairs. All comforts that obstructed or hindered the rushed serving of beers to desperate, thirsty masses of after-work men were removed and the pub as community centre was destroyed.

For this period the pub *was* just about the pub. But no longer.

Increasingly good pubs are returning to the epicentre of towns and villages. The troughs that once rimmed the bar have all gone, to be replaced with play areas for kids, comfortable lounges for the elderly. On their walls you'll find images from the town's and the pub's past. Great publicans understand that they are not proprietors, they are custodians, nurturers of a living organism which happens to be a pub.

In 2012 Peter Thoeming asked me to write a 'Pub of the Month' story for his motorcycle magazine. I jumped at it. There were two things I was mad keen on: motorbike riding and country pubs, although at that stage I was probably a motorcyclist who visited hotels.

Over time, as I learned how to immerse myself into the bush and into the towns and the pubs, I've probably become a pub aficionado who travels by motorbike.

In 2016 I had a coffee with Alan Whiticker from New Holland, with whom I'd worked on a number of books as a photographer. Alan embraced my idea for a book somewhat along the lines of my magazine articles and what follows is the result of that meeting.

This book is not a compendium, an all embracing overview of the greatest pubs in any given category or class. Rather, it's my disjointed ramblings about just some of the most memorable and richest pubs in the country.

I want this book to make readers inquisitive and restless. I want it to motivate people to get out and head to a pub, not necessarily any of those mentioned within, but any pub with character.

But not to visit them. Encouraging 'visiting' is not my plan. You 'visit' your sick aunt in hospital and spend time eyeing the clock. You 'visit' the doctor and perhaps the grave of some ancestor. Just as every person in every pub has a story, so too does every pub. But you won't learn its story by visiting, you need to immerse and immersion can only be done without a clock on the wall.

But pubs can also be about the journey to them. When Henry Lawson set out from Bourke to Hungerford he was effectively on a pub crawl, and his goal was the Royal Mail just across the border. He hated the journey and he hated the return but his stories of his hardships getting to the pub have become part of the fabric of the hotel.

So too I've included stories of my travels between hotels and my encounters with some not so great pubs.

Fingers may be pointed to some of the more famous pubs which are not included. There are several reasons for this. When planning this book, we originally had eight chapters but each chapter developed and fattened so much that we dropped this to just three and in so doing, some great pubs had to be held over to Volume 2.

But another reason why a number of high profile outback pubs are not included is sadder. If I go into a pub like the Nindigully and ask what river it is just outside, or into the Adelaide River Hotel and ask why of all the guns and other stuff around did they call the bar the '303', or into the Daly Waters pub and ask about the stock routes and famous tracks, and get a shrug, a 'Don't know' or an 'I only work here' type answer, it's pretty damn sure it isn't going to end well.

Disinterested absentee publicans who have no sense of custody and who want to return pubs to drinking holes serving food that's been prepared and frozen a thousand miles away; hotel owners who think pinning some hats to the wall and some notes to the ceiling and employing foreign female backpackers to bring in the farmboys without educating them about the pub, its environment and its history, are doing more to destroy country pubs than ten years of drought.

So the clichéd, formula-driven, tourist-targeting rubbish has not made it onto the pages.

However, included are 60 or so outstanding country, bush and outback pubs, some are extraordinary, all are memorable. I hope readers are entertained by the words and the images. I hope that you are energised and motivated to pack your swag and head out to where you can't see the air but you can sure see the stars. Because, not every fascinating person is in a bush hotel, and not every welcoming pub is in the outback but, damn, a hell of a lot of 'em are!

Before I go just a couple of things: I can't vouch for the absolute truth of any of the direct quotes. I can only attest to them being shared with me. Pub claims about past exploits are intended to be entertaining and if there's a grain of truth, then so much the better, but exaggeration, distortion and pure imagination are far more essential.

And poetry is meant to be read out loud. When you come to a piece of poetry in the centre of the column, saliva up and speak it. Then it becomes fully alive!

Finally, I hope I've done justice to the pubs and the people who've shared so many good times with me and who've trusted me with their stories.

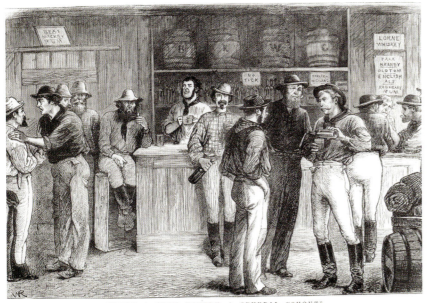
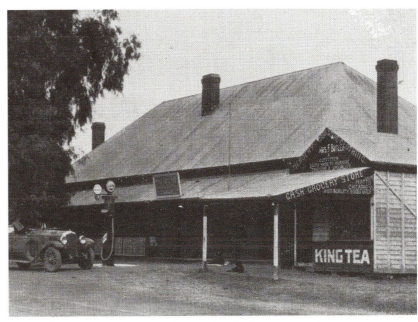

INSIDE A BUSH TAVERN—A GENERAL "SHOUT"

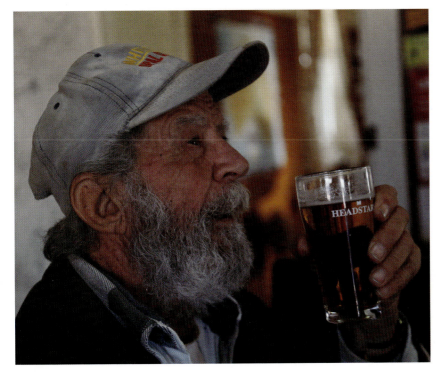

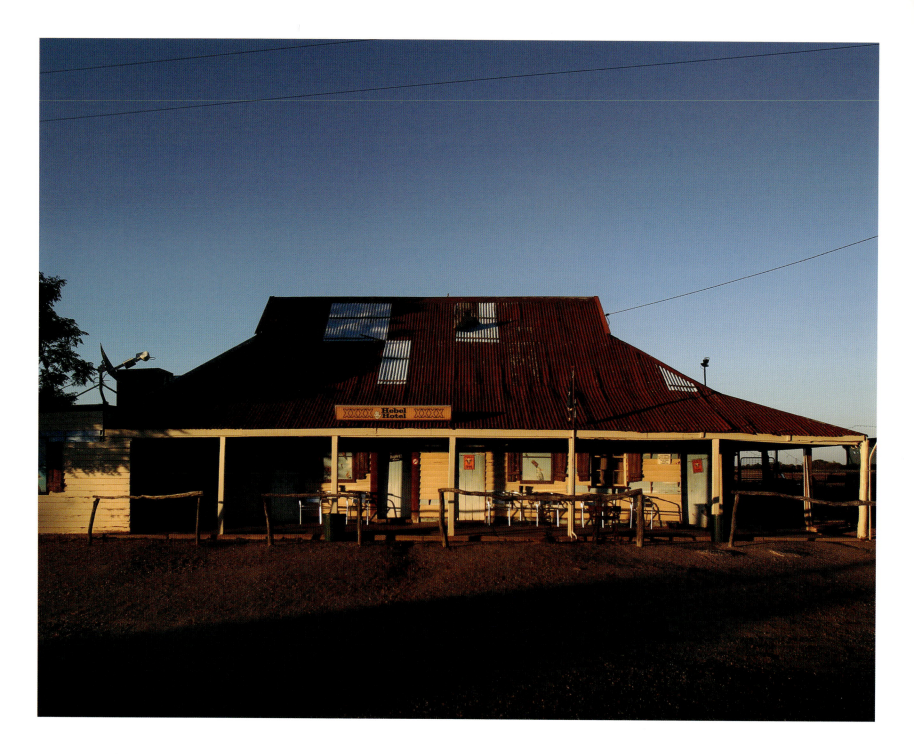

Part One:
Nothing but the Pub

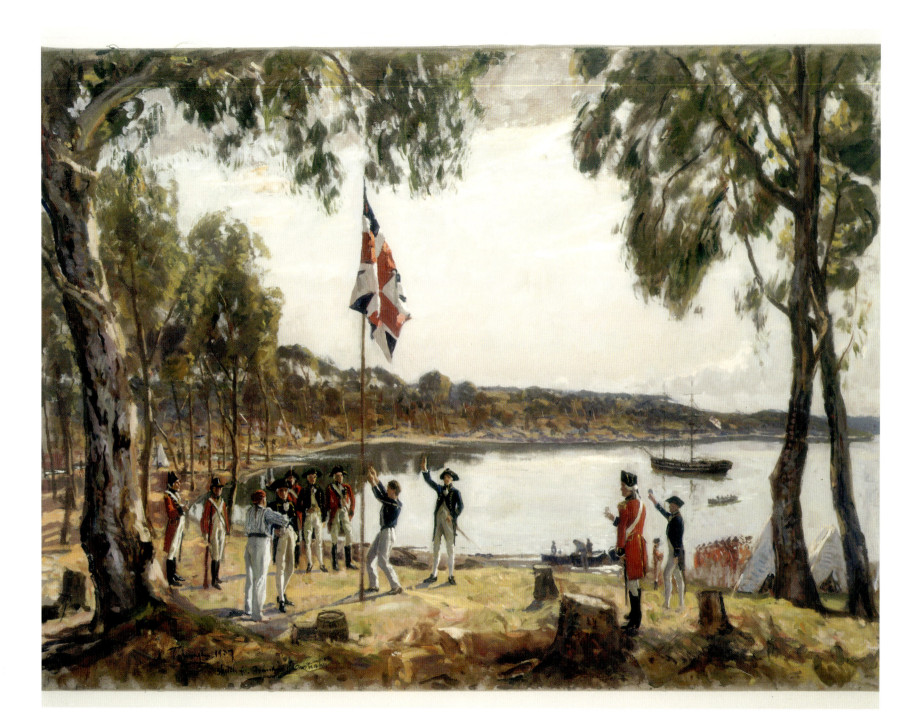

On 26 January 1788 an all-male party of officers, marines and convicts landed at Sydney Cove and set about bringing ashore provisions and stores, felling trees and pitching tents and marquees. As the sun set on this first day of white settlement, the men put down their tools, rum was served and a toast proposed to the health of the King and to his family and to the success of the new colony.

Eleven days later, with the bare rudiments of a town constructed, the women convicts, over a third of whom were prostitutes and most of whom were described by Reverend Richard Johnson, the party's chaplain as, 'prefer(ing) lust before their souls...(which they were) ready to sell...for a glass of Grog,' landed.

Arthur Bowes-Smyth, the surgeon amongst the party, wrote that is was 'beyond (his) abilities to give a just description of the Scene of Debauchery... that ensued during the night.'

(It was probably beyond his abilities because he wasn't there! He stayed on board and none of those chroniclers who *were* present mentioned what historians now call 'the myth of the foundational orgy.')

Not to worry! Ever since, liquor, drinking and pubs have been at the forefront of not just the Australian psyche, but they have influenced every aspect of Australian social life.

The first fleet had left an England that had two distinct types of licensed premises: the public houses (including taverns which served spirits, and alehouses which sold beer), and inns which concentrated on accommodation. The settlers, both free and convict, were well versed in this culture of drinking, but the unique combination of geography, exploration and climate dictated that Australian pubs would evolve differently, uniquely, without a template, without any necessity (or indeed possibility) of paying homage to any models, social or architectural, in the old country.

Pubs sprouted where stock routes intersected and where punts crossed rivers. They sprang up every 20 miles along every major highway, this being the distance of a day's travel for a bullock team. They were built beside every (and within most) railway stations and they mushroomed beside every Cobb & Co rest stop and horse-changing outpost.

And it was no chicken and egg story. There was no set sequence of development. Sometimes the pub came first, sometimes the town. Towns were built around existing wine shanties and pubs, towns have been named after the pre-existing pub and one town was even re-named in honour of a publican who'd passed away from, as his death certificate stated, 'exhaustion from intemperance'. Aaaaah!

And sometimes the pub was built but the town never came.

Thirty-eight kilometres north of Hay, on Henry Lawson's 'great grey plain' is the One Tree Hotel. A town was gazetted and the original pub built in 1862. And that was it! The town never materialised and the One Tree Hotel has stood on its own ever since. In 1897 its only companion, the actual single tree on that wide grim plain, blew down in a storm but the pub battled on. Six years later it burnt down, was rebuilt to the same design and lasted until 1942 when Frank McQuade, its last owner, called it quits. In 1991 it was placed on the register of the National Estate and today it stands alone, behind a security fence, one of the few standalone pubs that've never had a close neighbour.

Most of these standalones represent the last operating buildings in once prosperous towns and villages. These are tiny pubs which have truly stood the test of time, which have stood tall and resolute, as all around them, dreams have been shattered, hopes evaporated and optimism turned to despair.

For whatever reason, dotted through our landscape these isolated refuges are sentinels against loneliness and thirst. When you visit them, when they grace you with their hospitality, you ease back in your chair and look around at the vastness and realise that for now it's all *about the pub, the whole pub and nothing but the pub.*

TATTERSALLS HOTEL

BARRINGUN, NEW SOUTH WALES

There's something about the outback. You either 'get' it or you don't. The outback either touches your soul, or it doesn't. You connect with it, and, like artesian water, flow beneath its surface, feeding off it and returning the richness it gives you, or you skim over it, oblivious to its rich and endlessly changing character.

As you travel, the change from mulga to box, from turpentine to wilga, from gidgee to cypress to brigalow, will enthral you, or it'll all just be 'trees'.

The earth'll glide from brown to grey to black to red, from sand to clay to iron stone or it'll all just be dirt. The changes will either transfix you or they'll be unseen, unheard, untasted, unfelt and unknown.

'Getting' the outback is about your soul not your senses. It's about your core being in tune with the country's heart.

In the 1880s one of the more erudite transients, the Hon. (no less!) Harold Finch-Hatton published his, *Advance Australia!—An Account of Eight Years' Work, Wandering and Amusement in Queensland, New South Wales and Victoria.*

The Hon. Harold didn't 'get' Sydney, writing that he was, 'quite at a loss to imagine...where Sydney got its reputation for beauty. I never saw anything more forlornly ugly in the way scenery.'

But he 'got' the bush. He wrote of its 'lifeless solitude' then quickly added how, 'the sensation of loneliness very soon wears off...and even the endless trees come to look like friends.'

This pommie aristocrat felt the connect, he even honoured it with a capitalised name: 'There is a deep fascination about the freedom of the Bush,' he wrote, 'whose subtle influence very soon enslaves those who go to live there, and generally unsettles them for any other mode of living.'

The bush rewarded Harold with good finds of gold, and despite him elegantly insulting Mackay as the 'Boeotia of Australia', he got a really quaint town just 65 kilometres inland named after him.

Not that everyone who lives out here is so 'enslaved'. Fifty years later Myrtle Rose White wrote *No Roads Go By*, an account of seven mostly wasted years with her husband in the outback, working in the main for Sidney Kidman.

Of her first night on the station, she wrote:

> *I crept forth to take a dejected survey of the world outside...(t)he myriad stars were diamonds of the first order in that clear rarefied atmosphere. But what an appalling loneliness! And what a dreadful menacing silence...the terrible silence sinking in and sinking in...I stood there in the terrible frightening dark. It was a feeling I never entirely erased in all the years I lived in the bush.*

After seven years of hard slog, no nearer to owning their own dream patch of dirt, the depression hitting, Kidman rewarded White's husband's loyalty and effort by slashing his wages by 50 per cent. White got night sweats, but Kidman got a knighthood. And later he got a highway named after him. It stretches from just outside Jerilderee in the south to, depending on your map, either Bourke or 140 kilometres further north on the New South Wales-Queensland border at a fly speck town, Barringun.

Barringun's got a population of just three. When I first went there, it was four: Darryl (the only bloke in town) and his partner, Jan, who run the Bush Tucker Inn (no fuel), plus Darryl's mother. In December 2016 Darryl's mother passed away. It was a sad time but Darryl and Jan decided to stay. It was the life they knew.

And then there's Mary who runs the pub a rock throw to the south. I'd heard about Mary and rang to let her know I was coming out for a chat and a beer.

'You'll be wasting your time. I'm old and boring.'

I doubted that.

'And I've got no draught beer.' Which was fine because I have catholic tastes.

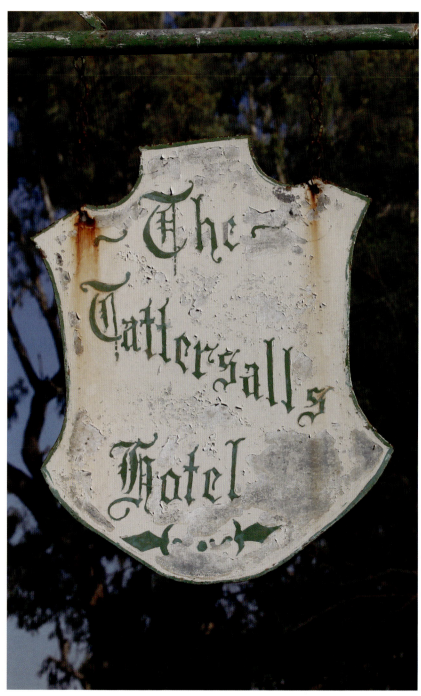

'And there's no accommodation.' Not a problem 'cause I have my own tent.

'Well the traffic'll keep you awake, there's four or five trucks through here some nights.'

I thanked her for the encouragement, said I'd see her in a week or so and began packing. Because a town of just four but still with a pub is enough on its own to get me riding a couple of thousand kilometres. But when you throw in the fact that Mary, at 92 years, is the oldest publican in the country, the whole thing changes from a 'can do' to a 'gotta do'.

I get to Barringun with my left cheek burning from the sun and find Mary in her favourite chair, Gidgee the dog at her feet. It's Saturday and there's a decent crowd in. Peter, one of Mary's sons, and his wife are helping out whilst the boss puts her feet up.

I grab a $5.20 stubby and sit down beside Mary and we begin chatting. The tale runs backward; the more recent stories come first and I keep gently pushing her back. Back through the passing of her husband Bay and the loss of her oldest son, Michael.

Back through buying the pub in 1977 from Neil Lack, whose late dad had owned it for many years.

Back through the days when Bay worked in Bourke for Hales, a major retail store whose tag line was simply, 'For Everything'.

Back through the seven kids and their early local schooling and then boarding down in Bathurst. Storeys of stories.

All this time Mary is holding a hand written note on a crumpled sheet torn from a pad. 'I want you to read this and tell me what you think.' Gidgee looks up as though understanding the import of the note. I read it, both sides, and then I read it again.

Then, some 2 hours and 52 minutes after we first started, Mary gets onto the day in 1948 when she first arrived out here.

With her 70-something-year-old mother and two kids, she flew from Sydney with the Butler Air Transport Company. There were fuel stops at Cessnock, Mendooran, Tooraweenah, Coonamble and Walgett before Mary caught herself looking down from the long window of the De Havilland Dragon 84 at the sun glistening off the river as the pilot used the Darling River for navigation.

'As we headed west, I looked down at that shining river and I thought: isn't this so peaceful and beautiful.' Mary pauses then adds, 'And, you know what, Colin? I've never ever changed…it was just glorious, it was perfect.'

Mary simply 'got' it. Before she even set foot on it.

I hand Mary back the note. Gidgee looks up, seems to relax an extra bit and lays her snout on the cool floorboards.

The pub has a stack of rooms (including a huge billiards room) but Mary's always slept in the front room, not because it's next to the road but because it faces east.

'The sunrises out here are the best in the world,' she confides and the next morning from my tent on the other side of the bitumen, a stupendous golden orb confirms her claim.

After shooting the sunrise, I finish my brew then head up to the Bush Tucker Inn, where Darryl cooks me up a decent breakfast, then it's back to the pub.

Each Sunday Mary rises early and watches 6am Mass on her television and when I get back she's in her chair, 'massarged' for the week and with Gidgee beside.

The sun climbs until the awning shades our faces and I ask Mary about Rose White's 'Appalling loneliness' and 'frightening dark'. She tells me how she's never lonely, how it's good when people arrive, and it's good when they go. How the sounds of the wind in the trees, of the windmill clanking, of livestock and native animals, and of the birds, are the theme songs of her life. She talks of the colours, which change every moment, and of the countless stars at night. She talks of her love of a good cuppa and of her dog.

And after a while, Mary asks what I thought of the note.

It was given to her in an envelope by a fella who'd come by with his wife and two young daughters. He'd waited 'til the others'd headed to the car and he and Mary were alone and he didn't wait for Mary to open it.

The note told of how, 20 years ago he'd passed through, doing it tough, and how he'd done something unspecified that'd weighed on this conscience ever since. Also in the envelope was a 'pineapple' and the final words were, 'I hope you can forgive me. Please find enclosed the $50 that was rightfully yours 20 yrs ago. Chris.'

I told her that I understood. I told her that whether he'd nicked money, booze or fuel, it would've troubled him stealing from someone like her. Because there might be something about the outback that some get, but everyone who meets her knows, there's *definitely* something about Mary. This incredible woman who'd told me she was boring with nothing to say has given me over seven hours of tape, over 400 minutes of anecdotes, recollections and stories.

I pack up the tent and load Super Ten for the ride south, graced with memories of one of the true legends of the outback.

A coupla days after visiting Mary, back in Bourke, I'm graced with the company of Phillip Sullivan, a proud Ngemba man, under the shade of a gum tree on the banks of the Darling. The Ngemba are the traditional owners of the brown land south of the river they know as the, 'Barwon'. On the other bank, the Barkindji, or 'river people' have lived since the dreaming.

For over an hour we talk about 'getting' the country. He explains to me the connection and the relationship between his mob and the river and then to the earth at large. He tells me a story, sets me a puzzle centred on a group travelling in the vast dry heat and explaining their oneness with the land. At the end he explains the importance to his people of 'getting' the land.

'They know,' he says with giant arms outstretched as is to encompass the world, 'the land will either take care of them or it will take them.'

It's a quote I'll never forget.

A bit later I catch up with Dave. He's in his sixties now and semi-retired but back in the eighties he drove trucks and came through Barringun very regularly.

Road trains were illegal in New South back then but they were okay in Queensland. There were four of us driving from a yard in Condo(bolin) and my run was usually up to Mt Isa. We'd leave Condo when it got dark and the cops had gone to bed and we'd drive through the night to get to the Barringun pub for breakfast. We had a deal with the copper in Engonnia (between Bourke and Barringun) that if we went through there between one minute after midnight and one minute to seven in the morning, he'd leave us alone. When we'd get to Barringun, Mary and Bay would make us breakfast of bacon and eggs and then we'd be in Queensland and the cops wouldn't be a worry.

But if you pulled up at Barringun and the red cattle dog was out front, you didn't get out of your cab. That dog guarded Mary and Bay like no other dog I've seen. One time my mate pulled up early and needed the phone box and he had to get his truck real close to the phone, climb out of his cabin but swing around onto the tray. He walked down the tray to the phonebox, climbed in through the roof of the box and then climbed back out the top when he'd finished. There was no way that red dog was going to let his feet touch the ground!

A few months later I'm out west again and hear on the mulga wire that Mary's in Bourke Hospital after a fall. Nothing broken and she's on the mend, but the family's decided that she should no longer work alone. I call a bit later and she's back in the bar, sounding as good as ever. She asks when I'm dropping by again and I tell her not as soon as I'd like.

'I'm too damn busy writing a book and you're the first chapter!'

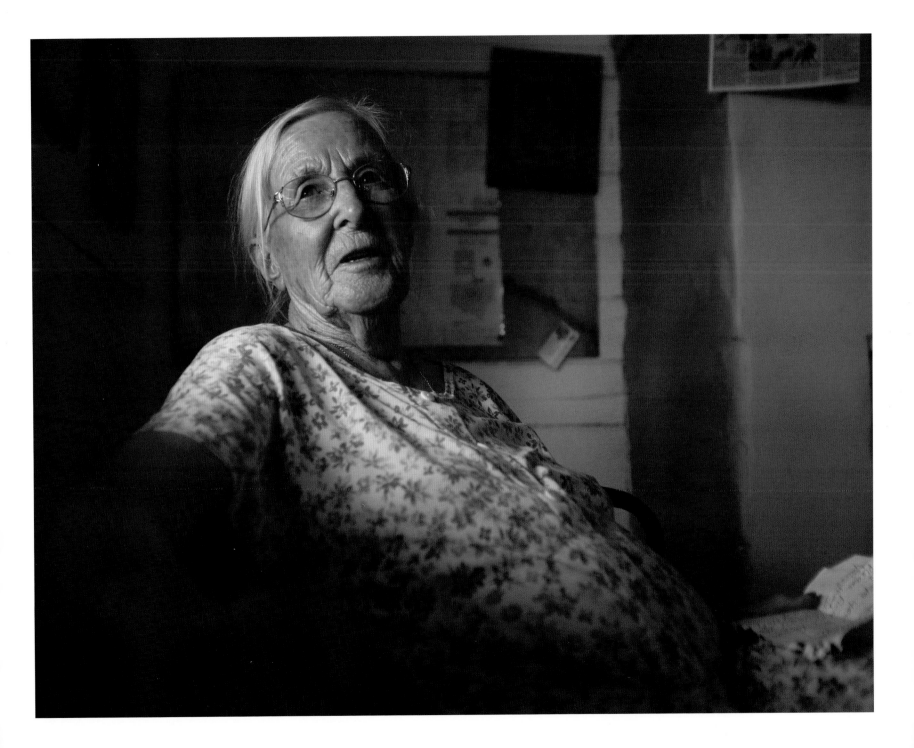

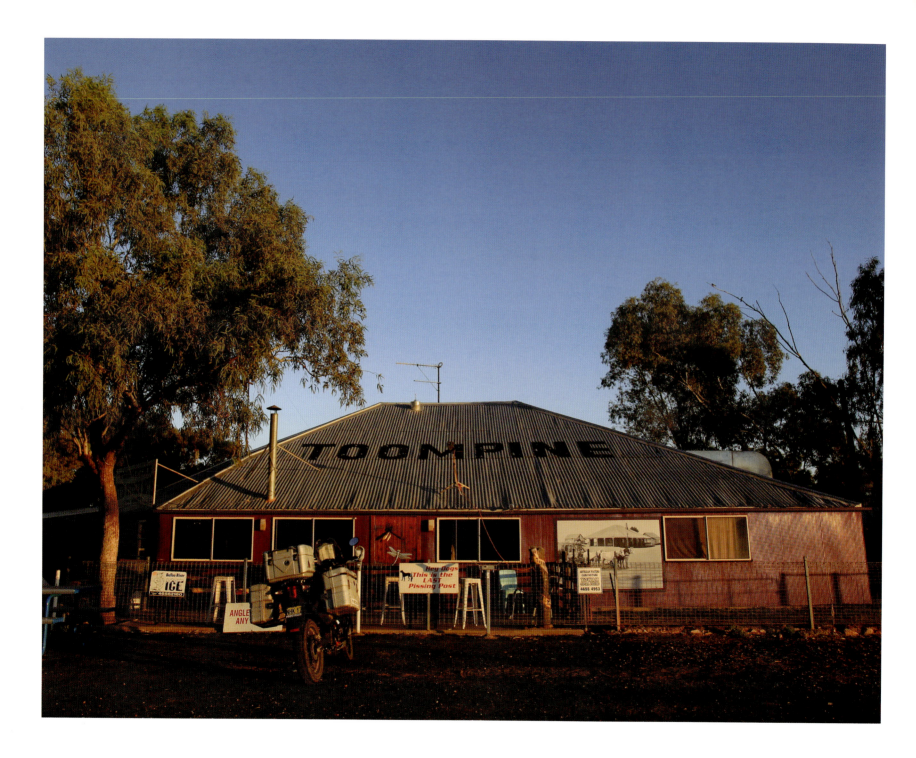

THE TOOMPINE PUB

QUILPIE AREA, QUEENSLAND

I'm pretty sure everyone knows that pubs are 'pubs' because they started out as public houses: *houses* which were open to the *public*. Often a married couple would simply set aside the largest room in their home, fit it out with seats around the walls for guests and set aside another back room where they'd keep the drinks, the glasses and any snacks.

The public would come to their house and so it became known as a 'public house' and soon this was contracted back to just a 'pub'. Any workers were classified as 'servants' and the boss was the 'host'.

This all changed in the mid-1800s when pubs began installing barriers in the lounge between the guests and the stock. This enabled the drinks to be kept within easy reach and sped up the service, especially once the barriers came to be topped with a counter of sorts.

Just as 'public house' was contracted over time to its first three letters and became a 'pub' so too did this 'barrier' get slimmed down to 'bar' (and of course over time this name of establishments' central locus came to be the moniker for the entire place). A place with a bar was a 'bar' in the same way a room with a toilet is a 'toilet'!

Bars didn't just separate staff and clientele on the physical level, they also separated them in a more figurative and emotional sense. Guests became 'customers', servants became 'barmaids' and 'barmen', and the host became the 'licensee'.

But now when I look at good pubs and think about what makes them great, one of the essentials is the blurring of this 'us and them' barrier. It's the pubs that make me feel 'at home', or at the very least in the *host's* home, that rise above the good and become memorable.

It's the pubs that are run by hosts who reach across the bar both literally and figuratively to their guests that are the opals in the rock.

And if you find such a place at the end of a long or taxing day it seems to shine even more brightly. Few pubs have had a higher lux for me than the pub at Toompine between Thargomindah and Quilpie. Its official name is the South Western Hotel, but to every traveller who's ever visited, it's simply, 'The Toompine Pub'.

I'd come up the dirt road from Tharg. The red dirt of the centre; of the outback. The red that magnifies every other colour: the sky, the clouds, the vegetation. Out here, every few hundred kilometres or so I just pull over and switch off the engine. Clear the head of noise and fill it with the quiet. These are the roads where I can park the bike slap in the middle and spend 20 minutes shooting a panorama, confident no vehicle will be seen, heard or forced to go around. Because it's not just the colours that are magnified, it's other stuff as well.

Physics tries to teach us that there is no such thing as darkness, only absence of light; no such thing as cold, only absence of heat; and no such thing as quiet, only absence of sound. Physics lies.

Out in the red heart, where the city has given way to the country, the country yielded to the bush and the bush surrendered to the outback, you will find a silence that is past quiet. This is a silence which has its own density and mass.

This is The Silence. It is not the absence of anything. It is the presence of itself.

Stop the bike in the heat of the day, when even the flies are cowering on the dark side of leafs and twigs, and absorb the silence. If a crow or corella or magpie happens to cry out, it's as though something tangible has been torn, ripped, damaged.

And it seems no coincidence that excepting the dingo, not a single of our mammals or our reptiles has a loud call. They too respect the silence. Silence is the music of the harsh. I savour it several times on the ride north to Toompine.

When I come in from the silence and the dust, Dogger meets me at the door of the pub. He reckons I look like I need a drink and he gets no argument.

The pub has no draught beer so I get a long, cold water and a freezing stubby for a reasonable five bucks, and Dogger joins me in the mid-arvo sun out front.

Blokes in utes drop by for a drink or some takeaways and all are up for a chat. Dogger's real name is Glen but fewer people call him that than call the pub the 'South Western'. He's the boss along with his wife Robyn. With each arrival he jumps up, serves the fella then comes back outside to continue the yarn.

Pretty soon Bobbie wanders over from his caravan parked 50 metres away. He's been here three days so he's considered a local and he and Dogger reckon seeing as I'm doing nothing, I might as well make myself useful and go down the creek with Bobbie to empty the yabby traps and get some dinner. Sounds a plan!

The Toompine Pub has what has to be Australia's biggest beer garden It's on 8500 acres and it's cut through with creeks and waterholes. Pretty soon Bobbie and I are in his ute and headed down to a creek with still a decent bit of water. He's already emptied the nets this morning and got a few dozen good ones.

We pull in half a dozen traps with maybe 20 blue claw all up, and Bobbie reckons it's about time to move the nets to a new billabong a bit further down. We load the traps with pickled pork ('the buggers can't resist this stuff'), chuck 'em into the brown waters, take the haul back to base and reunite 'em in with their mates from the morning.

Tight squeeze in the kitchen as we all help pull tracts out of the yabbies before Bobbie turns them all orange in a boiling hot bath, loads them onto a massive platter and brings them all out front where a shady mob of usual suspects is gathered. There're blokes from surrounding farms buggered after a hard day at it; a shearer on his way north to Adavale for just three days work with a small mob, a truckie having a break on the way east to Dalby; all with stories and, in the fading light, great, character-filled faces.

One of them has the most genuine sweat and red dust stained hat I've ever seen and I tell them how a bushie mate of mine described Bob Katter with his pristine Akubra as, 'all hat and no cattle'. They smile knowingly.

As the darkness takes over and the Silence seems a long way distant, we all hoe in and there's plenty to go around. Come to Toompine and you're welcome to throw your nets into the creeks and have your efforts cooked up for free in the pub. You won't be able to camp by the creeks but there's plenty of space around the pub itself, including beside the pond right behind the pub. I camped right beside the front door.

If you're not a camper, there's a total of seven rooms, all with air con available for guests: three doubles and four singles at $70 and $50 respectively. If you want to throw a swag but prefer indoors, there's plenty of space in the pistol club hall about 80 metres from the pub.

All are welcome to use the toilet near the gun club but keep your eyes peeled coz like so many country dunnies, the water attracts frogs and the frogs can attract snakes. The week before I got there a particularly keen blackie had to be forcibly removed!

There's no TAB, no Keno, no ignorant, untrained backpacking staff and a prominent sign proclaims, 'No Cockheads'.

There's undercover parking in the shed around the back but if you're there when it pours, get me a photo! And there's as much need to lock up your bike as there is to hide it from the rain.

Robyn will cook you up a feed from a pretty decent menu any time you want. 'If the door's open the kitchen's open,' she tells me toward the end of the night.

She and Dogger have managed the pub since 2014 and are trying to get the lease. Both are from out west, Dogger's the older brother of Donna who, with husband Phil, runs the motel down in Tharg, the most hospitable licensed place down there. After a lifetime of shearing and running catering at places like the Roma Saleyards, they're keen to make this their patch.

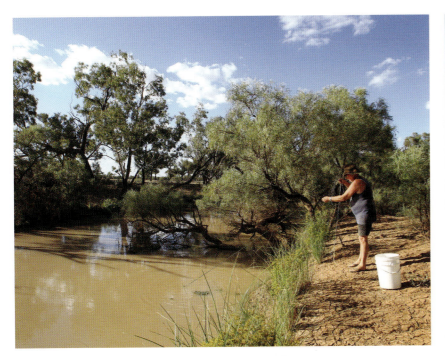

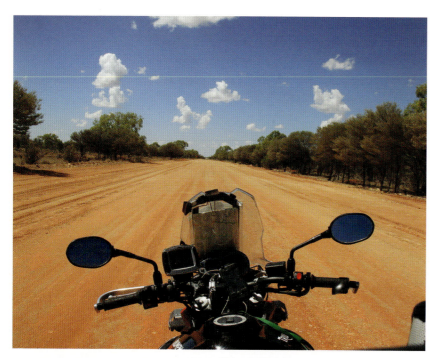
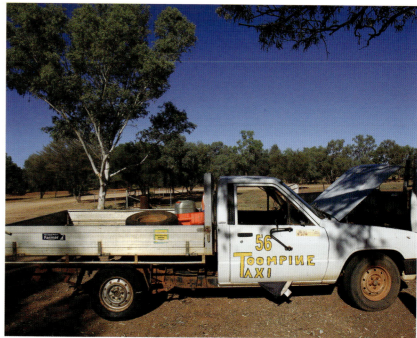
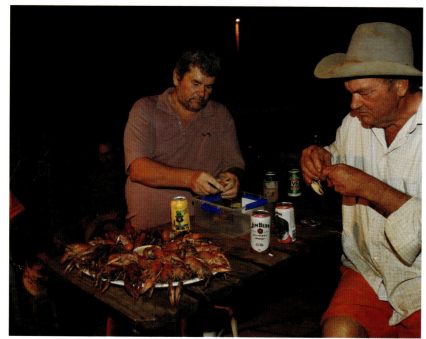

As we sit around chatting like you'd chat with friends who're putting you up for the night, I see a couple of laminated typed sheets on the wall and it turns out they are a short history of the pub. And there near the bottom of page two, it all becomes clear.

The pub was built in 1893 by a Mr Power, whose descendants still live in and around Tharg and Quilpie. It was built not as a pub but as, 'a homestead with five central rooms surrounded by a wide verandah and a separate kitchen block…over the years there have been alterations but in the main the appearance remains unchanged.' And, I think to myself, if the writer had added, 'character and feel' to 'appearance' they'd have summed this place up perfectly. This is a pub(lic house) with a bar but no barriers. It may be lacking in some amenities but the richness of its character and of its characters make it a truly iconic outback pub, and for me it's up there with the very best.

I throw the tent down beside the pub's front door and in the morning Dogger reckons, since I supplied dinner, he'd forgo the camping fee. A few blokes drop by for a brew in the gathering sunshine (great pubs face east!) and when it's time for goodbyes it's like I'm leaving family, like this public house was my house.

And that's the mark of a damn fine pub!

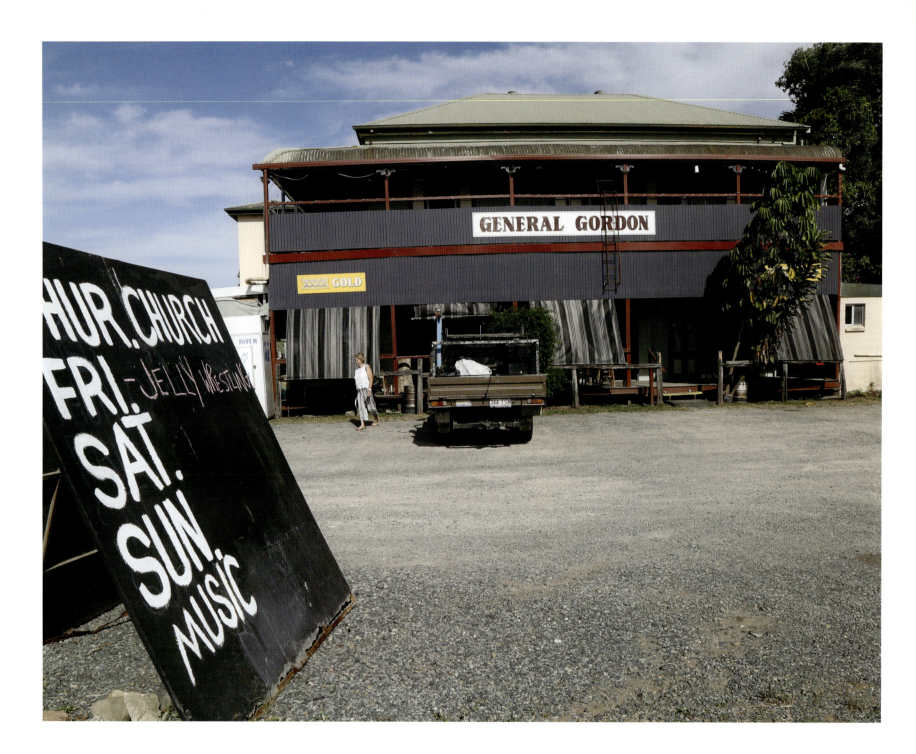

THE GENERAL GORDON HOTEL

HOMEBUSH, QUEENSLAND

How much good stuff does a person need to do in the sunlight so that people will overlook their shady stuff? This was occupying my mind as I jumped on the bike at Mackay for the ride south on the Bruce Highway.

In 1860, a year after Queensland was spun off from New South Wales and declared a separate colony, a couple of Johns, Macrossin and Mackay, put together an expedition in Armidale New South Wales to find new grazing land on the north Queensland coast.

Two hundred-odd miles north of Rockhampton they became the first white men to discover what became known as Pioneer Valley and named its river, the Mackay in honour of John Mackay's father. This didn't last long and was changed to its current, Pioneer River, in 1862 when the town was named after John Mackay.

Mackay was an early adopter of the 'The older I get the better I was' principle and subsequently petitioned the government several times for recompense for his discoveries, claiming to be the leader of the expedition. This of course was bogus, Macrossin was both the leader and chief financier of the expedition and Mackay never received any reward for his efforts.

In 1865, the year the American Civil War, fought over the slavery in the Confederate south, ended, he turned his hand to something way more lucrative, commanding ships doing trade with the Pacific Islands.

His major cargo was Melanesian and Polynesian men, recruited, coerced, convinced or simply kidnapped to work as cheap labour on the sugar farms in north Queensland. This cheap foreign labour, doing work of which the bosses argued, whites were incapable, formed the basis of the creation and growth of the sugar industry and was the closest Australia ever got to slavery. The practice of procurement of the islanders was termed, 'blackbirding' and John Mackay was one of the major players.

Just on 11 kilometres south of Mackay, I turn right at the Rosella Store and then it's just 5 kilometres to the General Gordon Hotel, standing alone in the cane fields.

Charles George Gordon was born the son of an English artillery officer in 1833 and by the age of 27 he was a Major General and in China fighting the Second Opium War. When the Eighth Earl of Elgin, son of the Elgin who'd looted the marbles from Greece, ordered the total destruction of the Emperor's Summer Palace in Peking, it was Major General Gordon who oversaw the 4000 troops who smashed what they couldn't steal before burning the entire fabulous structure to the ground.

This amazing building, described by Victor Hugo as a 'masterpiece...a dazzling cavern of human fantasy with the face of a temple and palace,' was destroyed in retaliation for the refusal of the Chinese to allow Western embassies in Peking and for the torture and horrific murders of several prisoners by the Chinese.

Once the Palace had been completely gutted, Gordon then oversaw an auction of the loot and distributed the money as bonuses to his troops. The Empress's Pekingese dog was stolen and presented to Queen Victoria. It was christened, 'Looty'.

Even today the Royal Engineers Museum at Chatham in Kent has a large stash of loot including an imperial couch with dragon carvings presented to it by General Gordon himself.

Gordon retired to Gravesend in 1865 and his relationships with the 'ragged street urchins' whom he took in, fed and washed has been the subject to much speculation, as has been his sexuality generally.

What's more certain is his seeming death wish, evidenced by fearless displays bordering on stupidity, against opposing forces in Crimea, China and in Africa.

Finally, in 1885, having allegedly defied orders to evacuate Khartoum, he was killed by a spear two days before a relieving party could to get to the besieged city.

So I finally get to the General Gordon Hotel three kilometres east of Homebush. A pub named after a fella who oversaw the sacking, looting

and destruction of one of the outstanding palaces of the eighteenth and nineteenth centuries, and whose nearest main town bears the name of a boastful explorer come leading figure in the exploitation of foreigners, considered almost sub-human.

I'm looking for Lorraine, the publican, but she's been taken ill and Hammo her partner is behind the bar. He's fully across the history of the pub and if there are any things he's not sure of, two full lever-arch folders have clippings and memorabilia of seemingly every aspect of the pub.

Hammo reckons it was accidentally built in the wrong place, probably in 1886 to serve the employees and management of the sugar mill about three kilometres down the road to the south-west, which had begun crushing cane three years earlier.

By 1910 a small town had grown up around this misplaced pub with a butcher shop opposite, slaughtering yards down the road, a one man police station right next door, plus a post office and a couple of other stores. Most of the residents were dependent upon the mill for their livelihoods.

Initially the primary source of the sugar had been the Homebush Run, first selected in 1862 by our mate John Mackay. By 1883 it'd been acquired by CSR, whose general manager Edward Knox built the business on keeping production costs down, especially the cost of labour.

Knox was concerned with the mortality rate of the Islanders and so imported first Cingalese, then Chinese coolies, then Javanese, then Japanese to do the work, which was 'unsuited' to white fellas.

In 1918 the pub became the community focus when the worst cyclone in Queensland's history hit the town. Fifty locals crowded into the bar and the adjoining hall housed a herd of local goats, who probably felt blessed.

The local copper took control, closed the bar because he wanted everyone sober to 'cope with the rising floodwaters', and the whole party lived for days on bread and fresh meat. Let's just say the goats weren't as lucky as they thought.

In 1901 the White Australia Policy, a cornerstone of Federation, had ended the practice of foreign indentured labour and slowly costs and competition tightened their economic grip on the Homebush mill. In 1922, barely recovered from the cyclone, the town had another kick in the guts when the mill crushed its last harvest and shut down. The businesses and the houses surrounding the General Gordon began to close and be vacated until by the start of World War II, only the pub remained, alone with the cane.

Today it's in great, caring hands, its past honoured and its future eagerly anticipated. It's popular with locals and with tourists, many of whom use the 72-hour free camping out back.

As I'm almost done, two minibuses full of women of a certain age, mostly in fancy dress, arrive for a couple of drinks and some fun in the beer garden. The jukebox cranks up and as they begin to play up one tells Hammo he's the most seducible bloke she's seen in ages.

I head out to the bike. There's nothing here to overlook, no shady secrets, just a pub with a story doing good things with a future built not on the surrounding crops and not on exploitation, but on the great work of its custodians and the loyalty of its clients.

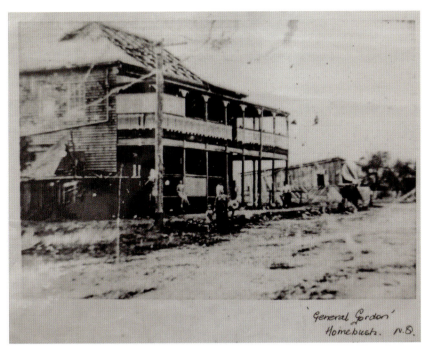

'General Gordon' Homebush. N.Q.

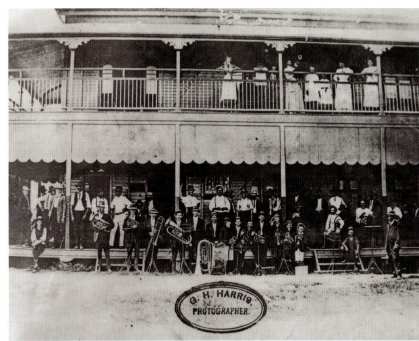

G. H. Harris Photographer

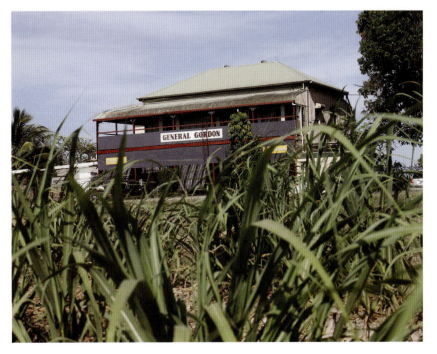

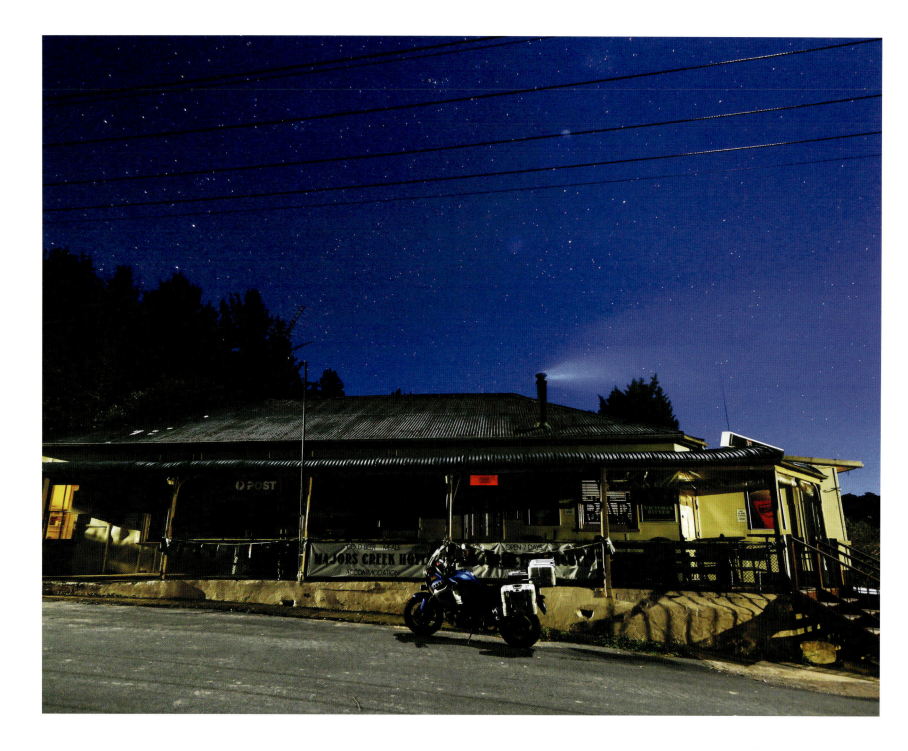

THE MAJORS CREEK HOTEL
MAJORS CREEK, NEW SOUTH WALES

I'm in Braidwood where the main street has more ex-hotels than extant hotels, and I'm in one of the brace of remaining ones, seeking a warm bum and a single glass of red before returning to the chill of the winter afternoon and the ride back to the Bungendore.

The Braidwood Hotel is the one you don't know about. It's the one you go past on the way to the Royal Mail or the pie shop or cafe, where you'll likely be seated between eccentric, sub-temperate locals and geriatric tourists on day release from Canberra.

It's a rare day in Braidwood when you don't spot a few sets of socks and sandals. It's all about comfort down here! This is a town where men tuck their singlets into their underpants.

The Braidwood Hotel has good food cooked and prepared by an actual chef, cheerful local folks on both sides of the bar, a good selection of beers and local wines and, most important for me this winter arvo, about the best bloody log fires in each bar and room that you're ever going to stand in front of.

When I yarn with Maddy behind the bar she tells me I've gotta get myself down to Majors Creek where the pub, owned by Kate who also owns the Braidy, is pretty damn special. Apparently there's bugger all else in the town: the pub's also the post office and apart from a couple of handfuls of locals, there's just big doses of quiet and roos.

Nothing else I really need to do today, so I finish my merlot and point right instead of left and in less than 30 minutes, with the low sun in my eyes, I'm crossing the bridge over a minor creek, which is Majors Creek, at the north-east end of the township.

Majors Creek's named after Major William Sandys Elrington, a veteran of the Peninsular War, a seven-year battle which had a couple of claims to fame: the defeat of that poncy bloke with his hand in his own blouse, Napper, and the real invention of guerrilla warfare. With the outbreak of peace, Britain had more surplus and unusable military officers than they could point a riding crop at so they pensioned them off, dangled the promise of a thousand or so free acres of more or less arable land in the antipodes and sent them sailing.

Elrington left Plymouth on the *Elizabeth* on 25 November 1826 along with his, er, housekeeper and son. They shared the voyage with three other families, a lone doctor, 60 sheep, a cow, oh, and, 32 steerage passengers who tastefully stayed below decks and out of sight. Four-and-a-half months later they got to Sydney and Elrington P&Od south for his promised land: 2500 acres on the Shoalhaven.

Now, just as the creek which was to become named, 'Majors Creek' wasn't a major creek, so too Major Elrington wasn't what you'd call a *major* major. When he cashed in his commission, he was less decorated than a Christmas tree in July, but when it came to bastardry, seems this bloke really was what university students call a 'double major'.

About the first thing he did was issue dire warnings to anyone thinking of driving cattle or otherwise crossing his land and his treatment of his convict slaves soon had him known as the 'flogging major'.

Obviously not a great bloke to work for and *The Sydney Morning Herald* reported that the infestation of bushrangers in the area had, 'been increased by several runaway convicts from the estate of Major Elrington.'

His personal zenith came in 1838. He'd had this Irish convict, Peter Neil, working for him since 1827 and in those days if a convict worked for one master for eight years and maintained good behaviour, he was granted a ticket of leave, effectively parole and freedom.

Neil fulfilled the eight years but Elrington refused to sign the papers. Peter Neil sucked it up and worked for another three years, when again he sought release. The boss had him arrested and charged and on 6 June 1838 Neil was sentenced at Braidwood to 75 lashes for insolence and neglect.

The convict appealed successfully and was granted his ticket of leave that October. The thoughts of Elrington are not recorded.

No wonder the pub prefers to be known as the Majors Creek Pub rather than the Elrington Hotel…bit like renaming the Belanglo State Forest the Milat Meadows.

Anyway, the next year he suddenly resigned as a Commissioner of the Peace and refused to ever explain the reasons, although the press reckoned it was connected with his mistreatment and refusal to sign the ticket of leave of another servant. In 1847, realising he wasn't going to get medals for being a dickhead, he took his bat and returned to England, leaving the district to some much nicer folks.

Once he'd scarpered the town really hit gold! In 1851 the place had 2000 miners and was the biggest goldfield in New South Wales. This was a town first then pub evolution, and soon two pubs were watering the hopefuls, the desperates and the few successfuls. The alluvial gold didn't last long and the solo panners were replaced by larger companies digging down into the reefs.

In the 1870s the Creek had a post office, four hotels, a chemist and two dozen other stores, three churches and two schools. By the turn of the century the gold was running out and the diggers were walking out.

By the start of World War II the population was down to around 500, but the government school struggled on until 1969. The old-school building, now a private residence, is on your left as you ride in.

And riding into town you soon get the sense that this is still a place of good folks. Between the bridge and the, er, CBD are two separate roadside resting areas, both well maintained with resting seats positioned to take in the view over the creek and the afternoon sun. I later find out that they are completely funded by Friday and Saturday raffles at the pub. So, don't be a tightarse, buy some tickets!

Anyway, I rock up at the pub, the only business remaining of the nearly 30 of 150 years ago, and of course the only hotel, and park Super Ten out front. I return the g'days of a couple of blokes having a fag on the church pews on the deck and head into the combustion-heater-powered warmth of the bar.

Linda's behind the bar and yes there's a spare room, and yes you can park your bike under cover and yes you can get a feed later and what'd you like to drink?

A young baby is being passed around for a cuddle from everyone, a pair of retired locals is yarning at one end and a group of blokes in work gear is hogging the fire. They're happy to move aside and let me thaw as we jaw, before I duck out to get a couple of sun-going-down images and the nip in the air has turned into a double with ice!

When I get back the blokes have gone but my keys, wallet and phone are still on the bar and Linda has a bit more time to fill in some gaps about the pub.

There are four rooms in the pub itself plus room for ten in an old railway carriage out the back with a good variety of single and double beds. It's 40 bucks a head including tea, coffee and cereal in the morning.

Now uniquely, the pub owns three non-contiguous bits of land: the block the pub and the railway carriage are on, a smooth grassed area complete with BBQ, picnic tables and wishing well across the road facing the 'randah, and a block of rougher country across the road on the creek side.

Riders are welcome to swag for free on either non-pub block but your best bet is the first one. Just five bucks for a shower but you might want to put it off. There's no mains water in Majors Creek and so H_2O is at a premium. Don't flush the toilets if there's (how do I put this?) only fluid in the bowl, and if you're showering, keep it brief and preferably do it with at least one mate!

This lack of water is reflected in no tap water available at the bar, but there's Lashes, Carlton Dry, VB, XXXX and Reschs from the keg and a schooner of XXXX is just $5.10.

There's no gambling but there's darts and pool and a good jukebox and the restaurant's open Friday nights, Saturday lunch and dinner and Sunday lunches, but I was there on a Monday and Linda rustled me up a top lasagna and salad. If you want food during the week, ring ahead and it'll be sorted.

As the evening develops the bar fills. It's Bruce's sixtieth and it's party time. A couple of locals tell me long yarns, which they don't want repeated, and they ask not to be photographed. The fire rages and the jukebox volume goes up and then Mick and Nick rock up after their gig on 94.5 FM, Braidwood's community radio station. The party mood cranks up another notch: bottles are bought, glasses are filled, toasts are made, songs are sung, laughs are had, logs are added to the fire. Repeat!

The pub closes when Linda, or whoever's working, reckons it's not worth staying open, so if you have a big and thirsty group, you could be in for a long night but most folks here have work in the morning so we wrap it up around 11.

Good pubs in the country have never been their town's drinking centre, they've always been the community's social locus. Folks don't go there

'to drink', they go there to celebrate and communicate, to socialise and organise, to catch up and to wind down.

The Majors Creek Hotel is such a pub. You get the feeling that even if all the old shops and shanties were still going strong, this place would still be the centre of choice for the Creek's social life. But now as a standalone, the only remaining place in town, it's not just the heart of Majors Creek, it's the lungs and the limbs.

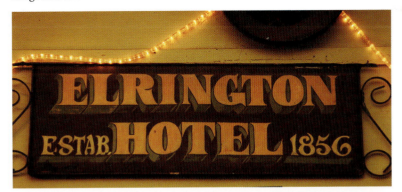

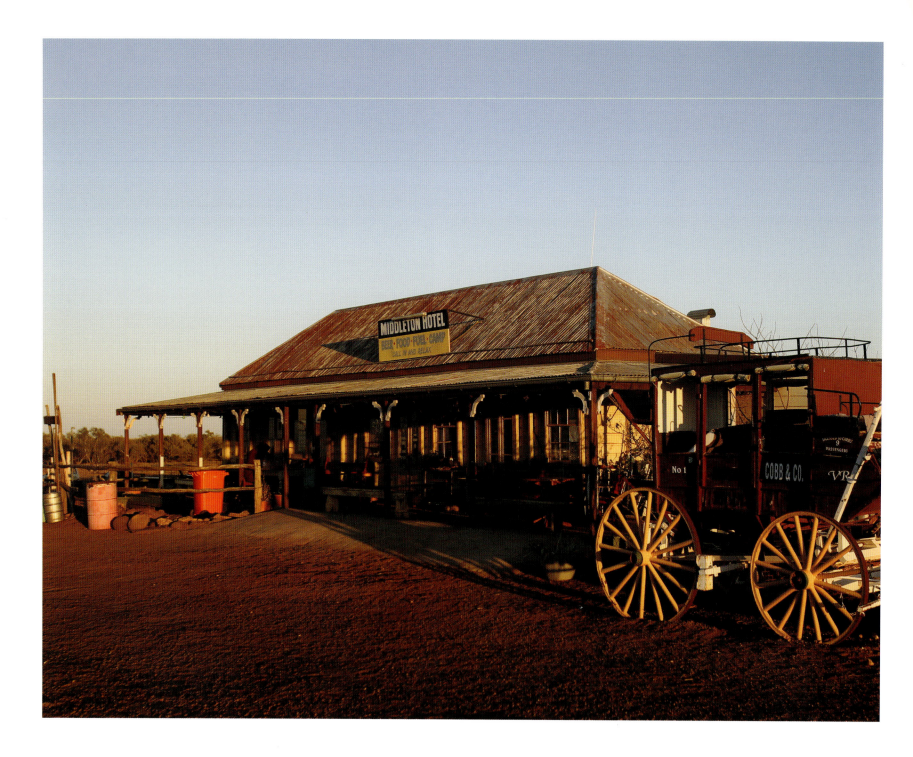

MIDDLETON HOTEL

MIDDLETON, QUEENSLAND

It was the light that drew me to Middleton. Actually it was the lack of it. It was that and a yarn on the mulga wire saying the pub there was a 'gotta-see'. And because I was camping, I didn't much care that it had no accommodation; apparently there was plenty across the road.

So anyway I headed down west from Winton, with the ubiquitous gales bashing me at every turn and on every straight (there ain't too many turns!).

The road from Winton to Middleton sees the country morph from harsh to brutal, from grey to red and back again. New hues come through but the toughness only ever increases. Hughenden is the end of the bush and start of the outback. This is the land of the laconic single finger driver's wave from the hand uppermost on the steering wheel. If you've been out there you know what I mean: the index finger raised, part in a kind of 'G'day' and part a salute for being a fellow crazy out here in the vast.

In the heat of the day I see nothing moving except for three emus midway down and crows and eagles on the regular roadkill, which points to a vibrant nightlife. Yeah, and night death. There's a few sheep ruminating on not much more than rubble and the occasional bunch of cattle. Most of 'em are greyish white, but I'm not sure whether that's their real colour or if they've just faded.

Five kilometres from Middleton a lone old shack stands solitary on my left. I imagine its history, its story of struggle, fleeting success but then eventual failure. Later at the pub that balloon gets well pricked when I find out it's just a film set from a recent flick. At least the Cobb & Co wagon out front of this once-upon-a-time staging post is real!

The 160 kilometres from Winton is mainly single-lane tar with a rare wider strip for overtaking. Eventually Middleton materialises from the road mirage. Pub on the right, a strange conglomeration of building structures on the left.

Now here's something I find really weird. There's a few—not many, but a good few—pubs which are so revered out in the bush that no-one ever parks right out front. Hebel was the first I've noted like that and I've been to a couple of others. Maybe drivers just know everyone's going to want to get a photo of the place, but I think it's more some sort of respect. You'd hardly plonk your rig at the gates of St Pauls!

Anyway, seems no-one parks out front of the Middleton Pub and so I choose near the Hilton across the road. Truly!

No-one's too sure who built the Middleton Hilton. I'm pretty certain it wasn't Conrad, but when I rock up a gaggle of grey nomads has taken up the lobby and are swapping the usual stories, myths, breaches of faith, lies, exaggerations, total distortions, fabrications, revelations and a few facts. Actually, not sure I heard any of the last. My kinda folks, but since I figure they might be table dancing all night with arthritic ankles and knocked up knees, I decamp over to the annex and shotgun the end part of the verandah. Then head over to the pub.

It's the second day after the Birdsville Races and I've been dodging endless caravans of caravans since yesterday and the pub is now filling up; folks smart enough to put it away when the sun gets low. It's going to be a good night.

The Middleton Pub has been run for the last decade by Lester and Val, and occasionally their son known only as 'Stoney', who also happens to own the Robertson helicopter parked out back.

There's no accommodation, all meals are from frozen, the beer is not cheap, there's no air con, no pool, no jukebox, no TAB, no Keno, no lockup parking for bikes, and nowhere to keep them out of the rain. Oh and showers are non-existent apart from the one you get from the overhead cistern as you stand at the urinals. These dunnies put the 'rude' into rudimentary.

Anyway, Lester's behind the bar, neatly decked out in his uniform of 100-year-old stubbies and blue singlet. No, that's it! If you're waiting on details of his footwear, shirt or jacket, sorry, but you might as well wait for the drought to break. (Oh, and I lied about the 'neatly' part.)

Val is out the back rummaging through the freezers to see what might be good for tea, with occasional appearances to help Lester when things get too busy.

There's no draught here, only cans, and it's all served with good humor and a wry grin. Lester's wit is more arid than dry and most enquiries are met with a rapid-fire, smart-arse answer, followed by a more helpful one. And don't even think of asking a question that's etched on the massive wall chart along with both smart and serious answers.

More refugees from Birdsville rock up, the front verandah fills as does the camping at the Hilton and the deck; sorry, 'my' deck over at City Hall. The bar and the balcony fill with characters; for some weird geological reason many of the rocks around here are smoother than the clientele.

Around 5pm Val puts word out that those wanting tea should put in their orders so she can start serving it at 6pm A line of mostly desperate single males forms, immediately placing preferences from fish 'n' chips, steaks and hamburger. No-one pays, just orders and gets out of the way.

An hour later the food begins to come out and it all gets repatriated to its owners and people are told how much to pay at the bar and they do because that's the way it is. This goes on for a couple of hours 'til finally Val, totally buggered from a day on her feet, plonks down with our group out front, as a few of us get up to clear away all the plates and bottles and she has some well earned.

By now son Stoney is working the bar, toward the end of one of their busiest days of the year. Over summer this place may see just a handful of people each day, sometimes not that many, and it'll be just Lester and Val, as Stoney is off rounding cattle in his chopper.

This is the home to the mythical Min Min lights, which Val reckons are nothing more than phosphorescent gases from the open bore drains, but my main reason for coming apart from the pub was for the deep black sky out here at night. If you want to see the heavens, this is the place to do it.

I go out and set up a camera to capture the pub and the stars and then head back over to camp. A couple of my new neighbours had warned me at the pub that they had a champion snorer in their number and damn me if he wasn't already hard at work!

I shift to the other end of the balcony then go back for my riding plugs. This guy could snore for Australia!

Well before the sparrows have even eaten the stuff that gives them their flatulence, the lights go on at the pub as Lester puts on a brew and waits for the twice-weekly postman who arrives around 5.30 from the east with food, mail, building supplies and a few other parcels.

We all share a coffee then postie's off, Lester stubs the lights, I get a couple of pre-dawn shots and we all go back to bed for an hour.

Just on sun-up Stoney takes off in the chopper for a day of mustering and the rest of the village begins to rouse. Folks wander across the road for a bacon and egg sanger and some instant coffee. Everyone's in good humor and as they begin to pack the swags and the motor-homers do what they need to, everyone says they'll be back.

They'll be back because this is not about the pub; it's about the building, about Lester and Val, about the Hilton across the strip, about the dust and about the quiet. It's about stars and it's about the people, about history and about fun. And it's about perfect.

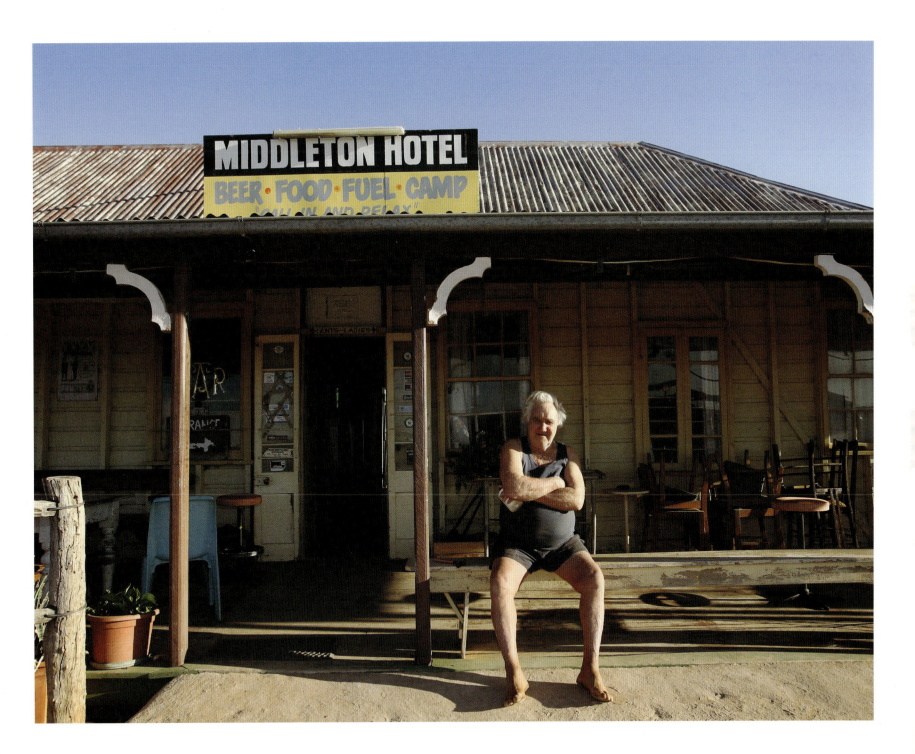

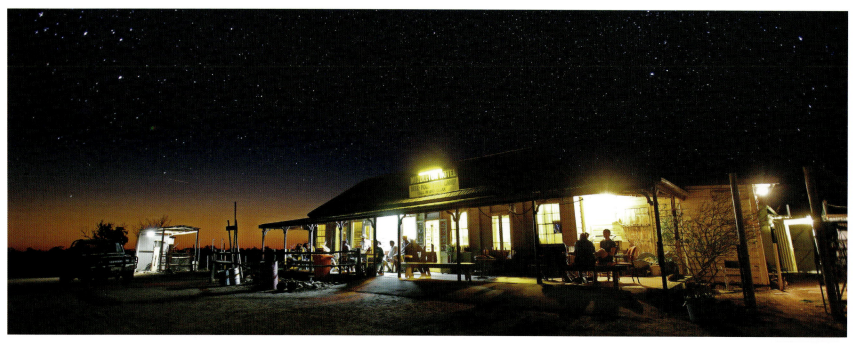

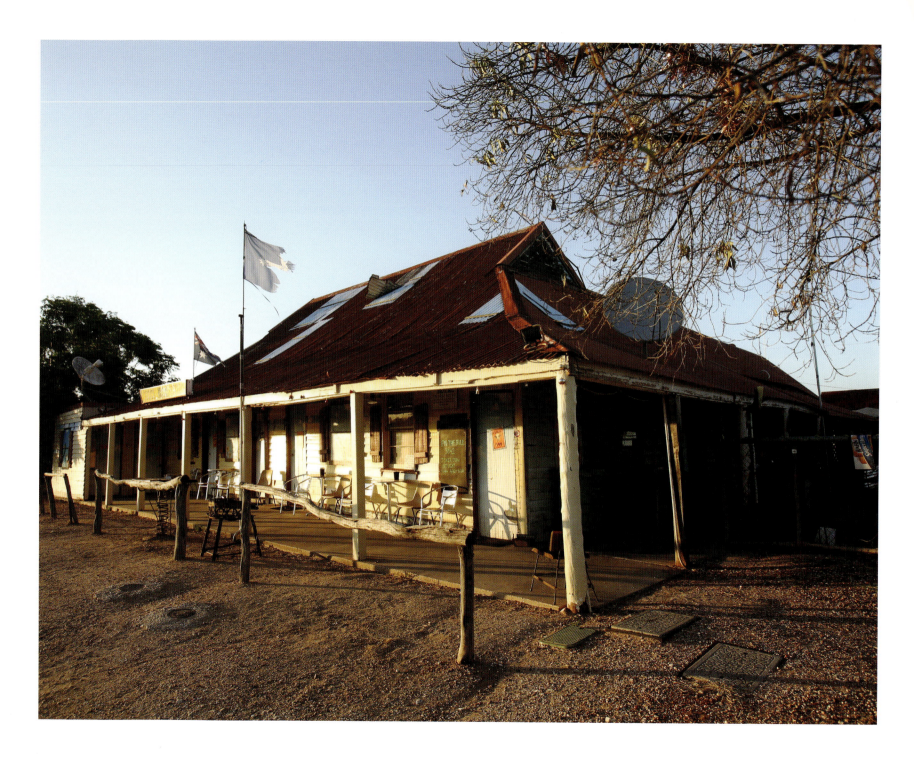

HEBEL HOTEL

HEBEL, QUEENSLAND

The sign announcing the border on the Goodooga–Hebel road signals the end of the dirt and broken grey soil track which passes for a road more than a state-line crossing. But way more eloquently, its colander appearance announces that the folks 'round here have guns, big guns. And they like shooting road signs.

I'd been at the southern end of the goat track on a mission for my late father whose best mate during his time in POW camp had been someone we all only ever knew as, 'Goodooga Bert'.

When Bert had left home and headed to the front, Goodooga must've been truly something; shops, and cinema, a theatre, a butcher, a coupla pubs, a local fabric, a culture. Today there's just a single pub, no shops, and the cemetery has three times the population of the town.

The locals in the pub were no more illuminating about Bert than the inmates of the graveyard would've been, so I headed for the border, the Hebel Pub, and a bloke I'd partied with the last time I was there a year or so back.

The cops had assured me the surface was hard packed and smooth. They lied. It was endless hourglass powder, too hot to touch under the 48-degree heat. It was hard going but eventually we got through to the white aggregate at the border with its target sign, and the easy seven kilometres into the one of the most iconic pubs in Australia.

No-one who has any interest whatsoever in outback or even bush pubs hasn't seen the Hebel Pub, either in the corrugated flesh or in pictures. Quite simply, this is the embodiment of an outback Australian pub.

I pull up out front in the afternoon shadow, go inside, grab a coldie from the owner and settle outside. Pretty soon the stillness is broken by a car's engine and my mate jumps out of one of his mates' utes. He's, er, 'acquainted' with the cops from up at Dirranbandi and no longer has the option of driving. We sit outside and talk of the awesomeness of Souths' victory in the NRL Grand Final in 2014, as utes and vans and 4WDs filter in and the pub begins to fill.

Hebel's total population is under 40 folks but chuck in the surrounding farms and this swells to well over, well, maybe 60! This Friday night, seems most of them are present and accounted for.

All the blokes ride ag bikes, and they've not seen one like mine before, so there's soon a gaggle around it until, kneeling, Mick calls me over with the news there's a pretty serious fuel leak from under the tank.

Oh great! I'm in a flyspeck town in the middle of Nowhereistan, it's going to be close to 50 Celsius tomorrow and my bike's likely to ignite if I touch the ignition button!

And then the call goes out for 'Greg'! 'He's got to be here somewhere!' 'He's always here on Fridays!'

Turns out Greg was in the dunny when the call went out, but soon he's under the bike searching for the leak. And he knows what he's searching for. In this town of 34, I've found a fully qualified Ducati mechanic, an ex flat track and circuit racer with a professionally equipped workshop back at his farm seven kilometres out of town.

'Bring it around at eight in the morning and I'll fix it for you,' he tells me, adding directions to his farm.

There's no scripting this sorta stuff. In a town of less than three dozen and with a bike suffering terminal explosive incontinence, I find a bloke with a full workshop and the expertise to fix the issue.

The next morning it takes Greg just on two hours to firstly change my dirt tyres back to roadies and then strip this bike he'd never seen before, remove the tank, locate the faulty O-rings, re-seat them and reassemble the whole thing again. (Oh, and then give me a ridiculously cheap bill for his trouble.)

Once fixed I head back into town to fill up but the bowsers at the pub are too hot to function, and for a minute or so I feel stranded yet again. Another local whom I won't identify sees my plight, and tells me he and his wife always have a ten-litre tank in his garage. Yes he'll help me and no he won't take any payment for it. Thanks Big Fella!

As the fuel gurgles in, I figure around ten per cent of the population had done me favours in 15 hours and I was pretty confident if I stayed a week most of the rest would've looked after me too.

The Hebel Hotel is one of those places where everyone has a story but not everyone has a surname. Some of the stories may be long and many are definitely tall but they all come from people who've not wasted time learning about life from books.

Tom's in his late eighties, I guess. He asks if the other seat at my table is taken and hearing it's not, plonks himself down and rolls a fag. Like many around here, he's an ex-shearer who's now turned to opal scratchin' and he's having a bit of luck. 'It's hot but it's easier on the body than haircuttin'.'

Tom reckons electricity coming was the best thing that happened to the bush.

See you can always find water and you can trap it when it rains but you can't go trapping electricity and carry it around with you. The first thing we done when we got power was to get a fridge and from then on we started eating a lot better.

Tom's father had taught him how to make a bower shed and with his wife Irene ('she's gone now, died 12 year ago') they built one as soon as they were married and moved in together.

After we had the thatched roof and walls, we dug a hole in the dirt floor, maybe three-foot deep, and kept all the soil to one side. We'd kill a beast in an afternoon, skin it and string it up overnight. Then we'd cut it into pieces and put the cuts into hessian bags, wet ones. Then we'd bury the bags in the hole and cover them with gum leaves, a real thick coating of gum leaves and then some soil. If there was enough water, we'd water the floor every evening, let it soak in overnight. That bower shed was the coolest place around. It was the woman's job to get up in the night, dig up the meat for the next day and then cover all the rest back up and water it to keep it cool. We'd get a full week of meat out of that until the meat began to sour and Irene would then sprinkle it with salt. So for the next few days we'd be eating corned beef but that was alright, and then we'd go out and kill another beast.

When we got our first fridge we couldn't believe it. Made everything so simple. But we kept the bower hut, just for a place to go and keep cool some days.

The electricity changed drinking habits too.

See you can drink spirits when they're not cold, rum and whisky, but a man can't drink warm beer, so once the pubs could chill the stuff, we all turned off the spirits and got onto this.

He raises his stubby.

And we'd drink it because we knew it was more or less pure, you understand? You could always be confident about the beer, the bloody water could've poisoned you in most places!

That's why I reckon us old blokes say, 'Here's health' when we raise a glass for a toast. I reckon we're actually talking about the contents in the glass, not just about wishing your mate a healthy time.

I excuse myself and head into the bar to get some photos and a key for my donga.

The Hebel pub has such classic lines that a succession of owners have refused to bugger the integrity of the building by adding accommodation rooms to the site. Instead, there are three dongas across the road and I'm in one of these air-conditioned boxes for the night.

In the morning I take all non-essential gear off my bike and head out to Greg, fuel dripping on my left leg. But there's no sparks and I make it unlit. It's early but I still need to wait as his wife calls him in from field work. Out here it's so dry that in good seasons the farmers dig massive holes and then bury their excess fodder.

Greg's been out digging up some straw for his hungry cattle and I know I'm digging into his work time, but he's eager to help. I offer to assist.

'It'll probably be faster if I just do it myself,' he says with insight and a smile. And of course he's right. Pretty soon it's all sorted, I've got his bank details for payment and I'm heading back into town for breakfast at the General Store where Barb and Ralph put on a great feed, and then I set sail for Lightning Ridge and a soak in its very hot artesian baths.

Four months later my mate rings me from Hebel with the news that the

pub's shut. He's turned up for a drink to be welcomed by bolted doors and a sign announcing 'Closed for a month for Renovations'.

Now the locals all knew that no works were planned and they weren't stupid enough to think anything other than the truth: the managers had done a runner. Packed up in the middle of the night and just disappeared.

This wasn't good news. The pub stayed closed for the first eight weeks of 2016 until Charlie, who'd met the owner down on the gemfields at Grawin, turned up to take over and the beer began to flow again. No more shonky managers, no more Scandinavian backpacker girls behind the bar to pull in the farm boys, no more irregular hours, just Charlie. And his dog, Chewie.

Charlie had left Melbourne to travel around the country and ended up in Grawin, where he got talking with the owner of the Glengarry Hilton. They hit it off and the timing was right. Charlie'd just patted a stray dog, which from then wouldn't leave his side, he was looking for a job and accommodation and figured he could run a pub.

When he got to Hebel, the pub had been pretty much stripped of its memorabilia, which he then found after breaking a padlock on a storeroom out back. He set about breathing life back into the place.

I catch up with him on a quiet night in late 2016 after first having a bite with Barb and Ralph, who tell me it's been a good season for visitors. There's been rain as well so the farmers are happy but they're looking to sell their store and adjoining caravan park.

> *We really love it here, but Ralph's refurbished an old bus and we're restless and ready to travel. Enough of listening to all the stories, time to make some of our own.*

I tell Barb that part of me hopes they'll find a buyer soon, the other part hopes they'll be here for years, and then head over to the pub.

Charlie's on a seat outside throwing a destroyed footy to Chewie who chases it down, does a bit more damage before bringing it back. Repeat!

It's midweek and it's quiet. On the road today I've seen one caravan and I've not seen another motorbike for three days. Charlie's last customer left an hour or so ago.

He tells me that Tom's passed away, as has the German opal scratcher I spent time with last visit. In two years the town's shrunk to just 23 people and there're only five kids at the school. More than ever the pub's going to have to work to make the town survive.

I get some shots in the 'bah' of Chewie savaging his footy then throw my tent beside the pub where it catches the evening breeze and I can get some night shots.

In the morning three tourist cars pull up at different times and as the sun comes up, something dawns on me. Some pubs, a very few, are so special, so beautiful, that without any formal decrees or signs, people show respect through giving them space.

Not one of the cars parks right out front. Every driver gets out up the road a bit and photographs the Hebel Hotel au naturel, unsullied by any obstructing vehicle. It's almost reverential, and as respectful as it is rare.

As I head north to Dirranbandi I hope that I won't any time soon be getting another call from my mate saying he's thirsty with no place to go.

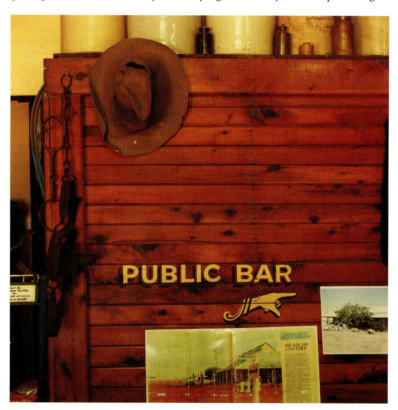

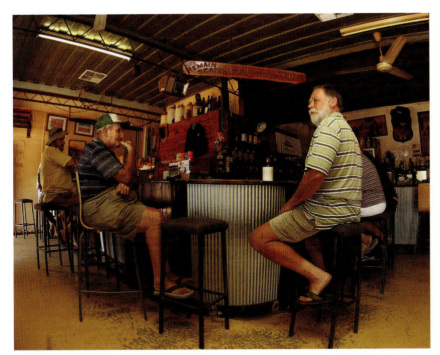

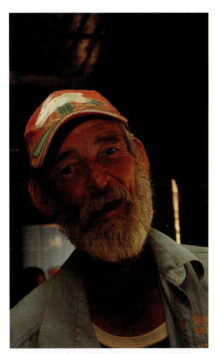

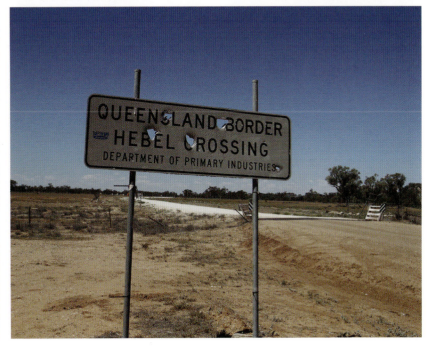

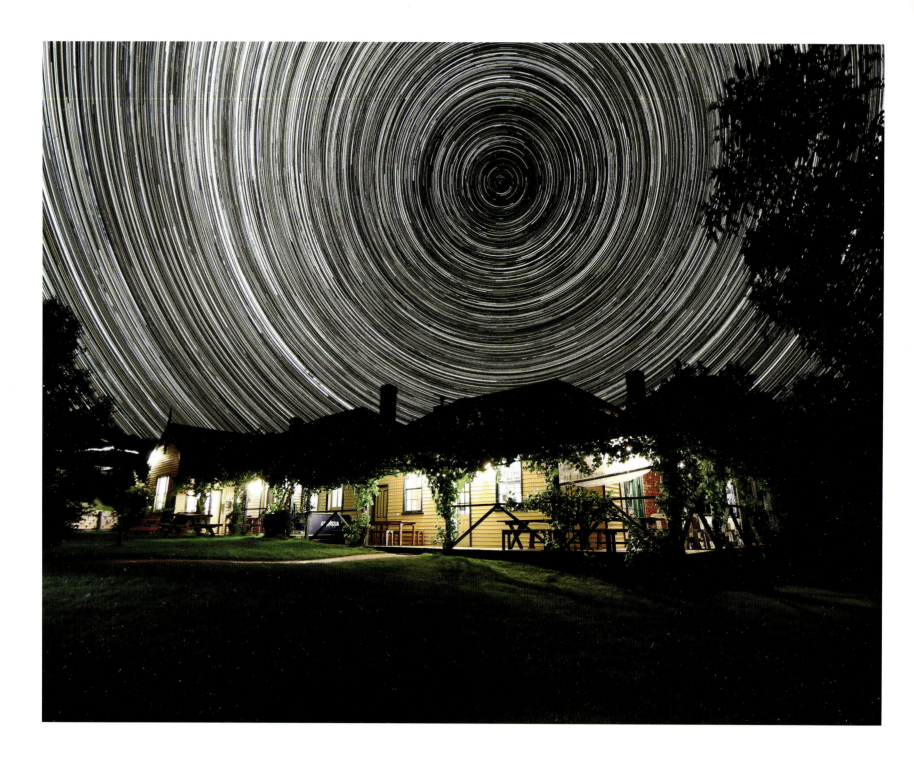

THE BLUE DUCK INN

ANGLERS REST, VICTORIA

My dad used to love the Aussie language. He'd worked in forestry camps north of Melbourne, gone off with the 6th Division to the war, got captured and then spent three years as a POW in Germany. These times, and the subsequent years doing honest toil with work mates who became real mates instilled in him a love of our vocabulary, the sayings and the vernacular of his home.

For my dad it was perfectly normal to stand in floodwaters up to his knees and remark, 'A few more days like this and the drought might break.'

Moonless nights were 'dark as dogs guts', a useless person was like a 'letterbox on a gravestone', and some things were as obvious to him 'as the legs on a giraffe'.

And he knew people, my dad. He told me never to trust a man 'who tucks his singlet into his underpants', to understand that 'the bigger the hat the smaller the farm' and to never get in a shout with anyone as 'tight as a rusty nut'.

But his favourite comment about this rich language he loved was pointing out that Australia is the only country in the world where a dark horse can be fair cow. He loved that! Thought it captured the very essence of the dry, laconic, ironic and colourful language what we speak 'ere!

And he loved the tales of our past. In 1957 when the film of Rolf Boldrewood's book, *Robbery Under Arms* came out, we piled into the old Vanguard and headed into Adelaide to watch it at the flix in Rundell Street. Afterwards we walked to Mary Martins to buy the book.

I didn't read it until years later and until I started researching a ride down through high country to Anglers Rest, this was the only Boldrewood I'd read. That changed when I found that his 1892 story *Nevermore* was centred around Omeo so I logged onto Project Gutenberg, got the PDF and got reading.

Boldrewood's Omeo is described as a, 'mighty rough town' which had 'the worst reputation of any goldfield' and where 'the worst villains in all Australia are gathered together.' The ride to it was, 'dreadful bad...long and tedious...(and)...positively dangerous.' In the town, 'you stand a chance of being arrested at any time,' and it was, 'the centre of a lawless region and a roving population.'

Surely, there must have been some bad stuff too!!!

So anyway I got myself to Corryong and then cut south on the Benambra Road through the gorgeous Nariel Valley before 76 kilometres of gravel, none of which was 'dreadful', 'tedious', or even 'dangerous'. I was beginning to feel fabulously let down by the time I rejoined the tar just north of Benambra for the sweet, sweet ride into the 'distant, rude...(and) isolated' Omeo.

I stopped for a refresher at the gorgeous Art Deco Golden Age Hotel before filling the tank and heading back north for the 28 kilometres of sheer riding pleasure on the newly sealed, smooth, serpentine and scenic Omeo Highway to Anglers Rest.

The Blue Duck Inn is a landmark pub for riders. It stands alone at the apex of a hairpin bend on the Highway. There is no town, no general store, no post office, just the Blue Duck. And a bridge. And it's beautiful.

I parked out front, exfoliated the riding gear on the vine-covered verandah and went inside, where the bar was bathing in the afternoon sun.

The Blue Duck is an inn, not a pub, and the rooms are fully self-contained, more motel than pub. The block of six rooms (four rated as 'rustic' and the other two as 'delux') is on the hill 40 or so metres up from the pub itself and when the vines are fully leaved, the approach is pure rustic beauty.

But opening the door, to my standard, 'rustic' room, I was hit by the beauty of the room. It was amongst the nicest, most tasteful and welcoming rooms I'd stayed in for a long while.

Light streams in through a skylight onto the polished wooden walls and floor. The room is dominated by a generous double bed and a wood fire. A gas oven and cook top is in the corner and under the window is a sturdy table setting for four. At the rear is another room with a double bed and a

set of bunks. The door to it carries a warning that if you've not paid for the extras, you shouldn't be a'comin' in!

With all beds taken, even with one rider in the doubles, each room will sleep four comfortably, but truly this is a place for couples and two couples are going to feel really at home.

What you'll notice pretty soon is the paucity of power points in the room. The Blue Duck is totally off the grid: no mains power, no internet, no mobile phone and all power comes from a diesel generator that chugs along in the background all night but is switched off when the bar closes.

Night power comes from the silent battery backup and is thus a valuable commodity. If you have batteries that need recharging, there's a million outlets in the bar when it's open so you just need to do it down there.

The power limitations are also the reason for the gas-fired fridge, the wood-burning fire and the lack of hair dryers, electric blankets and any air con. If it gets hot, open a window, they're all fully screened! If it gets cold, stoke up the fire and spoon that pillion!

All rooms, of course, are non-smoking, as is the front balcony of the block and the verandah that rings the bar.

Back at the bar I chat with Lana who's owned the place for seven years with her partner, Michael, a cabinet-maker who's done all the renos on the rooms and has overseen the installation of the generators.

This is their first pub after a background in B&Bs and they are fully converted to looking after riders. A standard week'll see about 100 motorcyclists dropping in on the way up or down the Omeo or looping to Falls Creek and Bright, and groups from clubs like Ulysses regularly stay for three days at a time. It used to be a Fisherman's Retreat, says Lana, but now it's a motorcyclists' retreat. (It's also the only place I've seen images of bikes on stubby holders!)

The restaurant is open Wednesday to Sunday (Monday is off-to-Albury-to-stock-up day) but a good option if you're coming with a group is to buy your food at somewhere like Omeo with its FoodWorks and good local butcher, and to cook up on one of the several beautiful BBQs in the Duck's grounds.

Not that the bar's not good! I love a place where photos and memorabilia of its past cover the walls and if you are eating in, their Rogan Josh is famous, they serve a nice smoked trout pasta and the 400-gram prime scotch fillet is their speciality.

A schooner here will set you back $6, which is the maximum I've come across outside north-west Oz. Rooms work out at $70 a head but if you've four in the room, Lana's prepared to haggle, but only if you tell her you're coming on two wheels when booking. But be warned that the Duck closes each year from the Queens Birthday in June until the first weekend of September.

After we get all the details out of the way Lana begins to tell the history of the place, how it's been standing for 110 years and how a bloke called O'Connell, whose picture's on the wall, first built it with the hope of servicing the miners in the local gold and tin mines. On getting the news that the government had refused him a licence to serve liquor and food to the thirsty and hungry miners, O'Connell exclaimed, 'Well that's a blue duck!'

Huh?

Lana explained that a 'blue duck' was a worthless mine, a hole in the ground with no metal worth mining.

'A blue duck,' she says, 'is a white elephant.'

I smiled. My arms goosed up.

How I wish my dad had been around still to hear that one!

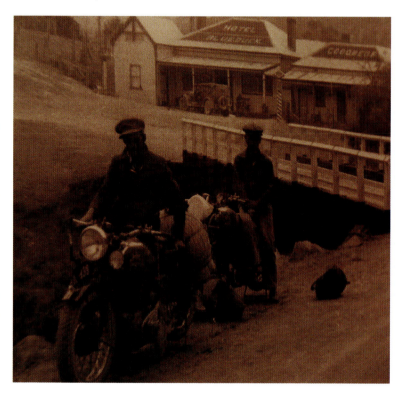

PRAIRIE HOTEL
PRAIRIE, QUEENSLAND

In ancient Greek mythology there were three fates: a trio of sister/goddesses who controlled all the major decisions and chance events of every person's life. For the Greeks, thread represented life and the youngest Fate was Clotho who spun the thread of human life.

At the end of the day, the low sun reflecting off the tarmac resembles, for me, a silver ribbon, and my mind plays with thoughts of the Fates and Clotho's thread and just where it is leading me.

I'm not sure where I was when I first heard about Prairie but it was somewhere in the Top End that someone in some pub had told me that if I was on the trail of special pubs, 'You should get yourself to Prairie. When we go to north Queensland, it's a must-visiter.' I stored the info and didn't think much more about it. I didn't really even have an idea of where it was other than it being the Queensland Prairie, not the South Aussie one, which is also very good.

A couple of weeks later I was on the Flinders Highway heading west from Townie to Mt Isa. As ever, I'd done enough planning and research to make the trip slightly predictable but not so much as to rule out fate.

The trip up from Townsville won't feature in any of my road porn collections but it's reasonably varied on a good surface all the way to Charters Towers. West of CT it straightens out, the road trains become longer and more numerous and the horizon flattens and spreads before you. A few small towns, in various states of decay, punctuate the ride. Homestead is now an ex-town, and Balfes Creek, Torrens Creek and Pentland struggle on, without help or support from a state government whose indifference borders upon sabotage and euthanasia.

Then bugger me, it's Prairie, 5 kilometres ahead. The Fates were at it again!

The Prairie Hotel is no longer the town's pub. It *is* the town. There's not much else here but a few failing houses, a couple of closed shops and a windmill that isn't what it seems. The pub itself is classic, single-storey, low-slung ,outback Queenslander, surrounded by hitching rails for your horse and a front verandah facing south, which must be wonderfully cool in the summer. The outside tables are modelled from old wool-classing roller tables and the benches from solid cuts from giant old growth. For some reason some kids' tricycles hang from the ceiling.

Now I'm struggling a bit with this next bit. I was going to say that when I got there on a lazy Tuesday arvo the place was empty except for Tom fiddling on his laptop behind the bar but that wouldn't really convey the effect. Because this bar, named the 'Old Ringers Bar', is never, *could never* be considered empty.

There's this old dentist's chair drawn up and ready at the bar's apex and the walls are covered in old bush hats, cross cut saws, water buffalo heads, footy shields, tools of trade, traps, old photos, XXXX ribbons...you name it. More tricycles hang from the ceiling. When you walk in you smile, and that, surely, is the sign of a great bar. I shelve my plans to press on. This'll be home for the night.

Tom and his wife Andrea took over this place when Andrea's mother Maureen passed away in 2005. Then it was, as Tom describes it, 'just a pub', so they both set about giving it some character. Today it is a quirky, unique, friendly welcoming spot for travellers (and the few locals who remain!).

Tom and Andrea run the pub on their own, and in the afternoon when the kids have to be collected from school, Tom leaves me on the verandah with my thoughts and my book and closes the doors for an hour or so. It's not a problem; no-one comes by.

Then as the sun dips lower, more vans and mobile homes arrive around the back and the bar begins to fill. The room has that special vibe that almost prevents people sitting alone and separate groups forming. All sit at the bar and the yarns, the stories, the fibs and the wonderful exaggerations begin to flow and flood.

Out back is a large non-smoking area near the kitchen, and if you've a texta you can leave your messages on the wall. Just be careful not to spill your

drinks on Tom's Harley, which is parked in here! This is where bikes can be parked under cover if the skies turn ugly.

Around 7.30 Andrea calls us to the dining room for dinner, and all those who've ordered sit down to a nice, home-cooked beef roast with vegetables on a magnificent gleaming timber table. And then the floor show starts.

Tom and Andrea have three beautiful young daughters: Lily, Bella and Cherry. The eldest two plus their best friend, Chloe from up the road, are just back from gymnastic lessons. Lily, the eldest, appoints myself and Alan, one of the grey nomads, as judges for their cartwheel exhibition back in the bar.

Young Cherry steals the show and the mass applause with her jumping and curtseys. Alan and I confer. One of us awards Lily ten, the other six, for Bella the scores are nine and seven, the best friend scores eights from both of us, while little Cherry also scores a seven and a nine. Well, bugger me! It's a four-way tie! Who woulda thunk!

The Rockettes wouldn't have got more applause. The girls take their leave and the laughs die down just a bit. Easy to understand why the pub's business card carries the names not just of Tom and Andrea but also of their three daughters.

Sometime after that Tom asks whether I'd be interested if he brought his pet water buffalo to the bar for a photo in the morning and I figure that, yup, that would be a fitting round off to a nicely surreal stay.

I head out onto the street where the road trains rumble past. A couple of 'em park up, the drivers come in for a softie and some chocolate. A sliver of a new moon hangs about the lights of a rig a bit down the road. The night is punctuated by kilometre-long trains on the line just across the highway, but it's all reassuring static and I sleep well in my donga.

It turns out that Tom has to run the kids to school and Buffy isn't exactly in the mood for an early stroll, so I walk the 20 metres to her paddock beside the old post office just up from the pub. Buffy's a wonderful beast. Friendly, with an incredible soft, low call, almost a purr. Gorgeous eyes which almost smile. When you meet her, just watch out for her horns but scratch her back, you'll both love it!

As I have my brew at a table out front, the grey nomads wander by from their free camp out the back to get some photos of the pub in the morning sun. All agree it was a top night in a top pub with top people.

I tell 'em about the three Fates of ancient Greece and the spinning of the thread of life. George, who's travelling around with his wife Eileen, sucks his teeth, 'Very fitting that them three Greek sisters brought you to the floor show by the three sisters last night, eh?'

Ah yes, fate can be a wonderful thing!

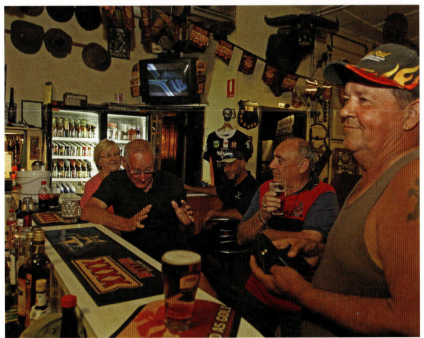

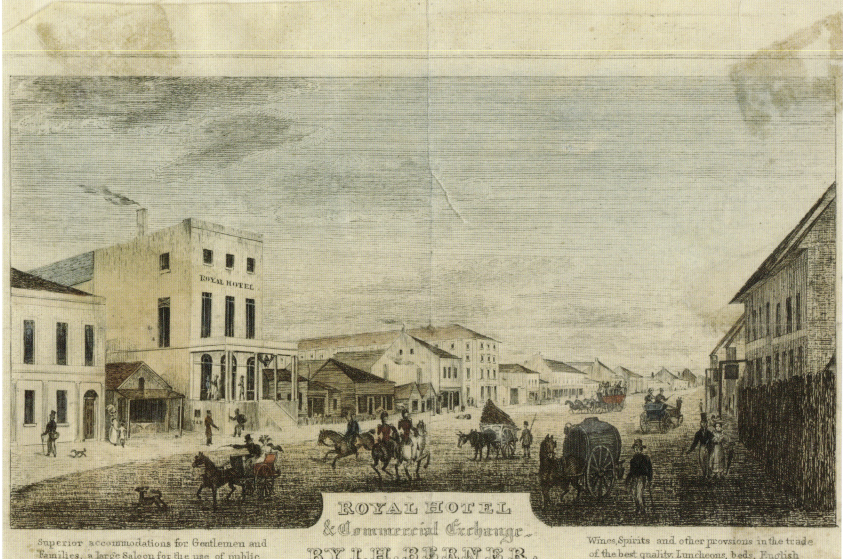

Part Two: Pub Royalty

ATTEMPTED ASSASSINATION OF H.R.H. THE DUKE OF EDINBURGH AT CLONTARF, N.S.W. — SEE NEXT PAGE.

On the first Tuesday of November 1977, Sir John Kerr AK, GCMG, GCVO, QC, the Governor General, mumbled his way drunkenly through a presentation speech to the winners of the Melbourne Cup. As large sections of the crowd booed, jeered and laughed, Kerr, the Queen's own representative in Australia, swayed and staggered dismissing the interjectors as mere, 'static'.

For the bloke who'd done Malcolm Fraser's dirty work and sacked the Whitlam Government, this was just another episode of comic infamy. But it was also more than that. It was another rich thread in the interwoven tapestry of royalty and alcohol that has characterised the history of drinking and liquor ever since the white fella first settled in this country. And the connection between royalty and liquor, between crown and lager, hasn't always been a smooth one.

More than a century before, just six years after her young husband Albert, father of her nine children had expired, due, it was rumoured, to sexual exhaustion, Queen Victoria dispatched her second son, Alfred, Duke of Edinburgh on a world tour. After Gibraltar and the Cape of Good Hope, 'Affie', as he was known to his mates, pulled up in his steam frigate, *Galatea*, at Glenelg in South Australia on 31 October 1867 to begin a five-month sojourn.

His time in Adelaide was suitably regal and jolly and he puffed off to Melbourne but things, well, things went downhill from there.

The Melbourne city fathers had the bright idea that the Prince's visit was a good opportunity for a feel-good loaves and fishes picnic by the Yarra. Get the city's 500 or so poor folks together for a free banquet with Affie and his entourage on 28 November. When they sought sponsors and donations, they were overwhelmed with offers so they became more ambitious, broadened their egalitarian dreams and made it open to everyone.

They had 120,000 pounds of meat including mutton, pork and hams, 4500 pounds of plum pudding, 5000 pies, 600 pounds of fish, 100 pounds of cakes, 300 gallons of beer, cases of champagne and claret and the pride and joy, the centre piece: a 600-gallon fountain of red wine.

Unfortunately 90,000 hungry thirsty folks turned up and their mood wasn't all that understanding and patient. The wallopers intercepted the Prince on his way to the fun and advised him not to front. They couldn't guarantee the safety of the women and children if he were to turn up and cause a stampede. The Prince heeded the warning and turned back. (He was a man who took police advice seriously having already relied on Police Commissioner Frederick Standish's recommendations when looking for a quality, discreet brothel down on Stephen Street.)

Anyway, the crowd took their vengeance for the royal snub. The food tables and tents were stormed and sacked. The *Melbourne Herald* claimed the size of the food fight was a testament to the wealth of grub on offer: 'That the food was there was beyond a doubt...it was actually being thrown about.' It continued:

> *Some climbed into the tree where the cask of wine supplying the fountain was placed, and, cutting the pipes, distributed the contents pretty liberally over the crowd, far more of the ruby stream going over the heads of the people than into the pannikins and buckets that were held up to catch it.*

To get away from the chaos, the Prince took off for the country. He headed for Ballarat where the cotton sails of a model of his ship the *Galatea* caught fire and ignited packs of fireworks that had been stored on the decks. Three young boys were in the firing line, couldn't escape, and died.

After this visit, which can honestly be regarded as setting the place on fire, the Duke left the Victorian bush and boarded his frigate for the cruise up to Sydney, where he no doubt hoped things would get brighter for both himself and the serfs. They didn't.

Prince Alfred sailed through the Sydney Heads and rocked up to Government House on 21 January 1868. The city was in a state of expectant frenzy. Sydney was different to its ruffian cousin down south. A couth and cultured time was seemingly assured.

After recuperating from his boat lag for a leisurely month-and-a-bit, the Prince got about getting about. On 12 March, having not learnt anything from their Victorian cousins, the locals bunged on a public picnic in aid of the Sailors Home at the oh-so-refined Clontarf Beach, beside where the Spit Bridge now disrupts traffic half a dozen times a day.

What could go wrong? There were no explodable model boats, no fireworks, not even a flammable dance hall. Yeah right!

On a glorious autumn afternoon the first member of the Royal family to visit the colony, Prince Alfred, Duke of Edinburgh, and his lackeys set sail on HMS *Galatea* from the Sydney Cove around to Clontarf.

The Sydney Morning Herald reported that, 'The squadron was the largest ever seen in the harbour, and their appearance, when anchored off the spit dressed with flags, was extremely pretty...' (I'm pretty sure scribes at the *SMH* don't use phrases like 'extremely pretty' that much any more!)

Now, folks who live around Coogee or Bondi will understand when they hear that the fun and innocent frivolity in the park were spoiled by an Irishman, although they'll be in disbelief when they hear that it was four in the arvo and he wasn't yet drunk.

After lunch William Manning invited the Prince to saunter down the foreshore, where a group of Aboriginals was going to perform. These 'First Feeters' were keen to entertain what a diarist of the time, Elizabeth Hall, described as, 'the Queen's picanninny'. But just a few steps into the promenade, the Duke of Edinburgh was shot in the back from close range. The picnic, and everyone's afternoon, went downhill from there; there really is nothing like a royal assassination attempt to put a damper on a bit of afternoon fun in the sun.

Henry James O'Farrell wasn't just an Irishman. He was an Irishman from Melbourne! And he also wasn't a great shot! The bullet went into the Royal's back, glanced a rib and did little damage.

Of the three grand present, a dozen went to the aid of the Prince and the other 2988 went after the Irishman. O'Farrell was badly beaten but escaped the mob.

'Lynch him' the *Herald* reported them as yelling, 'String him up!' But a couple of toffs and a few coppers intervened and got the badly bruised and battered assailant onto one of the ships moored just off the beach.

Where a welcoming committee of loyal sailors just happened to be waiting on deck with a noosed rope!

O'Farrell's handlers convinced them this just wasn't the way to do things in the empire (at least not to white fellas) and the ship cast anchor and delivered the Irishman to Darlinghurst Gaol (so they could hang him later).

The tended Prince returned to Government House on the *Galatea* whilst the picnickers held a spontaneous 'Indignation rally' to express their outrage at the alleged Fenian's 'dastardly deeds' and loyalty to Her Majesty.

In the days and weeks following these Indignation Meetings were held throughout New South Wales. On 21 March the *Sydney Mail* editorialised that, 'the (last) week had been one continuous history of indignation meetings to express horror at the atrocity.'

They included meetings at Grenfell, Cooma, tiny Araluen, and at Grafton, which had 'a monster meeting...(at the end of which) the National Anthem was sung...and three cheers were given for the Queen and Prince, and three groans for the assassin'.

Three groans; now there's a practice that should be revived!

By now you must be wondering just when we're getting on to the drinking part, and here it comes. The first meeting of the New South Wales Parliament post-atrocity was on Wednesday 18 March. All general and standing business was suspended so they could frame a letter to the Prince

in which they, 'express(ed) (their) horror and indignation at the attempt made on the life of Your Royal Highness, and to assure you that we have shared in the profound grief and sympathy which have pervaded all classes of the community'.

The Council also pushed through a Bill passed that same day in the Assembly. It's stated aim was '…better security…(and the) suppression and punishment of seditious practices and attempts.'

Section 9 of this *Treason-Felony Act* stated, if any person were found guilty of, 'us(ing) any language disrespectful to Her Most Gracious Majesty or… factiously avow(ing) a determination to refuse to join in any loyal toast or demonstration in honor of Her Majesty', they would be liable to 'be imprisoned with or without hard labor for any period not exceeding two years.'

There you have it! Two years hard slog for refusing to raise a glass to the Queen. Cheers!

I poured through the Acts of New South Wales and couldn't find when this had been cancelled, rescinded, negated, repealed or whatever so I gave the current governor, David Hurley, a shout. One of his man-servants called me back:

> *The New South Wales* Treason-Felony Act *of 1868 was so odd that it was apparently never applied. It did not find favour with the British authorities. Consideration was given to the exercise of powers reserved under the* Colonial Laws Validity Act *of 1865 to withhold royal assent, but eventually that step was not taken…it was recognised as an over-reaction and became a dead letter.*

He could find no record of the Act being repealed but he pointed out clause 11 which stated, 'No…prosecution (shall) be commenced for any offence under the ninth section of this Act after the expiration of two years from the time of the passing of this Act.'

As the Prince recovered, spending, it was reported, a fair bit of time in the billiard room, the good citizens concentrated on outdoing each other with ostentatious displays of love and devotion to the motherland.

A collection was taken up for a monument to the ailing Prince and it was decided that the most fitting tribute would be a hospital. The Prince Alfred gave his assent and the Royal Prince Alfred Hospital is still doing great work at Camperdown in Sydney.

O'Farrell was hung in Darlinghurst Gaol and for the next half century every second new pub in the colony seemed to be called, The Royal Hotel.

'The Royal' remains the most popular pub name in Australia and there's still close to 200 of them, most in New South Wales but a good smattering in Victoria and Queensland. I figured it'd be interesting to ride from the mainland's most southerly to the northernmost for a right royal pub crawl. But you don't plough a field by turning it over in your mind, so I packed Super Ten, my Yamaha Adventure Bike, and headed down to Portland Victoria to pay loyal homage.

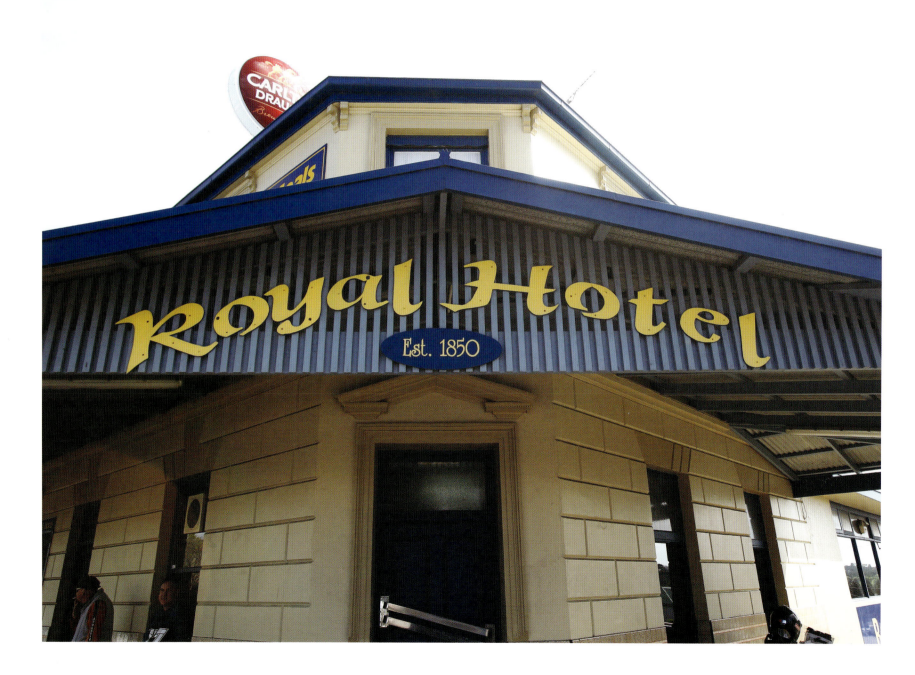

ROYAL HOTEL

PORTLAND, VICTORIA

The last 200 kilometres of the ride south to Portland, I'd been hit with a wind that could've blown a blue dog off a rusty chain. Fifty, 60, 70 kilometre an hour blasts constantly bashing me from the west, the bike dancing sideways each time a semi passed upwind, the rain squalls drumming on my visor.

By the time I hit Bentinck Street beside the port I just need a seat in the lee of the gusts and a place to put my feet up. The rains have stopped but not the wind, and I sit watching two tugs bringing in a freighter. For half an hour they battle the waves to get the ship to the jaws of the harbour but then at the very final moments, they turn it around, cut it loose and sent it back out to its anchorage to wait for some abatement.

I get back on Super Ten and head to the Royal. It's the only one of Portland's four pubs that's not on the tourist strip of Bentinck Street and this geography makes it more a pub for locals than a place for tourists. I park the bike under the side awning but the gale ensures the bike still gets a drenching. At four in the arvo inside it's all hi-vis tops and working boots. Phil's behind the bar.

'You'll be Colin and you look like you could do with a drink.'

He's batting 100 per cent so far, so I strip off the riding gear, grab a beer and a water and take a window seat to survey the place.

For 15 years before it separated from New South Wales in 1851, this part of the country was known as the Port Phillip District, and because it was not easily accessible from Sydney, white settlement was banned.

Larkins and Muir, in their book *Victorian Country Pubs,* argue that Portland and this entire Port Phillip District was actually *invented* in a pub, a pub in Launceston, Tasmania 'where a group of men had gathered in the billiard room one evening in 1834 and, having had a few too many, decided they'd like to live in Melbourne.'

Meanwhile, after two years of fruitless farming on the Swan River in 1832–33, Thomas Henty and his sons left Western Australia and headed to Tasmania only to find all the decent land taken.

They petitioned the British Government three times for permission to settle on the north side of Bass Strait but were rebuffed each time. Pissed off and impatient, they decided to do it anyway and in 1834 landed in Portland Bay and created the first permanent white settlement on the south coast. They built a rough house overlooking the bay, and the township was eventually surveyed in 1840 and the first pub, the Golden Fleece, was opened the same year.

According to Larkins and Muir, up to that point the most reliable supplier of grog was Jane Henty who, 'used to bribe sealers with rum to get them to church services in the shearing shed.'

The Hentys sold their home in 1847 and in 1880 this first building in Portland was opened as a pub. Today the Richmond Henty Hotel, stands on this same site.

The Lamb Inn was built in 1857 on the corner of Tyers and Percy streets. Made from local bluestone, it was built to last. It's had a few modifications and additions but today, having been renamed, 'The Royal' in 1889, it's standing tall and strong and it's my home for the night.

You get an idea of the age of the place before opening the door to the public bar. A century-and-a half of work boots have worn the doorstep down into a beautiful concavity.

An early TripAdvisor type review of this place said, 'flies were frightful, fleas were in countless numbers...(and) all I got (for breakfast) was some cold fish recooked, old bread with rancid butter.' I'm hoping things have improved a bit since this bloke, walking from Melbourne to Adelaide dropped by in 1880, but his bill of two and a zack would be a welcome cost!

I knock the head off my drink and join a group of workers at the bar. It's been a frustrating day for Ian, whose job is organising the gangs that

unload the ships. Turns out the freighter I watched was loaded with wind turbine sails and he'd just finished booking the morning shifts when the tugs gave up and set the ship free.

> *Once in five years event, they reckon this is today. Problem is we had a once in five yearser a couple of weeks back, and they said the same about another one a month or so ago. Time bloody flies down here, eh? Either that or they just don't have a fucking clue!*

We get onto the history of the place and some of these blokes have been drinking here for a while. Tom's now 52 and has been drinking here since he was legal.

> *Couldn't sneak in any earlier, everyone knew my parents. In the old days, before the meatworks closed in '96, this place was never known as the Royal. Everybody just knew it as, 'The Duck and Weave'. It was rough. The Borthwick Boys from the meatworks would work with carcasses all day and turn up here with the taste for blood. Us wharfies and the fishermen figured it was our pub and there'd be a blue most nights. If you didn't know how to duck and weave you'd be on your back pretty quick.*

This is Phil's second stint managing the place, the first was from 2007 'til 2009 and when he left:

> *The place was booming. We got it back to a safe, friendly pub for locals. No gambling. We made the decision to turn this into a pub where people talk and have a laugh, bring their families.*

A woman at the bar underlines his point.

> *My girlfriends and I all feel safe here. Once some tourist had a go at me, and the men stopped drinking and told him to shut up and apologise and then leave while he could. He turned to jelly and pissed off real quick. It's a great pub like that. We all look out for each other.*

At the far end of the room is a pool table but the eye-catching thing about that part of the bar is the seating. Echoing the very start of public houses in Australia when seats were just placed around the perimeter of the host's largest room, there's a unique fixed bench seat extending fully along both walls.

I get some shots as the conversation ebbs and flows. There's no cold fish on the menu so I devour a fine meal of marinated lamb, and slowly the workers cross the well-worn threshold and head home. Phil looks out at the weather. 'Even a bike doesn't deserve to be out in this. Why don't you ride it into the bar?'

I wear down the step just a fraction more and park beside the fire. It's a special pub that cares so much about the comfort of its guests and of their rides! Oh, and upstairs there's not a flea to be seen!

PORTLAND TO SNAKE VALLEY

The rain's gone but the westerly's still raging the next morning when I ride the bike out of the bar, but at least now it's from behind me, pushing me along the coast to Warrnambool and lunch at the Royal.

Thirty-five kilometres out of Portland I come across one of those weird, I don't know what they're called,d but they're dotted along country and outback roads: often trees, sometimes fences, sometimes an actual Hills hoist, from which you'll find hanging a particular type of thing. Sometimes it's bottles, or televisions, or bras, or undies or t-shirts. This time it's a shoe fence. Seems the rule is they have to be in pairs: I can't find any singles, no strays, just a hundred metres of 140 fence covered in old footwear.

Who the hell thinks of this stuff? Who starts it? Is it begun with just one pair or do you need a few to, er, kick it off? I have no idea and I don't really need to know. It's just one of those outback mysteries for me.

So I get a couple of shots, wonder at the silliness, and continue east. Twenty kilometres on, just short of Yambuk and the crossing of the Shaw River, I hit something truly unexpected: a herd of water buffalo. What? I pull out a longer lens and not long after I start shooting, a 4WD pulls up, the window comes down.

'They're Italian milking buffalo. Beautiful aren't they?'

They are sure are.

'They're mine. Would you like to come up to the farm and see the cheese we make from their milk?'

Is she kidding? Do buffalo act like bears in the woods?

I follow Thea's car up the driveway to the beautiful Shaw River Cheeses farmhouse and tell her about my royal ride.

'So I'm totally on-topic,' she smiles, 'my surname's "Royal".'

I'm thinking: You can't make this stuff up!

Thea, her husband Andrew and her father, Roger Haldane, run this beautiful farm making one of the very few ranges of pure buffalo milk cheese ('many of the others contain cow milk').

Roger must be one of Australia's most interesting men. He's illustrated a few books, helped found the tuna fishing industry in Port Lincoln, imported the first alpacas to Australia and then brought in the first Italian buffalo. Later, he and Thea imported the first herd of pure Icelandic horses, which they now also breed and sell.

As we talk Thea brings out some cheese samples. The mozzarella is her special pride and its texture and taste are indescribably special. They give me two hours of their time and a little goodies bag when I leave.

I get to Warrnambool two hours behind schedule but six months too late. The Royal is shut, bought by a bunch of city doctors and turned into a medical centre, so I head north-east for Snake Valley.

About 80 kilometres on and into the Corangamite Region the roads are suddenly edged with dry-stone walls. Built in the late nineteenth century, they're double-layered basalt with supporting rock throughstones. They seem as out of place as the buffalo, and a plaque at the viewing area explains their history.

The rain returns for the last 60 kilometres into Snake Valley, where the smoke from the pub's chimney means I'm about to get a whole pile warmer.

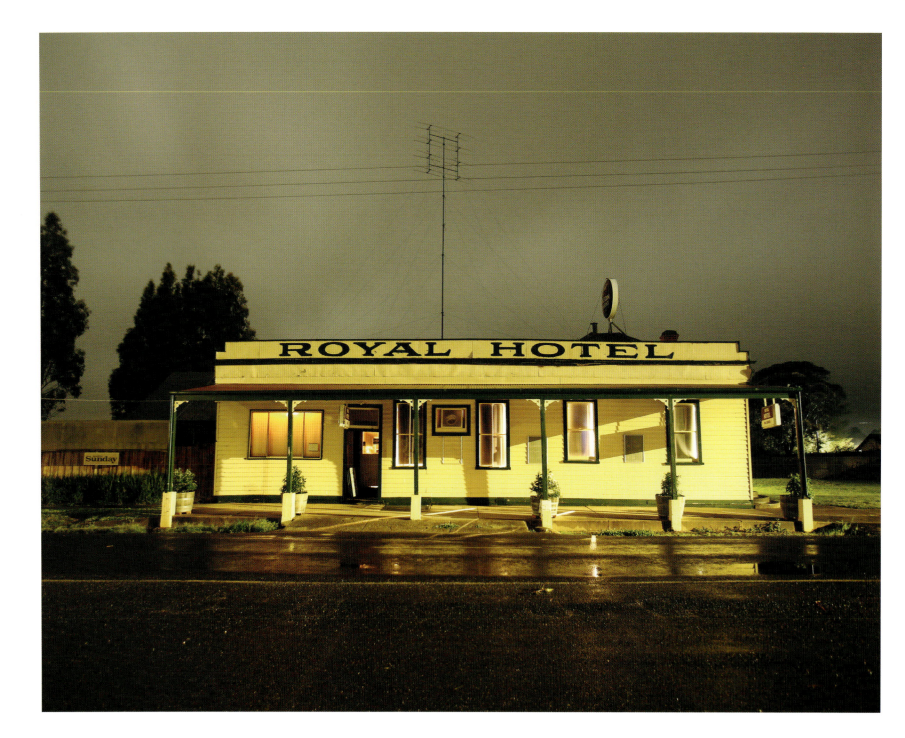

ROYAL HOTEL
SNAKE VALLEY, VICTORIA

The Snake Valley Royal's so close to the road that parking right out front is impossible, and across the road is a weird parking area that some genius in the Pyrenees council thought up and the locals immediately destroyed. I park Super Ten there in the rain and wind and head to bar.

Fay's working and immediately suggests I move the bike around undercover beside the boss's car. It'll be safe and dry and much closer to my $60 room. She passes me the key.

The room's got everything I need: strong hooks to hang the armour stuff, an oil heater to dry out my boots and an electric blanket on the double bed. Down the hall is a little kitchen with fridge and kettle: Simple needs fully met.

Back in the bar, I get a red wine and check the place out. There's a huge water buffalo head mounted in pride of place on the wall behind the bar. No-one's got a clue of its significance—who killed it, who stuffed it or who stuck it on the wall—but they're damn sure it's not from Yambuk. Beside it are half a dozen of those framed racing photos from the finish post of trotting races; all feature a thing called 'Belts' crossing the line first. There's a TV at one end, a bingo ticket machine next to the fire and a pool room out the back.

A trio of chainsaw jockeys comes in after a day cutting up trees that've blown down. I've passed half a dozen bits of their work on the way up from Mortlake.

Meanwhile, Cupcake's sucking on a long neck beside the raging fire and I muscle in to get some feeling into my fingers.

He's a shearer, had an early finish when the sheep got too wet, so he's kicking back; the first fella I've seen who wears orange Crocs to match his hi-vis top. Snake Valley's obviously some kind of fashion capital around here. Four years ago he had a stroke, the doctors reckon it was from the stress of year-round shearing six days a week. He's fully recovered but now has two days a week off and uses a harness.

It's pretty quiet, the fire crackles, the trio are entertaining each other and Fay is keeping an eye on things. Then Ian and his mates rock up.

They've all come down from a trotting stable across the valley and they've got a sleep-in in the morning, so they're up for a session. Ian and a couple of mates are blow-ins from the city but the others work the stables. They're an eclectic mix spanning the less-polished end of the roughness scale, and in their midst Ian seems almost genteel. The boss man hasn't joined them. Together with Fay and the owners of the pub and seemingly half the town, most of these fellas own a share in the trotter on the wall. And because it's racing at Ballarat tomorrow they don't have to get up at sparrows.'

We talk about racing and the red hots and they tell me to get on it. It doesn't win every race, but it's looking pretty good. I tell 'em I don't often bet and they're sceptical. They reckon I look dodgy enough to be a punter, so I dredge up one of my stories.

Many years ago a bloke I knew asked me to drive out to a midweek country race meeting. He had a horse running in the city that same day and he, ah, knew, this thing was going to win and he needed an unknown bloke like me to lay some bets.

So, he loaded me up with cash, and I headed bush, found a Telecom phone box, (this was way before mobile phones) called him and we synchronised watches.

Right on the agreed time I started layin'. Twelve to one was the first bet. Bookie after bookie wrote me cards and the odds shrank fast until the last was just 6/4. I got maybe 13 different bookies and then I just found a place near a loudspeaker coz they didn't have video monitors, and waited for the race.

The thing won easy and I pulled the tickets out and started collecting. I'm almost done and suddenly there's a couple of blokes

beside me. One flashes a D's badge and tells me he thinks I'm going to need their help to get outta there.

I tell them that I've got three more cashes to go and they say they'll just stick on either side so I collect all the money, from the last bookies. They walk me to my car, one stays while the other gets theirs and then they follow me until I'm about 30 kilometres out of town. Then they just toot their horn, do a U-ey, and I head back to Sydney.

I was a squarehead then so when I got back I asked the bloke about it and he explained all about shorteners and looseners, about 'boat races' and 'one-goers' and he told me what to look for in races when I don't have any inside info. You know, how to track the smart money.

I still have a bet every now or then but only when I've got the time to follow the shorteners. I don't listen to the urgers.

We talk of the old days when the trots truly were the 'red hots'. Where some races were seemingly so well scripted they deserved a Helpmann Award!

We talk of cattle prods, electric whips, flat tyres, getting a trotter to 'break', how taking the enforcer to a horse coming up the rise at Randwick was a good way of tiring it out well before the post. Of how looseners always come out of the barriers just that little bit hesitantly. And how to back winners, especially in 1400-metre midweeks.

Out here you need to trade intimacies to get intimacies, to get some confessions you have to confide yourself, to be entertained you must be entertaining. Pretty much like being in a shout. No-one's going to buy you a drink if you don't head to the bar when the circle comes to you and the yarns'll soon dry up if you don't make them laugh a bit yourself.

You can't just be a sponge.

We order dinner. I opt for the lamb shanks and mash, which is perfect, what my mum calls 'stick to your ribs' food, for cold weather. Seems there's only two sorts of people in the bar, those who live here and those who wish they did.

A few of the stable crew head out to play pool. One is the worst player I've ever seen. The white ball spends more time in the air and on the floor than on the table, but everyone's having a ball. Other locals drop in for a chat and a drink, a couple have dinner.

Before I head off, I settle the bill, careful to pay in only $20 notes. I leave the racing boys trading foul shots and fouler stories. Before I head, Ian grabs me, tells me he's not an urger, and that their horse is no certainty but still a decent chance. I note Belts's details: number nine race six at Ballarat.

Another Royal which ain't regal, but damn some of the drinkers are majestic!

In the cold damp morning I head out on the trail of another royal connection.

John Flynn went to the local public school in Snake Valley and I'm hoping they have a plaque or some other tribute. The deputy principal knows he attended but there's nothing: no plaque, no photo, no evidence and certainly no celebration or recognition.

John Flynn founded what was to become the Royal Flying Doctor Service. He was a dreamer who imagined it was possible before there were planes capable, who persevered until he got a financial break from HV McKay and a very cheap plane from Hudson Fysh, the founder of Qantas. This is the man honoured with his mug and his story on each of the 20 bucks I had handed to Fay to settle last night's slate.

Every one of us who travels into the heart of this land does so with a safety net of sorts. Every pub worth its salt collects for this safety net, the RFDS, with either notes stuck to the ceiling, an upturned umbrella where you chuck your change, or a simple collection box.

Yet the local Pyrenees Council can find the money to erect a hopelessly useless carpark but has neither the vision nor the will to honour the school of the founder of our most unique, iconic and respected national institution (along with the Surf Life Saving Association). I figure the Council must be permanently blinded by the sort of fog and mist that hits me as I head north and out of town.

It's a quick squirt east to Ballarat and with the seamless, endless mist, the morning sun is no concern. When I hit the town, I head straight for the pub.

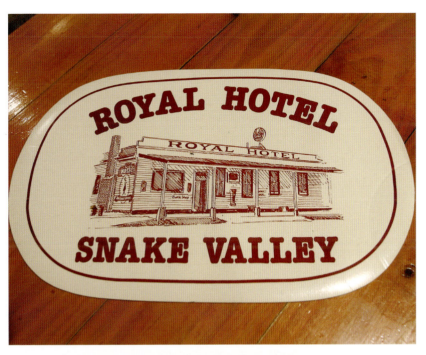
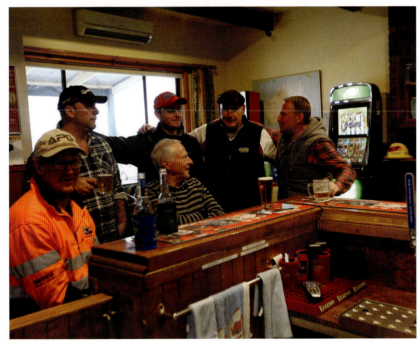

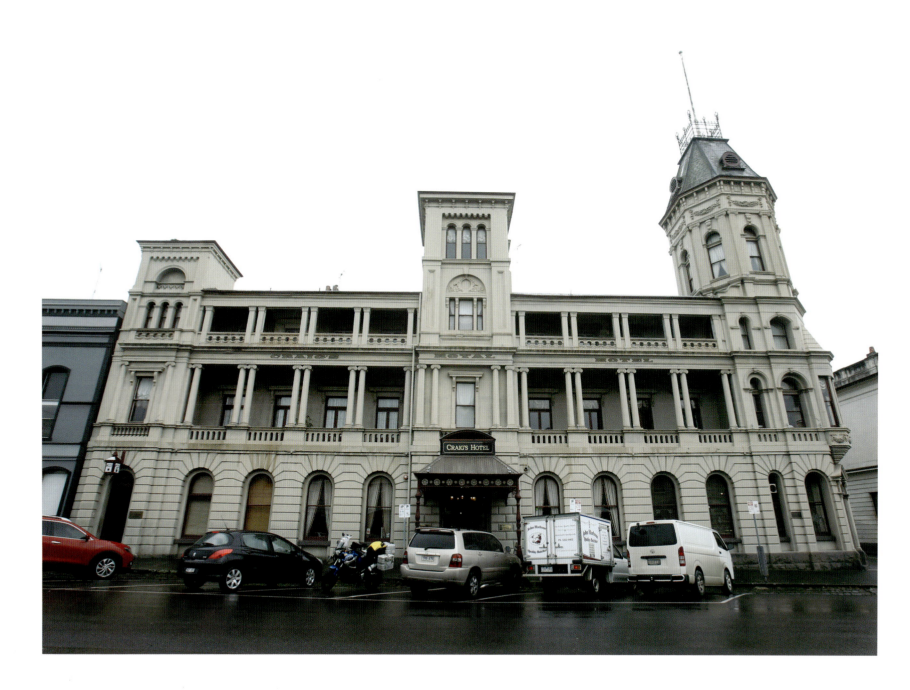

CRAIG'S ROYAL HOTEL

BALLARAT, VICTORIA

Craig's Royal Hotel, Ballaarat is truly regal. From its pedantic insistence on retaining the original spelling of the town to the massive chesterfield lounges that fill its front lounge, this is obviously a modern Royal, which honours and celebrates its history.

Walter Craig took over the existing 1853 Ballarat Hotel in 1858 and changed its name soon after. It's changed hands a few times in the last 160 years but its elegance and charm make it truly old world and special.

I park Super Ten right out front, head past the gleaming nameplates and into the welcoming warmth and hum. To the left is a vast, stunning, high ceilinged reading room lounge filled with wonderful furniture and ornate lamps. To the right is a more modern cafe where, already, local professionals and clients are doing business over coffees and some damn fine looking food. I order a double shot and a homemade tart and repair to the reading room. On one wall there's a framed list of famous guests, seemingly listed in chronological sequence beginning from day one but then finishing back in the 1960s.

In 1865, the final year of the American Civil War between the Yankees in the north and the southern Confederates, the Confederate ship, the CSS *Shenandoah* docked in Melbourne for repairs. With both sides using whale oil to grease their ships' cannon, it was on a mission to destroy Yankee whaling ships in the southern oceans. Oh, and predating ISIS by a full century and a half, this ship from the slave-owning South, was also on a more secret mission to recruit foreign fighters

Whilst it was being fixed the crew headed up to Ballarat for a 'buccaneer's ball' in the Craig's main dining room. Its captain, James Waddell, stayed at Craig's Royal and tops the list of notables on the wall.

Back in Melbourne, the ship was later surrounded by police on suspicion of illegally recruiting locals for the fight and although no action was taken, when it finally pulled out of port, 42 Victorians were on board and headed for battle.

By the time the Captain Waddell got the ship back to America, the war had ended and he surrendered, but not before his whale-lubricated cannon fired the very last shot of the American Civil War.

The second entry on the notable guest list is the members of the Eureka Stockade Royal Commission but then the third is an old friend of this chapter, none other than Prince Alfred, the Duke of Edinburgh, who stayed here in 1867. He probably would've stayed longer if he'd known what was about to happen in *his* next chapter!

The next royal to stay at this Royal was Prince Albert Victor, the oldest son of Albert, who'd later become King Edward VII. A pretty colourful character was Albert Victor: he was implicated in the Cleveland Street Scandal of 1889 when police discovered a gay brothel in London, frequented by aristocrats, politicians and, apparently, royals. Some writers reckon he was Jack the Ripper but this is probably rubbish.

Unlike the reports of Alfred using high class brothels in Melbourne during his stay, there's no scandal about Albert's time at Craig's.

Under Prince Albert Victor (if I can put it that way) on the list is Mark Twain, who stayed here in October 1895 before heading down to Melbourne for the first Tuesday's race meeting. The author of *The Adventures of Huckleberry Finn* later commented on the Melbourne Cup: 'Nowhere in the world have I encountered a festival of people that has such a magnificent appeal to the whole nation. The Cup astonishes me.'

The list goes on to include Lord Kitchener, Nellie Melba (who stayed just the once and didn't make endless comebacks here at least), and 'Ming' himself, Robert Menzies, the biggest Royal lover of them all!

Menzies's 1954 quote welcoming the Queen to Australia will forever rank at the top of cringe-worthy sycophantic quotes of Australian politics: 'I did but see her passing by, and yet I love her till I die.'

This is a Royal with a wealth of stories, a real jewel in this chain.

The coffee is perfect, the pie is exquisite and, fully gruntled, I head out into the incessant drizzle and continue north-east to Daylesford.

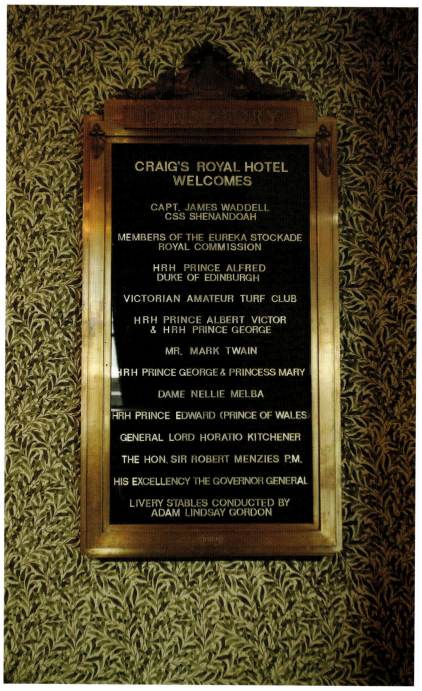

CRAIG'S ROYAL HOTEL WELCOMES

CAPT. JAMES WADDELL
CSS SHENANDOAH

MEMBERS OF THE EUREKA STOCKADE
ROYAL COMMISSION

HRH PRINCE ALFRED
DUKE OF EDINBURGH

VICTORIAN AMATEUR TURF CLUB

HRH PRINCE ALBERT VICTOR
& HRH PRINCE GEORGE

MR. MARK TWAIN

HRH PRINCE GEORGE & PRINCESS MARY

DAME NELLIE MELBA

HRH PRINCE EDWARD (PRINCE OF WALES)

GENERAL LORD HORATIO KITCHENER

THE HON. SIR ROBERT MENZIES P.M.

HIS EXCELLENCY THE GOVERNOR GENERAL

LIVERY STABLES CONDUCTED BY
ADAM LINDSAY GORDON

If Craig's Royal at Ballaarat (sic) has its history, its inheritance, well positioned front and centre, the Royal Hotel at Daylesford has long given up any links to its past. It seems almost embarrassed to acknowledge its history and its story. Long ago it gave up any pretence of being a pub.

It's been seemingly sliced into three distinct parts: expensive refurbed accommodation upstairs, a totally soulless gambling room with a wall full of blaring monitors and a very nice restaurant/eating area. Notice something missing? Ah, so you're after a quiet, relaxed indoor bar where you can have a chat and unwind? Nah! You're in the wrong place.

So I order soup du jour(ney) with crusty bread and a more-or-less local chardy and plonk myself down in the restaurant. Whilst the food is coming I duck into the gambling room, take the tip from the folks at Snake Valley and put five each way on number nine in the sixth at the Ballarat Trots.

The soup's just right for the cold day and the chardy begs for a confirmer but I've still got 300 kilometres to ride so out into the grey, gear up, and get going. I head north-east and the weather begins to clear. Through Heathcote, Nagambie, Shepparton and Wunghnu before reaching the Murray at Tocumwal.

The Murray's in flood and stranded roos, big and healthy from the good season and emboldened by necessity, watch from beside the highway when I take an off-track to check the flowing waters. Then it'll be north to Finley and west to Berrigan, where another Royal awaits.

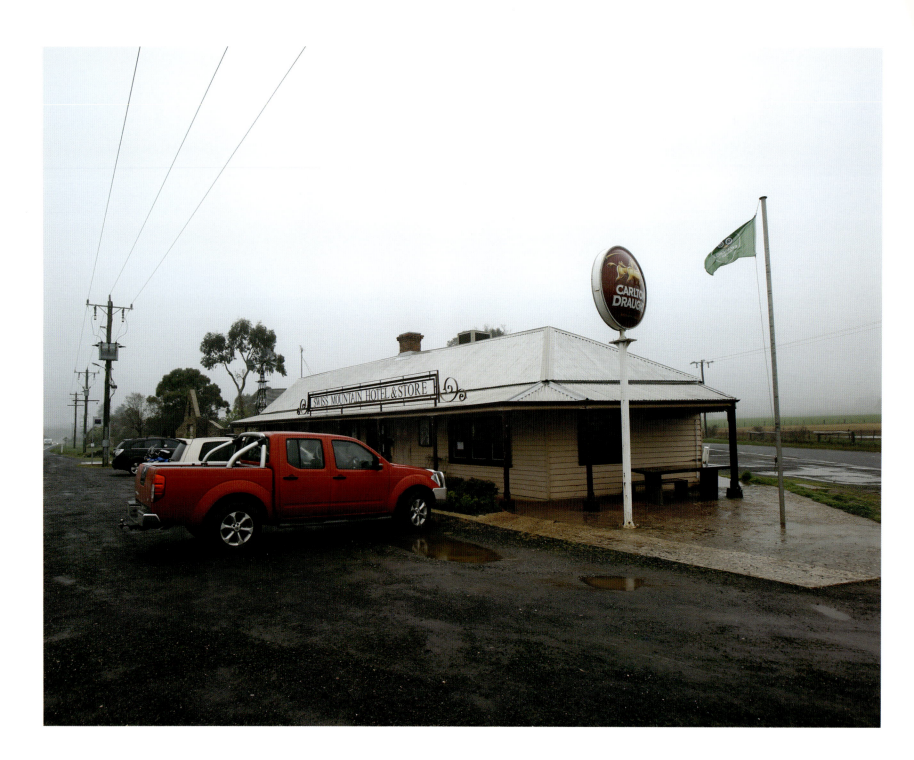

PLEB PUB: SWISS MOUNTAIN HOTEL

BLAMPIED, VICTORIA

This bit of the tale's about Royals but there's some damn fine plebs to be found along the way and it'd just be pure snobbery to ignore them just because they weren't born into the blue-bloods!

Thirty-five kilometres out from Ballarat, without much warning, I hit Blampied. I've done no research on this place, never heard of it and I'm damn sure not aware of any pub in the place. But out of the mist on my right I see a dignified, low-slung place with a sign, 'Swiss Mountain Hotel and Store'. Any pub with a sign like that, a sign harking back to when all pubs were the centre of towns, not just drinking holes but the full social hub, any pub so aware of the roots of pubs in the Australian social fields, is going to stop me. I get out of the rain and under the eaves, shed the wet layers and go inside.

Turns out that along with Hillston in New South Wales, Blampied is one of the few towns in Australia that's named after a publican. Louis Blampied built the hotel in 1865, originally naming it the Manchester. He must've loved pubs because Phil Cleary has found records indicating that in 1875 his son Auguste Blampied was the publican at the Mount Prospect Hotel and Charles Poole operated the Manchester.

Can't have been a cosy, neighbourly arrangement because in 1883 Auguste was murdered by Charles's sons, George and John. They were arrested but hired a lawyer named, 'Martyr' (truly!) who got them off with a bit of a lecture from the beek. I'm pretty confident the choice of pub to celebrate their victory was an easy one!

Andre Lafranchi bought the Manchester in the 1880s and with the three surrounding, long-dead volcanoes reminding him of his homeland, he changed its name to The Swiss Mountain Hotel. His family and descendants managed it for an astonishing 80 years until they offloaded it in the 1960s.

Inside, manager Euan is busy, but he's not too busy to share his knowledge of the past and his dreams for the future. He tour-guides me around the old photos on the walls and shows me the walls that they've knocked down to open the place up and make it more livable.

The place had been closed for two years when local identity Jim Frangos bought it in 2011, wrestled with the council and re-opened it as a pub. The restaurant is up and running with a menu including grilled haloumi, goat fetta risotto, slow cooked duck and local aged beef. They're working on a microbrewery, a bakery and accommodation, and yes, they'll be returning the rudiments of a general store.

It's a place with that intangible, that indefinable vibe of enthusiasm and good being: that casual, relaxed tranquillity that comes from being comfortable with your past and confident of your future.

Just north of Shepparton a sign welcomes the traveller to Yorta Yorta country and soon after I hit Wunghnu, pronounced apparently as 'one ewe'. Never heard of it! Sounds almost Asian to me, seems incongruous, out of place.

The building on the east of the main street, the Wunghnu Mechanics Institute was first built in 1870, but a couple of fires in the 1880s saw it rebuilt in 1890. The building's simply magnificent! For the last ten years it's been home to the Institute Tavern, run by Trish, who'll serve you food and drink (no accommodation) six days a week excepting Mondays.

Turns out the town's name is thought to be a variation on the Yorta Yorta name for a boomerang and there's no Chinese connection with the place at all!

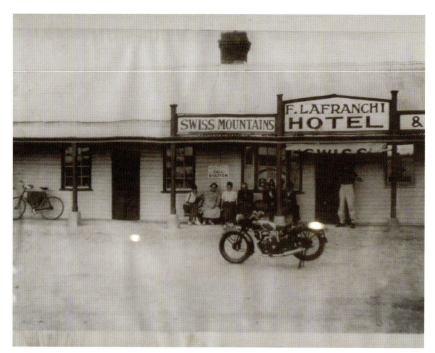

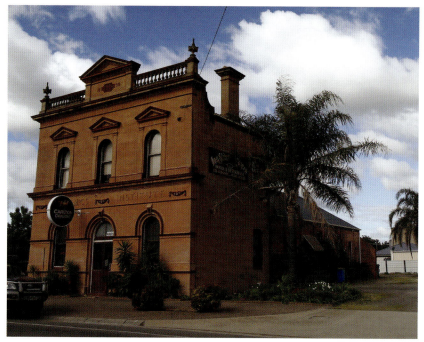

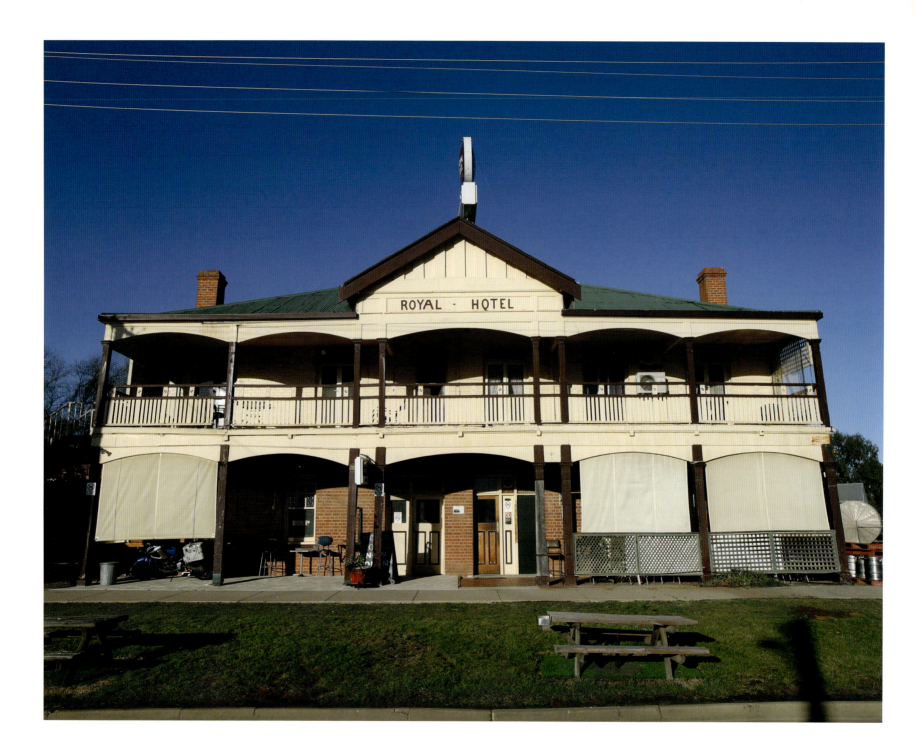

ROYAL HOTEL
BERRIGAN, NEW SOUTH WALES

When I was leaving Snake Valley I'd rung ahead to make sure I still had a bed. All was fine but there was someone I was hoping to meet up with.

'Do you know the current boss of the RFS?' I asked Beris who'd taken my call.

Came the swift reply, 'I better! I'm sleeping with him!'

I said I was sorry to interrupt and that I could ring back when they were finished.

'No, no,' she laughed, 'not right now, just when I get the chance.'

He was out on his farm working on fixing some of the flood damage but she'd try to get him in for a chat in the evening.

So after a good day in the saddle, having met two Royals and a couple of other special pubs, I eventually head up the main street of Berrigan with the grand old Federal Hotel on the right and swing left and the Berrigan Royal is right there.

A blue heeler barks and dances at a gate nearby, a gang of sulphur cresteds rasp the cooling air and a B-double pulls away from the corner, headed south. And then as I turn off the bike, the truck is well down the road, the cockatoos are gone and the heeler stands looking, just wanting a rub and a pat.

The sudden silence wraps me as I massage the dog's ears over the gate. Everything's tranquil, still. You know that feeling that you get when your hands have been really cold but then you get to the campfire and the feeling comes back and it's a warmth that has a special, unique character? Well that's what the silence out here is like after a day of noise; different to just quiet.

Anyway, I tell the dog I've got to go and head over to the pub. Beris ('call me "B"') is behind the bar, a few blokes in fluoro work gear are downing some amber and yarning. All look up, nod, say, 'G'day' and keep doing what they're doing.

B's bloke is caught up with fence repairs out on his property and can't make it, but dropped some stuff in for me to look at. Top job! Just as last night's Royal was in the town where John Flynn, creator of the Royal Flying Doctor Service, spent his primary school years, Berrigan and its Royal Hotel played a crucial part in the formation of the second of this country's truly iconic and special organisations.

In 1900 the first branch of what would become the Rural Fire Service was formed in Berrigan and the *Berrigan Gazette* of 30 November 1900 reported that the formation meeting suggested that the old bell at the public school could be, 'handed over to the town to be used as a fire alarm…and a suitable place to hang it…would be the archway over the back entrance of the Royal Hotel.'

One fella present that night was a Mr Corcoran who said he'd supply a 54–gallon beer cask, 'on behalf of the Narandera Brewery' to be used on a water cart as the first fire engine.

'Mr Ritchie then moved, and Mr Little seconded, that all present form themselves into a volunteer bush-fire brigade, and the motion was carried unanimously,' continued the *Gazette* before finishing its report, 'It was decided to erect the bell the next day on (the Royal Hotel's) archway…and ask the police to take sharp proceedings against anyone giving false alarms.'

It was this 'volunteer bush-fire brigade' that became the model for rural fire services across the nation.

Unfortunately the archway is long gone, destroyed ironically in a fire in the 1920s, although the exact date seems lost in the smoke of time. John, B's dad and current publican, reckons the fire was in 1928 and the pub rebuilt in 1931. Ian Fuzzard, the local historian, wrote that the pub was rebuilt in 1925.

Both agree that the first one was single-storey and the second a double-storey and both agree that the fire started in the adjoining hall, which the visionary publican Edward McGrady had constructed and turned into a theatre.

McGrady had installed the first electric generator in the town in 1919 and had allowed the council to tap in to power the street lights, but this noble

gesture throws a shadow on John's claims that it was the candles in the theatre that started the inferno.

When I get back to base I put in a call to Marnie Steer at the Berrigan Historical Society and I get the help so often generously given by the amazing people from such organisations throughout the country. Turns out both John and Ian are wrong.

The paper up in Cobram reported on 24 February 1927 that the previous Saturday, fire had destroyed two:

> ...old landmarks of Berrigan, The Royal Picture Theatre...and the Royal Hotel...Shortly after 8.30 o'clock whilst the Pictures were in progress, the film ignited in the biograph operating room... About an hour and a half after the fire broke out both theatre and hotel were a mass of smouldering ruins.

Justice can move quickly in the bush because the Cobram Courier's coverage continued, 'Three arrests were made, and at the trial on Monday, one of the accused was sentenced to nine months' imprisonment.'

The nitrate film which was used in the 1920s was well known for catching fire. Its flammability led to special fireproof boxes being made to house both projector and projectionist. Even today many in the industry call it the, 'bio box'. So anyway, given that even the paper reported that the 'film ignited', the bloke who went down was probably justified in feeling a little stitched up.

He was very likely innocent but 30 years before this, the citizens of Berrigan, a tiny flyspeck in the Aussie bush, ignited something else, something which would forever change the entire continent.

Back in the 1890s the push for Federation began in earnest. In 1892 Edmund Barton who was to become the first Prime Minister of Australia, popped by the Murrumbidgee area pushing his Federation cause. It was taken up and The Australasian Federation League was created, with branches in many small towns.

In 1893 it was the Berrigan group that suggested a Conference of all these branches and on 31 July delegates from 74 committees met in Corowa. It was this meeting, the brainchild of the citizens of Berrigan, that was the crucial first spark in the organised push for the federation of the Australian states.

The meeting began with the election of a chairman whose first words were to congratulate Mr Lapthorne, secretary of the League at Berrigan, for having originated the idea of the Conference.

The next day, the conference concluded with the secretary placing on record his belief that, 'Mr Lapthorne and the Berrigan Committee, as the prime movers and the instigators of the meeting, deserve great credit.'

Even in far off Queensland, a state which even then viewed any sort of progress to be a malicious southern plot, the importance of the Berrigan move was acknowledged with the Rockhampton Morning Bulletin calling it an 'important step because it is the first taken by the people as distinct from the politicians.'

Maybe better reflecting the thoughts of the north, the North Queensland Register printed in Townsville, dismissed the entire conference:

> A FEDERATION Convention—any assemblage of the class of professionals known as politicians is now known as a convention—is now being held in Corowa..... (and it has) provided many needy men with a pleasant excursion and high-class refreshments at someone else's expense, so there will be a least a hundred who will urge that the gathering has not been in vain.

As the crowd at Lang Park are wont to scream: QUEENSLANDER!!!!

Seven years later the momentum begun by the men of Berrigan reached its conclusion. On Christmas Day 1900, Edmund Barton, related to Banjo Paterson's mother (a link represented in the poet's middle name of 'Barton' and his nickname, Barty), named the first cabinet of the Federal Government, with himself as the inaugural Prime Minister.

The importance of Berrigan was forever assured and it's fitting that the Federal Hotel, built a decade before Federation, remains as the other pub in town.

Before I head up to bed I ask B if she can check the race results. Bloody beauty! My tip from last night's come through! Belts has won the sixth at Ballarat and I'm 30-bucks richer. I bet they're partying down at Snake Valley!

I'm woken early by the sun streaming through the windows in the room's door. There's few things better than a pub with an upstairs 'randah facing east. I make a brew and take it outside as the low sun cuts through the picket slats, feet up and feeling perfect.

Then down to catch up with John, who's in the cellar tapping kegs. These kegs are delivered weekly and are rolled down the same original, unrepaired gidgee ramp that was part of the rebuild of 1930. Thousands of kegs have eaten out a furrow in the concrete base and now the old concrete stopping block stands pretty much unused.

I stroke the smooth wood and once again whisper, 'C'mon, talk to me, give up your stories,' but the wood stays mute and resolute.

John and I say our goodbyes and I head out, thinking about that gidgee beer slide and wondering just how much that's being built today will be around and working in 85 years.

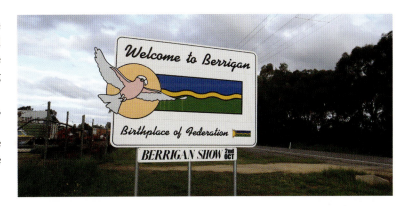

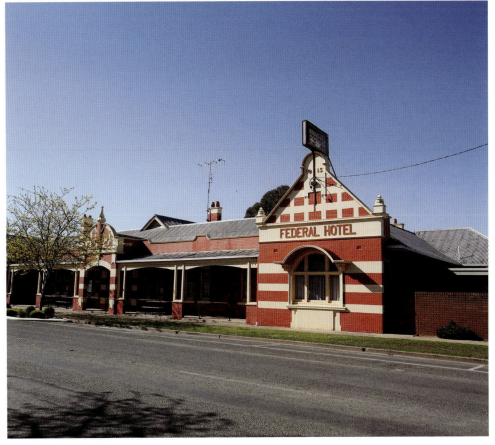

BERRIGAN TO GRONG GRONG

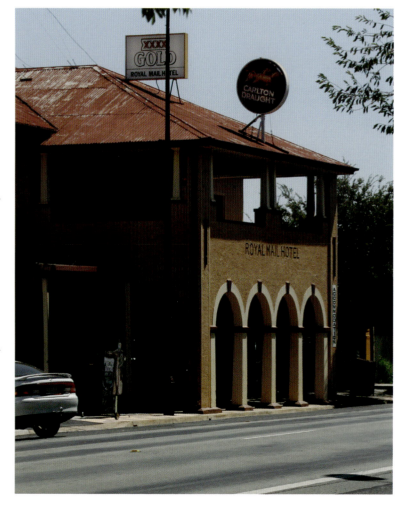

A quick half-hour squirt and I'm at Jerilderie, one of those towns living on a myth and a connection with Ned Kelly. The bearded bloke popped by with his mates in 1879. He didn't write his 'Jerilderie Letter' in the town and he sure didn't wear his armour helmet here, but that doesn't stop the town from using images of Ned's iron burqa as the place's emblem.

The police station at the east end of town has almost a dozen motifs of the helmet incorporated into its design. (When I was there photographing the downpipes a cop who'd been in town for 12 months came out and questioned me; he was totally unaware of the significance of their shape!)

In three days in Jerilderie, Ned and his mates relieved the bank of £2000, chopped down the telegraph poles, locked the police in their own cells and booked up the cost of shoeing his horses to the police. They held more than 30 hostages while shouting the bar at the Royal Mail Hotel, and burned the mortgages held in the bank's safe. So if you were paying off your place and enjoyed a drink with a bit of raucous company, you probably would've been sad to see him go!

Across the road from the Royal Mail, is a massive windmill which was built in 1910 for a bloke who keeps popping up in this book, Samuel McCaughey. It was relocated here in 1979 and provides two gallons of water per revolution for the lake beside it. On a hot day this beautiful, inviting lake is very visible just behind the No Swimming signs.

Seemingly in collusion, none of the three servos in town sells the grade of fuel my bike prefers so after a pastie and coffee and a fruitless search of the bakeries for a neenish tart, I head north for Narrandera and then Grong Grong.

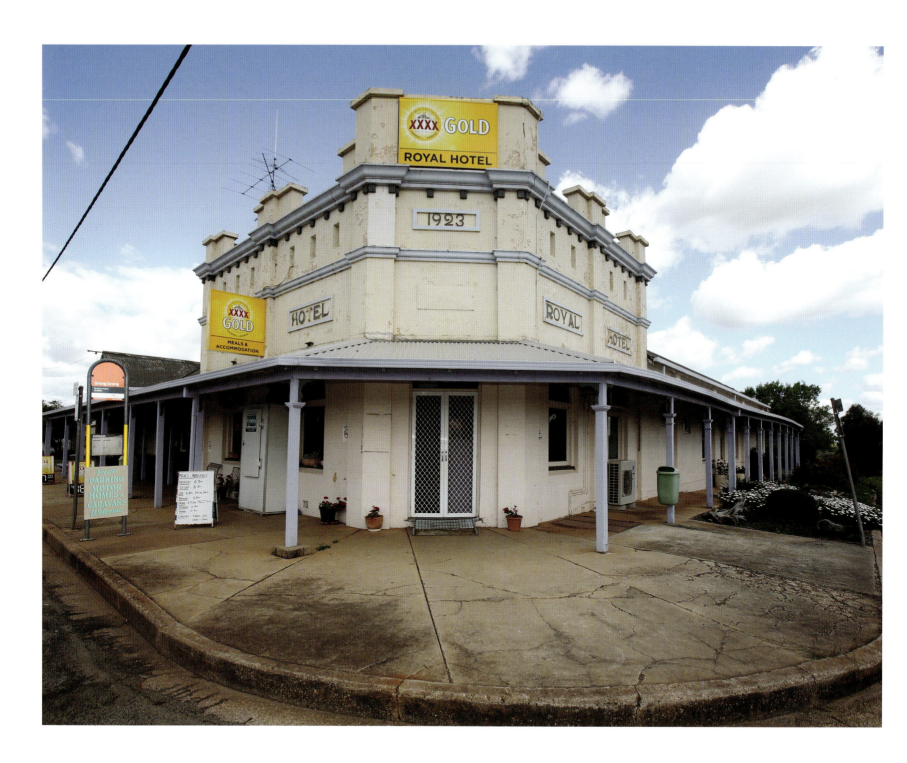

ROYAL HOTEL
GRONG GRONG, NEW SOUTH WALES

I've been chatting for a while with Kay, who, with husband Ted runs the Royal Hotel at Grong Grong, and she's expecting me when I cross the railway and pull up at the front door. Ted's inside using the pool table as his office desk: bills, invoices, letters cover nearly half of the green, and he looks up and says his g'day.

They've had this place for almost a quarter of a century, a long stretch for country publicans, and on this quiet arvo with no-one else around, Kay's feeling a bit nostalgic:

> *That chair you're in was Jack Evans's but his name wasn't really Jack, it was John. He'd have his scotch and soda and then take a pie home for his tea. Every now and then he'd take two pies and I'd ask him if his girlfriend was coming over. Every time he'd look at me the same way and every time he'd just say, 'No, the cleaner.'*
>
> *Next to him was Merv, and Jamie sat over there, and Wally would be in that seat. His wife Betty would come in and stand over there.*
>
> *Old Les Wall the stationmaster would come in on his crutches and sit and the end next to Cec. He was the only man who insisted on having his beer in the same glass, never a new one. Used to drink handles.*

All these old fellas have slowly passed away and now the last bloke around is Charlie Ross, who's had his seventieth, eightieth and ninetieth birthdays in the pub. 'We got out all our teacups and put on an urn for his ninetieth but no-one was interested. The place was packed and they drank us dry!'

With just 150 in the town and the regulars moving on, Kay and Ted were beginning to worry about the Royal's future when a traveller walked into their pub in 2011 and got talking. He was looking for a place to camp, somewhere off the road, away from the traffic, and out of that chat Ted decided to open up the field behind the pub for free, unpowered parking and camping.

The first year one shy of 100 vans overnighted and that figure has doubled every year since, and right as Ted's explaining all this, two gents come in. They've parked their rigs out back and can they have a couple of menus to 'take back to the girls' so they can decide what they're having for dinner.

The free parking has turned the pub around but that's not what I really want to talk about. I want to talk neenish tarts.

For 60-odd years Grong Grong was the fabled birthplace of the neenish tart, the ridiculously sweet little, well I'm calling it a pie, a cream pie. A pastry base, filled with mock cream and jam and topped with two-tone icing, they were probably the most fattening thing in any school tuckshop when I was growing up. And the most popular.

And it was all because some time in the 1980s *The Sydney Morning Herald* wrote a piece about them and a bloke from Grong Grong, called Doug Evans replied:

> *Dear Mr Journalist,*
> *My sister Venus and I clearly remember our mother's good friend Ruby Neenish of Kolabi via Ardlethan who got short of cocoa powder when baking for her daughter's unexpected shower tea in 1913.*
>
> *Made do by making them with half cocoa and half white icing. From then on they were known as Neenish tarts.*

Problem solved!

That was all good until July 2016 when Rachel Carbonell, a reporter with Radio National, took an interest in these things and began digging. Pretty soon she dug up Doug Evans. Now Doug's getting on a bit and he had a confession.

In the seventies and eighties a certain theatre critic at the *SMH* would dismiss sub-standard shows with throwaway line of, 'suitable perhaps only for the Grong Grong School of Arts.' Now this pissed off the locals like Doug

more than a little, so when he saw the *Herald's* interest in neenish tarts he sensed a karmic moment, fortified himself with a glass of red, and put pen to paper (as you did in those days!).

When Rachel Carbonell called Doug he decided to come clean and reveal to the world it was all rubbish, one big get-even. He'd made it all up. There was no sister, Venus, no Ruby Neenish and certainly no unexpected shower tea!

So Grong Grong's claim to fame is pretty much that its claim to fame is a myth, but geez, it was a fun myth! A myth which beautifully captures the spirit of country humour and the love of taking the piss out of slickers.

There's no bakery in Grong Grong anymore and the places I tried down the road didn't have any for me to bring but Kay had convinced Fran over at the general store to do her best. After we've chatted for a while, Kay pulls out a beautiful plate with a couple of almost melting moments sort of things but with the distinctive neenish duo-tone icing.

Now I know tarts and these aren't tarts but they're damn fine, whatever they're called. And the chardy washes mine down perfectly. Kay and Ted share the other, all the time chuckling about the story, about the way tiny Grong Grong fooled the smoke for decades.

Two towns, two myths; it's been a good day and it's not yet lunchtime!

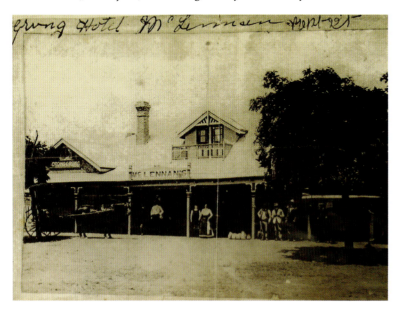

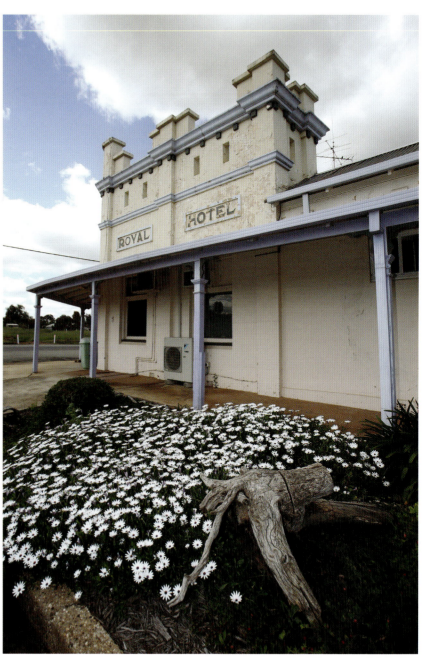

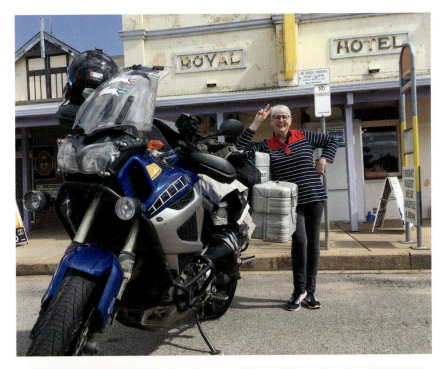

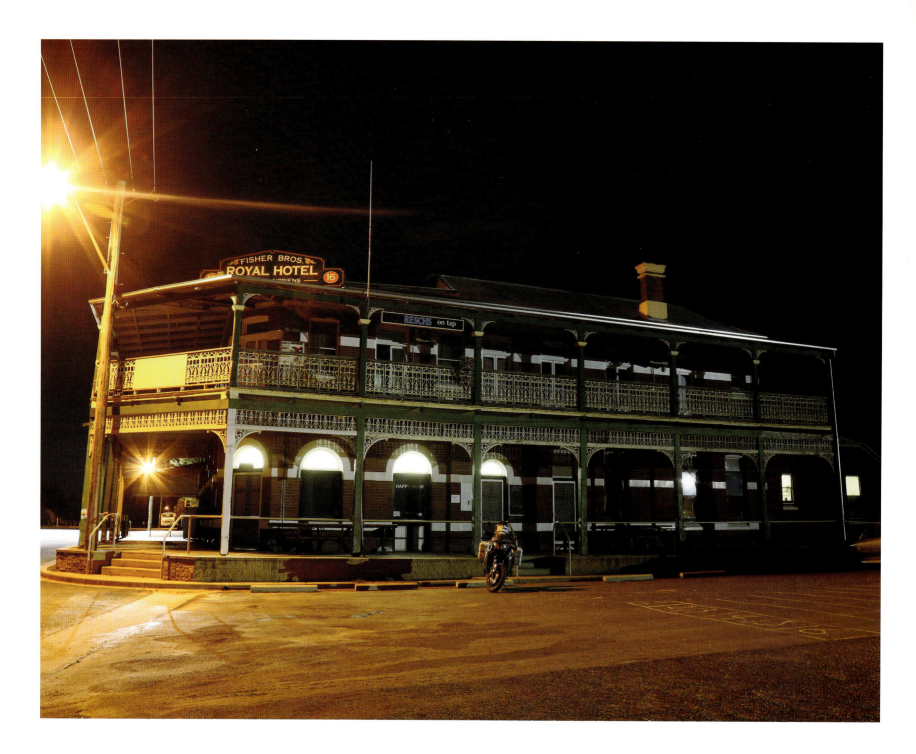

ROYAL HOTEL

MIRROOL, NEW SOUTH WALES

Bernley Bryce has spent his entire 85 years on the planet in the area around Mirrool, the last 30 in the town itself. He's been known as 'Bucket' since someone labelled him when he was playing football. He had his first beer in the Royal at Mirrool when he was 16. In 1969, his wife gave birth to a boy, and I'm in the bar of the Royal at Mirrool talking with that baby.

> *Back in the day men never went to the hospital, they all went to the pub and waited for the news. You know, to wet the head. So I'm one hour old and the phone rings at the pub and my dad answers it. The bloke says, 'Bucket, your wife's had a boy, so I guess his name's Billycan.' I've been called 'Billycan' ever since.*

Bucket started out with very little, shearing and doing farm work until he bought a fuel run based in Mirrool and moved over from Ariah Park. After a decade he went to work for Graincorp but gave it away about ten years ago. He handed it over to Billycan, who's having a drink in the pub after a day of fertilising crops on a farm just out of town.

He's also on the organising committee for the biggest event in Mirrool's calendar, the annual silo kick, held on the second Saturday of each October. He can't remember who came up with the idea of creating an organised event to see who can kick a footy over the 33-metre-high, ten-metre-wide silos, but he's pretty sure that drink was involved. And that it was probably after a bunch of young fellas and local footy coach Mark Newton had spilled over the road from the pub in 1990 or '91 and happened to have a football with them and…ah, well you get the picture.

Anyway the first competition was held in 1992 and was taken out by AFL player Billy Brownless. Six times since the silos have defied all efforts and have been declared the winner, and one bloke has taken it out seven times. That bloke's Rob Harper, now 46, with boots well and truly hung up.

> *I don't know exactly why I was so good at it. A bit of local knowledge about how the wind swirls around the silos, maybe helped a bit…When I kicked a good one, I never needed to look up, I'd know when it was going over. It was all just feel. And sound. When I kicked it right, it made this sweet sound and it just felt perfect through my boot. Like golf when you hit one sweet and it goes straight down the fairway.*

This thing is getting serious. This year it was taken out by a giant 16-year-old schoolboy, Riley Corbett from Ganmain. (He must've grown up eating the famous Ganmain Pies!) Anyway in the crowd of about 400 was a bunch of sporting scouts and one of them stuck a pen in Riley's hand and, well he's off to trial as a kicker in the NFL.

Rob Harper: 'I reckon young Riley who won it this year might be the bloke to beat my record; unless of course he ends up making millions in America.'

That second weekend of October's not just about kicking the daylights out of a footy and making it disappear. There's gumboot chucking and tug-o-wars and the Mirrool Cup held on the bitumen out front of the pub. Don't ask me to explain the rules, but there's money to be made and you'll most likely get a stitch from laughing.

And Mirrool used to be the home of the best-fed bogeye lizards in Australia. These shinglebacks were finely tuned racing machines with numbers on their backs. According to Des Delaney, who was on the kick committee for a dozen years, anyone finding a bogeye in the paddocks would collect it and hand it over to a bloke up the hill who'd feed them, really look after them and then in the first week of October, would paint a racing number on each lizard's back. Come race day he'd bring them down, bets would be taken and the reptiles would be set free in the middle of a large circle painted on the tar. First one to the perimeter was the winner! The prize for the bogeyes was being set loose in the afternoon.

Billycan laughs. 'For the rest of the year you'd be treating a field and come across a bogeye with a bloody number on its back!'

But the shinglebacks no longer race. A few years back a bloke from the RSPCA stepped out of his air-conditioned SUV and told them all they were naughty people. Feeding lizards, looking after them for nine months and then putting them on the pavement for three minutes before taking them out to the bush and releasing them, just wasn't on. So now the bogeyes of Mirrool run free and hungry, and the lucky ones even manage to cross the road.

The silo kick may seem like a good way to spend a weekend but there's more to this event. Across the road from the silos and the pub is a spanking new kids' playground, a new amenities block with toilets and shower, and a massive free camping site.

Every bit of it has been funded by this one weekend in October. This one event has energised and revitalised the town. The free camping draws nomads and tourists who in turn visit the other towns along the Burley Griffin and Kidman ways, and many of them drop into the Royal. But tonight it's just a steady stream of locals: me, Billycan, and a few other strays who're keeping Adam and his partner Selena busy behind the bar.

Hornet's the next bloke to wander in. His real name's Andrew but way back one night in the pub at Beckom his step-uncle reckoned he looked like a bloke he knew whose nickname was 'Hornet'. It stuck like dags to a sheep's bum and he's been Hornet ever since.

He's followed quickly by his childhood mate, Billy, for once his real name, as Billycan slips off home. Billy's like a country bloke from central casting. The hat, the shirt, the smile, the hands, the glinting eyes: a fella who laughs a lot, but not as much as the people around him. He and Hornet are somehow related through uncles and cousins and neither can quite work out how, but it doesn't matter. Family, mates, they don't much care, so long as they get on.

Hornet's got a glass eye, which seems to have a very enjoyable life of its own. A few years back he was drinking with some mates in Temora and there was a stink on the footpath outside the pub so out he goes to check out the action.

This copper grabbed me and tells me I'm drunk and I ask him why he thinks that. 'Your eyes are bloodshot' he tells me so I reach up with my right hand and cover my left eye and pull out the glass eye, close the eyelid and then open the palm of my hand to the cop. 'Is it still bloodshot?' I say and he looks at my eyeball in my hand and leaves me alone.

He used to have a couple of glass eyes and a girlfriend who got off walking around all day with one of them in her underwear, but she's moved on. 'But I kept the eye. They're worth a grand each!'

Billy doesn't just look country, he is country.

I could never live on one of them quarter-acre blocks with a little house. I need the open spaces. The life's too much fun out here.

It's like a couple of years back when a young fella went to visit his grandmother but she was missing so he rang the copper in Ariah Park and he came down and they searched the river. They found the body but when they got her to the bank there were three lobsters hanging off her. The kid asks, 'What'll we do?' and the cop says, well you take one, I'll take two, and we'll reset her.

Everyone laughs and I tell him it's rubbish—funny, but rubbish.

Adam leans across from the other side of the bar. 'Nah, it's true, we don't bullshit to visitors in this town. Not here!'

Billy concedes a little ground. 'It's all true—really happened except the last bit. They never reset her.'

Time for a pee, so I head out the back where standalone urinals are about navel height, the tallest ones I've ever seen. Almost have to stand on my toes. Some architect obviously taking the piss.

Anyway, I get back and Hornet and Billy are laughing. He's dropped his bloody eye into my wine; a standard party trick that a bloke called Ken Niblett used to do when I was at uni.

I take a couple of pictures, fish the thing out and chug the glass. Can't let the locals think you're overly sensitive. They feign disgust but it seems to break any remaining barrier. From then on we're mates.

Billy's fading . He's been crutching on his own all day. Sheep that were supposed to be done three months ago. He's knocked up and cuts out after another VB can.

Over a massive lamb shank duet cooked up by Selena, Adam's partner, I listen as Hornet tells me the story of the pain when the fencing wire went through his eye and he ended up in Wagga Base for 19 weeks, how he survived the ministrations of a doctor named 'Butcher', but eventually had the eye removed.

Then he's off too and the world goes quiet. Adam pours me a nightcap and Selena comes in from the kitchen. They took over the lease in 2014

after managing the pub at Darlington Point for a few years.

'They,' I tell them, 'were in good form.'

'Always are,' says Adam. 'Everyone in this town is like that, it's just amazing how good the people are here.'

Selena chimes in, 'We're so happy we decided to come here.'

I reckon a good few folks are happy they're here—a great young, idealistic couple in an optimistic town, pulling itself up by its own footy bootstraps.

A few months later I hear on the mulga wire that Adam and Selena are moving on. They've found a buyer. Sue and Michael from Ardlethan have taken it over. Another family taking on the challenge.

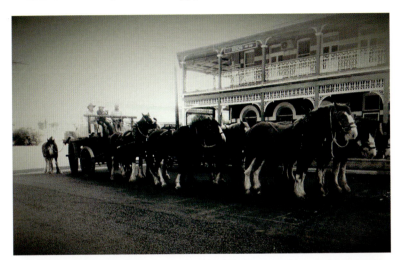

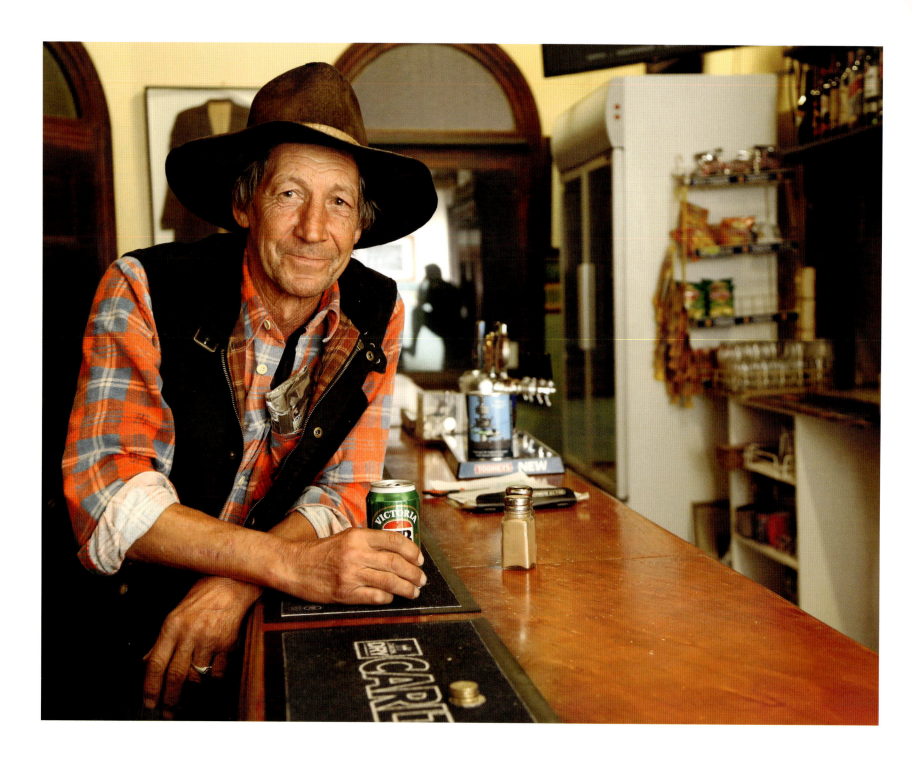

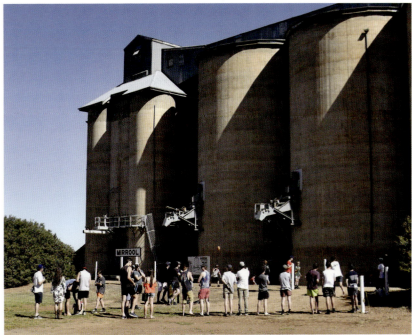

MIRROOL TO CONDOBOLIN

Next morning I take my brew in the sunshine outside, then drop down to chat with Billycan and Bucket at their place just down the road, and then head back a bit east before swinging north onto the Newell Highway.

Before I get up to speed I'm stepping back down the gears to check out the hallowed gates and grounds of the MCG before winding up Super Ten for the 50-kilometre squirt up to West Wyalong.

West Wyalong's got three pretty reasonable pubs but it's also a regional centre of something even closer to the heart of this country: sheep and yard dogs. Now I knew next to nothing about kelpies—before I got to West Wyalong I didn't even know the difference between sheep dogs and yard dogs.

But my timing's spot on and the Aussie Yard Dog champs are in full swing so I head out to the Showgrounds. I grab hold of Michael, a trials judge, to talk me through one competitor, and it all becomes a bit clearer.

Each dog and handler team starts off with a dozen sheep, three of which have blue dye between their eyes. The dog rounds up the sheep and guides them into a race, which is a bit too small for 12 sheep to comfortably fit. When the handler closes the gate behind them, it can't touch the last sheep so the dog runs over the backs of the sheep to push the front ones all the way up then works back to push the others.

Back gate closed and the dog returns to the front to push the sheep back so the handler doesn't touch them when he opens the gate to free the sheep back into the yard, where this process is repeated into a drafting race. Here the three blue-marked sheep are drafted off and sent away.

The handler must walk in straight 'not banana' lines between races and can only verbal or whistle commands to his dog, no physical moves allowed. The dog'll get disqualified if it bites into the meat of the sheep but nipping on the wool is all good.

It all makes for a great spectator sport, and in the Dogs Breath Cafe, the ladies are doing a roaring trade selling homemade lamingtons, muffins, sangers and instant tea and coffee.

The reigning national champion is Joe Spicer from western Victoria, not far from Casterton, acknowledged by pretty much everyone (except a few at Ardlethan, who claim they are the source), to be the home of the original kelpie. He runs the GoGetta Kelpie stud named, weirdly, after a sheep.

Joe's brought his champion dog, Gogetta Brew, back to defend their title before he pensions off the ten-year-old to a retirement of 'back door mat'. I start by seeking clarification about some of the language I've been hearing. Joe laughs as he reassures me.

'Sluts' and 'bitches' are just terms for female dogs. Doesn't matter if they've had a litter or not, the two words are just alternatives. When you hear it, the blokes are definitely talking about the dogs, not anyone they met in the pub last night.

At his breeding facility, Joe rotates 12 bitches allowing each to have just one litter per year, and he sells the pups at between 8 and 12 weeks.

By then most have shown what potential they have or they haven't. If a pup turns out to not suit the needs of the buyer who's reserved it, I let them transfer their booking onto a pup in the next litter.

But all dogs find a home on a property.

These dogs are simply not suited to being pets or companions. They are working dogs. They're too highly geared to live in the suburbs or a flat in the city. People in cities shouldn't be allowed to own kelpies.

There's six classes of competition at this event, from Encourage to Championship and since it's the dog that's rated, Joe has and entry in pretty

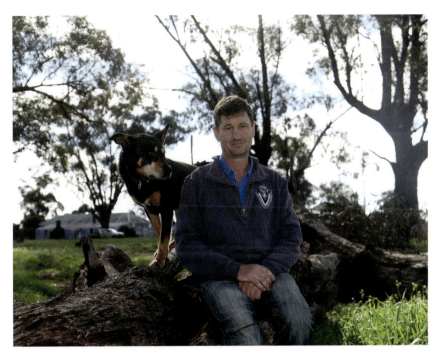
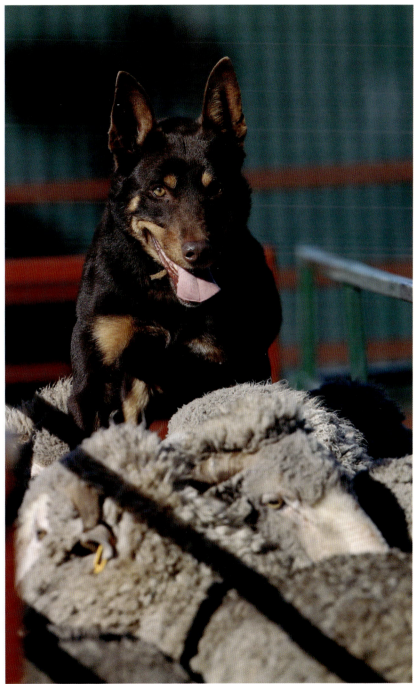
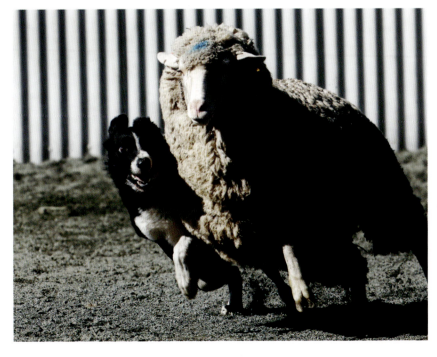

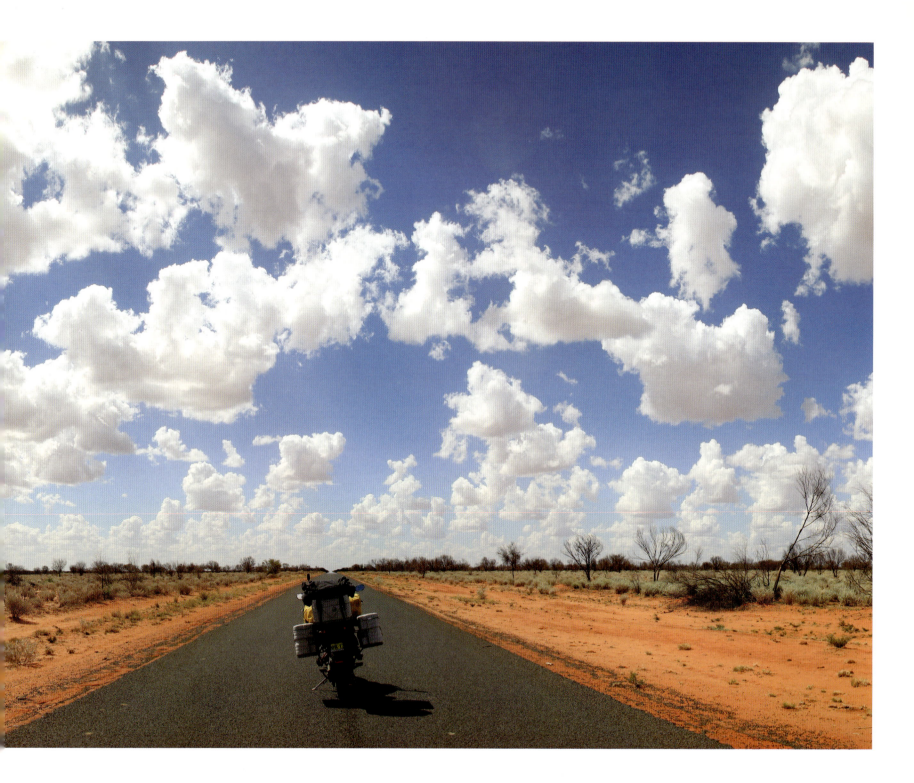

much every class. He's about to go out with his 'Improver Class' red dog, Regret, a three-year-old, still with a bit to learn.

'Regret?' I ask him, 'The same as in, "the colt from old Regret"?'

> *Yeah, exactly! Her father's name was, Aggro and she picked up his personality so I first called her, Aggrette but didn't like it after a while so I changed it to something a bit more common.*

I get a couple of shots of Joe with Gogetta Brew and tell him I'll catch up with him back at the arena. I want to see him in action with his slut.

Regret fails to get the sheep into one of the races and is disqualified but Joe's not too put out. He's other dogs in other classes and is pretty confident they'll do a bit better. Later I find out that Joe and Gogetta Basil went into the final round of the Championship as the tenth and final qualifier but put in the best round of the entire competition to overtake the others and win the biggest prize on offer.

I grab a lammo and a coffee at the Dogs Breath, devour the cake, take a sip of the drink then drown ants with the rest. Time to get moving north to Condobolin. The Bureau of Meteorology and SES are telling me I'm going to have problems with floods so best to do it in daylight.

Thirty kilometres north of the town I hit the first 'Road Closed' signs and check status and conditions reports. A bloke coming south stops and is 100 per cent certain the direct route is closed but I'll be able to get through from Lake Cargelligo in the west.

'Absolutely positive, mate, spoke with a truckie who'd just come through that way.'

I take the fork for the north-west, pass through Ungarie with its Humbug Street on the right and quaint and closed 'friendly' supermarket on the left.

Every road off to the north is closed and when I get to the lake I head straight down to the tourist info office. The Lachlan's in flood, evacuations are taking place all over the place and yet the visitor information centre has no information about road closures. The council chooses not to advise them so they can help tourists.

A few phone calls by the truly helpful volunteers and it turns out all access to Condo from the west is closed. The only way in is via Forbes to the east and even that's a bit iffy. Bugger it. I fill Super Ten up at a serious contender for the most unfriendly servo on the planet and retrace my path south-east on Wyalong Road, straight through West Wyalong and onto the Newell Highway to Forbes.

But at Caragabal the Newell is also closed, all traffic being shunted onto the Mid-Western. I stop and yarn to the SES bloke at the barricades and beg to be allowed in to view the flood. I want to see this monster who's repelling me at every turn. He lets me through but 'Take it easy, eh.'

Five kilometres up I come to the sea. It's always the width of the floods that astounds me. I park the bike at the end of the above water strip. Before me, beside me, and mostly behind me is water. I'm at the very tip of a thin bitumen peninsula with mirror water in every direction.

There's no flow, just flat still water to every horizon. Celebrating birds party in their hundreds. Fish break the surface and their ripples spread out and are gone. And when the birds hush there's just the silence, a thick silence.

I move slowly with my cameras, trying to get images which will do this scene justice. If I'd snuck in, I'd have camped right here on the road. The waters are subsiding, but I turn the bike around and ride out. I'm not going to get to the Royal at Condobolin tonight, so I decide to head back home to Sydney, regroup, change my riding tackle for the warmer climes, wait for the waters to go down and then continue north.

MANILDRA

After a coupla weeks in Sydney the water's gone down and my spirits are up. I change the thermal jacket and liners for a mesh armour suit and head west for Condo with the low sun on my back.

First stop is Manildra with its Royal Hotel, but first I'm after the AMUSU Theatre just up the road, and hopefully a cone at the infamous, dangerous and apparently perverting ice-cream parlour.

In January '15, the local school issued a list of guidelines for women teachers. They included:

> *You will NOT marry during the term of your contract.*
> *You will NOT keep company with men.*
> *You may NOT smoke cigarettes.*
> *You may UNDER NO CIRCUMSTANCES, dye the colour of your hair.*
> *You must wear AT LEAST two petticoats.*

But my favourite was number 4, which decreed:

> *You may NOT loiter down town in ice-cream parlours.*

What? So when I pass the massive silos which dominate the town, and head along the main street, I'm wondering just how, in a place of 520 people and about eight streets, do you work out the downtown from the uptown?

I'm searching for the dens of glacé depravity, hoping to pick up a gelato and some local gossip. But I figure my chances of chatting up any multi-petticoated, single, non-smoking, naturally coiffed teachers are obviously pretty slim.

Sadly there're no longer any ice-cream parlours to be found: not downtown, not uptown and none in the middle town either. Obviously shut down by the vice squad or maybe the temperance movement.

It's a shame, but understandable. The school guidelines were from 1915, not 2015, and now the town is cone free, just the servo and cafe selling hygienically sealed Magnums and Cornettos and somehow that doesn't feel the same.

So I head up to the AMUSU theatre and museum where I'm hoping for better luck. It's usually closed on Tuesdays but Joan, the president of the committee, has arranged to meet me and she's opened it all up just before I get there. As soon as I walk in, there's a sense of a special place.

Allan Tom was a picture-show man in the truest sense. In the early 1920s he began touring outback New South Wales in his van with his huge projector in the back. He'd back it up to the window of a hall, point the projector through, hang a screen on the other side, set up chairs and show silent movies. He kept this up for about two decades and in 1936 he built the AMUSU theatre in Derowie Street, in his home town here in Manildra, right next to the garage he operated with his brother. He ceased his road trips and concentrated on entertaining the people of Manildra and he did this for almost 60 years until he screened his last talkie in 1995, a week before he passed away.

His daughter took over the running of the cinema until Bob Carr's government supplied a grant to the local council to buy the place in 2002. The council didn't want to run it so they handed it over to a committee which scored another grant to buy the old garage building next door. They turned this into their museum and shop and have been running movies once a month ever since.

They had the space, they had the old carbon projectors and the seating but the museum was in need of some, er, filling. Then out of the blue a bloke called Alan Strachan rang up wondering if they were interested in some old movie posters. Alan was the cop for ages in Yeoval and ran the movies there for yonks. He had mates at the film distributors and when old film posters were being thrown out, he'd arranged that they were thrown his way.

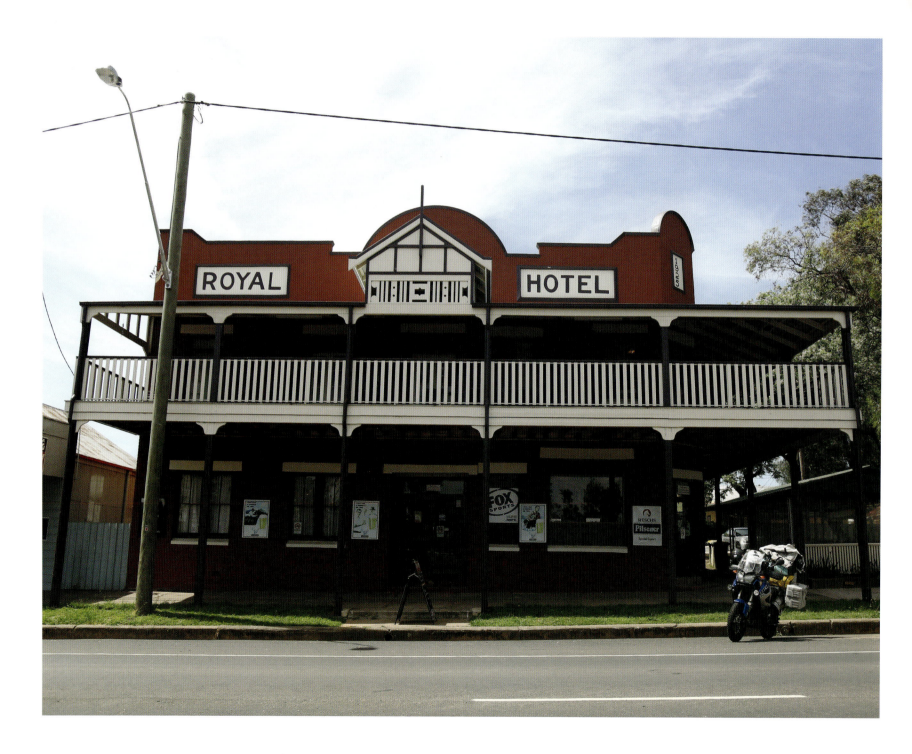

Joan and husband Allan were definitely interested—how many did he have? 'Oh, maybe 30 or 40,000.' He'd been collecting for 60 years. Joan hung up the phone and next day drove up to see him. 'He had this garage absolutely full of stuff. There was hardly room to blink.'

Their car was too small to carry the lot so they made a couple of trips, spent weeks sorting through it all and then working out how to display the posters and to sell the excess copies. 'From there, it began to take off. Other people found out about us and donated cameras, projectors, old records, posters, all kinds of stuff.'

I'm not too sure where any new donations might be slotted but it sure makes for a fascinating nostalgic display.

As we're talking a young fella comes in. He's finally sorted some old piece of farm machinery that he's been going to donate and is it okay to leave it out back? Joan shows him where's best.

'We're thinking of using the big yard out the back for an old farm machinery display. Not sure just yet, but if anyone wants to give us old things, we're open to offers.'

The ute is backed expertly down the side lane and the old plough off-loaded. 'My shit's your shit now,' he muses as he drives out, and Joan begins her tour of the AMUSU. (Say it out loud.)

The original seats, the posters on the walls, the beautiful ceiling and aisles wide enough to have serious Jaffa rolling competitions; this is how things used to be. Joan relaxes into a place in the stalls. Her comfort in this space radiates and her body shouts what her voice speaks. 'I just love it here, it's in my veins.'

The centre section is seven wide and scattered through the room are five 'love seats', doubles with no restricting armrest. We head up to the projection room with the old carbon projectors that handled the highly combustible early nitrate films, behind them a window with the place's name silhouetted against the cloudy sky outside. As we leave the bio box, Joan points out the bank of four wide seats at the back.

'Allan Tom used to call these, "the swimming pool", because this was where so many young men would learn the breast stroke.'

'I hope,' I reply, 'the girls were wearing petticoats.'

Joan, who's fully across the requirements for woman teachers from 1915, fires back, 'But I'm pretty sure that at intermission some of them would've had ice-cream.'

The AMUSU can be easily be booked by visitors and will screen movies on request. Just get your group to cover the public screening fee demanded by the movie company and settle back with your mob and enjoy the fun. My mind races to bringing a group of riders out here and watching something like *Easy Rider* or *The Great Escape* in the evening. Then I add it to my resolutions for the coming year.

I say my thanks to Joan and head down to the Royal Hotel. There's no problem parking. There's not another car out front, and there's no-one in the bar either, just a couple of men outside in the beer garden. I grab a lite, make some enquiries about accommodation, rooms, facilities that kind of stuff and then I ask if the boss is around. Yep, that's him, the big fella out talking with the other two in the garden.

Halfway through my stubbie this same bloke comes in and explains to the young woman who served me how to stack a fridge, which is right in front of me. I'm the only person in the bar and yet he deliberately seems to avoid any eye contact; not shifty, just oblivious. He's aware of me but for him, as a person, I just don't exist.

The attendant feels zero compulsion to tell her boss I was asking about him. I finish my drink and leave. And I'm disappointed because I was hoping to twin this town with another, 1200 kilometres to the west, which also has a tiny community cinema driven by a passionate committee.

But this other town, Blyth in South Australia, unlike Manildra, also has a great pub so time for a literary detour before heading into Condobolin.

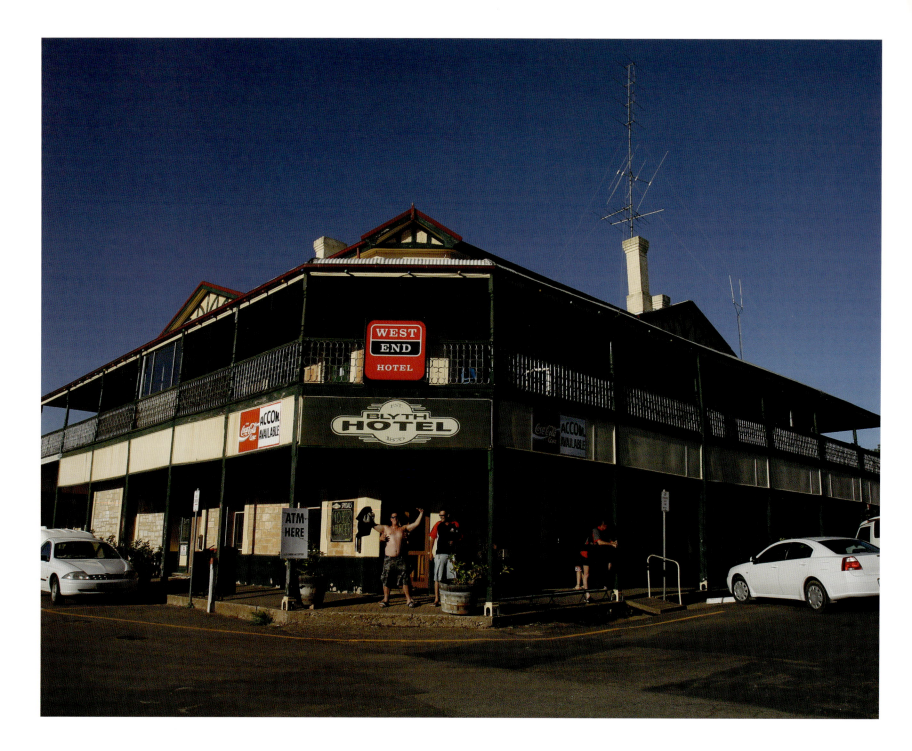

PLEB PUB: THE BLYTH HOTEL

BLYTH, SOUTH AUSTRALIA

In 2000 the Masonic Lodge in Blyth, 140 kilometres north of Adelaide, closed its doors and held an auction for all the contents and the building itself. Ian Roberts, a local artist whose studio was in an old church across the road, wandered over to check things out intending, if the building was going really cheap, to have a go at it. He put in the first bid, a woman from out of town put in the second and Ian put in the third. Then there was silence, the gavel came down, and Ian and his wife, Narelle, owned the hall.

> At the time I had no idea what we were going to do with it. My wife was the town librarian so we used it for a while as the town library, the town playgroup were using it and then I had a gallery over there.

Then one day Ian and Narelle, went down to Adelaide and with business done, went to a movie.

> We watched Russell Crowe in Master and Commander and I was just blown away by the sound, by the creaking of the boat, and I thought, 'Why can't we have that in the country, back in Blyth?' I suddenly felt short-changed for living out here.

The next day they caught another movie, this time it was *Elizabeth* at the boutique Nova Cinema in Rundle Street.

> Again, I was really impressed by the whole experience. After the movie I stepped out of the room and I thought, blow me down, it's the same size as our room, so I thought, yes, it is possible to have a very good movie in a hall that size. So when I got back I called a public meeting and 19 people turned up and we got prices to renovate the whole building and my wife and I funded that.

On 27 May 2004 the 112-seat Blyth Community Cinema opened with a sold-out showing of *The Man from Snowy River*. The next night was a sell-out too.

A committee was formed and a team of volunteers assembled. This was now the town's project and was self-funding. A candy bar was added. It doesn't stock choc-top ice-creams for the traditionalist but it sure sells Jaffas for the aisles!

Rights to screen movies are sold on a 'by the week' basis and the aim was to show a movie on a Saturday night and then again on the following Friday but things didn't quite go to plan.

> It's exceeded anything we thought. We now have at least eight screenings a week. Four are screenings of new release DVDs for the locals and the other shows are for clubs like Probus, Car Clubs, Garden Clubs, even the CWA, who book ahead and they choose any movie they want to see.

Ian's explaining all this in his workshop within his Medika Gallery, where he's painting a eucalyptus leaf using a model in a jar. Well it might be a eucalyptus. It could also be Corymbia or an Angophora for all I know. To me all three genera are simply gum trees, but to Ian each genus and each member is unique and special.

He's set himself the task of painting all 900 members of the three genera but only from cuttings from plants he has grown from seed. He explains and I try to get my head around it. Out on his farm he's planted over 750 different sorts of gum trees, nurtured them, catered to their specific needs and, as we speak, has painted just over 700 of them. I tell him he's on the home stretch and he laughs because it's growing more difficult as he nears the end.

> The poor soil eucalypts from WA are my special interest and they are very difficult to cultivate out of their specific environment. I have a

friend down in Adelaide who's the go-to expert in all things gum tree who's helping me and we'll get it all done eventually.

In 2013, for his services to the community in Blyth, especially his work in creating the cinema, Ian Roberts was awarded the Order of Australia.

A few years before Ian got his gong, the Blyth Hotel went on the market and Jarrod, a rep with the Australia Hotels Association, spotted the advert. He'd been to the place a good few times, and he and wife, Naomi, were looking for a change. The price was right, the timing was spot on, and in 2010 they bought the licence to the Blyth Hotel. It needed some work: the kitchen wasn't great and all the rooms upstairs had been ordered closed for failure to comply with fire regulations.

Jarrod and Naomi had the ideas, had the ambition, had the energy and the drive, but the cash was a bit of an issue. The winds of change decided to blow kindly on this couple. A massive wind farm was about to be built down the road at Snowtown and they sensed an opportunity. They hired the disused local hospital, cleaned it up and turned it into accommodation for the workers, hired extra staff from surrounding towns and pretty soon were serving 700 meals a week.

Yep! Digest that! One hundred meals a day in a town of 300 people. Every penny was reinvested into the pub. The upstairs rooms and the fire regulations were a priority and things were right on track until September 2016. The winds that had supported the town turned nasty and two tornadoes with winds over 210 kilometres per hour hit the town. Four houses were completely demolished, the Lutheran Church was wrecked, every building in the town had damage and the pub's verandah was ripped loose from the building. The roof lifted in parts, causing rain damage throughout.

The pub was fully insured but the insurance company was, well it was an insurance company: contesting almost every sentence of the claim, refusing to consider many and delaying settlement as long as it could. It then classified the pub as 'uninsurable' just to really rub the salt in.

Naomi and Jarrod just got stuck in with fixing the damage and helping the rest of the town recover. The rooms upstairs were completely refurbed with air con, new beds, new decor and fittings. The two shared bathrooms were completely upgraded and downstairs, the lounge was turned into a cafe serving breakfast to guests from 7am and meals and snacks to the townsfolk and visitors from 11am.

In 2014 they figured they were spending too much money on someone else's baby so they bought the freehold of the pub and changed its name to simply, The Blyth. Naomi explains the reasons for the name change:

We wanted to change the culture of the pub from a drinking place to a community centre. We wanted to make it comfortable for families to come with their children and for community groups to have their meetings here. And dropping the word 'hotel' from our name was part of that.

And it worked. Service clubs, church groups, hobby clubs and sporting clubs all now meet at The Blyth. Parents wait at the pub for the school bus to deliver their kids and then stay in the cafe section to chat and gossip as the ankle-biters play a bit of pool or darts and have a soft drink.

And as the community has become part of The Blyth, it has become even more part of the community. Naomi reached out to Ian at the cinema with an idea and of course Ian was supportive. Buy dinner at the pub, or stay overnight, and you'll get discounts on your tickets to the flicks. Meal times are staggered on movie nights to work around screening times. It's all of 25 metres from the pub to the cinema so an evening of pre-show dinner, a movie and then a drink after will involve you in a 50-metre walk, zero parking problems and a very safe passage. Try that in a city!

We are very aware that we are part of an entity, the town of Blyth. Of course we want people to come to our hotel but we also want them to enjoy the rest of our town and when one part flourishes, the other parts do too.

We talk for half an hour about service, and about the importance of custom from both locals and visitors and Naomi explains just how crucial it is to welcome a new face.

Some people who come in here want a drink or a meal. Some of them want conversation and some of them don't; that's our role, to work out and give them what they want. But other times someone mightn't want anything like that, they might need a battery or jumper leads or fuel or a pair of pliers or just directions. It's our job to try to help them whatever they're after. That's what being a pub out here is all about.

Can't argue with that, and as I'm about to tell her that she's captured precisely my feelings, that I want to bottle those sentiments and send them to Manildra, she adds a final sentence which should be the motto of publicans everywhere:

'We do our best to make everyone who comes in here feel like they belong.'

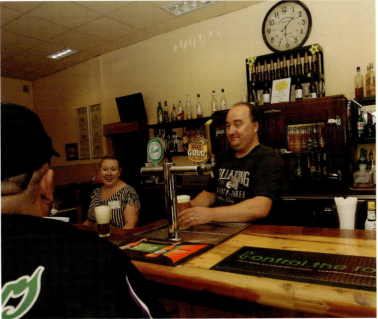

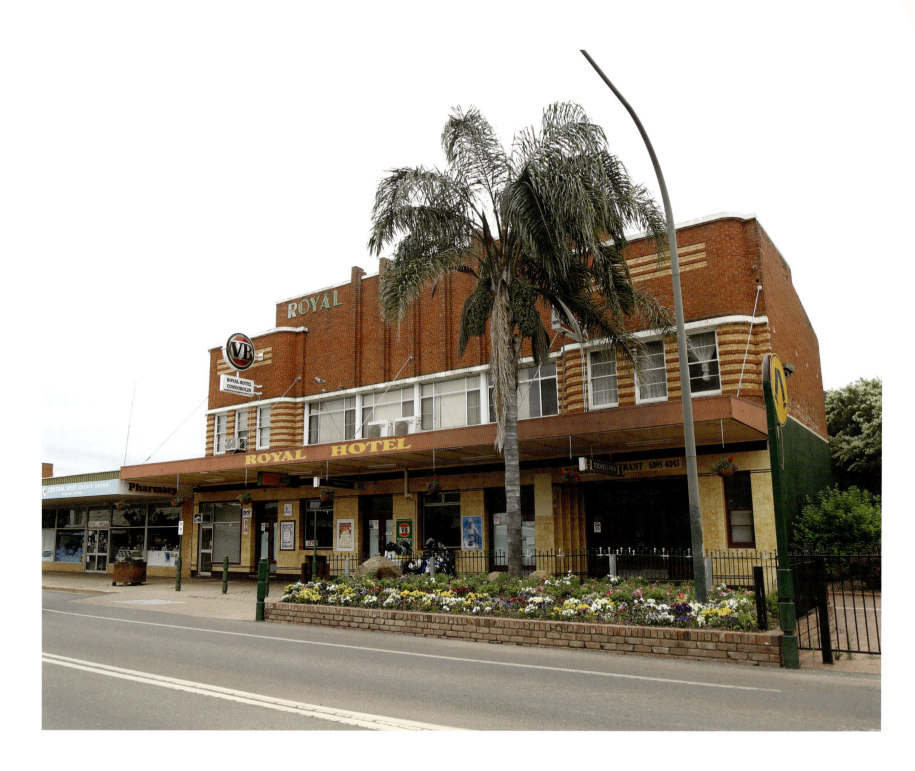

ROYAL HOTEL
CONDOBOLIN, NEW SOUTH WALES

Super Ten is happy right outside the Royal in Condobolin, and I head in. It's been a long day and I'm tonguein' for a beer, and the Irish backpacker takes only a minute or so to disengage herself from chatting with some farmboys to enquire if I'm right.

'Well,' I think to myself, 'I've just walked into your pub, have waited at the bar with some money in my hand, for you, the only person working here, to finish socialising and to make the obviously massive effort to walk over, so why don't you guess whether I'm right or not.'

Instead, I ask for a beer and head into the back bar so I don't disturb Miss Ireland's decisions whether she should swipe left or right. Ian's out here too—a fortyish commercial traveller for white goods company. He's had a decent day.

> There's been some good rain and that makes the farmers happy and when the farmers are happy, they spend and when they spend the shops in town are happy and that means I'm happy. Can I get you a drink?

Ian's like me, booked in here for the night but not yet checked in, just having that quiet drink before sorting out the arrangements. He waits at the bar with the empties. And waits. For all we know the lady's visa has expired and she's returned to the Emerald Isle or maybe she and farmboy have clicked and are in the back of his ute right next to the pig dog cage.

But no! We're suddenly hit with noise: a 747-helping of The Eagles is pumping out from an invisible jukebox. We can't talk and we can't hear. I head around to the public bar where cowboy and bar girl are swaying on their respective sides of the bar. She seems none too happy being asked if it'd not be too much trouble if we could get another round. It's been fully 15 minutes since the last pour and she can't remember what we had. And she's even less impressed being asked if the sound can go down a notch or two, maybe to somewhere around bearable.

Ian and I swap tales as we drink and then, when his glass is emptied he stands. They've lost me. Might just go find another place to stay. This place obviously doesn't need my cash.'

I tell him I understand, that if I'd not ridden for 14 hours and needed a bed I'd be out camping but instead I'll stay and head out early for some photos and then keep going.

It's all rather deflating. Last time I was here the owner, Bluey, was working and when he saw the South Sydney stickers on Super Ten's shield, he called in an ancient fan whose prize possession was an engraved Emu egg in cardinal and myrtle. It was a decent old night but the boss also runs a farm out of town and he won't be in tonight.

Ian leaves and I get some shots of the pub, the logo and the beergarden signs. A couple of local women, a mother and daughter, are found in the back bar. The mother's been banned. Or is it the daughter? Anyway the cops are called and they both get a ride outta there, sewer mouths running a flood. Miss Ireland is replaced by a compatriot, who's less engaged than a cell phone in the outback.

Upstairs there's only one other guest staying the night and we nod in the hallway. Next day a couple of hundred kilometres up the road I realise I've left my washing, my socks, undies and shirt hanging in the bathroom. There's only two numbers they'd have to call to find out the owner but I get no enquiry. I'm not a farm boy, I'm not under 25, and there's no free drinks or fun in it, so it ain't going to happen. I consign my clothes to the past.

My alarm screams at 4am and I gear up and head out (forgetting my washing) and head west on Gum Bend Road. It's dark and the mozzies are rabid.

Paterson's 'Clancy of the Overflow' has spawned more conjecture than pretty much any of his other poems. Just who was Clancy? And where was the 'Overflow'? The Overflow Station is north of Condo on the Nymagee Road but it'd be strange if this was the home of Clancy. The rivers are the

arteries of Australia and all early writers defined and described the country in terms of the rivers. Things happened, men went, drovers drove and shearers shore, up the Darling, down the Castlereagh, and in this poem itself, 'down the Lachlan' and 'down the Cooper'. To my simple mind it would be inconsistent if Paterson, who claimed until he died that Clancy was based on no single person, had shifted from anything other than a riparian reference when talking about the 'Overflow'.

Gum Bend Lake is an overflow of the Lachlan, an artificial reservoir almost two-metres deep when filled. It's modern—completed in 1988—and I'm not much fussed if it's got nought to do with Paterson. This is a modern overflow: an overflow of the Lachlan, where Paterson the poet had met Clancy the shearer 'years ago'.

I pull up short of sunrise. Not a breath of breeze. The leaves of night hang limp and still, waiting for the sun to lift them, the flies of day cowering underneath.

The overflow is like glass and the silence is only cut by corellas, then magpies, galahs and 'burras. The earth stirs and the colours change. I look west across the overflow as the spectrum rotates. The new day eases in and after I've finished taking some images, I make a brew on a picnic table, neither a flirting backpacker nor a hopeful, randy farmboy in sight, or in mind.

This is a beautiful country and I've been gifted another indescribably tranquil morning. I suck it all in, slowly pack up and head back to town, head east on Henry Parkes Way then north-east on Fifield Road.

PLEB PUB: THE FIFIELD HOTEL

FIFIELD, NEW SOUTH WALES

I'm not planning an early stop at the Fifield Pub but its blackboard A-frame proclaiming coffee and breakfast from 8am gets the brakes working and I pull up across the road.

A local dad and two sons walk out, coffees in hands, and we exchange a bit of news as I drop the jacket and neck sock. John's behind the bar, a large, almost Falstaffian, town-crier-looking bloke with mutton chops and specs.

'So you're writing a book about pubs eh? Welcome to Fifield, on the road to most places. What can I get ya?'

Aaaah, back in a family run pub! He calls my order for coffee and a bacon and egg roll to his wife Sharyn as I check out the place.

They've had it for two years; always wanted to have a pub and when their son, who was in Fifield with a drilling team called to say the 'sheila who had the place was wanting to sell,' they told him to tell her they'd drive out from their home in Parkes to check it out.

John had spent ten years as a boarding-house master at a college in Parkes before a 20-year stint as a removalist, first as an employee before buying the company when the owner died. Then his knees gave up and his son made the call.

'We probably bought it 20 years too late. I underestimated how tough the stairs would be on my knees, and they're getting worse by the month.'

So the work's been shunted onto Sharyn and John's not happy seeing her do so much. But they're keeping with their five-year plan to build the place up and then maybe retire back to their home in Parkes.

It's not uncommon to see a couple of trucks lined outside from about 8.30 waiting for the coffee to start. 'We're 12 hours from Brisbane, the same to Adelaide and 8 to Melbourne. If you're on the way to Sydney, you're probably lost.'

And it's passing trade that's keeping them afloat. Of the 44 people in the town ('I'm not sure if that includes Sharyn and me'), John reckons one third is over 70, one third under 12 and half the other third have been in for a drink in the two years they've been there. My maths ain't great but I work out that's about seven locals who drink here. I saw almost half of them on my way in!

There's free, unpowered camping out the back and a shower'll set you back a fiver. Only one camper has ever not dropped into the pub for a feed or drink and those that do all say they'll be back.

Running country pubs ain't easy. In tiny towns it's a slog. People like John and Sharyn who are keeping such pubs open, without holidays, without much help, without super and without much experience, deserve not just support—they also deserve respect. These are the people who feel a duty to keep rural pubs open, relying not on gambling, pokies or cheap foreign lures, but just on basic decency, friendliness and welcoming service.

I wish them both well. It's hard to believe that in 1962 there were 2000 people in this town, most employed in BHP's magnacite mine. The local footy club was winning premierships pretty much every year. But once the 'Big Australian' pulled the pin, the exodus was instant. Any house that could be moved was lifted and taken to surrounding properties and farms. BHP raised the hopes of the retrenched by promising employment at the replacement mine near Young. The workers moved and worked for just two years before they were sacked again. This time forever.

I feel heavy when I gear up and head east for Yeoval, Banjo Paterson's home for seven years, hoping for a good Royal. It's a good ride and my spirits are lifted further by a beautiful corrugated-iron shed with a unique curved roof around 20 kilometres out of town.

But I know that if it turns up trumps I'm going to be in a quandary. Will Yeoval belong in Royals or Poets? I decide to stick it in Poets.

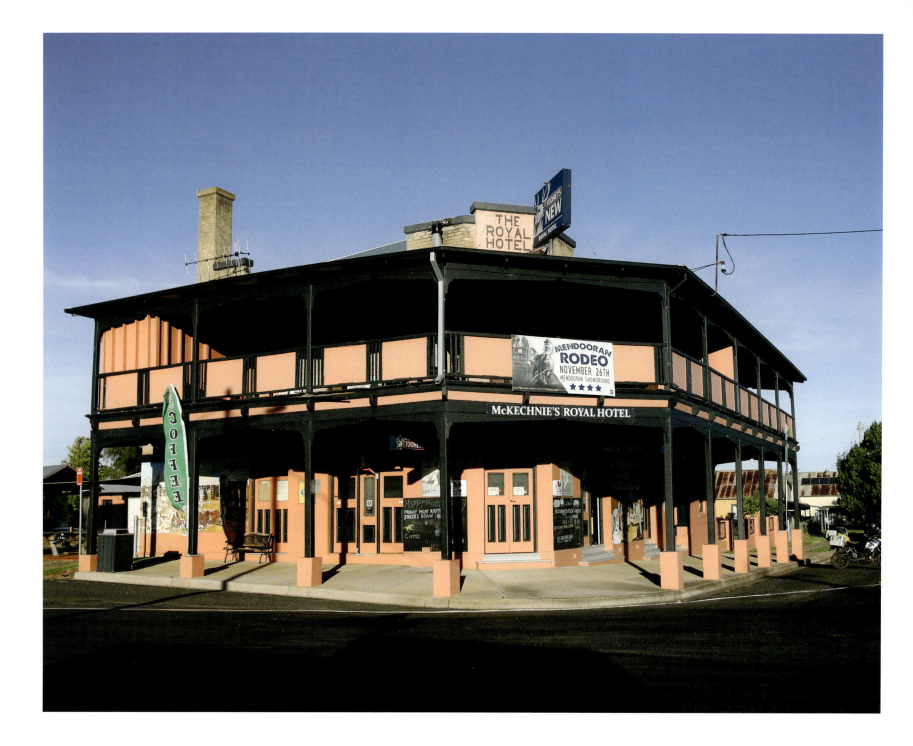

ROYAL HOTEL
MENDOORAN, NEW SOUTH WALES

Some joints have very weird claims to fame. A bit of digging, scratching really, can turn up strange stuff. I've been to Mendooran a few times. The first time I was just passing through and was struck by the murals. Every side of every building seemed to be painted and I took an hour I didn't really have, to get some shots of some of the better ones.

So when I had more time I went back to stay the night, planning to do a piece for my magazine, shoot the rest of the paintings, talk with the locals and the folks across the bar.

When I turned up, a bloke at the bar was well gone, spending his time between gulps of Bundy making awkward, slimy suggestions to the backpacker behind the bar. Turned out the drunk was the manager and just why he was spending the boss's money on staff so they could serve him free drinks and me, the only other person in the pub that night, I'll never know. But I did know that I'd not be writing anything about the place—there's always a stack of better joints around.

Word got to me that this bloke'd been killed in a motor accident, new people had taken over, everything'd been freshened up, and it was worth a visit. And I wanted to go back and get some pictures of the racecourse. Not because Ron Quinton was born here, but because history happened at the track.

In 1972, for some reason, the local race club decided to drop furlongs and on the first weekend of September, they staged the first metric race in Australia, a 2000-metre handicap. Two months later the VRC followed mighty Mendooran's lead and chopped 19 metres off the Melbourne Cup, switching it from two miles to 3200 metres. This is one trendsetting town!

There's a truck just pulled up outside the pub and the trucky follows me into the bar, having a softie and a bite. Terry woke this morning in Dubbo, did two returns to Nyngan and now he's loaded up with 31 tonnes of wheat and heading for Newcastle, about four hours away. Then he'll sleep in his rig, probably fill up with fertiliser to bring back this way and repeat that sort of schedule for the next four days, before a day off, before starting all over again.

In poor years around here they get about a tonne an acre, this year some of 'em are getting two-and-a-half. It's all gotta go somewhere and blokes like me have to cart it. There's no end to the wheat this year. Everyone's going to be happy.

As we both plough into a steak sanger, he tells me that a few days back he was up at Albert, swung around at the T just out of town, and there was another grain truck parked right near the corner.

I didn't know the truck but just as I was passing I saw a pair of yellow gloves waving over the top of the bin from the inside. Just out of the corner of my eye, like. So I pulled up and went back and turns out the bin was empty and the bloke had jumped in to clean it out but the hydraulics somehow closed the tray and he couldn't get out. Been in there for a good hour or so. It was stinking hot and he was near cooked. I got into his cabin and tilted the tray and he managed to climb out. Big bloke, had to be 20 stone if he was 5 pound. Drank every bit of water we had between us. Bet he didn't share that with the boss when he got back.

Terry finishes his tea and grabs his stuff. When he'd come in he'd told Theo that he was after a quick bite and was then headed to Dunedoo for a shower and a freshen up.

'Mate, kick back for a bit, get some tea and have a shower here. You right for soap and stuff?'

Terry had said he was good and looked at me.

'I'll be stopping here from now on, every time I pass.'

Theo and Susy took over the licence here in mid-November 2014, two weeks after the Melbourne Cup. They'd come out this way a couple of months earlier looking for a block of land for retirement but the block was under contract by the time they arrived so they retired to the pub for a consoling drink. When the publican heard their story she suggested they consider managing the pub and then spent an hour convincing them she was serious. They went back home to Newcastle, did some sums, made a few calls and two months later had made the move.

It's proven a lot more work than they expected and Theo's Suzuki Boulevard hasn't moved from the back shed since he first parked it there. But they've trained up a couple of locals who can look after it whilst they're away on a midweek break here and there, so they're sliding into the groove.

There's a couple of reasons why they remember when they started and what horse won the Cup that year.

> *If you're interested in the history of the race club, the bloke you really should talk to is John Hunter. He lives up the highway a bit. He's on the race committee and he also owns a one-seventh piece of Protectionist, which won the Melbourne Cup in 2014, a fortnight before we started here.'*

Really? I've lobbed at a country pub, trying to work an angle on their turf club and there's a Melbourne Cup winning owner just up the road? Theo gives me the number and I give John a ring.

Sure he's got time. Will be busy with shearing first thing but any time after ten in the morning will be fine. He gives me the directions to his place. Theo draws me a mud map to the racecourse, tells me I must make a detour to Binnaway and I head up the stairs.

Sometimes the way these things work out is too illogical and magical to grasp. I have a vision of throwing the pieces of a jigsaw into the air and them all coming down locked correctly together. This has indeed been a Royal with a surprise crown jewel, and I sleep well. An early brew on the 'randah and then down to the racecourse.

One of the committee members has beaten me and is mowing the inside of the track. It's all in fabulous condition, manicured almost. The good season that Terry was talking about last night has been equally good for the track. Too good, in fact. The 2016 meeting was a washout and, with no other nearby date a possibility, became one of very few to be cancelled. In the clear morning, the finishing post stands proud, proclaiming its existence since 1856, although it's only been on this site since 1905.

I get to John Hunter's place a couple of minutes early and Julie, his partner, meets me in the drive. Off to the side a couple of thoroughbreds come to the fence and check out the bike. John soon rolls up in his ute and we all chat in the sunshine firstly about the local race meet and the Mendooran Cup.

'I've never won it. Gone close but never pulled it off. Yeah, it'd be a thrill to win the big one at home,' says this winner of something way much bigger.

We head around the back to his man cave and sit under the fruit trees in his back yard. I ask them about that first metric race in 1972 and John says he was still at school but Julie's dad was secretary of the race club and the time. He lives down at Tumut now and she ducks out to give him a call.

John's lived in Mendooran all his life, his parents had a place nearby and he got married and bought this place around 1988. He reckons he had a bit of luck in a syndicate and had a couple of good bush horses and one thing led to another.

> *We were in the place at the right time, we won the Karaka Million in New Zealand with Ockham's Razor, then we won a Doomben Cup and there's nothing like this game for success breeding success...it's not my business, this farm is my business but it's my hobby, and it's my passion. Every time you win something in this game, you want to win something bigger. And you want to win it worse...The bloke who won it in 2016 for the fifth time is worth 700 million dollars, but when we won it, it showed the world that normal blokes can win it.*

John had bought his share after a couple of syndicate managers he knew rang him from Germany where they were about to buy a horse. Would he like to get a share in a Melbourne Cup winner?

'I trusted their judgment so I just said, "Aw yeah" and they turned out to be smart, I turned out to be lucky.'

John gets up and heads toward his shed; a purpose-built man cave with a bar and a television and walls totally covered with finish-post photos of his horses crossing first. Pride of place are the shots from Flemington, November 2014, and Protectionist winning. John and Julie going crazy and Ryan Moore, the jockey, all blue and black and white and beaming.

Julie joins us with coffees and a scrap of paper. In 1972 her dad, Tom Green, was the secretary of the race club and 'the local real estate agent,

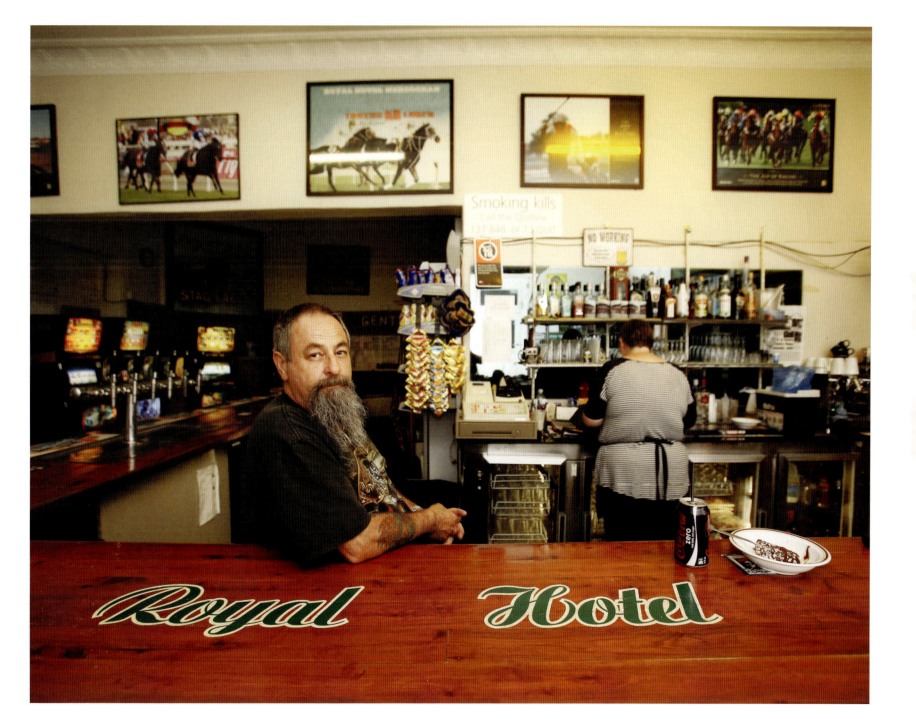

Tom Manusu said to Dad one day, "Why don't we make the Cup a metric mile this year?" So they just did.'

For the first two years it was 2000 metres but entries were sparse and in '74 it was shortened to the current 1500 metres.

We talk for almost an hour and then John suggests to Julie that she bring out the tea set. I'm not really into crockery but yes, okay, might be worth a look. Julie disappears as John hunts for a race book. The pint-sized woman returns smiling.

'This (pause) is the Melbourne Cup. $175,000 worth of it.'

By this stage I'd already written the intro to this section, recalling John Kerr's drunken speech at the 1977 Melbourne Cup. And now, here in a village of 150 people, as the result of asking some questions at the pub, I'm suddenly holding a genuine holy grail of Australian sport and culture. I pick it up and breach my 'no selfies' rule.

Later, down the road a bit, it dawns on me that they'd been sussing me out a bit; making sure I was just glad to see them and it wasn't a gun in my pocket.

Turns out there's a family do coming up and this is one of the rare times that the mug's in John and Julie's safe. These two aren't the only ones who've been in the right place at the right time. I ask if there's any problem with me writing that the Cup is sometimes here. John smiles, 'No problem at all, and there's no problem writing that the double-barrel shottie is *always* here!'

We get some pictures, share a few more laughs at I get ready to head out. The two horses are still checking out Super Ten as I wheel around and head back to the highway.

They've given me a pile of time during a busy season on their farm, two champion people who've lucked in and become owners of a champion. Once again I'm staggered by the places you can end up, and the people you can end up with, just by talking to folks in the pub.

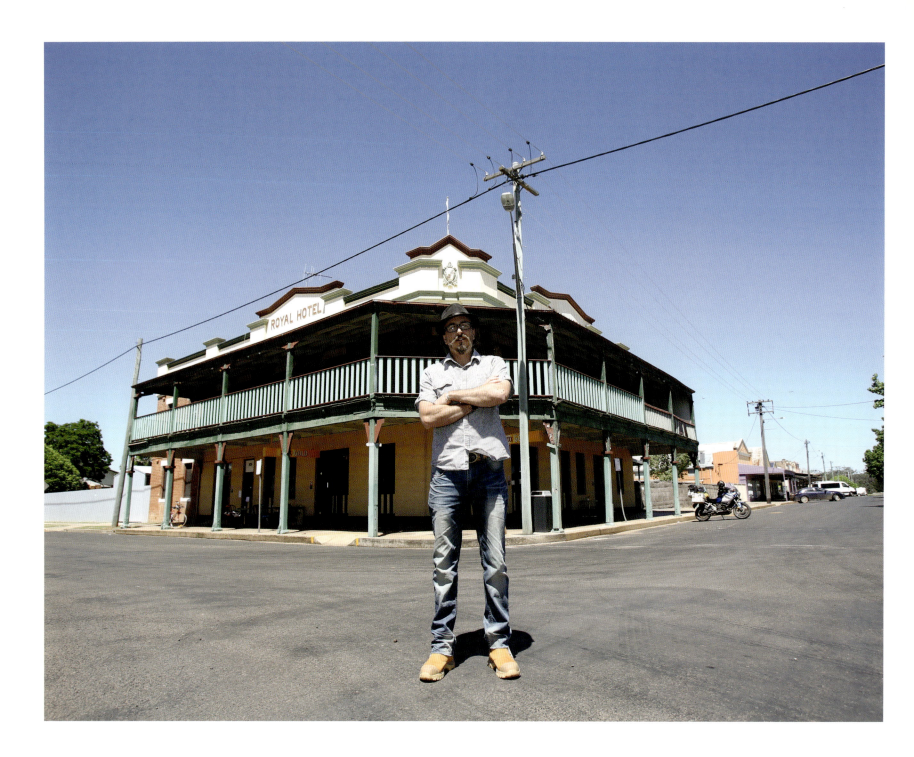

ROYAL HOTEL

BINNAWAY, NEW SOUTH WALES

When a publican recommends another pub to me, I listen. When three in a row tell me I simply must drop into a certain place, there's no chance I'm going to miss it.

Mark at Yeoval had told me to make sure I visited, and then Theo at Mendooran had underlined that I must not head straight up to Coonabarabran but to detour to the Royal at Binnaway.

As I pull up at the Royal, a cool dude is just heading out on a bicycle, a couple of coffees balanced in one hand. Before I get the riding gear off, he's back and he's Sean. I tell him why I'm in town and we pull up a pew outside, he rolls a durrie, I order some caffeine and pull out the camera and recorder.

Pretty soon Kylie, Sean's wife, in full chef's gear, joins us. It's the quiet pre-lunch time and both have time to tell of their passion, and that passion is this pub.

They're from Dubbo and in April 2016, with a background in cafes and catering, they bought the Royal Hotel at Binnaway. They weren't fazed that it'd been closed for the last six months or that its trading graph before that was a straight line pointed to the south east. They had other plans, other dreams.

It took them two months to clean the place enough to warrant hanging the 'Re-opening Soon' sign out front and in June they opened the doors. They'd knocked a hole in the wall to serve takeaways, installed a gift shop in one of the back rooms, landscaped the back area and turned it into a family backyard with more than enough stuff to keep kids of every age occupied.

The renos are Kylie's favourite part. She beams, 'I love being a transformational rennovationist.' A term I've never heard but immediately understand.

Deliberately they eschewed gambling and gaming. 'Places like this are really important because they are a meeting place for people. Where farmers can come in and catch up each week, where everyone can relax, enjoy and feel safe.'

'From the start we were embraced by the community,' says Sean, and that simple sentence is terribly revealing. Not 'the town', not 'the people', not 'the locals' but 'the community'.

I ask them what their dreams are for this place and Sean points to two empty shops across the road.

'We want to attract enough people from out of town that these shops will open, maybe a cafe, maybe something else to get money into our community.'

A woman comes by from the school down the road and orders half a dozen various coffees for the teachers. Kylie heads to the kitchen and Sean suggests I take a tour while he morphs into barista mode.

On one wall there's a vinyl wallpaper world map and underneath's an inscription, 'You haven't really been away, unless you've been to Binnaway'. Kylie's expert hand has added Binnaway is a font identical to that of Sydney and other minor places. And then there's the front bar. It's without beer taps and may be for a while. There's a fridge with stubbies and wine but for now the room is empty 'cept for the ghost, the shadow of a giant.

In 1977 Peter Finch played his greatest role as Howard Beale in *Network* opposite Faye Dunaway. This was the 'Mad as Hell' movie and it won Finch, who died in January '77 the first ever posthumous Best Actor Oscar.

But 21 years before this, Finch's star had begun its highest ascendancy when he starred in the Australian film, *A Town Like Alice*, which won him a BAFTA, and he soon followed this up with *The Shiralee*. This was a story of a battler, his swag and his child, and it was shot in Binnaway. A central scene involves Finch's character, Jim Macauley finishing a drink in the front bar, walking out the corner door and getting into one hell of a stink. I'm checking out the bar, imagining the scene when Sean joins me poses right where Peter Finch stood polishing off his beer. 'Pretty amazing eh?'

It sure is. The bar is pretty much unchanged and the leadlight windows are what you see in the flick. Time here has almost stood still in some sort of wonderful inertia.

Sean's keen to show me around: to show me what they've already done, and what their plans are. It's underpinned with an appreciation of the past, and understanding of the present and an awareness of the connection.

The Royal at Binnaway is closed on Mondays and Tuesdays and always will be. Sean and Kylie are here for the long haul and don't want to be burning out. Most Monday nights you'll find Sean at the other pub, not scouting customers, not beating his drum, 'Just hanging with friends. The people who run it are top people and there's room for us all.'

This Royal hadn't been on my list. It's a total bonus, a tonic for my faith after some ordinary places in the last few days. As I mount up, I'm grateful for the suggestions of others eager to spread the word about the job these two are doing.

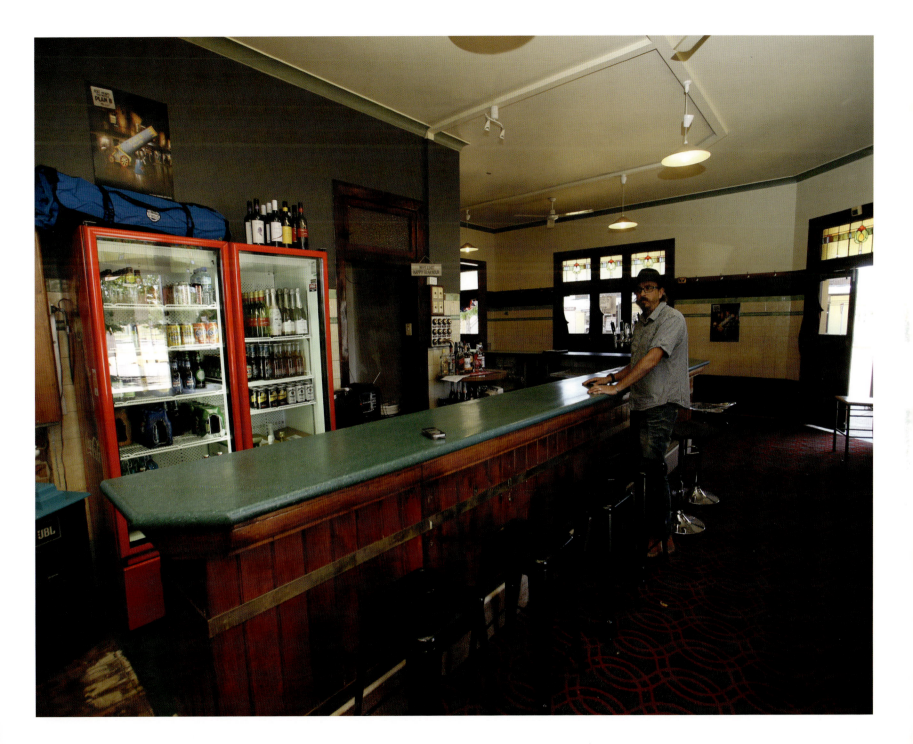

Mendooran To Wee Waa via Coonabarabran

When I woke in Mendooran I'd budgeted half an hour to shoot the racecourse, another half an hour to chat with John Hunter and another 30 minutes checking out the Royal in Binnaway. Nah! Make that over an hour with the Hunters and 90 minutes with Sean and Kylie at the Binnaway Royal. If I'd had a schedule, I would've been behind it, but I didn't so it didn't much matter that it's mid-arvo by the time I get to the Royal at Coonabarabran.

Which is shut.

Not just for the day, but closed, locked up, deserted. Pick up one in the morning, lose one in the afternoon, such is life!

I head down Cassilis Street to Birds of a Feather Cafe and regroup. I don't much feel like riding; the next Royal can't be reached in daylight, so I make a couple of calls then grab some fruit and a can of baked beans and head west for the Warrumbungles.

I've been talking with the people at National Parks about overnighting at one of the lookouts in the Park and the permission came through a few days before I left home. There's not a cloud and no moon so the stars should be about to put on a real show.

I find the lookout, set up the tent and whilst the Trangia camp stove is heating up the water, I scout around for some angles. Down below the occasional car hums by and overhead cockatoos, magpies and galahs head to their homes. Then all's quiet 'cept for the crickets. I have my brew in that perfect hiatus when the flies have gone and the skeetas aren't yet seeking blood donations.

The heavens don't let me down. I get some images then set the camera going to take some star trails for the next three hours, set the alarm and hit the sack. Around 2am I do some panoramas, now lit by a quarter moon, grab three more hours sleep and then duplicate the panos at daybreak. I'm joined by a couple who seem severely pissed that I'm camped out here but I can't be bothered showing them the authorisation, even as they get even by walking in front of my tripod. Ah, uncivilisation!

I pack the gear, head back to Coona then swing north. I'm in need of a bath and I know where the best one is. The road's smooth and clear through Baradine with its majestic Memorial Hall, and then on to Gwabegar, where the old disused rail line, my roadside companion for days, finally gives out.

From here it's 30 kilometres of good riding gravel through the Pilliga State Forest until I get to Pilliga itself. The town's on the left but I hang a right and two kilometres down the road are Pilliga Artesian Bore Baths.

These are my absolute favourite free artesian bore baths in the country. I park down the side, get into the sluggos and slide into the 38-degree water. Aaaaaaaaaaaaaah!! That's good. It's past good. I've spent a few good nights camped here and the temptation tugs at me again, but I've booked a bed up ahead so I stay an hour, playing under the borehead before letting the sun and breeze cool and dry me.

With the sun now in the west, I turn east, totally refreshed. Thirty kilometres down the road I stop at an old wooden building set back a bit from the road. The Cuttabri Wine Shanty was built in 1900 to replace the original 1883 Beehive Hotel, which had burnt down. It was a Cobb & Co stop and until the railway arrived, Cuttabri was a thriving town. It still has the number two wine shanty licence in New South Wales.

The bad news is that it closed down in June 2010 and was dormant for six years until two brothers and a mate from the Hunter Valley bought it with the intention of re-opening it as a wine bar. Unfortunately, the two brothers fell out and it remains closed; a beautiful old building with character and history but with a very uncertain future. I look at it from the seat of Super Ten and my only emotion is sadness.

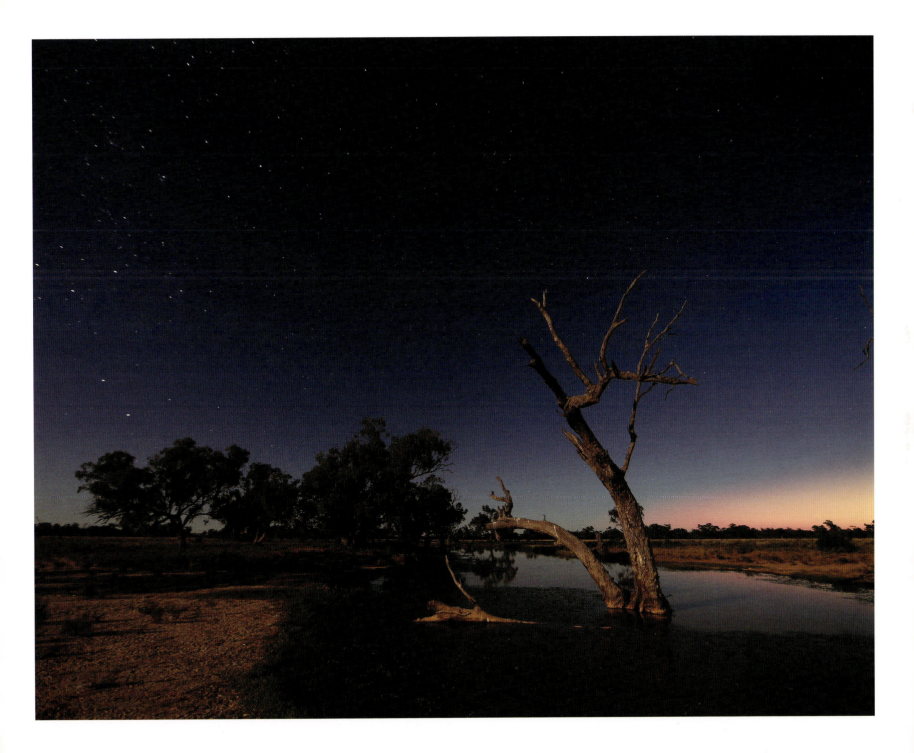

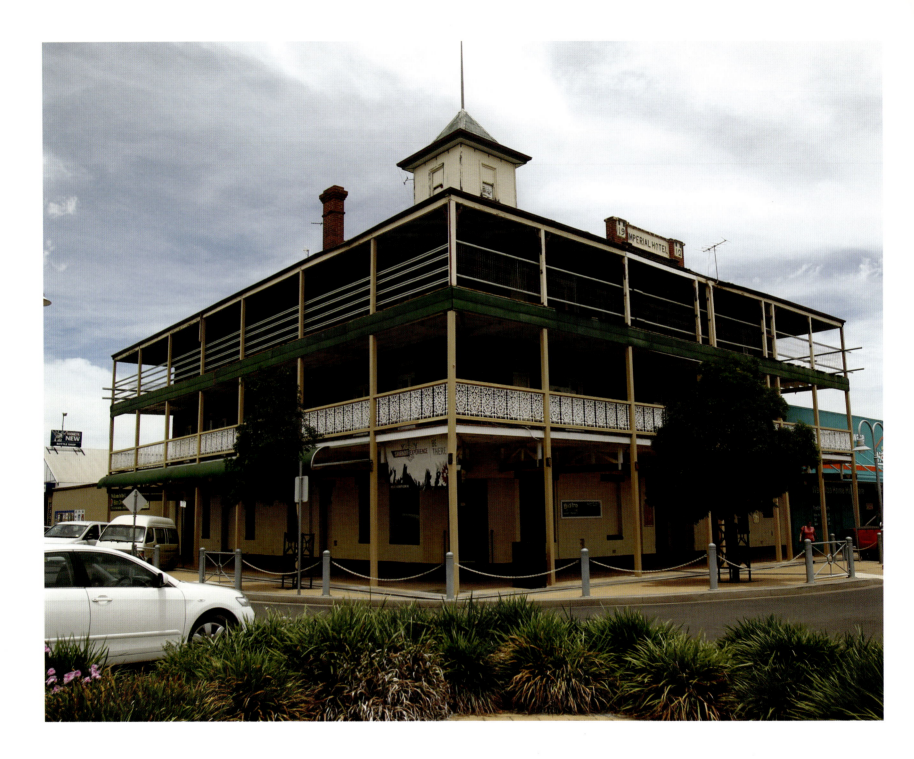

IMPERIAL HOTEL
WEE WAA, NEW SOUTH WALES

There's an east–west detour for heavy vehicles and folks in a hurry around Wee Waa. If you're a lover of great bush pubs don't take it!

At the eastern end of town is one of the very few remaining three-storey hotels in the bush. And one of the finest.

The first time I dropped in there, I was on the way out to the artesian spa at Burren Junction, about 50 kilometres further west. I spotted the grand, triple-storey building from the eastern end of town.

There she stood in the mid-morning sun: stately and elegant, redolent of a past grand era of tuxedo dinners and visiting string quartets. A bit of a distant sister to the Corones up at Charleville.

Inside there was none of the all-too-common condescension when I ordered a softie and a long glass of water; just a smile, and enquiry about where I'd come from and where I was headed.

In the middle of my interrogation of the barmaid regarding the history of the place, she pointed out the owner so I called him over and began the grilling. The embodiment of the dry, wry, laconic country publican, Barry gives a bit of the history, goes out back to grab some amazing photos of the original 1890 pub, which burnt down in 1912 (it was replaced by the current one the same year). Then I ask him how he came to be the owner.

Barry's got a face like a Shar-Pei and the corners of his mouth curl and his eyes glint as he leans over the table and confides, 'I've never minded a drink.'

I can think of no time in my life when I've felt more assured that I'm being told the truth.

In 2005 Barry and his wife, who's a Narrabri native, came out on visit from their home at Nelson Bay and as Barry tells it to me, he:

> ...got on the piss with the bloke who owned the place. It was a long session. When I got back to the missus I told her, 'I think I bought the pub,' to which she replied, 'you're fucking mad.'

> Anyway, turned out I'd offered him a couple of million for it and that afternoon he accepted and we had ourselves a pub. Since then I've put another one-point-five into it and it probably needs another mil to really set it up.

So it's become a bit of a money pit for this bloke who made his loot concreting around Nelson Bay on the New South Wales coast. But it's pretty clear that money's not really the point of this exercise. First thing Barry and his son Luke, who runs the place day-to-day, did was get rid of the TAB. 'It can bring in good money but it can also bring in trouble, so I got rid of it and ever since this has been a really friendly joint.'

Could've chatted all day but I had to get out for a hot soak at Burren Junction, so I took my leave and headed west. Turns out that the artesian spa at Burren Junction is probably the worst in the area. Some genius designer has stuck a pug-ugly circular platform in the middle and the 37-degree water is full of algae. I had a quick dip anyway and considered my options.

I could've camped beside the spa or there's the Junction City Hotel just down the road and therein lies another story.

These are the black soil plains, wonderful for crops but unstable for buildings. In 1911 the Coronation Hotel, a great two-storey version of Wee Waa's Imperial, dominated this town. Young blokes would land their planes in the main street, taxi up and park outside, have a drink and literally take off! Due to subsidence in this black soil, this magnificent building was tragically demolished in 1989 and replaced the same year by this ugly, soulless, nondescript non-event.

Rant: Outback timber pubs like the Coronation at Burren Junction are incredibly valuable jewels in the bush. They are unique to this land and each and every loss is to be mourned. When they go, they are not replaced. Enjoy them and savour them and never assume you are going to see them again.

I decided to head back to Wee Waa and spend the night with Barry. It wasn't a hard decision. I got back just in time to savour a country sunset back down Rose Street as I parked Super Ten right out the front of the pub.

Luke was behind the bar serving a room full of farm lads and contractors but there were rooms free and my knees were glad there was one on the first floor! My digs faced the front, which was a blessing for the view of the main street and the sunset.

Back in the bar I get chatting with a bunch of locals and I ask them about the Royal Hotel, a bit down the street. It's a building as pug-ugly as this one is beautiful.

'Mate it's just gambling and brawling down there. No-one hardly goes there since Barry's taken over here. It's a wonder it's still open.'

They fill me with local stories and gossip and I head up for a kip. At 3am I get informed that it's street cleaning morning and too few hours later I find out this corner is the pickup point for every loud speaking contractor and council labourer in the Namoi Valley.

Flash forward a couple of years and I'm coming into Wee Waa from the west. The Royal Hotel hadn't been answering my calls and when I pass it on my right, there's no sign of life. There's a bunch of hi-vised contractors drinking beers at the front table of the Imperial when I head into the bar, chatting with an old bloke in civvies who turns to me as I come in.

'G'day, Colin'

'Gee you've got a memory!'

'Nah, just warned you were coming!'

I plonk down at a nearby table and after the workers leave, Barry heads over. Turns out the Royal Hotel was on its knees and Barry bought it, sold the pokies for the same sum he'd paid for the entire hotel and then closed it down, keeping the licence. Some group has bought the building and intends turning it into accommodation, but that's not Barry's problem.

We talk for an hour or so. Barry's excited at how the pub's coming along. When I was first here the top floor was completely lacking the old ironwork and the flooring was unsafe. Now the verandah is fully restored and half the ironwork is in place with the second half about to go in. With the top floor open the number of rooms has gone from 13 to 23 and with some major works planned for the area, he reckons he'll be filling them each night.

When he talks of the pub, his love for the place comes through, the Shar-Pei jowls remain but the eyes come aglow.

We're joined by four grey nomads, two couples who've just finished dinner. They've been out sorting potatoes on a nearby farm, a job they do here for six weeks each year to help fund their travels. They do a similar stint down in Victoria. They explain how the spuds here are all grown to make crisps, entirely unsuited for mash or chips. These people know their potatoes! Everyone has a story, but they've got an early one in the morning so they're soon off.

Barry might've got rid of the TAB but that doesn't mean he hates a punt. Years ago he had a few racehorses when he lived on the coast but gave it away until early 2016 when he rang a trainer mate up on the New South Wales north coast and asked if he knew of any half-decent country gallopers on the market.

Turns out of the syndicate that owned one of his horses was bluing and they all wanted out and were asking eight grand for the horse. I told him to offer them five-and-a-half and he got back to me within an hour and said they accepted it.

Three weeks after buying it, the thing won at Narrabri. Barry pocketed five grand 'and that's not counting the winner's cheque.' Then it won the Armidale Cup on Anzac Day.

The bookies had it at 8/1 and I asked one of 'em if I could get 500 on it. He told me I could have a thousand so I asked if I could have two and he said, 'fine'.

So I pocketed 16 grand plus the winner's cheque just from that. I was starting to like this.

A couple of weeks back I saw this horse up for sale in Melbourne. It's from a horse that won the Kentucky Derby in

the States and Singo fell in love with it and brought it out here. It's called, Big Brown. Anyway this filly that I've bought, someone with a sense of humour has named it Divine Brown.

Barry never thought anything of the name until the wife of a mate from Newcastle rang him and asked if the horse had nice lips.

'How would I know? I haven't seen the thing yet, but anyway what do you care about its lips?

So she explained that Divine Brown was the prostitute in the back of the cab with Hugh Grant and then laughs. 'Well if it doesn't win you might get a blow job in the car on the way home.'

I figure I'm not going to get a better laugh tonight. Barry moves off to schmooze some other customers and I head up the stairs. Smiling.

WEE WAA TO MOREE

Just at the south-west approach to Narrabri the farm fences pull back several hundred metres from the road. This is a Travelling Stock Route (TSR), and this is the wide holding area where drovers can rest their animals. A windmill is spinning in the morning breeze, pulling water up into the tanks and the troughs, although today the expanse is empty of livestock.

This place holds some special memories for me. I slow before heading into Narrabri and turning north for the one-hour squirt up to Moree.

There's a great little detour east from Bellata and up to Pallamallawa, but I stay on Newell. Twenty-five kilometres short I slow for Gurley. It's just a pub, a Royal, and some silos. A dog on the pub porch eyes me distrustingly and then vanishes. No-one answers my knocks or shouts. A sign says it's under new management but there's no sign of manager or any other non-canine life form. Apart from the flies. Across the road two combines are harvesting wheat and dust.

Fifteen minutes later I'm in Moree and ordering a coffee on Balo Street. I'm in no hurry. I'm waiting for the pubs to open and for the sun to rise and gain some heat so I take it slow before heading south, back over the bridge, and making for the Moree swimming pool, down by the railway station and the Victoria Hotel.

The Moree Artesian Aquatic Centre is the most elaborate and beautiful artesian pool in the country, but once I park the bike out front, I grab a camera and make for the Victoria Hotel across the street. It's just opened for the day and no, there's no problem with me going upstairs to the balcony and getting some pictures of the pool. Because the Moree pool complex is not just a swimming pool. In the fight for racial equality in Australia, the Moree swimming pool is our equivalent of Rosa Parks's bus, of Martin Luther King's speech at the Lincoln Memorial in 1963.

Just two years after MLK's 'I Have a Dream' speech, a busload of students from Sydney University, including Charles Perkins and Jim Spigelman, arrived of this pool in Moree on their 'Freedom Bus' demanding that the law forbidding Indigenous kids from entering be overturned. For two days the students held firm until eventually the mayor relented and allowed the students and their band of Aboriginal kids through the turnstiles. In his book, *A Bastard Like Me,* Charles Perkins wrote:

> *When we got down to the pool I said, 'I want a ticket for myself and these ten Aboriginal kids behind me. Here's the money.' 'Sorry, darkies not allowed in,' replied the baths manager. The manager was a real tough looking bloke too. He frightened me. We decided to block up the gate: 'Nobody gets through unless we get through with all the Aboriginal kids!' And the crowd came, hundreds of them. They were pressing about 20-deep around the gate.*

Crowds of white locals abused and assaulted the students. Drinkers poured out of the Victoria Hotel, out of the very bar in which I sought permission to photograph, and hurled missiles and themselves at the protestors.

Ann Curthoys, the semi-official diarist on the bus wrote:

> *The mob from the hotel across the road decided that they were going to show these university students and niggers and black so-and-so's whose town this was. They came over and did most of the kicking, throwing and punching, and the spitting...I have never met such hostile, hate-filled people. The hostility seemed to be directed at us as university student intruders rather than to the Aborigines.*

But then on the second day there was a breakthrough, Ann Curthoys again:

> *The mayor came up to us and stated categorically that he would be prepared to sign a motion to rescind the 1955 statute we were protesting against, and would get two other aldermen to co-sign it.*

And Charles Perkins:

> *They let the kids in for a swim and we went in with them. We had broken the ban! Everybody came in! We saw the kids into the pool first and we had a swim with them. The Aboriginal kids had broken the ban for the first time in the history of Moree.*

Today, on the left as you walk into the pool there's a commemorative plaque and the iconic photo of Charlie Perkins in the pool surrounded by Aboriginal kids.

As I stop to sponge it all in, I'm in near disbelief that this happened in my lifetime; that when I was 14 and enjoying the privilege of a selective high school in Sydney, out in the bush, Indigenous kids were being banned from swimming pools, their parents barred from cafes and pubs.

Inside the pool I'm met by Alfie, a local Gamilaraay man and head lifeguard, and once we've had a chat I strip off and slide into the hottest pool. Pretty soon I'm joined by three black fella blokes from Coonamble, Wayilwan men in town for a religious conference.

In the hot communal bath we talk of 1965 and how wonderful it is to have those battles behind, how lucky we are to have inherited the victories of others, to enjoy the fruits of their sweat. We laugh and relax in waters that have been beneath the land almost as long as their people have been in it. We say our goodbyes and I head into town; there's a Royal waiting for me!

ROYAL HOTEL
MOREE, NEW SOUTH WALES

It's too hot to even shed my riding gear in the street, so I head into the bar of the Royal at Moree fully kitted out. There're a few other people in, the dreaded TAB dominates one end of the bar but not the whole room, and as she's pulling a beer for one of the punters, the young woman turns to me and smiles. 'Get comfortable. Looks like you could do with a glass of ice water.' By the time I get my gloves and jacket onto the seat, there's a clear, icy schooner of water on the bar waiting for me. And there's a smile behind it.

This is Maddie, daughter of owners Tim and Debbie, and if friendly is the thing that first hits you about her, a quick chat will show you that 'proud' is about the next most apposite adjective for this ever-smiling young woman. She's proud of her town, proud of her pub, proud of what her family's done to the place since they bought it in 2006 and she's proud of the service that they give to the community of Moree, a good town with a bad rap.

This is the second pub the family's had in the town. They took over the Moree Hotel back in 1991 and kept it until they all felt like a change a decade later. But then four years later the Royal came on the market. They loved the building, the location and well, the pub game in Moree, so they came back for seconds.

We're maybe 15 minutes into a chat about all these things that Maddie's proud of when the biggest object of her affection and pride drops by.

Jenny is Maddie's maternal grandmum, a scrupulously groomed and dressed mouse of a lady who still works a couple of days at the pub. Jenny and her husband were share farming in Tumut, battling ceaseless droughts and hard times, when a mate rang and told them the pub in his town had gone bust. The owners were looking for an honest couple who'd take it over rent-free, just pay all the bills and take any profits.

It didn't take much for Alan and Jenny to give up the fight with the land and submerge themselves in the huge culture shock of getting behind the bar of the only pub in Walgett. This was 1987.

We had three bars and they were all packed all the time. We worked without breaks and at night we'd just collapse. But that pub was very good to us. The locals accepted us quickly and we made some very good friends.

After almost four years the owners sold up and Jenny and husband Alan had to move on. They bought the town's two taxis and both drove for the next six years until Alan lost his life in a light plane crash. Meanwhile, Jenny's daughter Debbie had married Tim and moved to Moree with their baby daughter Maddie. Jenny missed them all too much so she left her close friends in Walgett, moved to Moree and began work with the family in the Moree Hotel.

As she shares her story, her granddaughter stands to one side, watching, the love in her eyes almost tangible. Jenny no longer works the bar.

They didn't want to teach me these new tills and I didn't want to learn, so I spend Fridays and Saturdays clearing the tables, providing the flowers from my garden and talking with the customers, making them feel at home. This is a wonderful town full of wonderful people and the visitors we have are all nice too.

I ask Maddie, this third generation pub worker, about the pub's logo which is everywhere. It's her own design, replacing the old emblem of a cotton ball and a bull, which was, 'very old school and dated. We were making a fresh pub and we needed a fresh design.'

It's on the glasses in the pub's fine-dining restaurant, which is open Fridays and Saturdays, and since my water's done its job and I'm now beer-parched, Maddie brings me a lite in one of these elegant numbers.

Up the stairs (suitably emblazoned with that logo again) and the walls are filled with framed old photos of pubs, a collection that Tim's been putting

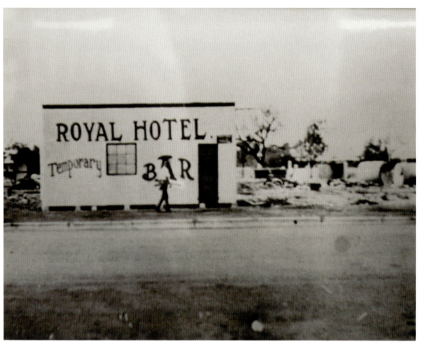

Royal Hotel Temporary Bar After Great Fire Which Destroyed Moree 3rd Dec. 1928

together for years. It all adds to a nice feel and there's a temptation to stay the night in my choice of hotel room here or motel out the back. It all looks very comfortable.

Downstairs, Jenny's off clearing tables and chatting with guests and Maddie is running the taps. She knows I'm about to hit the road and there's another glass of ice water waiting near my jacket. This is a family steeped in outback pub culture, who know that service isn't subservience, and who are natural experts in making every first time visitor feel like a regular.

During our chat, Maddie says to me, 'We just can't understand, it just breaks our hearts when we see some groups saying, "Don't stop in Moree."' And after a morning at the pool, the best strawberry milkshake ever at the Omega Cafe, and now an hour sucking in the vibes of the Royal Hotel, I don't get it either!

ROYAL HOTEL
GOONDIWINDI, QUEENSLAND

It's a quick 120-kilometre squirt up the Newell to the sadly down-at-heel Wobbly Boot Hotel at Boggabilla where I take a left, cross the Macintyre River, which is still the state border, left at the huge roundabout onto Marshall Street, and I'm at the Goondiwindi Royal Hotel.

Gundy's main claim to any space in the brains and memories of Aussies is as the home of Gunsynd, the Goondiwindi Grey. Bought as a yearling by a syndicate of four chaps from Goondiwindi in 1969 for just $1300, Gunsynd won $280,455 in prize money and included wins in the Doncaster and the Cox Plate. He won Horse of the Year in 1972 and two years later Tex Morton's song, 'The Goondiwindi Grey' won the APRA Song of the Year. Its chorus celebrated the horse who had:

...never thrown the towel in,
Been a trier all the way,
A horse we're really proud of —
The 'Goondiwindi Grey'.

I was young back then and not a big race fan, but everyone, just everyone, knew about the grey with a massive heart.

I'm here to talk to a bloke about horses, different horses. And about cattle, and about something very close to the historical arteries of this country.

In 2013 Tom Brinkworth purchased around 18,000 cattle from stations in the drought-ravaged Northern Territory and western Queensland. He assembled them around Winton and Longreach and broke them into nine mobs of around 2000. From these bases, they split up on various Travelling Stock Routes and began to head south towards Brinkworth's new property at Uardry in the Riverina.

I happened to be in St George having a yarn with Barry Doonan, a blacksmith and the current custodian of the heritage of the Condamine Bell. Over a brew, with his dogs at his feet, Barry told me that line I usually hate to hear: 'You should've been here yesterday.'

The day before, a couple of drovers from the Brinkworth mob had been in to buy a bell for their bell cow and Barry thought it'd have been sweet for me to meet them. Well, drovers don't move too fast, so once we finished I grabbed my Travelling Stock Route maps, made some guesses, and headed south to the nearest TSR bore.

I was in luck! The mob was just reaching the dam and the head drover was drinking his horse. No, there wasn't a problem with me tagging along. 'Might even get you working a bit. Our camp's about half a mile down this track.'

So I ended up spending a month with Bobby and Cheryl and Louise, their chief off-sider, as they droved their 2000 cattle south, to feed and water. I knew they were now based in Goondiwindi so I took the chance to repay some of my debt for their kindness and buy them dinner at the Royal.

Now 53, Bobby's been droving for the last 42 years. When he was 11 he was set to head out with some of the family cattle to find feed with his immediate older brother. One the last night before leaving, his brother headed into Goondiwindi on his motorbike for one last night in the town. He never made it. He pulled up at a stop sign at the edge of town, but the drunk in the car behind didn't, and Bobby's brother died at the scene. There was no time to grieve. The cattle were starving and needed to be moved and so Bobby's other brother, then aged 20, stepped up and they drove them together.

Five years later, with the drought still biting, Bobby took his first mob on the road, not point to point, just pushing them the required eight kilometres a day looking for feed. As he talks I hear murmurs of Paterson and one of my very favourite poems:

The drought is down on field and flock,
The river-bed is dry;
And we must shift the starving stock

Before the cattle die.
We muster up with weary hearts
At breaking of the day,
And turn our heads to foreign parts,
To take the stock away.

He became an expert rider and horse trainer and in the early 1990s was recruited to America and put in charge of a barn where his job was to educate cutting horses. This is a very specialised, expensive and lucrative sport where these quarter horses cut one cow from a herd and keep it separated, without input from the rider. In 1997 a young Australian woman named Cheryl turned up looking for a job. Bobby was impressed, she was hired and two years later she and Bobby married.

When I first caught up with them at the camp out from St George, and the cattle had been watered and fenced for the night, I told them about Barry Doonan and they explained Bambi to me.

The bell they'd bought was for Bambi, their bell cow, a grey Brahman that was almost a pet, brought with them when they left their home to start this drove. She was as much part of the team as the 14 dogs, the horses and the drovers themselves. I'd see her at work in the morning.

At the Goondiwindi Royal we talk about the heat, the dust, the prickles, the burrs, the baying at night and glorious sunrises. We talk how the stars were and the night it rained, gifting us with a perfect rainbow. We talk how the cattle flowed like a liquid above the dry ground, how they didn't pause overly when they found green feed. We laugh at how they educated me about the origin of the term 'bellwether', how it originally referred to a sheep that would lead a flock and have the others follow.

That next morning the canine chorus, the sun and the smell of the brew woke me early. Bobby rode into the mob calling for Bambi and brought her to the gate. Her Condamine bell clanging, she led the 2000 out to the troughs and then she, the 'bell cow' was pointed in the day's direction and the entire mob slowly followed. Silently except for their hooves in the dirt. It was all incredibly peaceful.

As Banjo has written, 'For the drover's life has pleasures that the townsfolk never know.'

And at the Royal, over a very decent pasta and beers, we talk about the night we had visitors with a welcome slab of VB, but who tooted when they left, and on that clear night Bobby heard thunder, and the way I saw his eyes widened in the campfire as he jumped up. 'They're rushing, get the horses out of the way! Don't go out in the open!'

The visitors' horn had startled the mob, and in the dark 8000 hooves were thunder without lightning. We had to let them pass and then the drovers mounted and I grabbed the quad bike. Bobby shouted orders and I went to my post. In an hour they thought they'd found them all and in that pitch black, brought them back and let them calm, as a couple of the crew fixed the electric fence. In the morning count, 27 were missing so two riders were sent out and brought them all back. They'd been together at the creek.

And we talk of how it all went sour. How the sad combination of vested interests, egos and local bureaucracy forced this drove to come to a premature end at Narrabri, where the cattle were loaded into road trains and shipped south. How Bobby and Cheryl cried as the last truck pulled out, how he was immaculate as ever that day with shirt ironed and tucked in and how we didn't know what to say when the time came to part.

I'm reminded again that the essence of pubs is not as a place where people have gone to drink, but as a place to meet, to catch up on business, to reunite with old friends, a place where celebrations are made and commiserations are spoken.

There is no place like a good country pub to catch up with old mates and reminiscing with Bobby and Cheryl, I appreciate again there's nothing on this planet (and nothing more uniquely Australian) than droving cattle (except perhaps talking about in the pub later).

Goondiwindi to Texas

I'm heading east so no point in getting up early and having the sun in my eyes, so I sloth for a bit. They've let me leave my excess gear in the office downstairs, which is always a blessing, and as I load up, a few locals ask about my destination and how it is on days like this that promise to be hot. I tell them regular drinking and regular soaking and they understand.

I head east out of Goondiwindi and then at the big roundabout take the back road just inside Queensland for a quiet trip through spinifex country to Yelarbon, where I stop for a quench beside the old dingo fence strainer post. Then it's onto the Cunningham Highway for a short bit before retreating again to the Texas–Yelarbon back road, closer to the border.

Before the Queensland–New South Wales border becomes a straight line at Mugindi and follows the 29^{th} parallel all the way to the South Australian border, three rivers mark the state line. At Goondiwindi it was the most westerly of these, the Macintyre, but about 30 kilometres east of the town, it's the Dumaresq that's the dividing line.

About 30 kilometres along the back road I turn south to Cunninghams Weir for a morning dip. The river's gotta be very low for this not to be one of the best swimming holes around.

With the heat rising, I park Super Ten, leave my boots at the water's edge, put on the thongs and walk into the crisp water and lie on my back. Heaven! Don't dry off, just get the boots back on, into the saddle soaking wet, and I'm cool all the way to Texas.

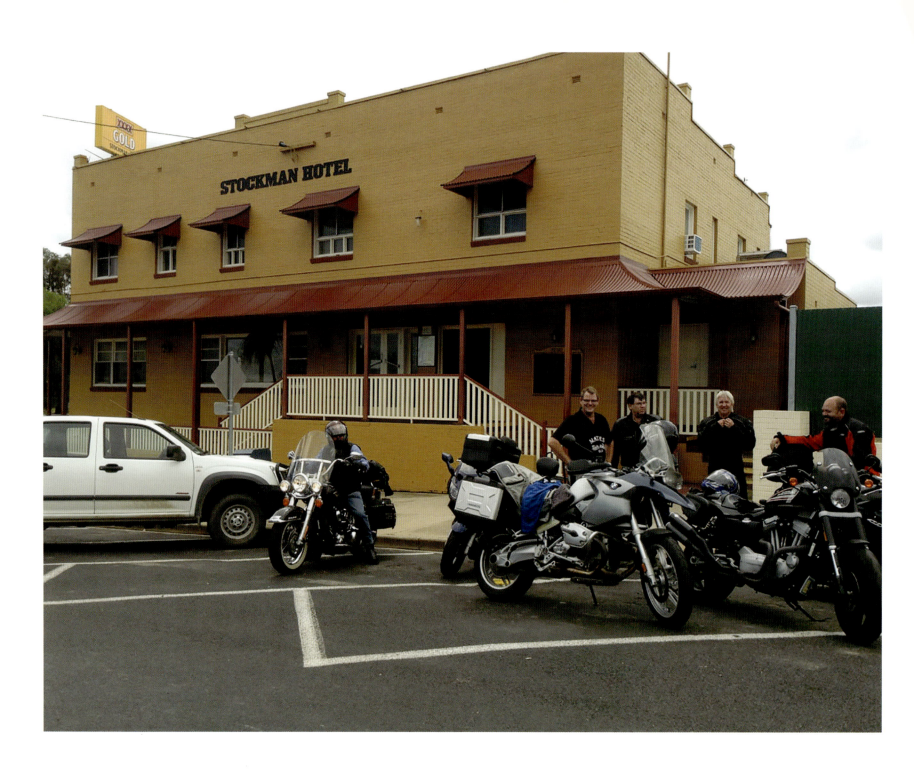

STOCKMAN HOTEL (EX ROYAL)
TEXAS, QUEENSLAND

Not too many pubs change their name nowadays but The Stockman Hotel on High Street in Texas used to be The Royal, until it was featured in a 2002 song by Lee Kernaghan, 'Texas Qld 4385'. In the opening lines, Kernaghan sings that if you're ever after a beer, a feed and a fight, the Royal at Texas 4385 is the place to go.

When Helen Rush and her late husband Jack took over the pub the next year, about the first thing they did was set about changing its bloodhouse image and part of that was getting rid of the name. Jack was from a long line of graziers and they owned some beautiful cattle country across the Dumeresq River in New South Wales so the name 'Stockman' seemed a good fit.

Kernaghan, never returned to the town despite singing toward the end of this song that anyone wanting to contact him need only write c/- Texas 4385.

Not that Kernaghan's absence worried Helen and Jack, who set about re-establishing the pub as the hub of the town of 900. From the outside the pub looks like the proverbial brick shithouse and it's painted the fetching colour of fungal toe but inside it's a haven for locals, families, and travellers.

After a few years at the Stockman, Helen Rush started a campaign to attract motorcycle tourists to the pub and to the town. She'd noticed that riders were amongst her best and easiest customers and was savvy enough to know a steady weekly stream would be better for Texas that an annual big event.

The devil's in the detail but she did the research, mastered the tricky bits and revamped the pub. A motorcycle cleaning kit was set up and put behind the bar, strong hooks for armour jackets were installed in all the rooms, the parking was upgraded so up to 60 bikes could park under cover. She produced maps of the best riding routes in the area and had them printed and available online, and riders who booked a room were given their first drink free when checking in. That's all good, but not enough *per se*, to drag in the travellers. It needed the whole town to get on board. They did.

Once the town had grasped the difference between bikers and bikies, they all rallied behind the concept and Texas, led by the Stockman Hotel, became fully 'motorcycle friendly'. Riders responded with their wheels and pretty much every weekend a group of riders is booked in. Midweek, most nights will have a solo rider or two staying at the pub.

Ride down High Street in Texas and pretty much everyone will nod or wave. There's simply no town like it for welcoming riders. Down by the river there's one of the best free camping grounds in the country—this place has the whole package.

Helen decided that the pub wouldn't do breakfasts or have a coffee machine (apart from the instant upstairs in the common room for guests). 'We have a couple of really nice cafes in town and we want them to grow with us,' is how she put it to me.

In 2013 Helen decided that the pub was going to open an hour later each morning, but she had a problem. One of the locals was on the doorstep every single morning, and summoning up the courage to tell Marty that from next Monday the place would start serving juice at 11 not 10, was proving a challenge. Eventually she had to break the news and the logic and wisdom of Marty's response was, well it was special. 'Thank God for that,' he said, 'I can sleep in for another hour.'

In 2015 Helen Rush's efforts to put the pub at the centre of the town's total rejuvenation were recognised by the Queensland Hotels Association when it named her 'Hotelier of the Year'.

A few years back, not too long after opening, with Marty on his perch out in the smoking section, I ran into Russell down near the TAB window.

Russell Hilton was a jockey-sized bloke, probably no more than 60 kilograms, pretty deaf by now but with a firm handshake and eyes that looked into mine as he spoke, but which glazed as he tried to remember some detail to his stories.

He was born 89 years before at Silver Spur, about 20 kilometres east of town. There were 17 kids who survived, and Russell was the youngest of the ten boys. In 1939 he knocked back school and started trapping rabbits.

I'd wake early in the morning, when it was still dark, and go out and empty the traps. I had between 60 and 70 of them. I'd kill and gut the rabbits and then re-set the traps, take the rabbits home and clean up a bit. Then a few hours later I'd go back to the traps, empty them again, and usually move them. I'd do this three times every day.

Russell had to catch 120 rabbits every day.

We'd get a halfpenny for each rabbit and I had to make five bob a day to give to Mum so that meant catching, killing and cleaning 120 rabbits every day. Otherwise we'd bloody starve.

Each lunchtime he'd take the pelts to the rabbit works at the east end of town where he'd be paid his five bob and the older men would sort, grade and pack them.

I'd ride in on my horse. I'd never been allowed to come into town until I was about 14 and then Mum let me come in to watch the pictures in that beautiful hall that's still over there on the other side of the street.

Then war broke out and the army was looking for soldiers for its light horse regiment.

I was too young. This was June and I didn't turn 16 until October and the army was needing 18 year olds. So went to see Doctor Burton who was the registered doctor in Texas and convinced him to make me a certificate saying I was 18 already. See I'd worked out that the army was paying five bob a day and for that, all I had to do was wake up, do some drills, go on parade for a bit and sleep all the night in my own bed.

Four of his brothers signed up with him and, with their horses, they caught a train to Toowoomba via Inglewood and Warwick and then for five weeks or so:

We did all the training and that's where I came to grief. We were out on a bivouac and we were doing a charge with our swords drawn and all the bloody rest of it but they'd taken my horse off me. They had this disease going around, see, and mine got sick so they put me on another horse, it was Jimmy Kemp's mare. I'll never forget it. Well we come to grief and she fell on top of me and buggered my hips up.

They put him in hospital in Toowoomba for a bit over a week, then when he was discharged, the army told him he was needed down in Gatton to look after the horses. His brothers Ernie and Dick went with him.

By now my brother Ernie had the stripes, he was a bigshot. He was a corporal, but ended up a sergeant. Old Thomas Blainey came around and saw Ernie at work and said, 'best bloody drill sergeant I've even seen.'

It was in Gatton that Russell caught meningitis and he was rushed to hospital and was about to be discharged and pensioned out of the army but there was a hitch.

They found out I was only 15. And the youngest you can be discharged from the army was 18 so I had to stick around. I didn't end up coming back to civvies until 1946.

When he finally was discharged, it was a Friday in June 1946 and Russell caught a train to Brisbane but there was no connection to Sandgate where his family now was.

So I found a place to stay because the next day was the Doomben 10,000 and I hitched a ride with a fella I know and went to the races. At the turn of the big one, Bernborough was near last and I was near a bookmaker who shouted, 'Nine to two Bernborough'. I had the 20 quid the army had given me in my pocket so I shouted out, 'I'm on.' The bookie looked at me and my uniform and said, I'll make it an even 100 for you digger. Well Bernborough came flashing down and won, and I had 100 quid.

Russell didn't return to Texas but found a wife, and then went bush, cooking for shearers and sending money back to his wife. He kept busy on his visits home and pretty soon had five kids.

One day he returned from Windorah and his wife had her bags packed. She was leaving. This wonderful man, eyes weeping, tells me the details but asks that I don't share them. The boy who had spent 18 hours a day catching rabbits to make five bob to feed his family, had become a father and husband

who'd travelled the dry plains working to feed his children, never drinking or wasting a farthing, just sending every penny home. In his absence, his wife had him charged with being a delinquent father.

'I sat in the front room and watched the policeman take my five children away. I never saw them again.'

In a bar in a small pub in Texas Queensland, two grown men, one almost 90 and the other just gone 60, sit in silence and wipe tears from their eyes.

Then he reaches for his wallet and pulls out a photo he's kept there since it was taken more than 85 years ago. It shows him standing to the side as his mother feeds a pet sheep and kangaroo. He's never lost his wallet and he's never lost his love for his mother.

> We didn't have a lot of food back then but we still had enough for a few pet sheep and a couple of roos. But they all had names and the rule was that we'd never eat anything with a name. Those animals never knew how lucky they were!

Three months later Helen Rush rings me. Russell has died. My tapes of our yarn may well be the last recordings of this extraordinary struggle of a life.

Russell Hilton and his brothers have a place in Australian history. They are the only set of ten brothers who all signed up for the Second World War and who all came home. Not all saw overseas service, but six did, all with the Light horse. Before this half dozen could return, they were forced to shoot their own horses. Russell, was the last of the line, he outlived all 16 of his siblings.

He taught me many things this man. Perhaps the most telling was to never travel thinking I shall return: to not ever not do something, ask something, record something, visit something, talk to someone because 'I'll do it next time.' Next time so often doesn't come and every time the urge comes to not bother about doing something *now*, I think of Russell Hilton.

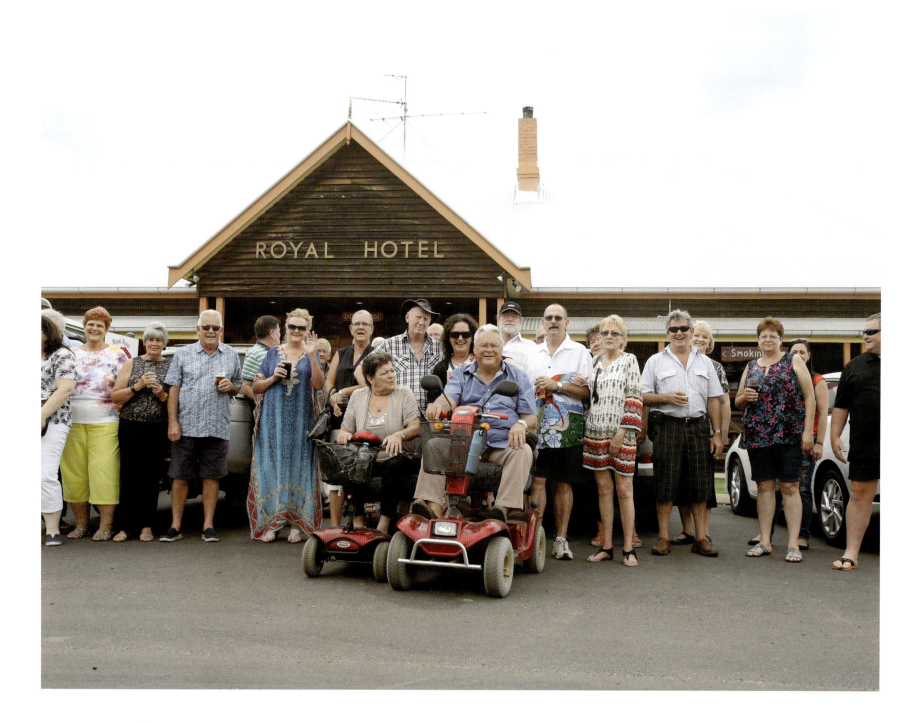

ROYAL HOTEL

LEYBURN, QUEENSLAND

Three quarters through a lap around Australia, it dawned on Shane and Samantha that they'd like to run a pub. In 1997 they were based in Darwin, he was breaking his back building iron skeleton houses and she was an accountant, when the time felt right for a break so they headed off on a 12-month lap around Australia, and they loved it.

Sixteen years and two kids later they were due for a bit over two sabbaticals so they ramped up the van, gathered up their son and daughter and set off on a lap of honour. The kids were enrolled in School of the Air in Katherine and often when they reached bigger places there'd be a parcel of texts and notes waiting at the post office. Schooling was pretty laid back. At the end of a fairly typical day Samantha looked at the kids over dinner one night. 'Well we've seen three towns today and two pubs, so that's geography done.'

Midway through the Queensland leg of their loop, they realised that they were really enjoying the pubs, and they'd begun to look at them differently.

'We'd go into a place and start thinking, what are they doing right, what could be improved. We both realised at about the same time, that this was something we'd like to have a shot at.'

So they starting looking at pubs from Tully on south and then heard that the Leyburn Royal, owned by Shane Webcke, the ex-rugby league star and now television identity, was 'quietly' on the market, so they made contact. It was just what they wanted.

He'd had it for 15 years and was a bit over it. For us it was perfect—a great pub in a great community, and I might be a builder, but I wasn't looking for a place that needed renos. Shane had done a great job and this place simply can't be improved. Maybe make some outside fences a bit more rustic but apart from that, we all love it.

The racket from a busload of tourists in the front bar proves too much so we head out into the sunshine to talk about the story of the pub. As Shane tells me about the bloke who built it, I get resonances of another place far to the west.

There's a silo town about 100 kilometres north of Griffith and at the edge of the Great Grey Plains. It started out being known as Redbank and its first pub was opened in the 1860s by a gentleman named, William Hill.

Hill's drinking was legendary. His customers were probably lucky that there was any booze left over for them! When he died in 1867 his death certificate put the cause of death as, 'exhaustion due to intemperance'. The town was mighty impressed and two years later the locals had the named changed from Redback to Hillstown and then quickly to simply Hillston. It may just be the only town in Australia that's had its name changed to honour a drinker and a publican.

Shane and Sam ended up buying the Leyburn Royal in 2014 and already they know their stuff, know the story of the pub and they know the town they've joined.

Four years before the drink finally got to William Hill, James Murray built the Royal Hotel at Leyburn. Like William Hill, James Murray enjoyed a drink and he too died of 'intemperance' just six months after the Royal was finished. Today it's the oldest continually licensed hotel in Queensland operating in its original building.

Shane's a qualified builder and he explains which parts of the building, especially the trusses, are all original and points out the almost invisible expansion joints marking the line where renovations started.

It's obvious that these two, in charge of their first pub, are carrying on a tradition of caring, mindful owners. They know the complete history of the place, from James Murray on. When Shane tells me to check out another of Murray's pubs, the old Felton Inn, and directs me in terms of a river: 'Just cross the Condamine and it's on the right,' I know he's someone who's spent meaningful time in the bush.

Midway through the chat, we're engulfed by the partygoers from out

back. They're celebrating the golden wedding anniversary of a local couple and the pair is about to make the grand entrance.

'Apparently,' says Sam, 'they're each driving their own vehicle. Grab your camera, it could make a good photo.'

We leave our drinks and keys, our phones and our wallets on the table and head out onto the main street. Right on cue Rex and Loma come spinning around the corner on their electric mobility scooters. They do some figure eights in front of the crowd (later insisting they were 'wheelies'), pause for a groupie and head in for the fun.

Shane stands back and smiles. 'It's fantastic to see people having fun at your pub.'

Then Shane spills one of the real secrets of a good country pub.

> *When we were travelling and started looking at pubs, one of the things we found that was common to all the good ones was that they were family owned. And most of them employed locals. All our staff are from Leyburn, even those in the kitchen. It cements your place in the town to have people who've been born here serving other people who've lived here all their lives. Because the regulars, the locals are your lifeblood. The buses and the visitors from out of town are fantastic but it's the regulars who keep you going and who help give the place its character.*

To which I can only say, 'Amen.'

When I get home I give Shane Webcke a call; I know him from a previous life. I'd had a drink with him in the bar at Leyburn and knew how much this pub and its welfare meant to the big guy.

> *I had to sell it, life was just getting too busy but if I'd had to vet maybe a thousand people to take over the pub, I wouldn't have found a better couple to be custodians than Shane and Samantha. They're the reason it's now going so well, and listen, I just love going back there for a beer. Those two are the reason it's going so well. They understand that there's stuff in there that was there when I bought it and it didn't belong to me, and it doesn't belong to them, it belongs to the pub and its history. And they get that.*

There's about 500 people in Leyburn but the greatest number to ever've been in the town was September 1949 when over 30,000 jammed in for the fourteenth Australian Grand Prix. It was held just out of town on a World War II airstrip and proved to be a one-off, and Leyburn's place on the motor-racing calendar was short lived.

Then in 1996 a local motor sport nut, Mike Collins, saw the 50-year anniversary of the race coming up, contacted the Historic Racing Car Club, and things got rolling. The airstrip was no longer viable so the concept of the Leyburn Sprints was hatched and the race went gangbusters in 1999. It's grown ever since and last year's crowd of over 12,000 provided the pub with a month's turnover in four days.

It's an event unique in Australia; a time-trial with just one car on the track at a time. And somehow it's totally apposite that two people who gained the inspiration to buy a pub whilst doing a leisurely lap around their home country, are now co-hosts of a unique race, a frenetic lap around their home town.

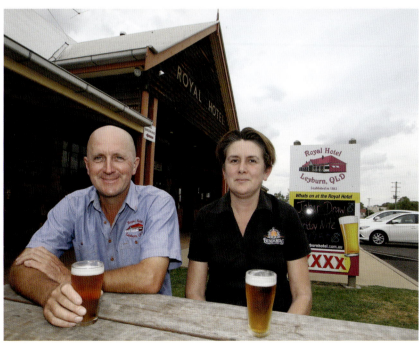

Leyburn to Quinalow

Life's way too short to ride ordinary roads so I head out from Leyburn, cross the Condamine, and to my right is the unmistakable shape of an old pub, an ex-pub now a private home that Shane had told me about.

This is Felton Hall, built by James Murray in the 1880s, still in wonderful condition, a stately, elegant structure, spoiled by some disgraceful Colorbond additions at one end, but still evoking its prime as a watering hole for both men and horses.

Then it's north through Mt Tyson, named after James, the first Australian born self-made millionaire and subject of Banjo's 1898 poem, 'T.Y.S.O.N.' It's a fly-speck place with a beautiful school. I pause Super Ten and pull out my *Collected Works*.

> *There stands a little country town*
> *Beyond the border line,*
> *Where dusty roads go up and down,*
> *And banks with pubs combine.*

Banjo's tribute was published in the Australasian Pastoralists' Review just 11 days after Tyson, who never swore, drank alcohol or smoked, died of 'inflammation of the lungs' just up the road at Felton. When Tyson passed away, his estate was equal to 1.3 per cent of Australia's GDP and the saying, 'As rich as Tyson' was entrenched in local slang.

Then it's north to Jondaryn, over a couple of strange intersections before a back road ride to catch up with an old mate at the Quinalow Pub.

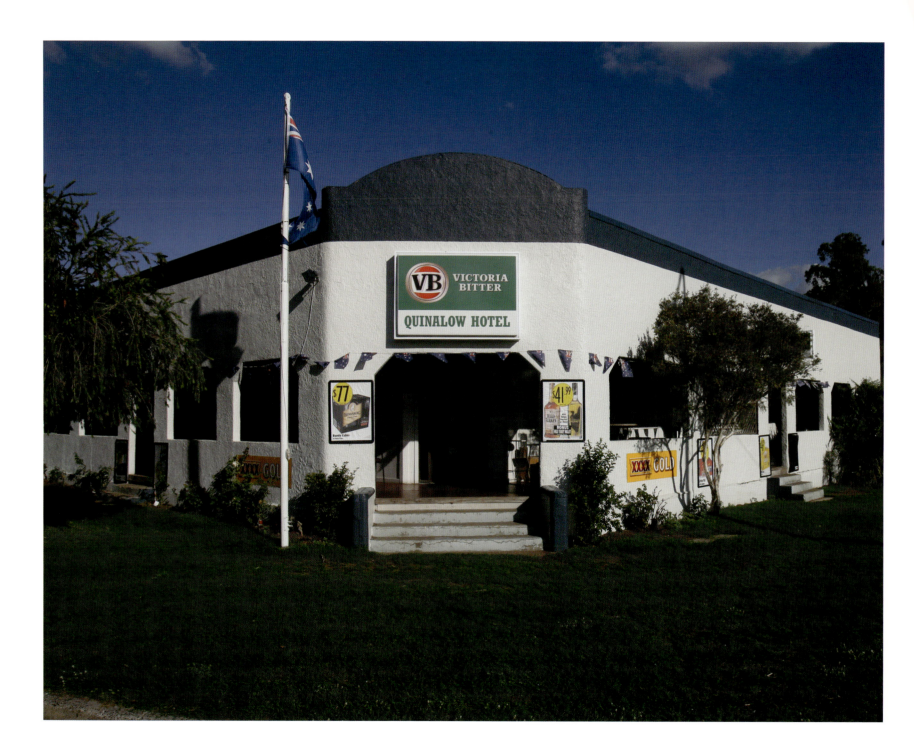

PLEB PUB: THE QUINALOW HOTEL
QUINALOW, QUEENSLAND

The pub at Quinalow (town population 40) is owned (again) by Greg and Cheryl who've had it (this time) since October 2012 when they bought it from the bloke who bought it from the fella who'd purchased it from the bloke who Greg and Cheryl sold it to 20 years ago. (You follow that?)

Greg, an ex-taxi driver, plasterer, restaurant owner, ex lots of other stuff, and Cheryl, both hard-core biking people, sold out of pubs and kinda retired to their boat at Manly, Queensland, but kept coming back to this place. The GFC knocked the stuffing out of their investments in 2008, Greg went back to plastering but the work dried up and the sums didn't add up.

In late 2011 the owner was looking to get out and retire to a life on the ocean waves and...well I guess you're ahead of me...

Greg and Cheryl factored in the enjoyment they'd had last time they ran the pub and figured if they were going to return to Quinalow they had no need for the boat. So they swapped it for 75 per cent of the pub and fixed the rest with their remaining hard-earned, and they were back.

In 2015 they needed a break but this time installed managers, hoping for a couple of years on the road. A kitchen fire that nearly destroyed the pub convinced them they'd chosen the wrong babysitters so in 2016 they returned to the town and the pub they love.

'The break was just what we needed. When we took it back over, we were completely refreshed, like the Energizer Rabbit and now the place is really starting to take off.'

They've ripped out the kitchen and replaced it, refurbed the rooms and the bar. The last time I was here we'd talked about a pub not too far distant, a pretty damn fine place, where the manager had racked up gambling debts of over $90,000 in a single weekend. The owners of the pub were responsible and had to sell it to cover the debt. Greg knew the story and wanted to install Keno into the pub but there wasn't the bandwidth to support it.

'I don't want gambling or pokies as they take over the town and bleed some of the locals dry, but Keno can add a bit of fun to the place.'

Telstra welcomed their return with the installation of a new tower, bringing full 4G reception, and a month later the Keno booth went in.

He might be a good publican but Greg's also a total rev-head. We take a walk out back and he shows me his other acquisition, the pub limo, a 1989 stretched Ford LTD. There's enough room for eight humans, an ice bucket and a couple of slabs. To thank the people who'd helped him when he returned, Greg roped in Arthur, a retired bloke from down the street who'd been a limo driver in Brisbane.

Half a dozen of them went on a 12-hour pub crawl to Toowoomba stopping at every licensed joint along the way. People from around the place heard of the fun they had and now it gets regular use, especially on weekends.

His other joy toy is a vintage sidecar rig based on a 1923 Triumph and with a BSA industrial motor which is started with a pull rope. This is a boy with way too many toys but he sure plays well with others!

It's mid-afternoon and the heat hangs like a shroud. The swimming pool across the road looks inviting but it belongs to the school and is empty and closed. It's only open on Summer Sunday arvos, so I pour a schooner of ice water down inside the front of my jacket, gear up and head north again.

I bend Super Ten through the curving, twisting back roads until I hit the dreaded New England Highway, where I swing left for the quick squirt to Cooyar.

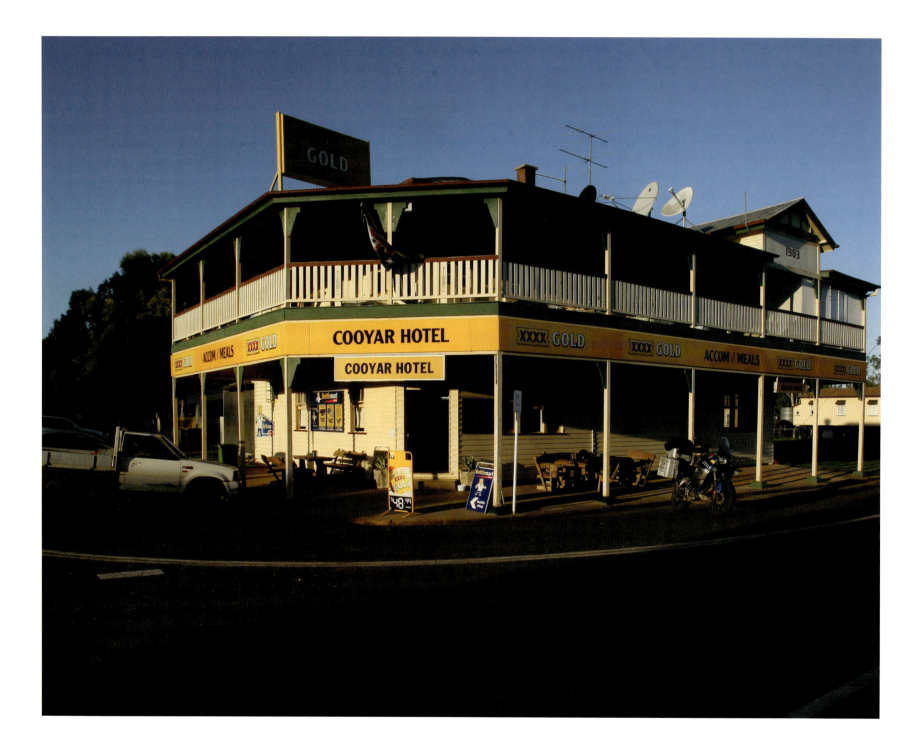

PLEB PUB: THE COOYAR HOTEL
COOYAR, QUEENSLAND

Boss lady Karyn is behind the bar and recognises me when I come in, but the place looks somehow different. It's late Saturday afternoon and the seat at the corner of the bar, and the one beside it, are empty.

'Where's old Billy and Sharyn?' I ask.

She flips the beer tap off. 'Billy died about a year ago. Sharyn still comes in but not as regular.'

Saddening. I was really looking forward to catching up with old Billy. He was a fixture. There in the corner, always with his brown Ascot cap, walking stick hooked to a thigh, sipping his rum and water. Karen has kept the shot glass that was always his.

On the wall is an old photo of a bullock team with a load of giant blackbutt, and last time we got talking about bullockies and their legacy.

'There's three things that the old bullockies put into our language.' His words are slow and deliberate. 'You know what they are?'

I thought I knew one but wasn't sure if it was true.

'I know about "offsiders".' This kind, gentle man smiled and asked me to go on. 'The way I heard it, a bullocky would always have a helper and the boss would always work at the back near left side of the wagon and his mate would work on the other side up the front.'

Billy nodded, smiling. I figured he approved.

'And cattle are like horses, they have a near side and an off side and because the mate worked on the right side, or the off side of the cattle, he became known as the "offsider".'

'Very good. What about the others?' asked Billy, emptying his shot glass.

I told him that was the extent of my bullocky knowledge, so he ordered a refill from Karyn and began.

Well the bullock teams were always paired up, two by two, usually eight but sometimes more when they were pulling something bigger than normal. Each pair were yoked together and then connected to a centre thong. This was the harness. But between the back pair was this wooden shaft which was connected to the swivel between the front wheels of the dray and the team was connected to this shaft by a pin.

At the end of the day, the bullocky or his offsider (he looks at me and smiles) would disconnect all the straps and then, so that the bullocks could graze, they'd pull out the connecting pin. And that's where the saying, 'to pull the pin' comes from.

He tells me about a bloke up in Gympie who has a working bullock team, he can't remember his name, and another bloke who has the largest collection of Condamine bells in the country.

'And what's the third thing we got from bullockies?' I ask.

But he can't remember. It'll come to him the moment I've left. I tell him I know that problem. Billy Hanson no longer takes his place at the corner of the Cooyar Royal Hotel, and another long-termer, Chris, who always wore his white cowboy hat, has also passed away. But Karyn seems to be a constant.

She took over this pub with her business partner, Shirley, in 2008 and very soon after she officially became the ugliest bartender in Queensland.

The U.G.L.Y. campaign (it stands for Understanding, Generous, Likeable, You) is run each year by the Leukaemia Foundation. Karen's husband, Paul, had died from it in 1991 and so getting involved was something both obvious and dear to her good heart. She raised the most money and took out the title in three of the first four years and came second the other year.

Paul suffered for 18 months, the last 13 he was hospitalised in Brisbane. Karen knows better than anyone the costs involved and her eyes come alive as she explains the UGLY programme.

One hundred percent of the money raised goes to funding accommodation for the partners or carers of the leukaemia victims.

Last year I raised just on $20,000 and that bought 237 nights for the loved ones of the people in hospital. I'm pretty happy with that.

And well she should be!

I duck upstairs to check if anything's changed. There's nine rooms that can fit 20 people and all but two face onto the 'randah. The other two are quieter and open out onto the back deck where the old rocking chair is rocking in the breeze—one of the best ever places for a morning brew when staying over. Nup, the good stuff's still as is!

A travelling rep from Shannons rocks up. Nick was here last time as well. He's pulled up his van out back in the free camping area (three bucks for a shower, five for power) and outside in the covered beer garden a handful of hopeful local musos are strumming and jamming and making musical noise.

It's about time for the roos to come out so I decide to hit the road. Billy's seat is still empty but other voices fill the bar. A couple of cars pull up and their commercial-traveller drivers front up for a regular stop off on their way through.

'I never go past this place,' says one bloke, still with his tie on. 'One of the best pit stops on the road.'

It's raining to the east and when I cross the road this great pub is encased in a perfect full rainbow, which stays to my right most of the way up the final stretch of the New England Highway to its termination at Yarraman.

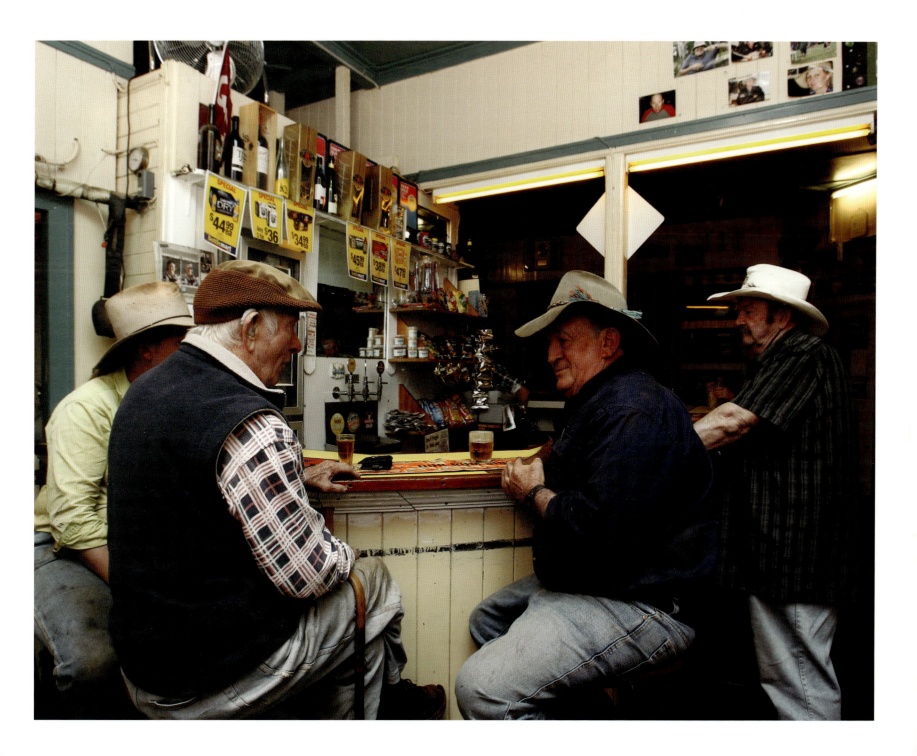

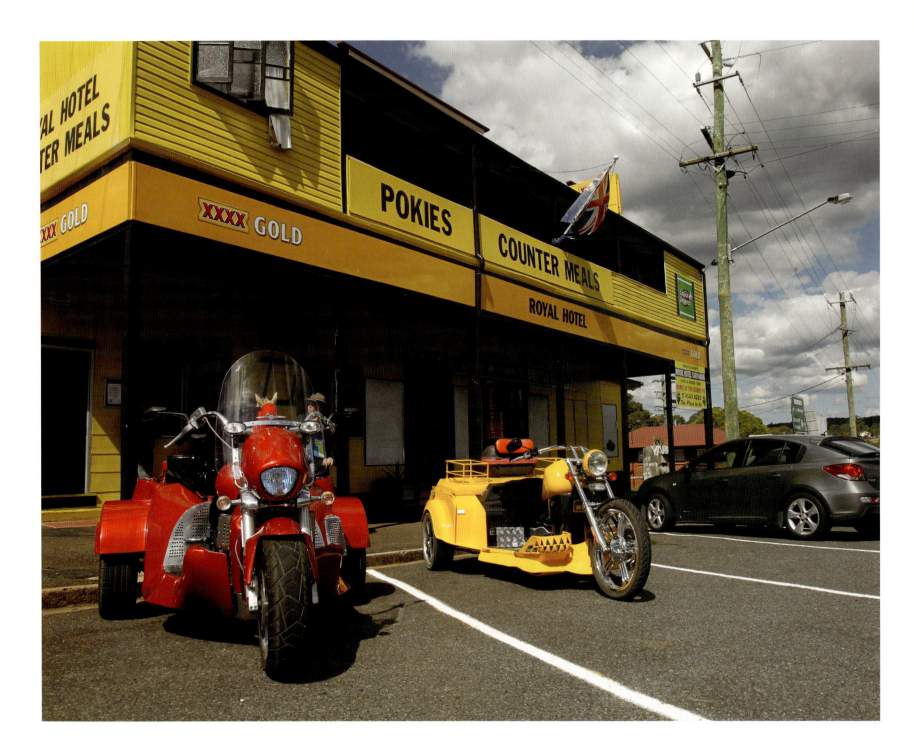

ROYAL HOTEL
YARRAMAN, QUEENSLAND

Around 2014 I got a call from someone in Yarraman who'd read some of my pub reviews in a magazine, wondering if I'd be interested in having a beer with a horse.

'Where mate, and when?' was my immediate response, from memory.

'We're in Yarraman. It's at the very end of the New England Highway and one of the locals here has a horse that doesn't mind a beer at the Royal Hotel. And the town could really do with a mention in your magazine.'

I told the voice I'd be on my way as soon as, would prefer separate glasses if possible, and would also prefer not to get into a long shout with any member of another species.

I had a bike based in Brisbane back then and no rider needs too much incentive to take a spin over Mt Glorious, up to Somerset Dam then onto the D'Aguilar Highway, through to Blackbutt and then the quick squirt to Yarraman.

When I get there I spot a sidecar rig parked outside the Yarraman Pie Shop. I'm running early so I duck down to check it out. The 2012 orange Ural belongs to Oscar from Tara and he's just off on a leave pass for a few days. Oscar is a very cruisy fella and he cruises right on 80 kilometres per hour when 'everything begins to sing, the vibrations give way, the rattles stop and it begins to purr.'

Over a very decent pie I hear that it's his second Ural, the first was a 1994 model that he bought in 1998 and took around New South Wales with his partner. The did a lap of Bathurst and halfway through the Cutting, it jumped out of gear. 'It taught me what fear is.'

He shows me around the bike, the spare wheel, the centre stand whose only use is for fixing punctures, and the screen he's bolted on to keep the bugs out of his face.

We both could spend the morning yarning in the sunshine but at 80 kilometres per hour this is a big country and Oscar has to get moving, and besides, I have an appointment in a bar with a horse.

It must be the day for three-wheelers coz there's a couple of them out front of the Royal when I pull up—gleaming things that seem to've been cleaned more than ridden. The riders are inside but the bar turns out to be equine-free.

Half a beer later Mel turns up on her horse Mr Ed.

Mel's been living in Yarraman most of her life, and most of that life's been spent in saddles by the sound of it. We do the introductions outside and then she rides in.

Mr Ed loves his beer but doesn't take cans or stubbies, only freshly poured glasses of amber happiness, and I begin wishing that someone will sprout the obvious, 'See, you don't need to be a Clydesdale to be a draft horse.' But no-one does and so later, in the safe haven of my office, safe from the jeers and the approbation of barflys and unable to hear the groans of my readers, I take the chicken's way and do it myself in print instead.

Please forgive me.

The weather's closing in so I park Super Ten under the cover of the verandah and take my kit upstairs. I'd come here to have my drink with a horse and to write a review of the pub. But upstairs is a total mess. It's so bad that rather than write my Pub of the Month column, I am inspired to pen 1500 words for an article entitled, 'Pub of the Month – NOT' in which I rant through the litany of the little (and the big) things that piss me off when staying at pubs.

Things like the jug never fitting in the basin so you can fill it, the taps for the shower being on the other side to the shower head so you get soaked when turning them on, those bloody bits of soap that are in shiny sealed envelopes that you can't open with wet hands. And the toilet paper: why is the roll always behind me when I need it and I can't find it? Why the hell are the ends folded over? How is that going to enhance my morning movement? Why is the air con unit 23 centimetres above my head when I'm sleeping? And why are there hairs in my bed? That kinda thing. We had

more feedback from readers that month than for any other piece of jibber, all of it supportive!

So anyway, the pub never got a mention and I tried to maintain the memory of Mr Ed guzzling a schooie whilst erasing all mental images of the rooms and the bathrooms. Then I heard a new bloke had taken over, that he was fixing it up, doing his best and well, it *was* a Royal after all, and right on my route for this trip. So I rang him, said I was coming through and would he be there.

Kris Currie told me he'd make sure he was there and when I front up he's true to his word—behind the bar on a very quiet night.

Kris is an ex-NRL player who had a decade in hospitality in and around Toowoomba before a five-year stint FIFO on the gas fields of the Bowan Basin before quitting in 2015 to sell commercial real estate back in his home town. He now had a wife and two small kids and a portfolio of pubs on the market. He knew the business of pubs from both sides: he knew their value and the importance of local feel, and he knew the hours involved in running a country pub:

> When I went for the interview for the job on the gas fields they asked me if I thought I could handle working two weeks straight then having two weeks off. I told them that their roster meant I'd be having 26 weeks off each year and that I'd spent the last ten years and never had more than three days off at a time. They asked me if I thought I could handle 12 hour shifts and I told them a pub day starts around 8am and finishes around midnight, seven days a week, 52 weeks a year. They told me I had a job.

So, when in early 2016 a mate who owned the Royal Hotel in Yarraman rang and said he was in trouble, that his managers were walking out and the pub might have to shut, Kris knew the size of the task. He went home, discussed it with his wife and the next morning made a call. In July he took over the shambles:

> The books were in as big a mess as the rooms. It was pretty much chaos. For the first three months Jason (a mate) and I just worked every waking moment and slowly we got on top of it.

First up they ripped out and replaced the kitchen and went looking for a good chef. They found an old acquaintance in Toowoomba, a fully qualified chef who'd just quit, and signed him up. A local woman who'd worked for ages at the pub was kept on and an adult apprenticeship arranged for her. 'People have to eat and they appreciate good food.'

The day before there'd been two wedding receptions in the dining room, mostly people who'd come in from surrounding towns, and there are bookings from a car club for the coming weekend.

The locals are supporting the Royal and the pub is reciprocating to the community. It's all part of Kris's five-year plan to make it a go-to destination at the top of one of the longest highway arteries in the country.

I tell Kris about the afternoon with Mel and Mr Ed drinking beers, but they'd moved up to Blackbutt well before July 2016. 'Nah, you won't find any horses in the bar anymore.'

He pauses, probably realising he shouldn't verbalise his next thought but then he succumbs, 'In fact I hope you don't see any long faces around the place anymore.'

To which I can only say thanks and goodnight.

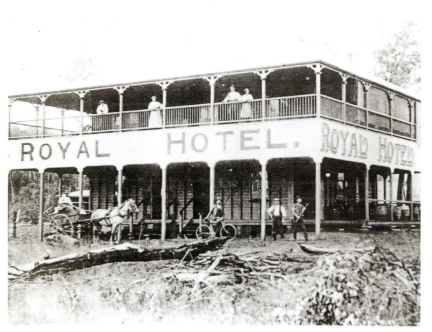

Yarraman to Mulgildie

Next morning the weather is catching up to me—a storm coming in from the south-west—and I have a long day's ride ahead as the distances of Queensland take over, so I have my brew overlooking the top of the NEH and get moving. I head straight north.

Now just what you can expect from the next township, just 20 kilometres up the strip, depends on which version of the old tune, 'Brisbane Ladies' you've been brought up with:

> *Then onto Nanango that hard-bitten township*
> *Where the out of work station hands sit in the dust*
> *And the shearers get shore by old Tim the contractor*
> *I wouldn't go by there but I flaming well must*

Or:

> *Next night through Nanango—the jolly old township*
> *'Good day to you, lads' with a hearty shake hands*
> *'Come on, this is my shout! Well here's to your next trip*
> *And we hope you will step in tonight at our dance'*

My favourite version is something else again, and since the poem's also known as 'The Augathella Drovers', you'll find all the details in another part of this book. Anyway, with the sprinkling rain there was no dust for any type of activity by the station hands!

Then onto Kingaroy as the soil changes from grey to brown and red, and where the silos are brilliant in the afternoon sun. I've taken the direct route north so a bit north of Wooroolin I head west for Durong, cross the Boyne River and stop at a gorgeous General Store. One of those bell things chimes when I open the screen door and young Katie comes scampering around and asks what I'd like. She's all done up in jeans and boots and country shirt, really looking the goods.

She's ten and a half and working for her dad during her school holidays. I retire to the shade outside and Katie brings me her father's makings: coffee and a damn fine bacon and egg roll. When I'm done I take the crockery inside and ask Katie what she's saving for.

'A motorbike. I already have a quadbike but I want a two wheeler.'

I tell her that's a great ambition as I give back the stuff and her eyes make it very clear that she doesn't get too many five-buck tips!

Totally gruntled, I turn north on the Mundubbera Road for an easy 100 kilometres before pausing to admire the bridge over the Boyne River. Then it's into Mundubbera and the Royal Hotel. Damn! The main bar is just a gambling den with screaming commentaries and every outside table is taken by a smoker or two so I head for the back bar inside.

There're four seats here and the beer taps aren't working today so I'm at the mercy of a pretty disinterested bar person who offers no water but manages to serve me when no local happens to be also wanting a drink. Why can't these people take an hour's drive south and learn what service is from a ten-year-old girl and her proud dad?

No point in wasting time here. It's only 40 kilometres up to Eidsvold where the Cafe on the Corner always has a smile and a decent brew. When I get there I'm not disappointed, have a quick recharge and then head for another pub that I know won't let me down.

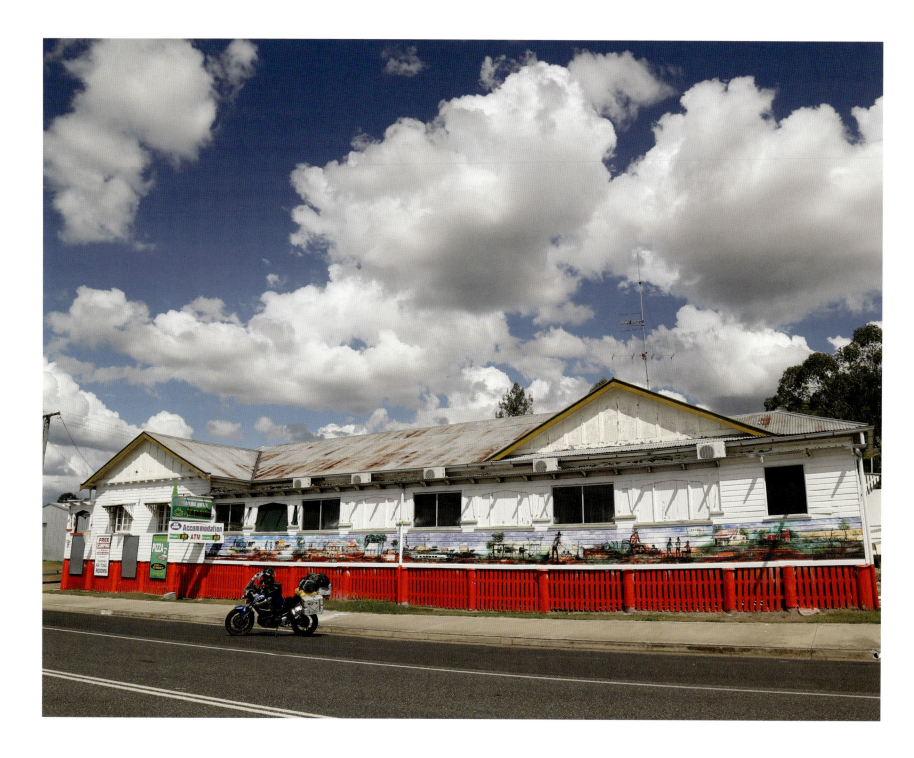

PLEB PUB: THE MULGILDIE HOTEL
MULGILDIE, QUEENSLAND

The first time I found this place it was by accident. Oh, and in desperation. I'd been travelling south on a camping ride and it'd been a bit too long since a shower or a swim so I was looking for a commercial park and I headed out to Cania Gorge. The owner, when I finally found him, happily told me that if I didn't feel the 33 bucks for an unpowered piece of grass was reasonable I could head up to his competitor who charged exactly the same.

So in the fading light I headed south for Monto, where there was nothing, and then kept heading, hoping now for a side road just to throw the tent. I slowed for Mulgildie and its pub and a couple of signs out front: 'Free Camping at Back' 'Air Con Rooms from $45.00'.

By now I wasn't up for camping so once I'd shed my gear on the hospitable deck, I went inside where Tony, the owner, was happy to see me, happy that he had a room for me and was more than happy to show me to it.

'Oh we're not busy tonight so I'll upgrade you to a double bed.'

First impression was of being in someone's private home. A quirky, vibrant person with a passion for art and collectables, a person with an obsession with cleanliness, a person who loved their home and loved having guests. Polished wooden floors and laden sideboards, alcoves and curios: everything the testament to an individual caring hand. More a B&B in the Cotswolds than a Queensland bush pub! It was no surprise to later find out both owners, Tony and his wife Julia, are artists.

I parked the bike beside the back door and unloaded. As I headed for the bar, I mulled this: what box hasn't been ticked here…for the cost of a couple of glasses of wine more than Big 4 was asking for an unpowered slice of dirt, I was in an air conditioned, spotless room with a TV and a comfortable bed, close to a fully working bar run by a friendly owner.

I ordered a merlot and kicked back. The bar was populated with other pub guests and every occupant of every caravan and motor home parked in the free camp beside the pub dropped in during what was left of the evening. No-one was on their own, all who'd arrived independently were now mates with other guests; they played pool and the jukebox didn't stop.

After some of Julia's best lamb shanks and perhaps a second merlot, I head across the road to get some images of the pub at night. I set the tripod up, attach the camera with its remote, set the exposures and head back to the deck of the pub.

I'm trying to get a shot of a blurred moving vehicle in the foreground and the pub filling the frame. A few trucks pass through, I try a couple of different techniques and then a canopy semi passes at speed but I hear its brakes screech and its tyres scream.

I head out onto the road and the driver, massive tyre wrench in his hand is storming toward the camera.

'G'day,' I say. 'How's it goin'?'

'What the fuck's that?'

I tell him I'm a photographer and taking some night shots of the pub, trying to get the blurred lights of a truck in the foreground. He relaxes and chuckles.

'I thought it was a fucking unmanned speed camera and I was coming back to smash the bastard to pieces!'

We laugh together in the night and as he heads back to his rig, I figure I might take the camera back to the safety of the bar!

In early 2016 Tony and Julia decided it was time to move on and installed a manager. They were hoping that the one-year trial would lead to a sale. The manager, Nicole, was a warm and friendly host and when I met her I left saying I hoped it would all work out and she and her family would be there long-term.

But it didn't. Like so many across the country, everyone discovered that managing even a very good pub in a tiny town in the bush is way more problematic than it seems.

In January '17 the pub closed and Tony and Julia rainchecked their retirement plans and moved back. The Mulgildie hotel was closed for a month as the pair re-found their feet. Everything's back to where it was. I chat with Julia about the place:

> The break did us good! We've both come back refreshed and as full of energy as two old folks like us can be. The people in town (Monto) are all on side and the Council now supports our free camping whereas they fought us for a long while.

It's a good pub, the Mulgildie Hotel and it's reassuring that it's overcome a hiccup and is back on the rails.

I head north through Monto, past the roadside advert for the Monto Stockmans Store—one of my all-time favourite signs, one that says so much about the laid-back psyche of the folks out here.

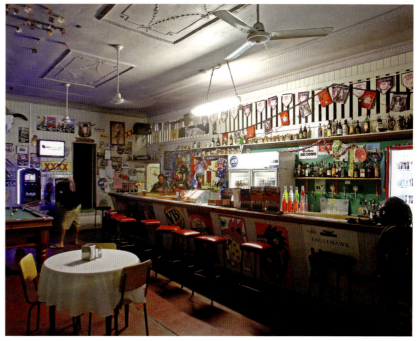

Mulgildie to Rubyvale

As I come over a rise just south of Dululu I check the sky in my mirrors. They show only darkness, rich purple and black. I pull over. I'm being chased by a massive storm front and it's gaining fast.

A couple of shots for a panorama and then as the rain begins I stop at a small intersection. All along this road, along so many roads are warning signs of railway crossings on side streets or on the highway itself. Most of these tracks haven't been used in decades, many not since before I was born, and yet the pointless, redundant signs and lights remain.

Cut one down and leave it outside your place in the 'burbs of Sydney or Brisbane and it'll be gone in an hour. How come these bloody things are still standing; still cautioning about trains that'll never come, dangers that are long since dead?

As I take some photos the rain gets heavier, but in the 35-degree heat it's a welcome warm shower. As I flow down the curves and twisties and into Mount Morgan, I feel that I've outrun the storm, and the skies are clear when I swing Super Ten into a park out front of the Royal Hotel at Bouldercombe.

The Bouldy has no accommodation any more. There's free camping beside the pub but a few nights ago my fly ripped in high winds and any rain would mean a wet night. Tomorrow's a school day so I can't pitch the tent in the bus shelter. I decide to have a beer then check the BoM to figure out my options.

No need to bother. By the time my glass is empty, it's pumping down outside and I've been told that they don't do meals on Sunday nights. I scout around this run down pub. There's no atmosphere, no vibe, not a single magnet to cause me to stay.

An old photo of the place in its jumping days shows maybe five dozen men on bikes out front of the place. In their stead, all that's out front tonight is my single bike and a cane toad-racing circle permanently painted on the bitumen. Now *that* would be a fun event!

There's one bed left at the Gracemere Hotel where the kitchen's still open, the staff help me with my gear, there's a choice of reds, and the air con in the room is already at full tilt. For what I need tonight, it's simply perfect.

The next morning I find the servo around the corner from the pub is as friendly as its neighbour but I make the mistake of heading into Rockhampton for an early breakfast. The absolute worst eggs benny in the country is offset by the view of the stunning, white, three-storey Heritage Hotel being renovated on the corner of William and Quay.

Originally the Commercial (the name can still be seen behind the XXXX fella at the top of the corner of the facade), this is one of the most beautiful pubs you are ever going to see. In 2015 its owner of ten years couldn't make a go of it and closed its doors in March. It was bought that November for $1.4 million after being listed in 2012 with a $7 million tag. Wow!

This stunning building, one of so few three-storey iron-lace pubs in Queensland, deserves to live on. The original hotel was built on this site in 1959 and became 'The Commercial' in 1865. It was demolished and rebuilt in 1897, so she's an old one, but with style and class. If Katherine Hepburn was an Australian pub, she'd look like this. As I take some shots I wish the new owners all the very best.

Then it's west from the Fitzroy River on the Capricorn Highway, sun at my back and a lot of miles to go. I love this highway. It leads from the lush and verdant of Rocky's Quay, Australia's epidermis, to the harsh and sparse vastness which is this country's heart.

For the first 200 kilometres to Blackwater a rail line, this one fully used, keeps the road company. Bulk coal trains with countless carriages take me minutes to overtake as they head back up for another load.

I pause to stretch at Dingo and then again as I check out the rusting Vanguards at Blackwater. This was my dad's first family car. We lived in Elizabeth in South Australia and on colder mornings, maybe every morning,

I'm not certain, he'd get the crank handle out of the boot, stick it in the slot under the front bumper bar and wind up the thing. He always wished we lived on a hill so he could clutch start the bugger!

Anyway, after the Vanguard graveyard, next pause is to see Leichhardt's Dig Tree at Comet before I make it to Emerald, with the sun now just slightly ahead of me. The streets are chockas with utes and vans with explosives flags. There is not a single pub worth visiting in most of these mining towns. Not a single pub with a sense of history, not a single publican with a sense of custody of the story. Inflated prices, opportunistic exploiters at every turn, so I grab some fruit from the IGA and head down to the park to wonder just why a man named Cameron Cross decided to erect a 25-metre-high reproduction of Van Gogh's *Sunflowers* in the middle of a reserve in Emerald.

A nod to the elegant railway station and, with mixed hopes and expectations, I point Super Ten west for the Rubyvale Royal.

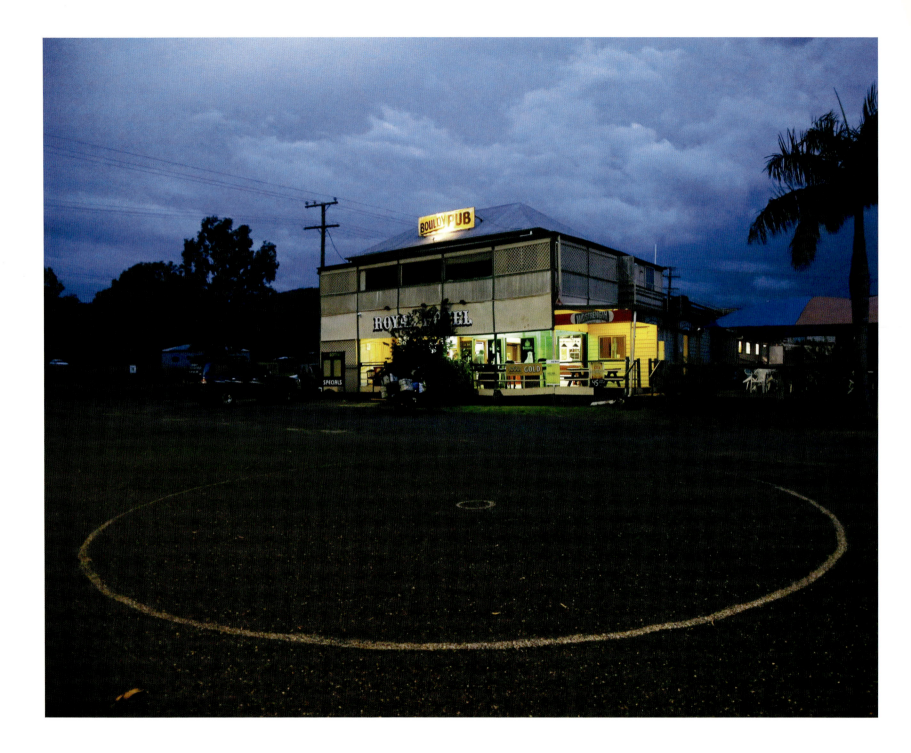

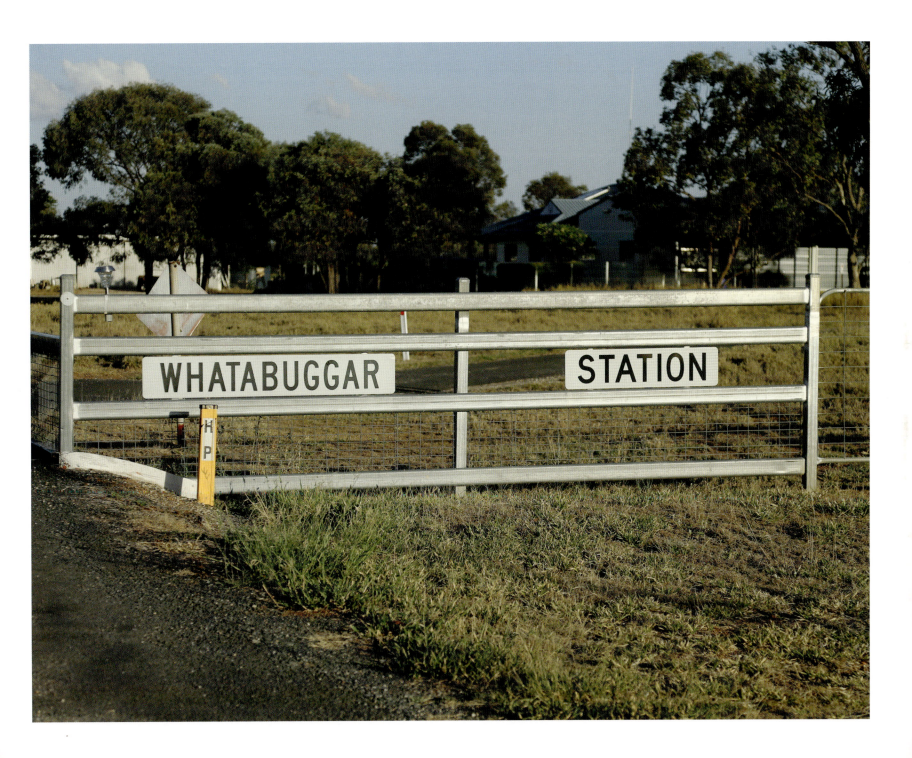

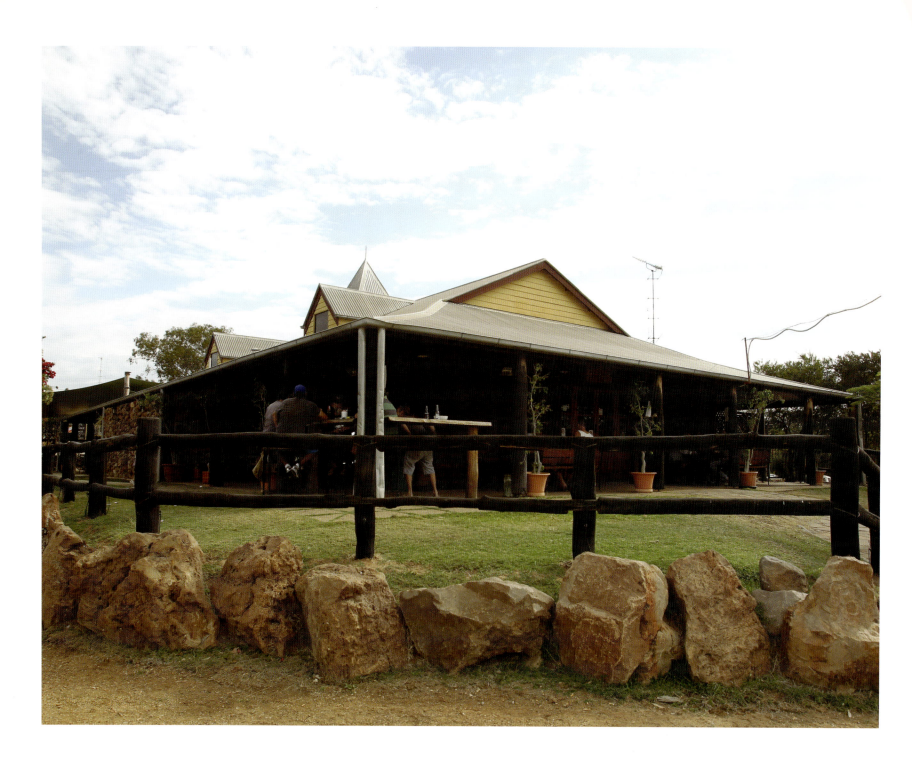

THE NEW ROYAL HOTEL

RUBYVALE, QUEENSLAND

The first time I came here and walked into the bar, camera with flash in hand, images flooded the mind of flicking the switch in a cheap hotel and watching the cockroaches scarper. A barmaid came over.

> I'd be careful using that thing in here. Not too many people here want their photo taken. Most of 'em don't have a second name and many don't have the same first name for more than a couple of weeks.

I took the advice and trod carefully.

The first white name for this place was Policeman's Creek and the first Royal Hotel was built in 1908 by Kate Leahy. She ran the place until 1937 when another woman, Rose Collins took over. It was a robust kinda pub. In 1923 the local cop felt compelled to send a missive to his superior:

> A good many rowdy characters, and miners, and others who gamble, visit Rubyvale...and during the absence of the Police a good deal of Two-up (is) played on Saturday and Sunday...Owing to continual complaints being received re the conduct of the miners at Rubyvale weekends, it was found necessary to make...periodical patrols.

But the miners were good drinkers, and it was a good pub while the gems lasted. But by the end of the 1950s the hopefuls were breaking more useless rocks than the inmates at Boggo Road. In 1961 the Royal Hotel closed and two years later the school followed suit.

The town remained publess for three decades with several applications for a licence refused. In 1995 Donald Carne applied to open a pub in Rubyvale and the appeal against it by the publican at Anakie down the road was dismissed. In March 1997 the New Royal Hotel in Rubyvale was opened and despite being placed in receivership briefly in 2009, it's become a landmark in the Gemfields.

It's won QHA Country Hotel of the Year for 2014, '15 and '16 but hell, I can't understand why. I've been here a handful of times and each time I turn up full of hope that it's going to be great. I've sat at the bar on a weekday, alone with the staff, and not a single chat has been initiated across the bar. I've asked about the story of the place and have been directed to a plaque on the wall. I've asked about which Aboriginal mob are indigenous to the area and been met by shrugs and suggestions to try Google.

The owners have done a good job, and have created a quality watering hole, but holes don't have souls and this place is bereft of spirit. Credit to them for their honesty in calling this place 'The NEW Royal Hotel' and not pretending that the pub itself has any connection with the Royal of Kate Leahy or Rose Collins. So maybe it's just the brashness of youth. This place was only opened in 1997 and so there is no history to treasure and to value. There is no sense inside of any engagement or any sort inheritance of any past story. Sure there's the plaque with its timeline but it's done without any sort of connection.

This pub is a Gen Y teenager: self-obsessed, constantly taking selfies whilst being ignorant of anything resembling the bigger picture and blissfully unaware of anything without a social media presence.

Like those god-awful 'Irish' pubs that breed in the bigger cities like people who rely on the 'rhythm method'! The Rubyvale is a formula. It could be franchised and copies set up in any town you could name and it'd be the same.

The pub's website boasts that, 'the Pub is open rain or shine, summer and winter', and that, 'the pinging noise (from the poker machines) means that someone has just financed his dinner!' Oh joy! A pub that's weatherproof and provides pokie machine tunes to enhance the mood!

I finish my drink and head out. The clouds have gone and it'll be a clear night. Why settle for four stars when you can sleep beneath a million?

RUBYVALE TO BELYANDO VIA CLERMONT

The Peak Downs area is a special place. I detour off to the north-east to find a roadside camp I've used before. Throwing a tent is a matter of timing and I make coffee as I wait for that tranquil time when the flies head off but the mosquitoes haven't arrived. Then it's good to throw up the tent, get the gear inside and zip it all up without flying company.

The night is crazy beautiful. I wake regularly to check the stars and the night colours under a quarter moon. The Southern Cross arcs across the tent's mesh canopy. Exhilarated, but with little sleep, I head for Capella with its boab tree-lined main street, then up past the gate for Logan Downs and on to Clermont before the sun's too high.

Capella and Clermont, Logan Downs, the Peak Downs and so many other stations around here were major players in the 1891 and 1894 Shearers' Strikes, massive social movements that brought pre-Federation Australia to the very precipice of revolution and insurrection.

Before I head into Clermont I duck down to Wolfang Creek, where a major strikers' camp was set up in 1891, and then up to the top end of town and the Clermont Railway Station.

It was at this station in March 1891 that one of the ugliest confrontations of the strike occurred when George Fairbairn, the owner of Logan Downs and a leader of the Pastoralists who were shipping in scab labour, arrived on the train with two other militant graziers and an escort of only a few police. Swords were drawn, horses set loose and rocks hurled, but all survived.

And it was from this railway station that Julian Stuart and other strike leaders were dispatched by train to face trial in Rockhampton. Stuart was jailed for three years at the island prison on St Helena, off Brisbane.

After I get some shots of the station I turn to where the Commercial Hotel now is. Usually when you say something like, 'the pub's not always been here' you mean that the building wasn't always a pub, or that a pub with the same name used to be somewhere else in town but now this place is it. In Clermont it's uniquely different. Both the town's pubs, this one, the 'top pub', and the 'bottom pub', the Leo Hotel a few blocks down, were originally built elsewhere and both were later moved to the current positions. All because of a flood.

Originally the Clermont township was located down beside the confluence of the Wolfang and Sandy creeks but on 28 December 1916 a wall of water hit the town and more than 60 people died. Most buildings were destroyed but two of the major hotels, the Commercial and the Leo, survived. The Queensland government decided to relocate the town, the pubs were reinforced, the foundations cut. They were harnessed to a steam engine, put on rollers and rails, and hoisted up the hill. The Commercial was moved first and so was taken to the top of the hill. The Leo was next and it was shifted just about as far as it had to be. They must've done a good job because both are still standing.

It's still early and both are closed so I head around to the IGA, pick up some breakfast makings and ride down to Hoods Lagoon at the bottom of town. I loop around it so the lagoon is between myself and the town and I'm on the main street of the original settlement. There's toilets but no camping.

I'm not the only one who reckons this is a beautiful spot. No sooner off the bike and about to settle down than I get a lecture from a hit squad of local ducks about their claims over most of my food. I fend them off with a few bribes thrown far out into the water and chow into my tin of baked beans.

Over the anatine demands I hear the clopping of a horse, and ambling down the old main street is Jessica, in a horse drawn covered carriage. This 23-year-old local is on her daily ride getting the horse's miles up before starting her business.

When the tourist season comes around you'll be able to order your meal at the Leo Hotel and while it's cooking, take a 20-minute lap behind the horse down to the pub's original site, around Hood's Lagoon, and back to your steaming meal.

The centenary of the town's move is coming up and Jessica knows every detail of the story. It's her own original idea and I wish her well and tell her to count me in next time.

She rattles the reins and moves off. Why does fate do this? How do chance and circumstance so often combine to amaze us? Every time a disassociated pub like the Royal at Rubyvale disappoints me, the next moment I'm cheered, lifted by a Jessica or a Leo, completely in touch with their roots, with their story.

The Council sprinklers are already working on the lagoon grass so I stand under one, fully kitted up except of my helmet. Totally soaked I climb onto Super Ten. In this heat that'll keep me cool for maybe most of the next hour, but I'm dry by the time I pull up for fuel at the Belyando Crossing Roadhouse.

Not many roadhouses are so bad they are remarkable but Belyando is up there with the Barkley Homestead at the top of the shockers' list. The water in the screen wash is putrid, signs forbidding pretty much *everything* are everywhere and any semblance of hospitable service is foreign.

I grab a key for the toilets, stand fully clothed under the shower for a minute and then head again to hit the Gregory. As I move I begin to cool.

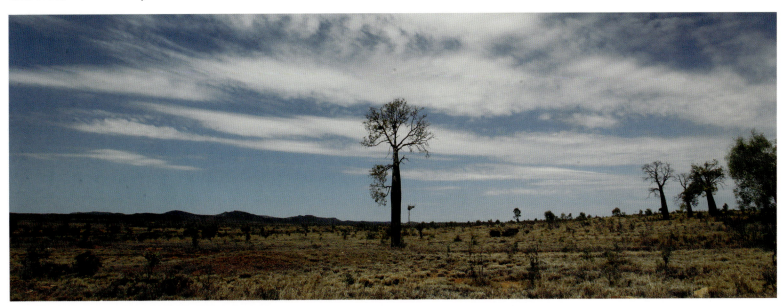

Belyando to Charters Towers

I pass a nicely filled dam with a bunch of horses up to their necks in the water. A couple of them scarper when I walk down but one white fella couldn't give a bugger and stays submerged, eating something.

I bang off a couple of shots and not long later there's a ute checking the fences so I pull up and ask them about the horses. It's this family's farm.

'Yeah, they all love eating the waterlilies. There's a grey who's in there all day chomping away.'

I tell him that's the one I saw and he just laughs. 'Natural way of keeping the weeds down, eh?'

A hundred kilometres or so north and I see a caravan with signs of life, parked beside a large dam about 200 metres off the road, so I hit the brakes and head up the sand pathway. Bruce comes out to greet me with the advice that this's a private station, he's just a caretaker ('Makin' sure the bastards don't steal the irrigation pumps!') and I won't be able to stay. I ask if I could try to convince him otherwise and he says to give it a shot.

I tell him what I'm doing and he tells me to make myself at home. There's just one problem. I'll have to put up with his gennie going for a coupla hours from 7.30pm.

'Eileen and I've been married for 56 years,' he explains. 'Every single evening I take her to the movies. Out here we just sit back in the van and watch one on DVD and we need the gennie to run the extra power.'

How bloody beautiful! I give 'em a coupla hundred metres space, and throw up the tent beside the dam.

I end up staying two days with this ex-shearer and his wife, shooting the breeze during the day and shooting the stars at night. Over a brew on my departure day, we (once again) get onto pubs. I tell him about Oscar Wilde's quote, 'I prefer women with a past. They're so damn amusing…' and how I've changed it to, 'I prefer pubs with a past, they're so damn interesting…' Bruce knows a couple 'just up the road' that fit the bill.

(For me Wilde's quote is inseparable from Mae West's 'I like men with pasts but prefer them with presents.' But I digress!)

The pubs Bruce's got in mind are at Ravenswood, south from Charters Towers on the Burdekin Falls Dam Road. Oh and whilst I'm there could I take a message to Woodie who runs the council camp ground?

'Just be careful getting into a shout with him.'

I thank Bruce for his kindness, say bye to Eileen and head north to 'the world'.

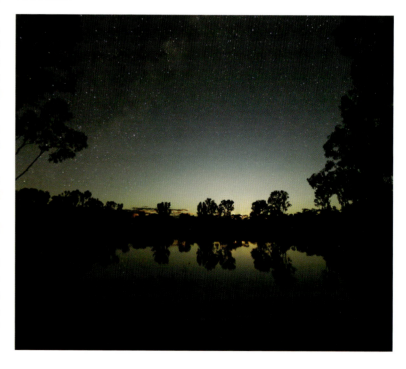

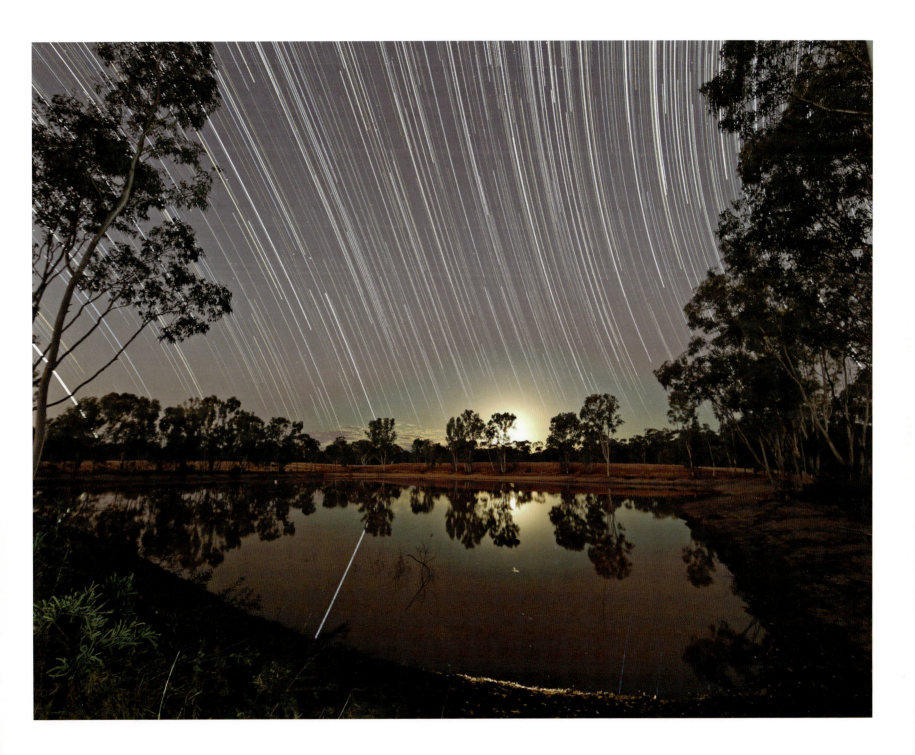

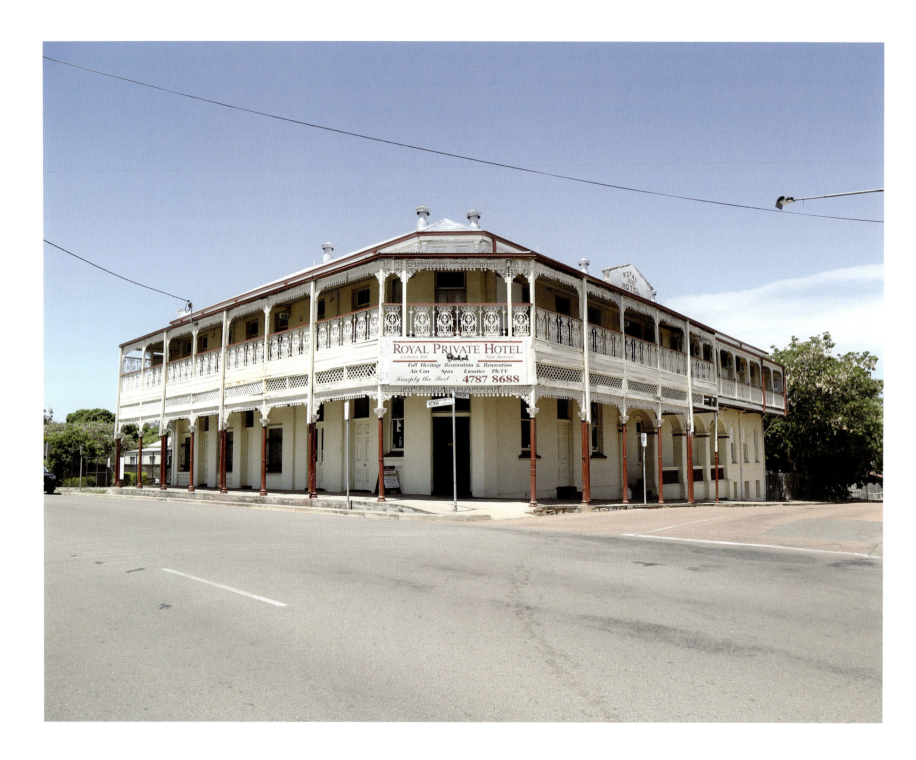

ROYAL PRIVATE HOTEL

CHARTERS TOWERS, QUEENSLAND

It's been a couple of years since I was at the Royal in Charters Towers but when I walk through the door and into the totally unique reception room, Patricia looks up from behind the 'Welcome' sign and guest book on the desk and says, 'Welcome back Mr Whelan.'

The room is…well 'quirky' doesn't come close. It's a stirred but not shaken cocktail of a dash of ye olde curiosity shoppe, a jigger of the little shop of horrors, a half measure of your old aunt's garage sale, a nip of old technology museum and a dose of old-school orchestra instrument storeroom.

I flop onto the sofa, about the only horizontal space without some relic or adornment, and Patricia heads out back, without my asking, to get me a long cold glass of iced water.

A couple of French tourists is having enormous fun on the pianola but thankfully they're leaving the bagpipes alone. I spot the old squeeze box and tell 'em my dad's advice, 'A gentleman is a man who knows how to play the squeezebox but chooses not to.' A cloud of Gauloises chuckle breath envelopes me. I kick off the boots. Patricia's excited.

'This is the last time you'll see the room like this,' she spouts before adding, 'Unless you come back soon.'

Gold was found here in 1871 by a party of five roaming prospectors from Ravenswood who applied to the gold commissioner, W.S.E.M. Charters for protection of their discovery. Either to fulfil a sweetener with the application or to ensure future assistance, the prospectors named the find Charters Towers, after the commissioner and after the terrain. Nothing suss about that!

The place immediately went gangbusters and within four years the goldfields had produced their first millionaire, Frank Stubley (who died without a zack on an outback road just a decade later.)

The Royal was built in 1888. It wasn't the first pub in the town, and it sure wasn't without competition. By 1890 the town had 64 others for its 25,000 locals. That year there was so much gold coming out of the ground the only stock exchange to be built outside a capital city was started. Charters Towers had everything a person could possibly want and was dubbed simply, 'The World'.

The gold's all gone from here now, the world's shrunk a bit but Charters remains one of the most beautiful towns in the Queensland outback. Through amazing luck, providence and foresight, the great buildings of the town, the banks and the exchange, the old pubs and the halls, have all been retained and cared for. It's always good to come back here.

The Royal Hotel continued trading as a regular hotel for 60 years until a wowser bought the place, relinquished the liquor licence and turned it into a boarding house and private hotel. Which is how it was when Patricia and husband Tony bought it in 2002.

Tony managed for the first bit but, well, he's no longer part of the scene and now Patricia's doing it on her pat. When I first chatted with her after the split she'd put the Royal on the market. 'Too many ghosts, too many memories,' she told me, completely enervated, jaded.

But when I walk through the door in late 2016 she's all invigorated, refreshed, champing at the bit. After I've finished the cold water and she's checked in a couple of young blokes who're up contracting, she sits down adjacent.

'I must tell you our exciting news.'

She's applied for a liquor licence, going to turn the wheel almost full circle. The Royal's not about to be a full pub again but the front section is to become a wine bar showcasing Queensland wines, maybe some tapas and canapés.

Patricia takes pity on my knees and shoulder and sticks me in a ground floor room with an ensuite. The room's immaculate. I boil up a brew, crank the air con up and lie back on the double bed. The French are still pedalling

away on the pianola and one of them's proving he's not a gentleman. At least he's accomplished. More or less.

On the balcony outside, other travellers discuss their day and their plans for tomorrow. Upstairs, other voices come from the massive common room area which'll remind you of some relative's home you love to visit. Every person in this place right now feels at home. And I know that's how it'll be tomorrow and how it was yesterday.

When I head out later for a feed at Henry's a couple of doors down, more guests are checking out the antique phones and photos on the walls. They're all loving it.

Chatting the next morning with some folks in the Tourism Office, it sounds like Patricia's found a gap in the World with her wine bar project. All say there's nowhere for a quiet drink of quality wine in a space aware of its heritage, its story.

Damn, I'm going to have to come back again!

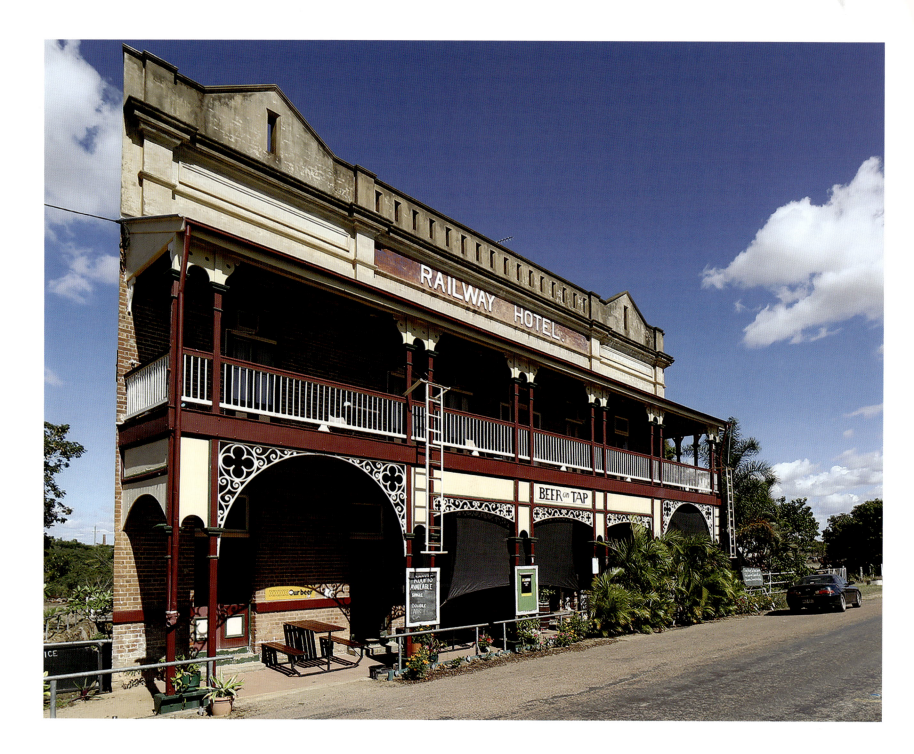

RAILWAY HOTEL
RAVENSWOOD, QUEENSLAND

So the next afternoon I'm cruising south past the top servo then left into Ravenswood's main drag to be welcomed by the drop dead gorgeous Railway Hotel on the right.

There's a couple of photographic themes I keep an eye out for when riding around in the bush: one is brick chimneys and fireplaces in the middle of nowhere, the only remnants of a long gone home or pub. (See the yarn on Hill End.) Another is buildings which aren't built quite square, with one corner at less than 90 degrees. When you look at these buildings from a very specific angle in line with the acute corner, they look almost two dimensional, like street facades from an old western movie. There's no trick photography, and no photoshopping later, they simply look almost unsettling, strange, without any high-tech help.

They're not common and there's no predicting where they'll spring—I've probably only got a dozen in my collection and so when I pull up outside the Railway at Ravenswood, I'm near speechless at the beautiful example (almost directly) in front of me. It's not yet noon and already I've struck gold. I get my shots quickly before any cloud can dull the effect and then head inside.

The first train arrived in Ravenswood in 1884 and the Railway pub joined in 18 years later. The trains quit coming in 1930 but the pub's stuck around. It's now owned by Robbie, who got it dirt cheap from a debt-chasing bank which'd repossessed it after the previous owners, the Odins outlaw motorcycle gang, went bust.

A back buggered from 17 years working in the mines has stopped Robbie's dad, Charlie, from riding his Highly Dangerous, so now he pretty much runs the place and he pulls me a cold one from fresh new taps.

It's quiet so Charlie has time to jaw and I settle down and we go through the usual deets of facilities and history and gossip and other rubbish and then we get onto the pub's longest term resident.

When Charlie and Robbie first bought the place, like so many country pubs, there were no locks on any of the room doors, or on downstairs access, and their sleep was regularly interrupted by footsteps up and down the bloody creaking stairs. So they put locks on the rooms and padlocks downstairs.

In the mornings, even after nights when they had no guests, the padlocks would be open, the locked doors swinging. It got way too scary for Charlie's daughter and she hit the toe back to Charters.

Pretty soon the young woman apparition made herself known. She'd brush by them as they sat on the bar stools, she'd perch on a seat, visible to just one of them and smile. She'd move things around on the bar when no-one was watching.

Last year a group of tourists booked out the pub. Around midnight, Charlie heard voices and banging and the bloke in room 12 was packing his stuff and getting the hell outta there because Ghost Lady told him to leave. He spent the night sleeping in his car out front.

Another time, Charlie's alone in the pub, mopping the floor, and he feels a breeze and turns to see small footprints across the work he's just done.

I figure to make tracks too so leave my gear there and head down to the other pub, the Imperial.

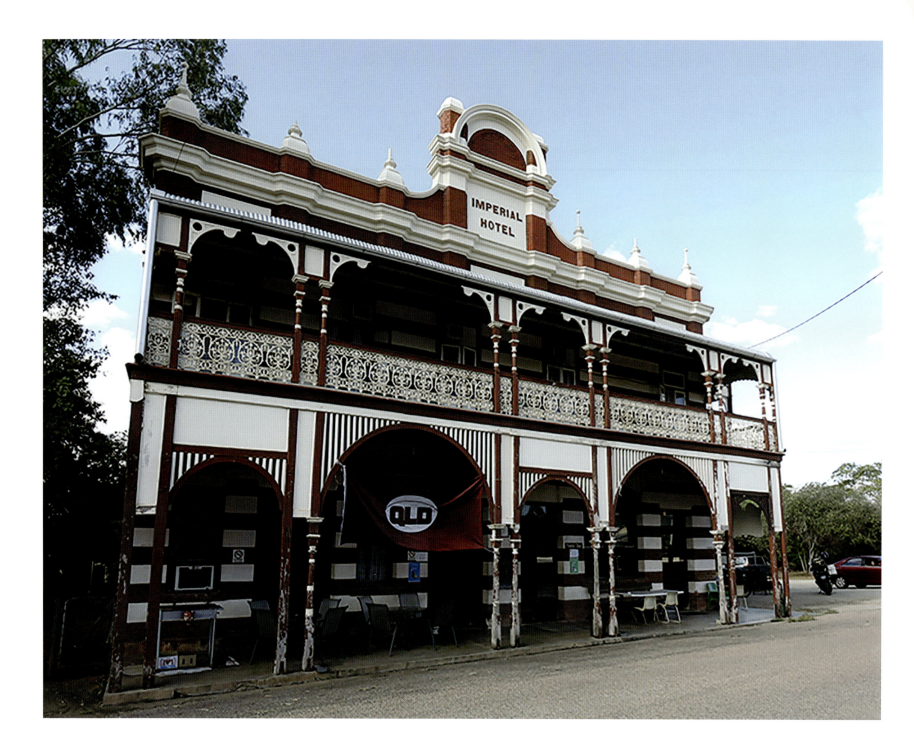

IMPERIAL HOTEL
RAVENSWOOD, QUEENSLAND

I park the bike beside a Husky resting in the shade and then walk back up the street to check something out. Bugger me, this pub too has an acute join, not quite as stunning as its neighbour but still, from a specific angle it gives me another for the collection of facades. Then I head back to the bike and in through the side door. Suddenly I'm in the most magnificent billiards room I've ever seen in any pub anywhere.

Gracing the middle of the polished wood floor is a Herron and Smith 12 x 6. I slide my hands over the surface and feel the rub of the green then take in the historic photos around the walls.

I head through a doorway, passing the amazing mahogany staircase and then I'm into the bar with its beautiful cedar and pressed-iron counter imported from England, whilst the Australian cedar centre piece is breathtakingly beautiful.

The husky's owner is the only other bloke drinking so I pull up a pew and find out that, like the barman, his name's John, who tells me the dog's 'Bosun' and 'he's me ride home.' I'm not sure what that means exactly, but I let it slide.

A schooie's just five bucks here too ('cheaper than Townsville') so I hoe into one and begin cross-examining publican John. He's a retired applied mathematics teacher and he and wife Di came here in 1999 to visit their daughter, who was married to a bloke working in the mine. They fell in love with the place and made 'the best decision of our lives' and bought the pub.

The Impy's a bit smaller and accommodation's more expensive than the Railway, but the beds are all old brass beauties, in keeping with Di's claim that the pub is 95 per cent original.

It's also home to an official ghost; another lady ghost, and she lives in room 12A. John and Di are very happy to tell you all about her but it's the ghosts in the billiard room who interest me more. Eddie Charlton played on that table in 2002 and Walter Lindrum apparently racked 'em up 50, years earlier. I go back out and suck it all in, feel the rub of the green.

As the arvo wears on a bloke slides up to an outside table in a motorised wheelchair. He's got a face so hard, if you threw rocks at him you'd get gravel. And eyes that could stare down a brown snake. One of his legs has been amputated above the knee. You know he hasn't learnt about life from books. Turns out he's Woodie from the camping ground so I give him the message.

'Shearer Bruce told me to tell you you're a grumpy old prick.' The hard face softens just a little and he asks if I'd also been warned about drinking with him.

I assure him Bruce did, but could I buy him a drink anyway? 'Well that'd be nice. Bit hard to drive this thing into the bar!'

Woodie fixes his death stare on me and asks why I'm asking so many questions. I tell him about my book and he tells me he'll talk and I can take some shots.

As long as you're not working for those bastards at the Townsville Bulletin. They sent a woman up here to talk to me about Vietnam and I gave her some books which she never read, wrote a bullshit article full of errors and it took six months to get my books back.

I put his mind at rest and we shoot the breeze. Eventually we get around to his leg. 'Can I ask you how you lost your leg?' I delicately ask.

Woodie looks at me with almost distaste. 'I didn't lose my leg. I know who took it. I know when he took it and I know what he did with it, why do you fucking think I lost it?'

I figure he's been asked before.

While we're chatting, another bloke with another dog drops by. Garry's been here 23 years. Was living in Townsville after his wife left three months after the wedding, and a mate was headed into the hills for the weekend.

Garry came along and they went back a couple of months later too. The third time his mate turned up to collect him for the trip up to Ravenswood, Garry was waiting roadside with two suitcases and a bag containing the few things that would fit.

'What the heck are you doing?'

'Goin' up with ya, but not comin' back. Goin' to live in the bush up there for a bit.'

Garry lived rough for a few years and then moved to a place in town. The 'bit' has stretched to over two decades and he won't be moving any time soon. He comes by the pub a couple of days a week.

'Get a bit tired of raiding me own fridge all the time,' is how he explains it.

I leave them all, plus a pile of miners who've arrived, and head out to scout for places to shoot the stars once the sky turns black. I find some old mining diggings and a church, and as I head back I look up. Drinker John is on his bike. True to his word, too pissed to pedal, he's being towed home by Bosun!

I walk back to the Impy, knowing there's not a ghost of chance of me leaving next morning.

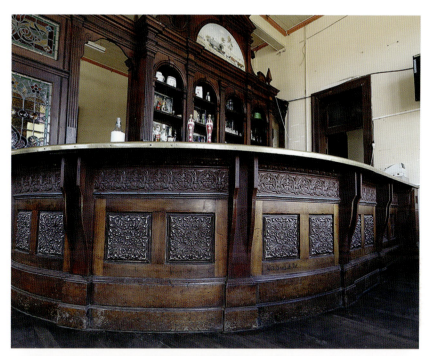
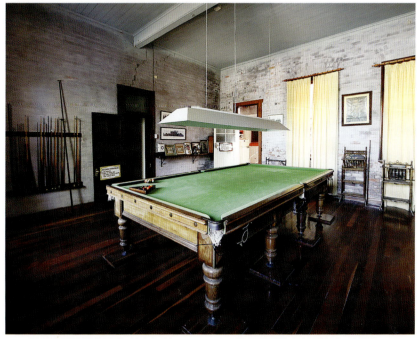

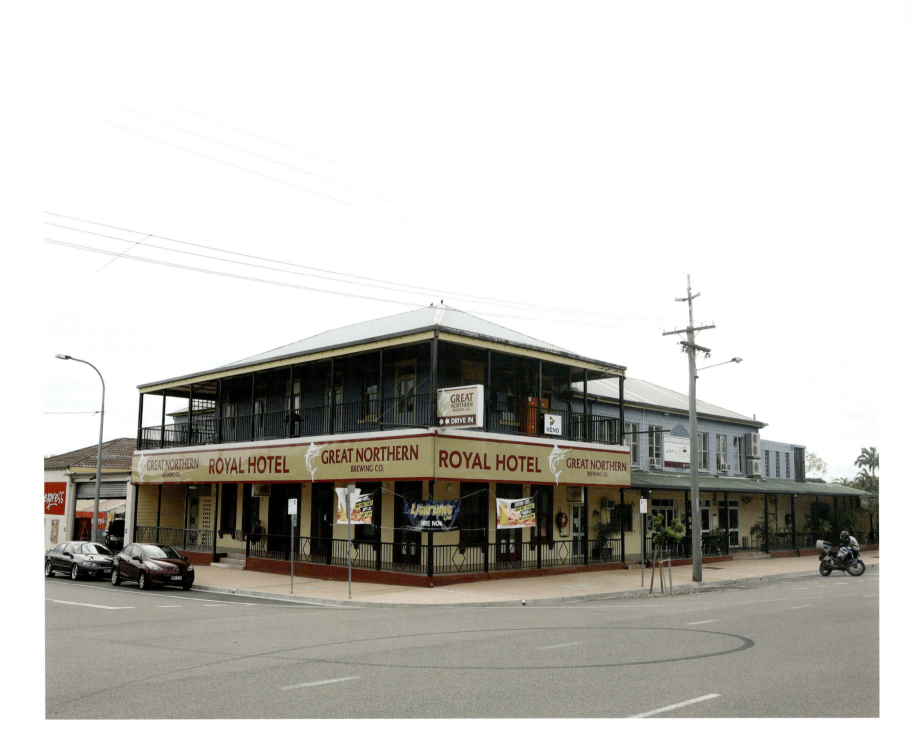

ROYAL HOTEL

TOWNSVILLE, QUEENSLAND

After an easy coast down through the mountains to the coast, I'm on a stool outside the Royal Hotel in Townsville, where I've started an argument between some of the locals about the oldest pub in the place. It's a pub argument; that kind of discussion where everyone is damn sure they're right until someone has the bloody hide to produce some proof and the others, go, 'Really? Bugger me!' What is impressive is the wrong knowledge.

'This is the second oldest, the West End's been around since '85.'

'No 1895.'

'The Mad Cow's the oldest but it's not a pub any more.'

'What about the purple pub on the Strand.'

'What about Tatts, doesn't that date from 1897?'

'The Mansfield started in 1899.'

'The Big O is the oldest but it's shut down.'

While we're trying to sort it out, a woman on a bicycle pulls up. 'Here's Alisha. Her folks own the West End. She'll know.'

I ask her why she's drinking here if her parents own a pub themselves. 'It's on the way home and it's rude to pass a pub, in my book.'

She grabs a drink from Suzy and comes back out and yes, the West End has been going since 1885, and yes that makes it the oldest pub still operating as a pub in Townsville. The talk just flows on to other pubs, gone but not forgotten.

The exquisite three-storey Buchanan's Hotel, a white lace beauty built in 1902 and converted in World War II to accommodation for US troops. Lyndon Johnson stayed there during the war and returned in 1966. Just weeks after a developer was refused permission by the Heritage Commission to destroy it, this beautiful pub was burnt to the ground.

They all stress to me, 'Make sure you write it was burnt, not that it just burnt.'

And the astonishing Queens Hotel on the Strand. In 1872 the Queens Hotel was built facing the water, but like so much up here, history was shaped by the winds, and in 1903 Cyclone Leonta huffed and puffed and blew down most of this stick hotel. It was replaced by a magnificent stone masterpiece which took more than 15 years to finish. An atypical building up this way, but sturdy, strong and wind (and fire) proof. Thankfully the building remains but it's no longer a pub. This mob at the Royal knows all these stories: they know where the pubs fit in and they know where their pub fits into the story of Townsville's hotels.

I head back in for a refill and get chatting to Suzy. In the 1980s Suzy was living in Sydney's western suburbs. Her sister was living in Aitkenvale, a suburb in far-off Queensland, and was liking the life. Suzy figured she'd do a road trip up north, visit sis in Townie and then head up to Darwin. So she packed her stuff and her budgie into her car and hit the Pacific Highway. She liked Townsville; liked it more than her sister did. Six months after she arrived, her sister headed south, her budgie died and Suzy's never left.

'I never got to Darwin, still haven't. Too much fun here.'

Behind her at the bar, blackboards dispense wisdom and explain the pub rules. Beside me is Pete. We grab our drinks and head outside. Pete's not sure whether he's a blow in or he's been sucked in. He's from Tasmania but in 1971 he was working with a mate as a roofer in Alice Springs when Cyclone Althea hit Brisbane on Christmas Eve:

> *First thing we did after recovering from New Year's Eve was pack our truck and head east. We figured there'd be a lot of work for us. But it didn't work out so we ended up working for the same mob we were contracting for in Alice.*

But he liked the town, stayed upstairs at the Royal for two or three (not too sure which), years and now lives up the road. There's no longer rooms available upstairs, all taken by permanents who call this pub, 'home'.

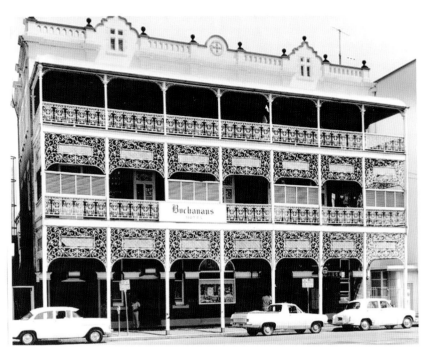
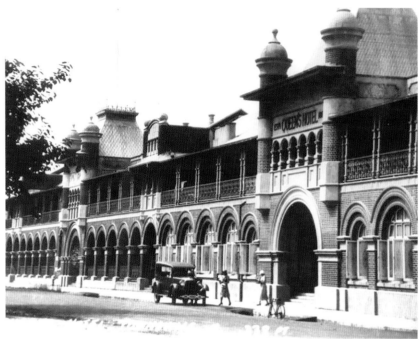
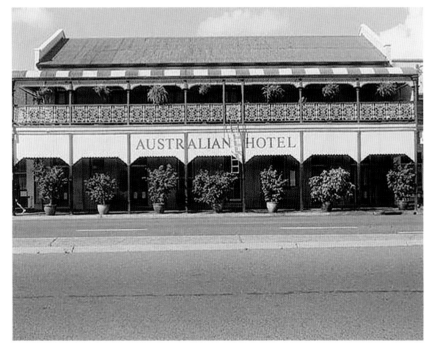
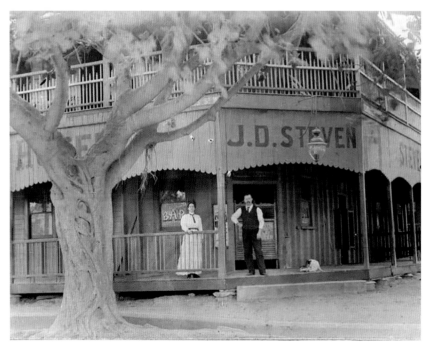

Rhino turns up in his dark green Jag and a voice announces, 'Ah, the Dukes of Hazard have arrived.'

Rhino's a man who likes his Jaguar, but he doesn't worship it. He likes to drive it. Fast. One of his more famed drives was on a gravel backroad, giving it the hammer with Pete in the front seat. They hit a crest and whilst the Jag might be streamlined on the road:

> *It's not really all that aerodynamic, probably needs about 400 kilograms in the boot. The front wheels took off first which is fine, but they also landed first and that's not quite so fine, but I kept it straight and we had a long landing strip so it was all good.*

Pete reckons there was a warning sign to slow down for the crest.

'Mate at the speed we were going there was no time for reading.'

I ask old Pete about his time here at the Royal, how many publicans has he been through? 'Been through? I've been friendly with them all,' the words eke slowly out. 'But never that friendly.'

I don't understand but then replay my question and realise I've not used that bit of slang since high school.

I tell Rhino that no, he can't have a spin on Super Ten, and Suzy calls, 'See ya,' as she leaves for the day and others split for home.

An arvo in a fair dinkum town pub winds down and not a single person leaves without wishing me good luck and safe travels. Another good one added to the list, I fire up Super Ten and head off to see a mate.

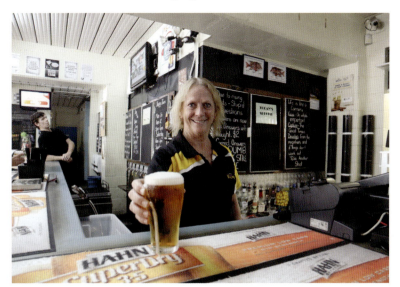

TOWNSVILLE TO INGHAM

It's not much over an hour up to Ingham from Townsville but the road is boring, infested with disinterested hi-vis-vested stop/slow sign-waving, safety-boot-wearing figures, all conspiring to wreck any possibility of an enjoyable trip. If the weather doesn't get you, the roadworks will.

And in the morning, with the pubs not open, the best options for cooling down involve being underwater somewhere. Luckily this little stretch has a couple of absolute beauties. About 55 kilometres from Townsville I take the turn west for Paluma and then 4 kilometres later I have a wonderful choice.

Straight ahead, up twisting, winding road, bereft of caravans or trucks, is Crystal Creek with its stately old bridge over some rapids and pools. To the right is Big Crystal, a much more open stretch of water with a sandy beach and some rock jumps. This time I turn right, bend the bike over through a succession of curves and twists and park the bike.

The sandstone beneath the rippling surface resembles salmon flesh, fish all over the place. I take it in and then jump in. Swimming is an obvious expression of immersion. Immersion into the country, into the culture, into dry surrounds, is far more subtle, less obvious to others. To swim in country rivers is to draw their yourself into their arteries, their life sources and flows. Floating in these waters is to be in the river, with the river. When you are immersed you cannot be somewhere else.

But floating like this is not just pure pleasure, it's also both instructive and revelatory. As I float on my back, submerged apart from my toes and face, the calm takes over and again I meditate on the process of being where I am, with where I am. And again I resolve to do this on dry land, on my bike and in the places I go.

Totally refreshed, rejuvenated, I head back down the mountain, left and then left again on the Bruce Highway but then 20 kilometres on, it's time again for a detour, this time to the Jourama Falls. A short bit of gravel road through cane fields and I'm in the parking area.

Two young Dutch women are having lunch at the table, summoning up the courage to go for a swim. I ask if I can duck down there first and they are sweet. This pond is tortoise heaven, and I creep down there trying to spot a few but there's only one around and I go back for the tourists.

I show them the frames in the back of the camera then spend five minutes convincing them that tortoises don't bite and that any crocs will be freshies, and we head down to the water, being careful to avoid trees that may have drop bears hiding in ambush.

Again a perfect soak and it's off to Ingham, where some of my favourite roadside landmarks are missing. On the approach to the town there used to be a series of roadside signs for Lee's Hotel in Ingham. You know, the type, 'Just ten kilometres to…', 'Just five kilometres to…' sort of things.

For years Lee's Hotel in Ingham has misleadingly claimed to be 'The Original Pub with No Beer' despite not even being in existence when the original poem was written. I note the absence of these amusing fibs and figures; maybe they've come clean; maybe the owners have decided to actually tell the truth.

But no, right outside the Tourist Info Office is a brown tourist sign still advising that I'm just 400 metres from, 'The original Pub with No Beer'. Oh dear.

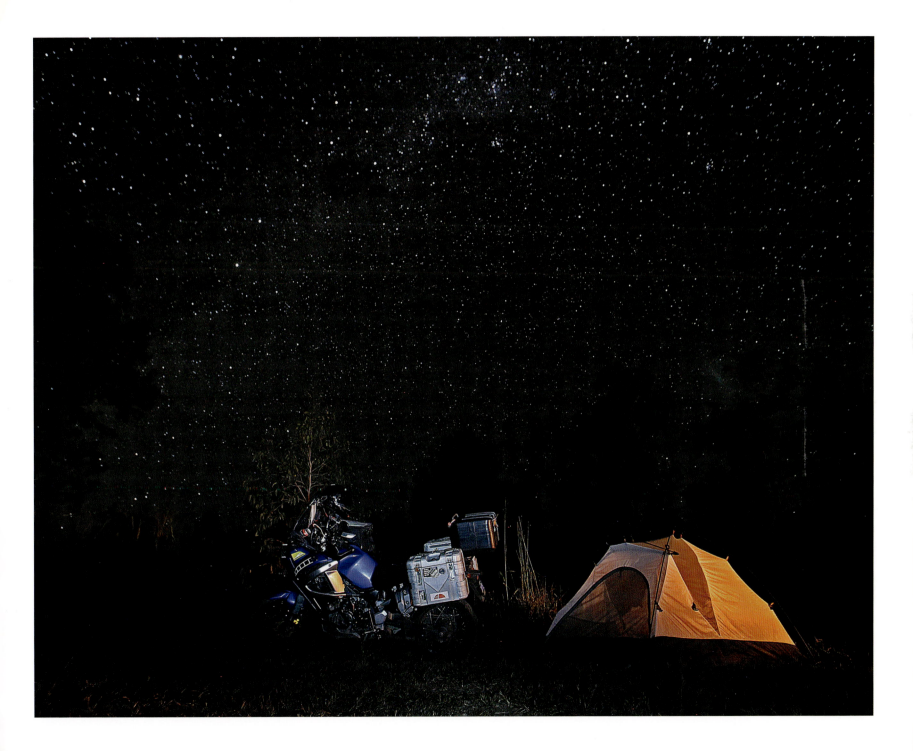

ROYAL HOTEL
INGHAM, QUEENSLAND

It's almost a century since Alan's grandfather and his brother left their villages of Lu and Pontestura in the Italian province of Alessandria and boarded a ship in Genoa for a trip to Australia. The plan was to work for a few years, make a bundle and then return home and live the good life. That work was to be in the cane fields of Northern Queensland and once the brothers arrived in Brisbane, they headed to Ingham and were soon cutting cane.

The Australian sugar industry needed labour and their passage, their entry into Australia, and their employment, were facilitated at each stage by the every level of government. Sugar was a labour-intensive crop and from the very start the issue of labour and its costs was problematic for the industry. The first granulated sugar from cane was produced in 1862 and just six years later the Queensland government was using penal labour to produce half a ton a day on the prison island of St Helena in Moreton.

In 1863 Robert Towns's schooner, *Don Juan* docked in Brisbane with 67 Kanakas from the Pacific on board. They were bound for his cotton plantation on the Logan River and Towns was savaged in the newspapers for introducing the 'slave trade' to Australia.

When the arse fell out of the cotton business with the end of the American Civil War, the Kanakas and the hundreds of subsequent shiploads brought over by increasingly shonky, desperate, corrupt, and dishonest captains, responsible for these boat people, were simply shifted into the sugar cane.

By the early 1880s there were over 47,000 blackbirded islanders, but there was increasing community disquiet. Then in 1884 when the *Hopeful* arrived with 103 'recruits', the master, the bosun and other crew members were arrested and hit with a number of charges, including wholesale murder.

A year later a Royal Commission described blackbirding as being rife with, 'deceit, cruelty, treachery...kidnapping and cold-blooded murder.' It was the start of the death of Australia's version of the slave trade. Sir Samuel Griffiths introduced a series of Acts which sought to terminate the granting of licences to recruit Polynesians from 1 January 1891.

So what's this got to do with Alan and his ancestors, eh?

The plantation owners opposed the Griffiths Acts, arguing against it on two fronts. Firstly cheap labour was essential to the industry and also that white men were unsuited to such hard work in the tropics.

Griffiths caved and the section prohibiting continued entry of Kanakas was repealed. But politics on the wider scale were taking over and with Federation at the dawn of the new century came the *Immigration Restriction Act* of 1901. This was the White Australian Policy.

Now the plantation owners were in a bind. 'Coloured labour' was cut off but there was work 'unfit for the white man' that needed doing. Enter the southern Europeans, the Italians and the Greeks. White enough to satisfy our racist strictures but tough enough to swing the cane axe. The call went out, and Alan's grandfather and his brother answered.

The two brothers worked the cane and saved every penny they could. As soon as they had the funds, they sent the ticket money back to Italy and another brother came to join them. With three working and saving, the fourth arrived in no time and then cousins. They all liked it from the start, even more once their number swelled. Any thoughts of returning to Alessandria were shelved, and when no more family needed a lift down under, they saved, spent and invested their money in the town.

They didn't care that they were the collateral beneficiaries of systemic racism, they simply did their thing, lived their lives and adopted the country that had taken them in, albeit for their own means.

When Alan was 14, in 1959 his dad bought the Royal Hotel and set about improving it, scrubbing it up to compete with the almost dozen other pubs in town. He lived upstairs with his family until he passed away in 1994 and Alan's older brother, Dennis, took it over until he was killed in an accident just four years later.

By 2005 it was proving too much for Dennis's widow, Cheryl, but Alan couldn't bear to see it pass out of the family. Alan and Sharyn were running

the newsagent in the same building. 'I just felt very connected to the hotel. My grandmother died here, and my father died here and it was a good decision to buy it.'

He breaks off to serve a young couple who perch at the far end of the bar.

'The pub's been good to us and we want to be good to it. It's given our family some very good times but the time's come to move on. We want to sell it but not just to anyone.'

Neither of their sons is interested. 'We can't even get them up here for Christmas.'

Alan's wife joins us after working out back with a large group in for the buffet luncheon. Sharyn, whose family came out from Scotland, has been married to Alan for 46 years and the Royal Hotel is dear to her as well.

'We've been here a long time and it's part of us but we're not young anymore. We want to celebrate our golden wedding here, just not on this side of the bar, please God.'

Alan's never returned to the village of his grandfather and he's not all that interested, wishing instead to spend his retirement in Ingham, the home that his ancestors chose and broke their backs to make their own.

It's a great story that's bookended by two periods of xenophobia and racism in Australia's history, and in a town where the pub next door has reinvented and reinterpreted history to suit its own hopes, Alan's and Sharyn's is a genuine tale and deserves a happy ending.

Before I leave Ingham I duck next door to the Lees Hotel. The windows still carry the logo which lies that the hotel was established in 1875, when in fact it was built in 1960. The large wall plaque carries the date of the poem written in 1943, the words coming into the hands of Gordon Parsons in 1956, and the recording of the song by Slim Dusty in 1957.

But they've been canny enough not to put in the year the pub was built and they continue to call the pub down south the Taylors Arms, when it's actually at Taylors Arm. At the bottom it's still claimed that the owner is Scott Midgley, despite him selling out almost a decade before. The woman behind the bar tells me the roadside signs were taken down not for any desire to be truthful but rather as a cost-cutting measure.

If Lees Hotel is the original Pub with No Beer, then anyone who swims at Cheviot Beach down in Portsea automatically becomes Harold Holt and anyone who heads out to Greta and stands on Ned Kelly's grave becomes liable to arrest for murder and highway robbery. Spare me!

I crank up Super Ten, cross the cane-train lines and head up the Bruce Highway.

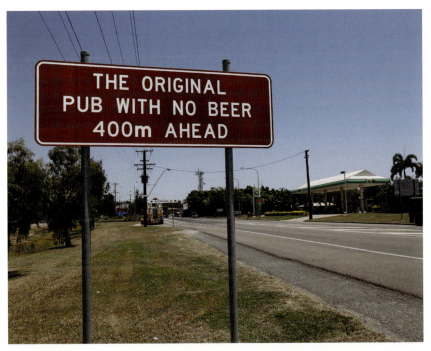
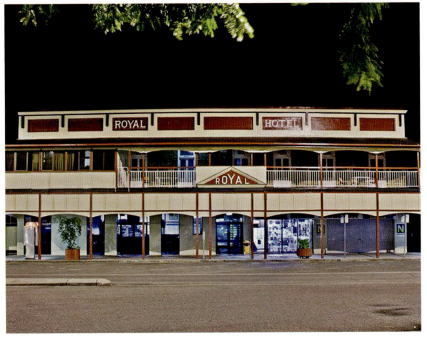

INGHAM TO HERBERTON

As I wind down from the hills to the coast, the panoramic beauty of Hinchinbrook Island reveals itself on the right and then it's into Cardwell with the long boardwalk, before becoming immersed in cane all the way to Tully.

Dark clouds overhead and the low sun combine for some brilliant, stunning light, but the wettest town in Australia stays dry for me and I push for El Arish.

Before things in the Middle East became too weird and dangerous, I slept in my tent between bombed out ruins in El Arish on the shores of the Mediterranean with some local Arab fishermen. They were good people who shared what little they had. El Arish in Queensland was named after the one where I'd stayed. The first time I came through here I thought I'd stay at the noble El Arish pub and after a drink asked whether there were any rooms. But no, they didn't have accommodation anymore, the upstairs was the owner's place. So I considered my options over remnants of schooner. A local fellow who'd overheard me at the bar came up.

'Mate, it looks like you've got a tent on your bike, if you wanna sleep on my front lawn you're welcome. A beer'll cover the rent!'

So I bought a round, then another to cover the cost of using his hose for my shower in the morning, and followed him home. Two towns called El Arish, almost half a physical world apart and with a measureless cultural gap between, but both with good people right at the surface.

This time around I just grab a softie, stretch the legs and keep going up the Bruce and then take the turn west for Silkwood, with its grandiose hotel and simply wonderful National Bank, just possibly the smallest bank in the country. Then up the back road, pausing for the cane trains to South Johnstone, where the tracks run so close to the Criterion Hotel and the trains so constant that during the harvest season, there's no cost for most of the rooms.

Then it's left on the Palmerston Highway, up through the mountains. A few years back I invented the concept of road porn. Some bike riders get off on beautiful motorbikes and they'll post pics of bikes on social media and call them, 'bike porn' but for me the machines are just tools to do jobs. I coined 'road porn' for roads just like the Palmerston and as I bend Super Ten into the curves I laugh again at how the road signs indicating serious bends always have an arrow pointing to heaven.

By the time I reach Millaa Millaa I'm ready for a soak. There's few better places for a shower than the Millaa Millaa Falls so I wind down to the edge of the carpark, grab my microfibre towel and wade in.

The water comes from the same heaven that the twisties lead to and I view the world through the curtain lens of the clear falling water. There is no need to hurry, Herberton is just half an hour away on some wonderful porn roads, so I wait until my fingers are totally shrivelled and the cool turns to cold.

When I pull up at the Herberton Royal there's a bloke standing outside.

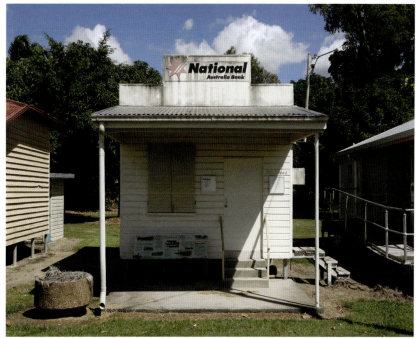

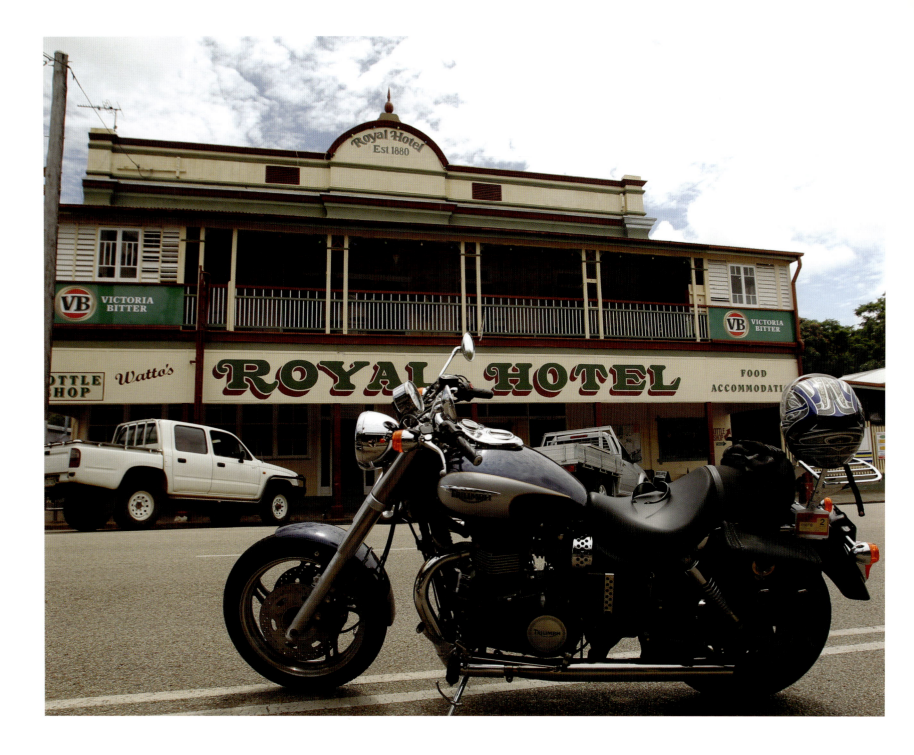

ROYAL HOTEL
HERBERTON, QUEENSLAND

I'm at the end of my Royal Ride. This is the final pub. The most northerly Royal in Australia since the Royal at Mossman burnt down for the second time in 2011. And that's a pity on many counts: a pity for the people who'd bought it two years earlier intending to turn it into shops but who never began the renovations; a pity for the people of Far North Queensland who lost an historic building and drinking hole; a pity for the heritage of pubs not just in the area but in all of Australia; and a pity for me as this pub had some good stories which I would've like to have shared.

Stories like how it was a nomadic pub like the two down in Clermont. It was built in Craiglie around 1890 and moved to Mossman about 1892 and was named the Royal.

Stories like the first time it was burnt down two years into the great Depression in 1931. Things weren't easy, but seems torching a wooden pub was. As the flames took hold the pub's yardman was passing and he raced to the wood heap out back to grab an axe to break down the doors and try to douse it. From the dark he heard his boss, Joe Aldridge's voice, 'Come away you silly bugger, there's ten gallons of petrol in there.'

The Mossman Royal was rebuilt in 1932 and kept going until its owners raised the white flag in 2007, called 'last drinks' for the last time and handed in the licence. It stayed closed for two years until it was bought with the aim of redevelopment but then one of the most popular trifectas in Australian turned up trumps again: struggling pub, optimistic developer, catastrophic fire.

Can't help bad luck, but talking about trifectas, there's one fella I'm hoping to catch up with in Herberton. I heard a ways back that Gus Philpot, who rode a famous winner in what should've normally been a forgettable Commerce Novice (second division) at Eagle Farm on 18 August 1984. I'm hoping to catch up with him and talk about this memorable race because the horse under Gus that day was Bold Personality, but its *nom d'equine* in the novice handicap was Fine Cotton.

Gus was an apprentice at the time and was completely exonerated of any involvement in Australian racing's most famous uncovered racing ring-in scam, and I reckon he might have some stories.

But I'm two years too late. After living in the Tablelands for about five years, Gus Philpot's now stabled back in more temperate climes. Turns out the bloke who was outside when I pulled up was Paul, the owner, who is already behind the bar by the time I get inside, and the handful of locals plus a couple of riders all nod a country greeting.

I'd booked ahead for a room. I'm going nowhere tonight so I order a full-strength and a schooner of water. The water gets sculled at Bob Hawke speed and I press the cold beer against my forehead.

Paul's a city guy, born and raised in Sydney's Cronulla, and after a career with CUB he took a tree change, taking over the Royal in 2008. Herberton wasn't so good for his partner, who returned to the coast, but Paul loves the place and his pride and happiness shine through as he tells me about the town and the pub's attractions.

And he points out Garry at the end of the bar. Garry's an ex-bush jockey and if I was after Gus for some horse stories, Garry'll be a good substitute.

I leave my stuff on the bar and move the bike around the back for the night. The local cop cruises by and nods. Sometimes you want a beer, sometimes you feel you need a beer and sometimes you think you deserve a beer. Tonight I feel all three. I stick another on the slate and head over to Garry.

He rode the country circuit for 20 years but never got to town. He tells stories of winning all seven races on the programme one time and about winning on the same horse twice in two days. And he tells me about 'Greenhide'.

'Greenhide' was a steward and an important man to have in your corner. This was the bloke who checked the scales before and after every race and if you were doing any business, 'Greenhide was fine so long as he was getting a bit of the action.'

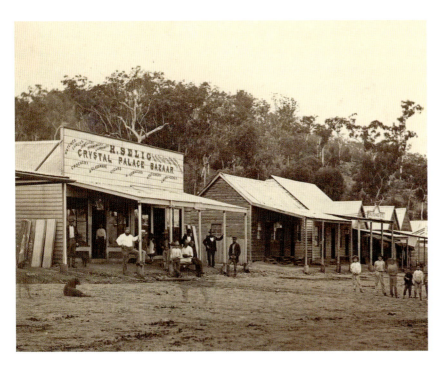

See, the easiest way to arrange the odds was to play around with the weights. Ride it heavy one day and then light the next day, or if you were helping another horse to get up, riding yours heavy was the easiest way to slow it down but still look like you were working'

Garry sometimes didn't know his part in any business until he was in the saddling paddock and the trainer would give him his instructions. 'You couldn't always tell by the weight of the saddle, but you usually had an idea.'

But getting his instructions late created a problem with letting his mates know what the plan was, but a system was worked out.

If I was riding light and supposed to win, I'd head out from the saddling yard with my race goggles up on my cap. But if I was riding heavy, I'd have them down around my neck. And if there was no business, and most of the time there wasn't, I'd head out with them over my eyes.

When he came back to scale Greenhide would be standing right close to the scale and he'd yell out, 'CORRECT WEIGHT!!!,' sometimes before Garry even had both feet on the thing.

'Good times. We all managed to make a living and no-one got hurt!'

Time for Garry to saddle up so I order tea and chat to Paul. He's a qualified chef with almost three decades' experience in the hospitality game and he's very happy to've settled in the oldest town on the Tablelands.

'It's a great little town. The people who live here are all here through choice and the visitors just keep coming back because they love it.'

The pub claims to have the equal longest continual licence in Queensland and high on the facade '1880' elegantly states its age. It's been too long a ride and too long a day to bring up the Farmers Arms at Cabarlah, which dates from 1863. But look, it's certainly old—built for the hopefuls, the desperates and the successfuls in the gold rush of the 1880s.

Just for a change, this pub's been in the same place since it was first built as a single-storey pub with rough accommodation out the back. A second storey was added in 1920. Accommodation out the back is now for swags and tents and campers can have a shower for just five bucks. Herberton is surrounded by State Forests and the pub is a magnet for dirt bike riders who base here for a weekend of fun on the trails through the trees. There's a free high-pressure hose to wash down the rides at day's end.

My meal is all I wanted but somewhere during main course, the adrenaline stops flowing, the relief of ending this Royal Ride replaces it, the tiredness hits me and I head up the stairs. My room upstairs is elegant and homely. The doors open directly onto the verandah which, for a great change, is totally non-smoking. I sit on the balcony, feet on a table as darkness takes over the town and the mozzies drive me inside. I'm relieved this Royal Ride has finished on a high, and soon I'm amused that even though I missed a chat with Gus Philpot, the sheets on my bed are pretty damn fine cotton.

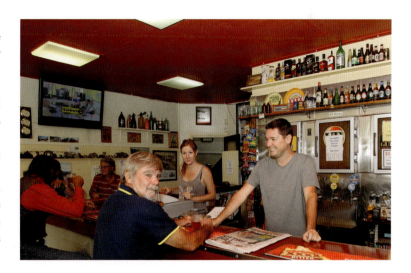

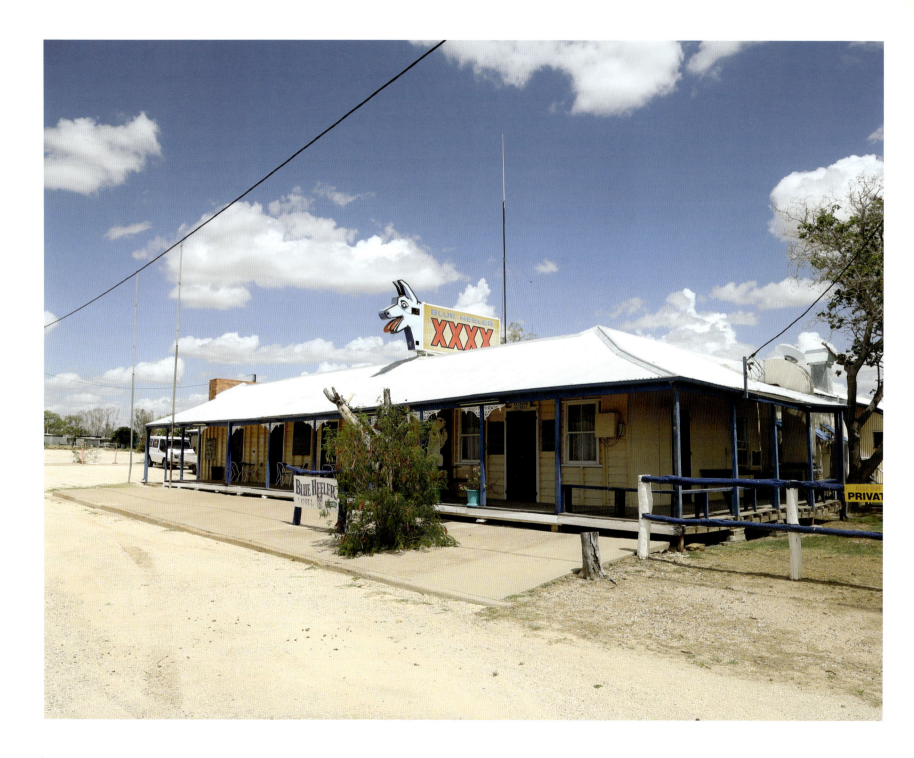

Part Three: The Poets

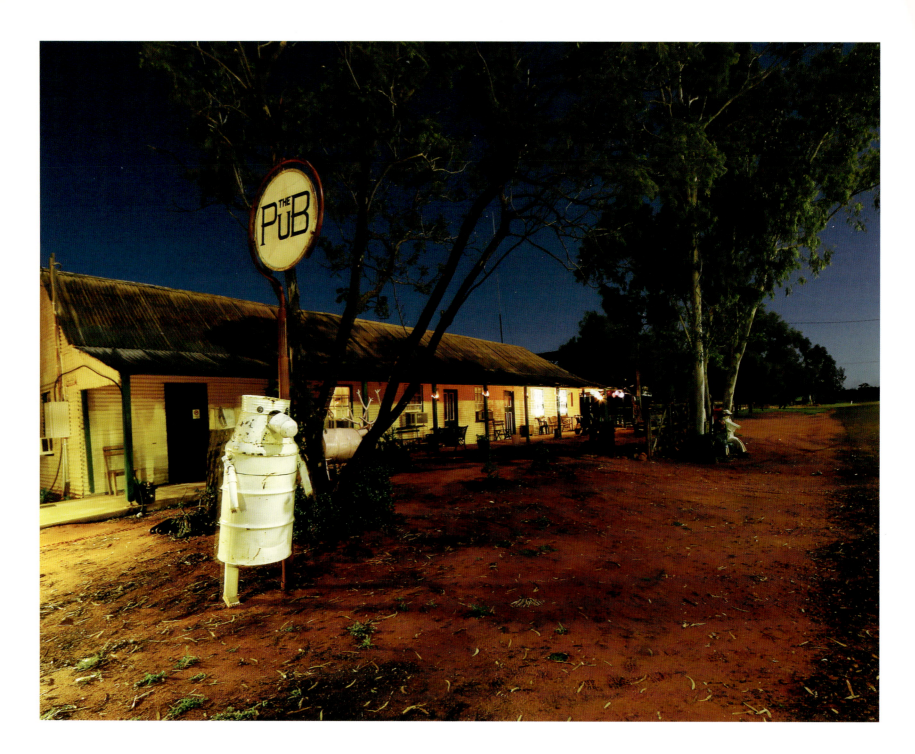

> *We sat in a hotel,*
> *And drank the amber ale;*
> *And as I touched the bell*
> *I listened to his tale.*
> — Victor Daley, 'The Old Bohemian'

In 1893, after a polo match between a team from Sydney and some Snowy Mountains locals, the players and supporters went back to the Prince of Wales Hotel in Cooma. One of the players that day was Banjo Paterson and back at the pub he was asked to recite his poem, 'The Man from Snowy River', which'd been published three years earlier.

Paterson explained he'd just written a new, perhaps more relevant 'jingle', so as the players, officials and others listened, Banjo read, for the first time ,'The Geebung Polo Club'. The warm reception must've been unusually enthusiastic as it was soon published in *The Antipodean,* but the act itself, of reciting poetry or singing songs, was a completely normal practice in Aussie pubs.

The first performance of 'Waltzing Matilda' was in a pub, indeed the first theatre in Australia was in a pub. On a baser level, pubs were where drovers and farm hands and bullockies and itinerants would sing bawdy songs and dirty ditties.

But the connection between poetry, songs and stories wasn't limited to bar-room performances. Almost without exception our poets and writers focused some of their work on pubs, alcohol and drinking. Not all were complimentary. In her signature poem, 'Australia' one of our erstwhile early temperance advocates, Mrs Staniforth bewailed:

> *Drink and debauchery stalked hand in hand*
> *Throughout the length and breadth of this fair land;*
> *Convicts made publicans—no wonder then*
> *The should spread snares to catch unwary men!*
>
> ———
>
> *In Sydney, the great capital, alone,*
> *Ev'ry fifth house a publican does own;*
> *In country too, wherever white men go,*
> *There Satan's strongholds rise and prosp'rous grow.*

But such sentiments were countered by the likes of Victor Daley:

> *I pity those who have to walk*
> *In sober ways and sad,*
> *And keep a guard upon their talk*
> *Lest men should think them mad.*
> *Or careless speech should show*
> *The felon thought below.*
>
> ———
>
> *Who does not drink he does not know,*
> *And he will never find,*
> *What merry fellows live below*
> *The surface of his mind:*
> *These other men to me*
> *Are right good company.*

If poetry truly is 'ordinary writing elevated', then a good pub must surely be 'hospitality heightened'. For me this is a perfect cocktail and the few pubs that follow are truly at the top of the pile.

In the late 1960s and early 1970s I used to sneak down to a pub on lower George Street in Sydney. It was known as 'Jim Buckley's Newcastle Hotel'. Its name might've been just the 'Newcastle Hotel', I don't know, but I do know that Jim was such an intrinsic part of his hotel that it only seemed right that his name was part of the pub's. Jim knew I was still at school, but he didn't much care. He also knew I had no money but about this he did care. Middies were 18 cents but I didn't pay for many back then. The best nights were when Frank Hardy was still there after a hard day of drinking and he'd hold court in the back corner. For me it was ironic that Frank's surname was mainly, 'hard'. This was a strong, aggressive, outspoken, passionate, argumentative man who knew politics, knew literature, knew people and knew poetry.

It was in these after-school arvos at Jim Buckley's, when I'd told my mum I was at the Mitchell Library studying, that the connection between pubs and poets and politics all came together for me. Frank Hardy knew a lot of Paterson and Lawson by rote, and this knowledge was deeper within him than a stomach full of booze. I saw early that the three had been intertwined since the day the first white settler was paid in rum, not far from the Newcastle Hotel.

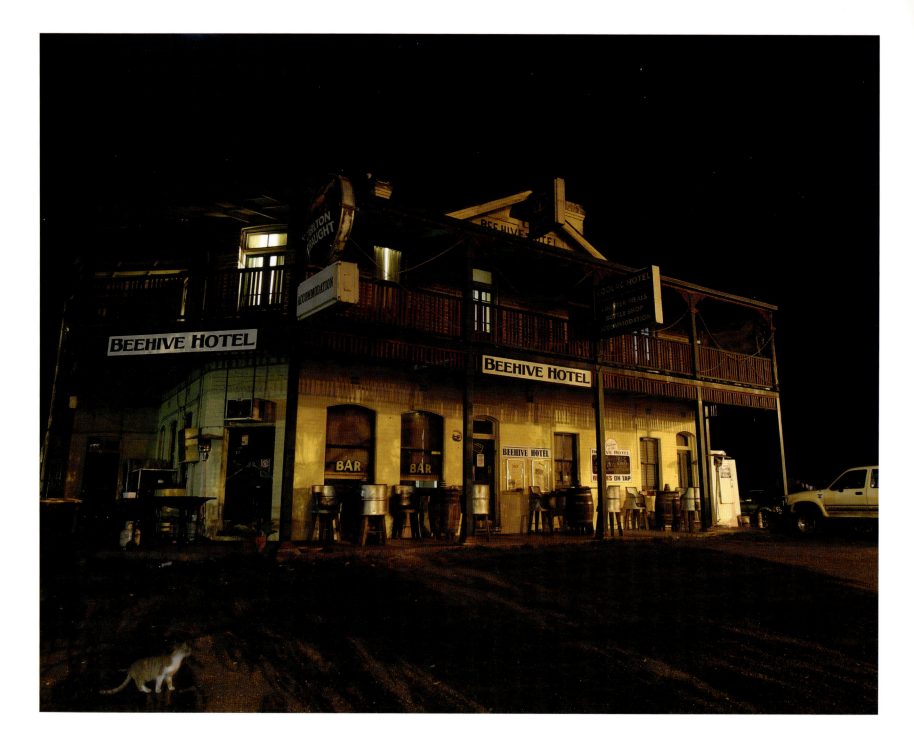

BEEHIVE HOTEL
COOLAC, NEW SOUTH WALES

Just south of Coolac the Adjunbilly Creek joins the Tumut River, which soon after adds its flow to the mighty Murrumbidgee. To the west of the township, the Muttama Creek flows south and joins the 'Bidgee a couple of kilometres downstream from its junction with the Tumut.

This is an area of coming together. And just as it's a centre of confluence for some of Australia's great watercourses, it's also a point of intersection for a couple of streams of our poetry history.

On one of the rivers, probably the Muttama, one day in the 1830s a (probably mythical) bullocky was having a miserable time. It was this bloke's day that led to the Dog on the Tuckerbox statue 12 miles south of Coolac (and five miles from Gundagai). The statue is based on a false and wowserised PG-rated rewrite of a great old folk poem.

'Twas gettin' dark, the team got bogged, the axle snapped in two
I lost me matches and me pipe, now what was I to do?

For a hard-living, hard-swearing bullocky this was a bad day but things got worse:

The rains come down, 'twas bitter cold, and hungry too was I
And the dog shat in the tucker-box nine miles from Gundagai

This of course was way too much information for the do-gooders and the puritans and so they sanitised the verse and in so doing, made it meaningless. You've got a bullock team up to their bellies in mud, a wheel on your wagon has smashed, you can't have a smoke or make brew and you're going to worry about where your dog is sitting? Really?

I could forgive the blinkin' tea, I could forgive the rain
I could forgive the dark and cold, and go through it again

I could forgive me rotten luck, but hang me till I die
I won't forgive that bloody dog nine miles from Gundagai

Fifty years later, *The Gundagai Times*, so very sensitive to the primness of its handful of readers, published its 'original version' of the cleaned-up poem:

As I was coming down Conroy's Gap,
I heard a maiden cry;
'There goes Bill the Bullocky,
He's bound for Gundagai.
A better poor old beggar
Never earnt an honest crust,
A better poor old beggar
Never drug a whip through dust.'
His team got bogged at the nine mile creek,
Bill lashed and swore and cried;
'If Nobby don't get me out of this,
I'll tattoo his bloody hide.'
But Nobby strained and broke the yoke,
And poked out the leader's eye;
Then the dog sat on the Tucker Box
Nine miles from Gundagai.

In 1923 Jack Moses completed the emasculation of this originally boisterous, bawdy bush tale into a wowser-friendly, acceptable piece of sentimentality with his, 'Nine Miles from Gundagai' which includes:

It's when you've got your bullocks bogged,
That's the time you flog and cry,
And the dog sits on the tuckerbox

And ends in:

> *Nine miles from Gundagai.*
>
> *The dog, ah! well he got a bait,*
> *And thought he'd like to die*
> *So I buried him in the tuckerbox*
> *Nine miles from Gundagai.*

Must've been a small dog or a bloody big tuckerbox!

The truth of course, especially if it's in any way scatological, has a way of squeezing through the sphincter of prudishness. Ron Edwards, who knows pretty much all there is to know about the old poems of Australia remembers his childhood in Geelong in the 1930s:

> *The sweet shop across the road from our school used to sell small metal toys known as Gundagai Dogs. These were in the form of a dog, 5 cm high, hunched in the defecating position. Small pellets were supplied with the dog and one of these was pushed into its anus and a match applied. There was a hiss and a splutter and then, to the amazement of us children, a long ash coloured spaghetti like core would begin to issue forth, winding across the ground until it was three or four times the length of the dog. It was the only childhood toy that I regret not having kept.*

Anyway, in 1932 the refined people of Gundagai decided it'd be good for tourism to have a statue of the sedentary, poo-free canine. They also realised that sticking it nine miles from Gundagai would mean it'd actually be closer to Coolac than their town, so they put it five miles out instead!

Jack Moses was a mate of Henry Lawson. In his ramblingly strange 'Joseph's Dreams and Reuben's Brethren', Henry refers to the Jewish-heritaged but Anglican practising Jack:

> *I mean no slur on any tribe*
> *(My best friend was a Yid),*

Three years before Moses's book of poems came out, these two great mates, Lawson and Moses, caught the train from Sydney down to Coolac and got off at the old timber station, still there today beside the rusting tracks. Henry had been shunted down there by his friends, once again worried about his drinking and his depression in Sydney.

One evening the pair took a walk down to the 'Bidgee and came across a drovers' camp and, without revealing their identities, they joined the group for an evening of jawing, singing songs and reciting poetry. One of the drovers got up and recited a Lawson poem oblivious to the fact that one of the faces reflecting the campfire glow belonged to the author. Moses was later to write that he could see in Lawson's eyes, 'the satisfaction…that this was his best reward—to be loved and appreciated by his bushmen.'

In those times Coolac had three pubs but now only the Beehive remains trading. Thankfully the other two buildings stand strong and beautiful, one, known as 'The Windmill Store', is across from the pub and the other's at the far south end of the village.

Lawson took up in a small house next to the Beehive, writing to his mate Jim Gordon there was, 'a pub next door' but not mentioning any bouts inside.

Jack Moses didn't stay long in Coolac leaving Lawson on his own with his housekeeper Grace McManus. He was once again broke and would sit at the pub and write letters to his friends, trying to touch them up for a loan. One was to his mate C.J. Dennis, author of 'The Songs of a Sentimental Bloke'. He mentions being, 'sentenced to six months in the bush' and begging for some money, giving his address as care of the Storekeeper, Coolac. The store still stands and trades on the same spot. Above the doorway a small sign testifies, 'Est. 1895'.

When I pull up in front of the Beehive, the porch is packed with more than the usual Saturday arvo crowd. There's been a reunion at the Rural Fire Service and the laughter booms in when I take off the helmet. Andrew, either the boss or the son of the boss (depending on who you ask) comes out and welcomes me before I'm even off the bike. It's going to be a fun session.

I pull up a pew at a table with three old timers. There's John and his

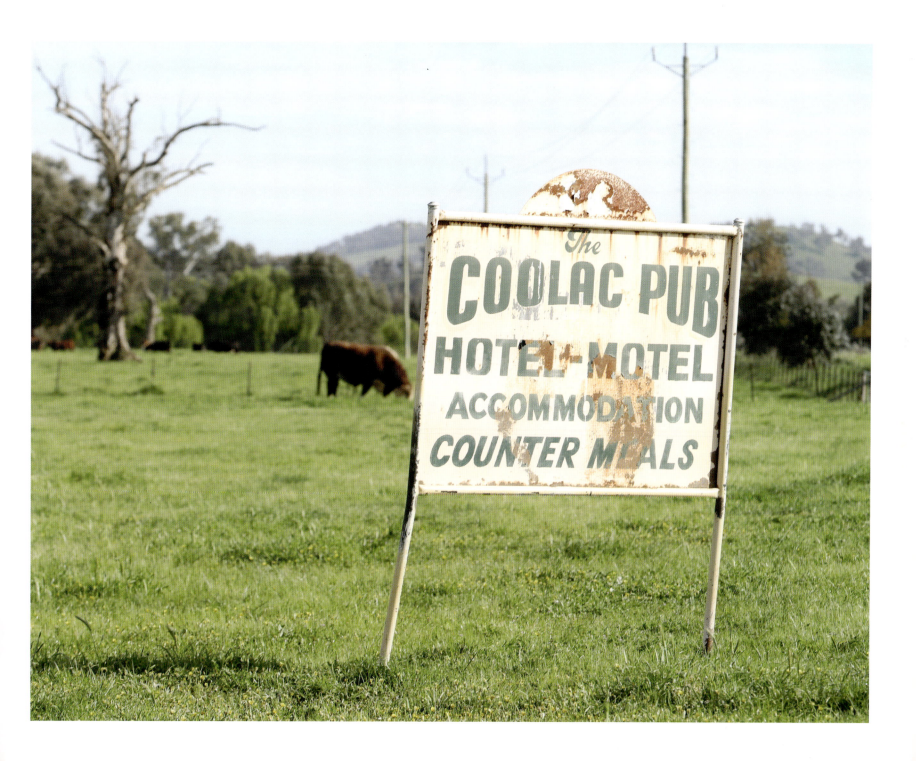

old shearing mate, Keith, and there's Bob who's come over from his home in Merimbula for the RFS do.

Talk soon gets around to Henry Lawson and they tell me that all that remains of his house are the stone outlines of the front and side walls, against the north wall of the present pub. The subject then turns to publicans, to droving, to droughts and of course to dogs. It always gets to dogs. Not a bloke in the bush without a dog story or two.

John recounts the time Bob's son Kelly had a very pregnant bitch on the back of his ute when he pulled up at the pub. While he was at the bar his mates put her in the cabin. At the end of the evening Kelly opens the door of the cab to find the driver's seat covered in afterbirth and half a dozen heeler pups.

And then there was the local whose brother ran the dog pound in a rural centre not too far away. Every couple of weeks the train would deliver all the stray cattle dogs and kelpies from the town and the bloke would take 'em back to his place and advertise them for sale as 'fully trained'.

He had half a dozen sheep that'd been mustered a million times and they knew the game better than the dog. When the people arrived to check out the dog he'd throw it into the yard and the sheep would head straight for the race with the dog in pursuit looking like he was mustering them. Sale!
 God knows what happened when they got the thing home and found out it didn't know how to scratch itself!

Bob chimes in:

And what about that time a couple came down from Sydney in a convertible Mercedes, bought a dog and then headed to the cafe, got three hamburgers, one for him, one for her and one for the dog? She got in the back, he drove, and the dog, with its bloody burger, sat in the front!

But this bloke's favourite trick was to advertise 'Champion Dogs' in the papers in Sydney and Melbourne and when the buyers arrived, he'd sadly tell them that they'd missed the champ by 30 minutes, another bloke had just bought it.

'But listen, you've come a long way for a wasted trip so why not take one of these much cheaper pups. It's got great breeding and is sure to be a champion one day.'

And of course they did. Another stray off the farm to a good home! The laughter is magnetic and others have joined the table.

'Didn't he go up?' one asks and yes; he was busted once for cattle duffing and did a stretch at the big house at Bathurst.

We get onto publicans and John reckons that not the previous one to Andrew but the one before that was the worst:

I've drunk Reschs Draught since I gave up raspberry cordial when I was 16. Middies. Every bloody day I'd come in, this bastard would ask me what I wanted. Every bloody day! I got sick of it. Almost enough to make me give up. Almost! This bloke now though, he's good. Sees me pull up and starts pulling my beer. It's there in my spot just before I sit down. It's like coming home.'

And that's it isn't it? A good pub, a good public house, is really a public home.

I know there's a long night ahead at the Beehive. A night of sharing stories, sharing time and sharing laughs. Time to change batteries on the voice recorder and to buy a round. I head in to see Andy at the bar.

'One for me, John, Keith, Bob, Bob's son and his wife and for Billy.'

Andrew doesn't flinch; pours 'em and tells me what's for whom and puts it on my slate.

I'm like John, I'm feeling at home in this village of confluence, where not just streams and poets, but also old friends and new faces, blend naturally together.

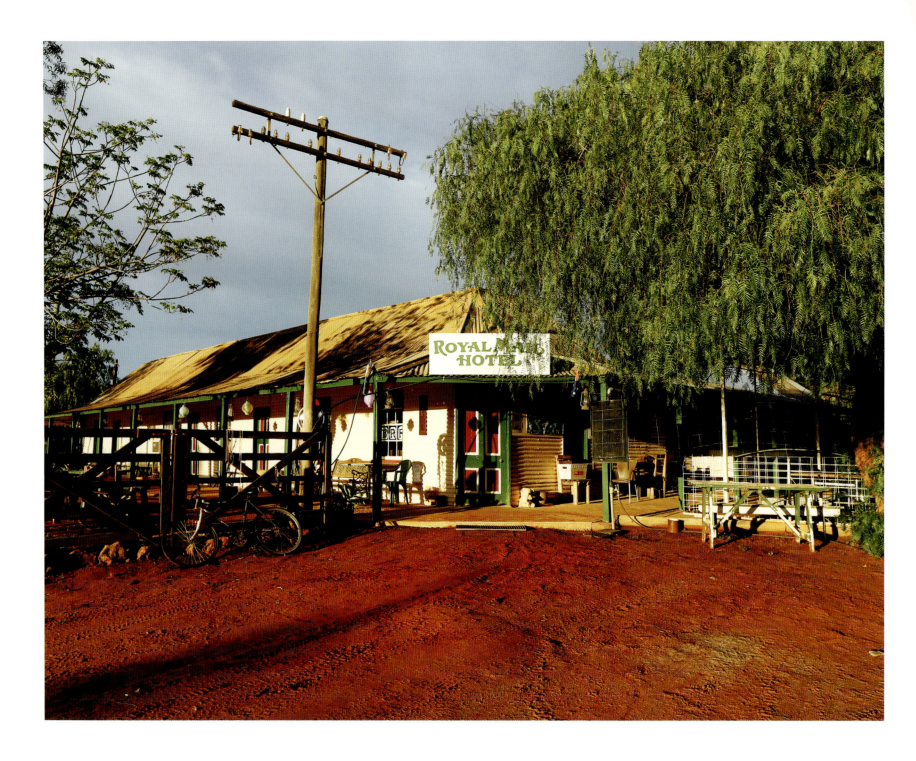

ROYAL MAIL HOTEL
HUNGERFORD, QUEENSLAND

When Henry Lawson left Hungerford in 1893, after a stay of possibly just one but probably two nights, to walk the 220 kilometres back east to Bourke, he turned his back not just on the town, but also on the bush. He never returned to the outback, despite the trip giving him material that would fill his stories and his 'sketches' for several years.

The day after arriving here in 1893, after walking from Toorale Station with his mate Jim Gordon, Henry wrote to his Aunt Emma. He told her that she could have:

> ...no idea of the horrors of the country out here. Men tramp and beg and live like dogs...The flies start at daylight and we fight them all day till dark—then mosquitoes start.

Describing himself as a, 'beaten man', he vowed to, 'start back tomorrow... (and) never to face the bush again.' Lawson would later write that the town straddled the border with 'two houses and a humpy in New South Wales, and five houses in Queensland...both the pubs are in Queensland.'

And he added that, he believed (wrongly) that 'Burke and Wills found Hungerford, and it's a pity that they did...'

Before he left the most westerly, the most outback town he'd ever visit, Lawson took in the sights, Hungerford's only two real claims to fame: the gate on the main street where the rabbit-proof fence traced the border line and the Paroo River just to the north of town. He wasn't impressed by either.

The fence was just a bad joke for him, a symbol of waste and stupidity, '(A)n interprovincial rabbit-proof fence—with rabbits on both sides of it—runs across the main street,' he wrote. 'The fence is a standing joke with Australian rabbits—about the only joke they have out here.'

And what passed for the Paroo River wasn't much better. That same year, his 'The Paroo River' was published, and it wasn't flowing with praise:

> *It isn't even decent scrub,*
> *Nor yet an honest desert;*
> *It's plagued with flies and boiling hot,*
> *A curse is on it ever;*
> *I really think that God forgot*
> *The country round that river*
>
> ———
>
> *'But where', said I, 's the blooming stream?'*
> *And he replied, 'We're at it!'*
> *I stood awhile as in a dream,*
> *'Great Scott', I cried, 'is that it?*
> *Why, that is some old bridle track!'*
> *He chuckled 'Well I never!*
> *It's nearly time you came out-back—*
> *This is the Paroo River'*

In the morning, Henry Lawson, for once, kept his word and turned his back on Hungerford and the far outback and began the trek to Bourke. He never returned.

Reading through his impressions from what has been described as 'the most important trek in Australian literary history', it's just not possible to be unimpressed by the strength of his venom, the depths of his disgust and the breadth of his distaste. For a town to make such an impression, for its scenery, its constructions and its people, to be just one massive shit sandwich, it has to have a certain strength of character. To hate something you have to respect it, and I needed to find out just what it was, slash is, about Hungerford that makes is so, well, Hungerford.

So I headed out there.

The road out from Fords Bridge, where Henry'd spent a couple of nights

at the Salmon Ford Hotel (see page 261) on his way west, had only just been reopened after some good rains. The wet, red soil was a challenge but at least the dust was down. Eventually, three kilometres from town I turn north onto the Wanaaring Road and suddenly the famous gate is in front of me.

There's a joke around these parts about a fella driving his ute through the bush and he comes upon a bloke walking the road. The driver stops and offers him a lift, but the walker declines, saying, 'Bugger you mate, you can open your own gates.'

Anyway, I park the bike and open the gate for myself, read on the sign that it's a thousand-buck fine for leaving it open, so I push the bike over the border, or what I think is the border, and latch the gate behind me.

The Royal Mail's 50 metres up on my left and I'm tonguing for one! I nod to the old couple on the roadside seats, but they ignore me. They both look totally stuffed. Graham's behind the bar yacking with a trey of the locals and since this is a stubbie pub, I order a shortie of Coopers Ale and grab a stool outside. I don't always drink this stuff but I wanted to check that the service had improved since Henry's time when he reckons he 'asked for an English ale…(but) got a glass of sour yeast (for) sixpence' at the then Royal Hotel.

In those days there was draught on. The cellar where the old kegs would be rolled down the earthen ramp is still as it was; all cool and welcoming through the trapdoor behind the bar. The mute walls shout hints of ghosts and stories and tales and myths and exaggerations when I survive the old ladder and take myself on a tour.

Anyway, my beer's perfect, as is the afternoon as I face the east and watch a full moon rise over the old corrugated place opposite as the sun sets behind me. A 4WD pulls up right out the front and an old bloke, a very old bloke, crawls out. He can hardly walk and needs to lean first on his truck and then on the fence and then on the walls of the pub. But he's not too crook to say, 'G'day', which I return, and then when the bottle's empty I follow him inside.

There're eight stools at the bar and by now five are taken. I check with Graham if any of the others is the permanent perch of any local who's about to show and he points out the safest one to park on. It's on the eastern wall beside Aldon, who asks what the hell I'm doing in this part of the world. I tell him about Henry. He coughs, actually sorta splutters, and puts down his beer.

'That fucking pisshead imposter! He never walked out here, he was just on one of his bloody pub crawls!'

Aldon hates Henry, hates his maudlin, sad, grim stories. He's read every word Lawson ever wrote, all the works of Banjo too. When he finished he donated his Collected Paterson to the library at Broken Hill. 'Lawson never wrote anything bloody happy!'

Al reckons there was a shanty or a pub every day's walk from Toorale and I reckon he's right on the first three. After Fords Bridge, Henry made for Lake Eliza with visions of swimming and cold beer leading him on.

We quite forgot our aching shanks,
A cheerful spirit caught us,
We thought of green and shady banks,
We thought of pleasant waters.

But all he got was disappointment:

A lonely pub in the mulga scrub
Is all that the stranger passes.
He'd pass the Lake a dozen times
And yet be none the wiser;
I hope that I shall never be
As dry as Lake Eliza.
No patch of green nor water seen
To cheer the weary plodder;
The grass is tough as fencing-wire,
And just as good for fodder.

Henry's next stop was at Yantabulla, which is now a ghost town of corrugated iron and decaying cars, and the mosquitoes are still big enough to have names. 'Pegasus' would've been fitting for a couple I see there on the way through. But after that, there's no sign, no evidence of any respite from the searing heat, and Lawson certainly didn't mention any, either on the way out or on his way back. So I'm not sure Al's not falling into a bit of myth, but then Lawson had warned about the locals.

It wasn't just the natural splendour and the efforts of distant governments that earned the poet's scorn; he wasn't exactly unstinting in his praise of the populace either!

He wrote that all the trouble in the town was on the Queensland side where the pubs were, but placed a caveat on the claims saying:

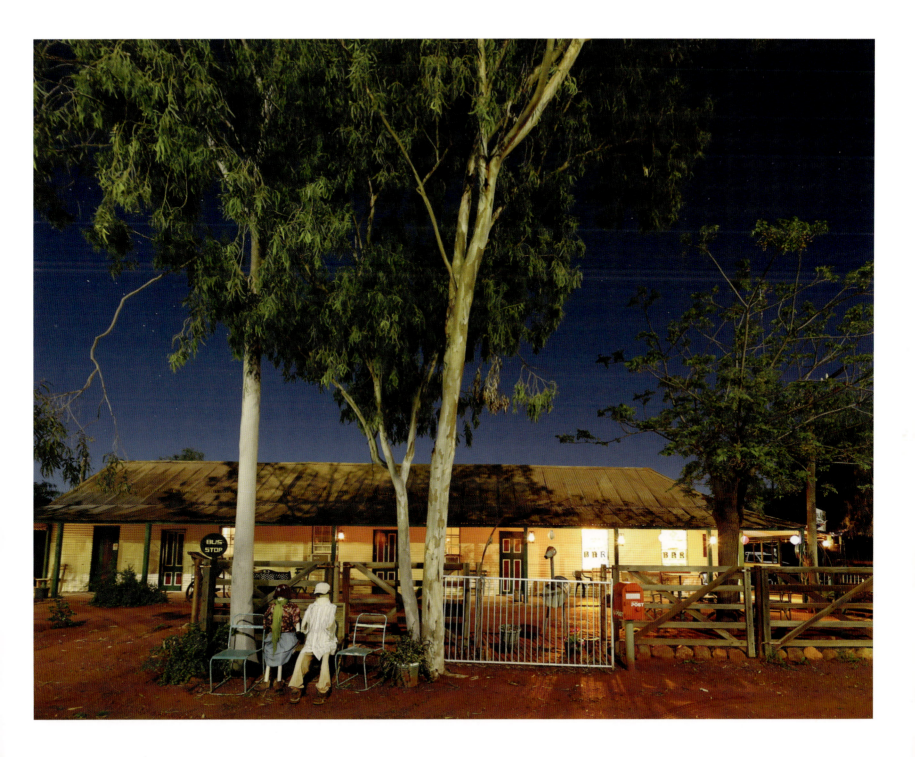

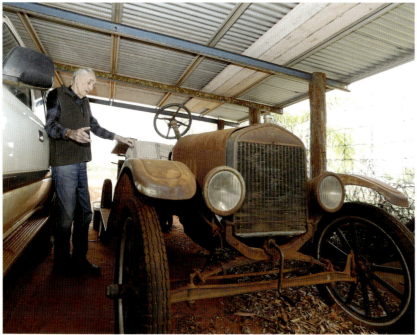

(a)t least, I believe that's how it is, though the man who told me might have been a liar. Another man said he was a liar, but then he might have been a liar himself—a third person said he was one. I heard there was a fight over it, but the man who told me about the fight might not have been telling the truth.

And you know, he might've been onto something. When I chat with publican Graham a bit later I do my usual spiel about being happy to turn off the recorder if there's anything he wants off the record. 'I don't give a shit,' says Graham, 'I've always got two answers for every question, the truthful one and the bullshit one. I'll leave telling the difference to you.'

Anyway Al's disdain for old Henry seems to almost mirror Henry's for Al's hometown of the last 26 years. Al arrived here with his wife in 1990 after a career as a suburban fencing contractor in Brisbane and, well, they both just liked the place. When the locals heard of his occupation they put his name forward for a gig with the mob controlling the fence, which had grown from its original three feet six inches high for rabbits to six feet above ground and a foot under the ground to keep out wild dogs as well.

'The first thing you have to know about the fence,' Al confides from his corner at the bar, 'is that it's not on the border. It's a chain inside Queensland.'

He reckons that when Queensland went to New South Wales in the 1880s and asked for help keeping the southern rabbits out of their state, the New South politicians didn't want to know and told them to do it themselves. So they did. Sticking it inside their own state so if the threat ever receded they'd have full control over pulling it down. Sixty years later karma raised its beautiful head when New South Wales went to Queensland and told them their wild dogs and dingoes were destroying the New South lambs. This time Queensland told New South to stick it where the sun don't shine. 'And there ain't many places like that around here.' They had no interest in keeping their wild dogs inside their boundaries and if it worried the southerners they'd graciously allow them into Queensland to upgrade the fence at their own expense.

So anyway, it's now in pretty good shape and Al reckons it, 'keeps out all pests except Victorians.' He looks serious but I think he's joking.

At the far end of the bar, past Graham's partner Carole, and locals Craig and Tony, sits the old bloke from the ute. Mac's about to turn 90 and he's been in Hungerford for the last 30 or so, ever since his ex-wife sold the family home without his knowledge, kept all the money but sent him an envelope with a gift voucher inside. So far Mac's not used it. It was for a coffin.

Mac's not in great health, the joints don't bend so well and the bones are no longer strong. He could do with a few more teeth over which to pour his favourite Bells whisky and his hands eloquently tell stories of a life spent working. He's one of those blokes who can fix stuff. For the past ever, if it's been broken in Hungerford, Mac'll fix it for you: irrigation stuff, tractors, washing machines, bicycles, window panes, oh and engines, any type of engine, anything mechanical. If it stopped for broke, Mac would get it going again, especially cars.

He also lives in Hungerford Heights, the only two-storey place town. Years back the post office up on the main street closed down so Mac and his mates surveyed it then stuck a whole load of poles into the ground back on Mac's plot.

They cut the post office off its foundations, rolled it around the corner then lifted it onto the poles. Mac camped beside it as he built the ground floor lounge, kitchen and bathroom underneath and after six months he moved into the duplex mansion.

I later ask Graham what the hell a frail old bloke, with his trouble just moving on a single level, is doing living in a two-storey place, and he just smiles.

'I reckon he figured that coupon might've been used before he got to this stage.'

But Mac's got it sorted. He sleeps upstairs and comes down just once each day and then back up just the once in the evening. On the fourth Thursday of every month, the Flying Doctor Service touches down on the all-weather strip just out of town and the doctors head for the medical centre next to the pub. In one morning they can check out Mac and everyone else in town, plus any who come in from off the surrounding properties.

'We get the very best doctors in Australia out here,' reckons Graham, 'every medical student in the country wants to have RFDS on their résumé and they fight like crazy to get accepted. Only the very best get a shot at treating us old blokes.'

Like the tops of many wooden ceilinged bush bars, this one is spotted with 5, 10, 20 and 50 dollar notes pinned to its lid, chucked up there by drinkers and by Graham himself on the other side of the bar. Every couple of months he takes them down and adds them to the contribution to the RFDS. Each harvest is around a grand for the outback's favourite cause.

By around 7pm, all the locals have gone back to their homes and Carole serves me up a whopping steak sanger 'n' chips for tea and then I head out to photograph two icons of the bush in one frame: the dingo fence and the

southern cross. The old pair are still on the seats outside. Still totally stuffed. I get some night shots of the pub and then hit the sack.

In the morning, after one of Carole's big breakfasts, I set off for Mac's place. When I headed out here I had a few ideas of what I'd be doing, the kinda people I'd be meeting and the things I'd be seeing. Included in amongst them wasn't having a 90-year-old bloke showing me over his 1925 T Model Ford, which he drove around town up until about four years ago.

He meets me at the door, standing with his walking frame which's got an old Globite school case on its seat. He makes me a brew and then we head out to check the beast. It's not running at the moment, an issue with the electrics, but we lift the bonnet and poke around a bit. There're three pedals for the driver. The left is to go forward, the middle for reverse and the other is the brake. The petrol tank's under the seat and there's no fuel pump, meaning that if you need to get up a steep hill, you have to turn around and reverse up, keeping the tank higher than the engine. Reverse never got used much in Hungerford.

This one has a starter engine but the crank at the front was used most of the time. Mac reckons he could get it going with an hour or so of tinkering but he wouldn't drive it coz 'it's never been registered and, well, things aren't quite as relaxed about that sort of stuff as they were back in the day.'

We go back inside to our brews and Mac opens his old Globite. It's an original, his own school case complete with internal wooden frame. It contains a jumble of photos, remnants and testaments to a life well lived. He digs out some shots of the T model, laden with kids and guests and visitors and tourists. 'It's brought a lot of fun that car.'

I head out back to the pub, thinking once again how amazing this country is, about how so very close beneath the surface are the hidden gems. Henry Lawson may've been right about the harshness and the flies, but his bitterness blinded him to beauties which he wasn't prepared to see.

Turning back toward the pub I almost hit a jogger. A female jogger!!! Huh? Turns out Lea's the local cop. Hungerford's the smallest town in Queensland with its own police station and the copper's after some photography tips. After going through a few basics, Lea tells me that these pointers should really help with her, 'forensic photos. You really don't want to see some of the things I have to photograph.'

Nah! Despite Henry's sage advice about the veracity of many of the claims made by the locals out here, I'm happy to take the uniform's word on this one.

Back at the pub, Graham's been up for hours. He's the postman, the rain-gauge checker and the river-level documenter. No rain's fallen in town but the river's rising almost to the top of the pipes and he reckons it'll cross the road in three days' time after big falls upstream. It sure isn't Lawson's, 'bridle track'.

The Paroo's just north of town, crossed by a causeway, not a bridge. The river's more an expanse of channels than a single flow and it's a full kilometre between the river signs on either side. No matter how dry the season, Graham assures me that it flows at least once every year. On a wall in the pub is a framed picture from the 1930s of a dray and a car crossing the flooded Paroo. To keep the car afloat, they're using a canoe. It's a great little piece and the canoe now lives on the fence at the northern end of the pub. (I ring the pub four days later and water's a full metre above the road surface.)

On the same wall is a photo of a thermometer with the mercury at 52°C. In 2013, after over a week of 45°C days, the celestial oven got serious and passed 50°C on two successive days. In the shade.

On the tar that day it measured 70°C on the only thermometer in town that'd go that high. Al swears that when the locals die they always ask to be buried with a jacket in case they go to Hell and it's cooler than they're used to.

I've not opened my wallet since I arrived. Everything's been put on the slate, so I settle the bill and head out. I open the gate and park slap in the middle of it and set the Garmin GPS. It puts me at S28 59.939, just a tick north of the 29th parallel, which is the border. Al was spot on about the fence being a chain inside Queensland. Here was a man whose word Henry could've trusted.

I push the bike forward so I can close the gate and Henry's in my head. If the outback had been some sort of liquor, some fermented concoction, he would've persevered, gone back for a second and a third swig, staying with it 'til he got the taste and learned to love it.

But you can't get drunk on the hardships of the bush, for it is a different elixir, and for once he was abstemious, oblivious to the intoxications that the outback had to offer. And in leaving as he did, so soon and so splenetic, he left a poorer man.

I head south knowing I'll be back. I'm not turning my back on the town or on the outback as Lawson so bitterly did. Because Henry Lawson was wrong. He talked of 'facing the bush' in some weird adversarial bent but the outback isn't like that. It's not something to be faced off, you don't stand up to the bush. You immerse yourself into it, let it surround you, and as you become part of it, it becomes part of you.

So I turned my back on nothing, just my front to somewhere else. And eased myself back into the glorious harsh desolation of the red earth which is the road to Wanaaring.

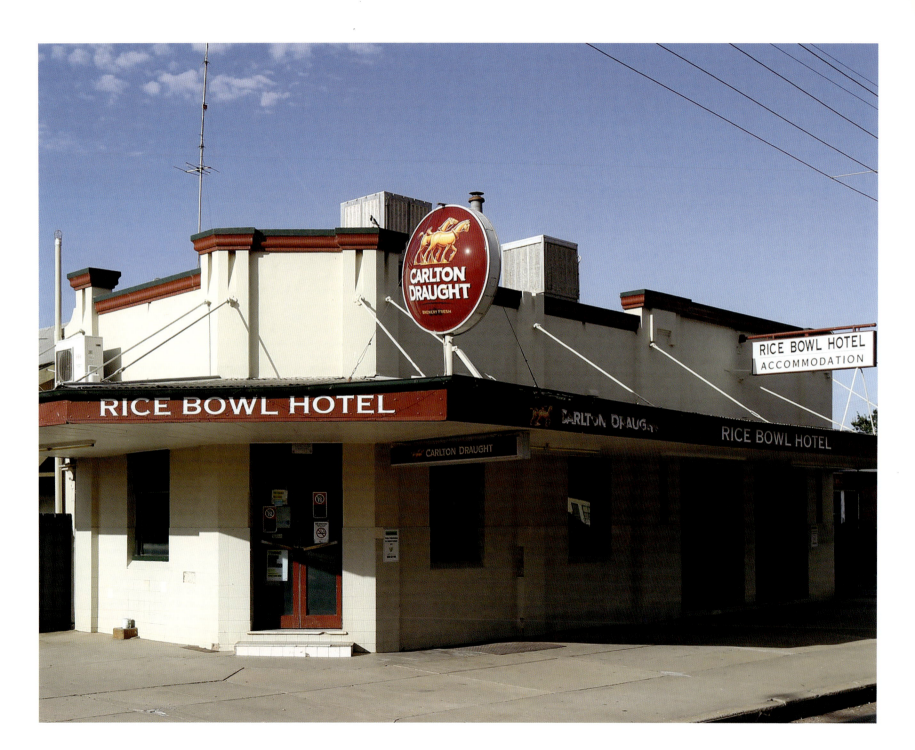

RICE BOWL HOTEL
WHITTON, NEW SOUTH WALES

You can say a lot of things about Henry Lawson's poetry and writing but when it came to drinking, the man who famously said that, 'beer makes you feel the way you ought to feel without beer', was an unadulterated amateur. And I mean that in the original meaning of, 'amateur'.

As anyone who spent school hours declining Latin nouns and conjugating its verbs, both irregular and regular, will be only too painfully aware, amo amas amat, amamus, amatus amant have given us, 'amorous', 'amiable' and, well, 'amateur', and their meanings all concern love. An amateur is a lover, and Henry Lawson was a sure lover of drink. It didn't love him back but it very seldom does.

In 1915 his love was getting a bit, well, dominating, and so Jules Archibald, his boss at *The Bulletin*, went to the New South Wales Premier William Holman with an idea. He convinced the politician to create a new job as publicity and media officer at the fledgling Murrumbidgee Irrigation Area in the Riverina and to give it to Henry Lawson. Oh, and to make the office at Leeton.

Leeton was the target because the surrounding area had been largely bought from Samuel McCaughey, a trailblazing farmer, grazier, politician and devout Presbyterian wowser and prohibitionist, who'd insisted the place remain free of pubs and wine saloons.

At least that's how traditional wisdom sees it. The truth seems cloudier than a good ale. There is no evidence that McCaughey attached such conditions to the sale of his land and I'm calling a lie on this 'fact'. Hours, days, weeks of research have failed to find any conditions attached to the sale of land by McCaughey to the government. McCaughey received neither a penny more nor less than any other landowner in the area.

In November 1913, an application was made to L.A.B. Wade, the Commissioner of the Water Conservation and Irrigation, for a conditional residential hotel licence by two businessmen from Ardlethan, Messrs Hollibone and Navin. The very day after receipt of their application, a response was drafted, 'I am directed by the Commissioner...to state...that the Commissioner regrets he cannot see his way to grant your request, at the present time.'

Two days later, on 17 November, on the letterhead of the Water Conservation and Irrigation Commission, Wade responded to a request seeking information whether he would be open to the idea of putting a referendum to the people regarding a 'hotel for the area'.

> *I do not propose granting permission for any person, during at least the next 12 months, to apply for a wholesale or retail license to sell spirituous liquors. The whole matter of the requirements of the settlement in this regard will be considered at the end of the next year—1914*

Now if Wade's hands had been tied, if there'd been some caveat or restraint on his power to grant such permissions, he would have said so. If Samuel McCaughey had sold his land subject to certain conditions, Wade would have quoted them and been off the hook. But he didn't. And this lack of resting back on a restrictive legal situation can only mean that it did not exist.

Years later in the 1920s, Robert Carter, a particularly tenacious bulldog of a lawyer represented several businessmen in their applications for liquor licences in Leeton.

This was someone who would've known every bit of the law and yet on 12 April 1921 when, after many exasperating encounters with the WCIT, he wrote to the Minister of Agriculture, he was unaware of any formal legal impediment, 'For some reason this Area was singled out as the only place within which a license under the *Liquor Act* could not be applied for.'

The claim that Leeton was dry due to restrictions or conditions placed by McCaughey on the sale of his land can only be pure myth. But whatever the reason, whether Wade was under the thumb of prominent temperance advocates, which seems likely, or it was his own doing, Leeton remained without a pub or wine saloon.

So Henry was shipped off there along with his er, 'housekeeper' and installed into a pretty little cottage beside an irrigation ditch. From day one, he bemoaned the unnatural and unhealthy lack of pubs. In his 'First Impression of Leeton', he railed that:

> We oughter have a pub. It would promote the healthiest kind of good-fellowship…a pub would make the town like a home to many. It would be a haven, and a refuge to many a weary, work-worn, married man caught in a dust storm on his way home.

Lawson later penned from his 'pulpit':

> (A)ll the things are here that are in most country towns—more; but lo and behold! The pub is not here, my brethren. And verily I say unto you that a Place is not natural without a Pub…There has always been a pub, ever since (and before it) a certain man went down from Jerusalem to Jericho…and I'll bet the 'priest' and the Levite who passed by on the other side were wowsers and prohibitionists.

All this didn't mean Leeton was totally devoid of drink. Robert Carter, in his letter quoted above went on to say:

> (the lack of a hotel in Leeton) does not mean that this is a prohibition area…the residents here consume as much liquor as in any other district but the liquor has to be purchased outside the district, to the enrichment of those who have no interest in the place.

Henry and a slab of mates soon had a workaround for the dryness of Leeton! Each Saturday morning a train would pull out of the town bound for either Narrandera or Whitton, both just outside the 'dry' zone. This 'drunks' train' would wait there until Sunday evening when it would return with its skint 'n' pissed cargo to Leeton, and Henry and his mates would endure another dry(ish) five days.

The poet wasn't too fond of Narrandera. He called it, 'an ungodly town just outside the area' and he claimed that the strongest opposition to 'our honest agitation for a decent pub' came from Narrandera's jar exporters of 'tangle-foot and smiling-juice.'

If the week's only train was headed that way, he probably would've just crossed the road from the station to the Star Hotel or gone down the main street to the Murrumbidgee Hotel. Both are still standing though the Star, a magnificent building, is currently a workers hostel and in need of TLC and a cash injection.

The Narrandera Railway Station is beautifully restored and worth a visit. The rights of railway travellers to a drink at station refreshment rooms dominated hours of parliamentary debate in the early 1900s, and you can see the windows through which they served the hooch to those in the station carpark.

But it's likely that whenever he could, Lawson headed instead to Whitton, which he preferred. Henry wrote of meeting a 'blanker' who'd just signed up for the army and was based in Hay. This fella had come down to Narrandera on a break, but he'd been shouted a '…raw and maybe doctored Australian 'port wine' (which had) done the business for him.'

Henry gave the recruit a recuperative hit from his flask and told him to head for Whitton where 'he'd have plenty of time…to go across the road to the hotel to get a good honest, long beer.'

The Whitton train station has been moved down to Gogeldrie Street and is part of the great little town museum. This is a top place and you'd have to be a pure bred fysigunkus to not be interested in some of the stuff they have in there. The original rail tracks have grown over, the passenger trains no longer come. Thirteen of the 14 pubs which existed back then are gone but the one that exists (again) will still give you one (or two) of Henry's famed 'good honest, long beers.'

The way I hear it, the previous publican thought that actually getting a licence was just unnecessary city-based red-tape bureaucracy and for some reason the cops kept busting him for illegal trade. They closed him down and the town was without a pub for nine months in 2009. The Rice Bowl Hotel at Whitton was saved by Colin and Cindy, two locals who watched in horror how their town fabric decayed when the pub was closed.

> There was nowhere for people to go. The parents went in to Leeton and the kids were left to make mischief around here. Crime went up and everyone started locking their doors for the first time. The place was coming apart at the seams.

Cindy was born and raised in this tiny town of 350 and had worked in the pub since she was 18. Colin is a recent blown-in of 20 years and together they

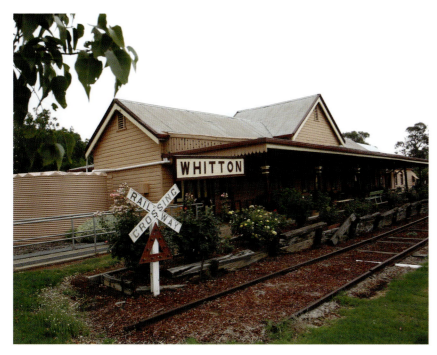

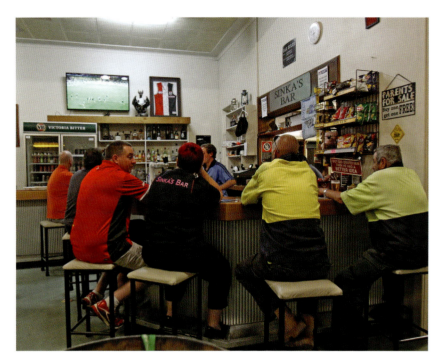
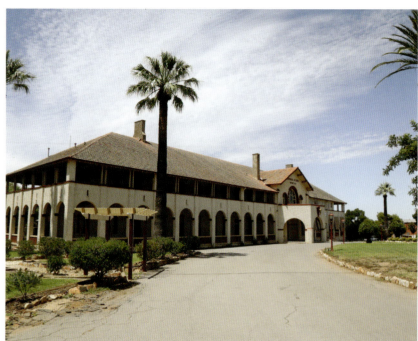
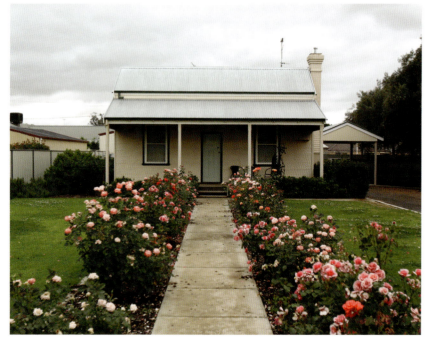

realised that the town needed the pub, it needed Lawson's 'refuge' and 'haven' for the 'work-worn' and for the traveller and visitor. With no pub management experience between them, with Colin working part time as a TAFE instructor and Cindy at the Bank in Leeton, they decided to do their best to save it.

And their best seems to be working. When I ask Colin how it's all going, he replies with a smile, 'It's still going!' Not yet able to pay full-time staff wages, they pretty much run it on their own with one local woman helping out and with the midday help from Colin's dad Max who 'pulls beers and yacks with his mates each lunchtime.'

And that's what this pub's all about. When I pull up, both Colin and Cindy are sitting my side of the bar chatting with a few locals in fluoro as Carole pulls the drinks. The pub doesn't serve meals, which would normally be a problem in a town without a general store or restaurant.

I'm as hungry as a black dog—lucky there's no rag dolls around. Some of the others are aching too. Cindy passes around a menu and we all order Chinese. She rings it through to the restaurant and then jumps in her car for the 50 kilometre round trip to Darlington Point to pick it up. There's no delivery charge. The grub's gone in moments but no, Cindy's not going back desserts!

A few other blokes drop in on the way home from work. Some sit around the bar, others in circles around the barrel tables. Laughter erupts regularly and glasses get refilled with honest beers. I know if the ghost of Henry Lawson came by, he'd raise a glass and say, 'I told you so, can you remember what I said? I told you a pub:

> ...would promote the healthiest kind of good-fellowship...a pub would make the town like a home to many. It would be a haven, and a refuge to many a weary, work-worn, married man caught in a dust storm on his way home.'

I raise my honest beer and think, 'he knew his stuff that Henry!'

PS: Henry's plea for pubs in Leeton for social reasons failed but finally financial pressures, the flow of money out of the town to the pubs and sly grog shops of Whitton and Narrandera, plus the cost to maintaining the government's Hydro Hotel, brought results. Money once again spoke louder than social need.

The Hydro was the first to be licensed and in 1937 the Wade Hotel, named after the man who for so long had refused to allow pubs in this town, designed by Walter Burley Griffin, was opened in the middle of the main strip. Down the road a bit and around a few corners, on the plinth beneath a statue of Sir Sam McCaughey is a plaque. It makes no mention of prohibition or liquor, but at the very bottom is the single word family motto in Latin: '*Viet*' (I conquer).

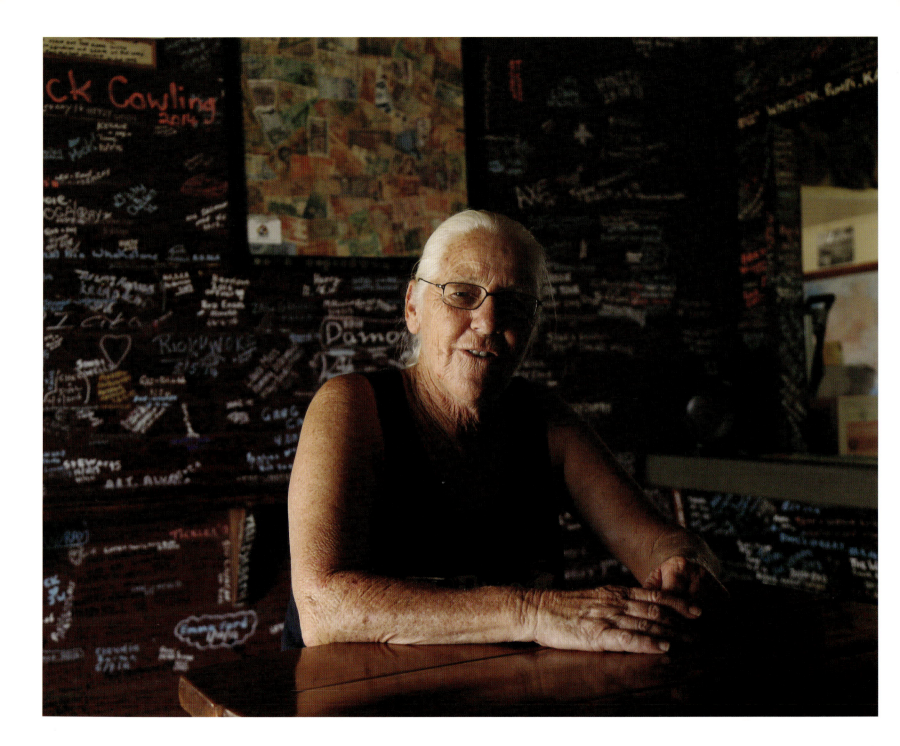

BLUE HEELER HOTEL

KYNUNA, QUEENSLAND

If Waltzing Matilda is the poem, the song, the anthem most central to the Australian psyche, and for my money it is, then Kynuna, 1500 kilometres north-west of Brisbane is the place most central to poem.

Twenty kilometres east of the town is the Combo Waterhole, and not much further to the west is Dagworth Station. In August 1894, with the Great Shearers' strike beginning to weaken, Bob Macpherson, manager of Dagworth Station, announced that he would not employ unionist labour and that he would be shearing his flock of 80,000 with scab workers on 3 September.

On 1 September a group of strikers set up a camp in a dry channel of the Diamantina about ten miles distant to Dagworth. That night, overcast and moonless, they crept towards the Station and its woolshed. Inside were 140 lambs, brought in to avoid wetting from the threatening rain so shearing could start on schedule.

In the sheds nearby Bob Macpherson, his sons, his employees and a single policeman, slept with their rifles loaded beside their beds. The shearers too were heavily armed with rifles, guns and kerosene. On a signal, the unionists began firing, the sleepers awoke and returned fire. Over 100 shots were fired, every one of them missing, but the shearers managed to spread kerosene on the upwind side of the shed, and it was red steered. The raiders withdrew to their camp.

The next morning Macpherson formed a posse with three local troopers and they tracked the strikers to the Combo Waterhole, a billabong on the Diamantina surrounded by coolibah trees. What exactly happened next isn't ever going to be known but some details are.

The shearers' attack party had two leaders, Samuel Hoffmeister and John Tierney, both seasoned agitators and organisers. Sometime around the arrival of Macpherson and the troopers three, Samuel Hoffmeister, a German who was known as, 'Frenchy' was killed, shot through the mouth.

He'd been in good spirits. His team had just torched a scab-employing pastoralist's wool shed, and despite fierce gunfire, all had returned unscathed. It'd been a good day's work.

Macpherson and the troopers, one, two and three, all later claimed that 'Frenchy' had been dead when they arrived. On 4 September, the *Brisbane Courier* ran coverage of the incident:

> *A man named Hoffmeister, a prominent unionist, was found dead about two miles from Kynuna. The local impression is that he was one of the attacking mob at Dagworth and was wounded there. There were seven unionists with Hoffmeister when he died. These assert that he committed suicide.*

It was clear to all that these men had played a part in the torching of Dagworth but only five of the seven were arrested. John Tierney, known to be a leader, a ringleader, was not amongst those detained. At the hastily convened inquest, all five strikers supported the police version that Hoffmeister had committed suicide and soon after, all five were released from custody without charge.

On the morning after the battle, Bob Macpherson told the police that he had recognised John Tierney's voice shouting instructions and Tierney was arrested on 13 September up in Hughenden. His charge sheet read:

> *On the morning of September 2nd...(the offender)...set fire to a woolshed at Dagworth...(and)...was a leader of a number of men by whom the Dagworth woolshed was burned, and several shots were fired...with the intent to murder. But suddenly, just as the compliant shearers in Kynuna had been released, the police chose not to proceed and Macpherson changed his tune and claimed he could no longer identify Tierney's voice.*

Every shearer who testified at the inquest and who backed up the police claim that Hoffmeister had died by his own hand, was rewarded with the dismissal of charges against him.

By the time Banjo Paterson arrived at Dagworth Station in late 1895, the Shearers' War was over. The solidarity of the pastoralists with the armed backing of the government had strangled and crushed the union. The battle at Dagworth Station was to be the last armed battle between Australians and it was the last major battle before the strike ended, although ill feeling and distrust continued between the camps. Then one evening, possibly soon after writing his first version of Waltzing Matilda, Paterson and Macpherson went to the Kynuna Hotel with the rest of the Macpherson clan and other visitors.

The made themselves comfortable in the dining room at the eastern end of the building whilst a group of unionist shearers drank in the bar. It had been a good season, the sheep were back and feeding on the growth from good rains.

Paterson wrote, '…there was grass everywhere, beautiful blue grass and Mitchell grass with sheep all fat and the buyers all busy.'

The Macpherson clan would've been in a relaxed and cheerful frame. Between the two rooms was, and is, a wall with a guillotine window. The Macphersons were drinking champagne and Bob passed some through the window to the shearers in the bar. The poisonous atmosphere was washed away in a bubbly tide.

Banjo wrote a piece entitled, 'Golden Water'. It was about artesian flows and the profound effect the countless bores were having on fortunes out this way. 'The districts around Longreach and Winton were inhabited by squatter kings who made royal progresses to each other's stations…'

But toward the end of this yarn he switches to another golden fluid and his night at the Blue Heeler Hotel. '…I have seen the Macphersons handing out champagne through a pub window to these very shearers (who burnt down the woolshed).'

The Kynuna Hotel changed its name to The Blue Heeler 'sometime in the sixties,' according to Pat who now runs the place with her husband.

On a searing morning with a burning crosswind I ride in from Julia Creek. The four-strand roadside fences are clogged with driven tumbleweed. A massive trailer is pulled over with one of its 80 tyres punctured. The escorting cop hopes I have a lot of water.

The Blue Heeler doesn't open 'til 11 and I'm early. A breakfast at the roadhouse up the hill and then down to the pub where a magpie decides to have a serious go. The swooping gets so bad I do the external photos with my motorcycle lid on and then sit on the porch for 20 minutes with the bloody thing eyeing me from the dirt.

Pat opens up right on 11 and she's wearing, okay, I'm not going to say it's the exact same singlet she was in three years ago, the last time I was here, but it could be, or it might just be an identical replacement. Her white hair's plaited in a long ponytail and as she talks it's obvious her words are as measured as her thoughts.

The country's too dry to waste water and time's too precious to waste words out here. She pours me a chilled water without me needing to ask and then enquires where I've been since last time, where I spent last night and when will I be home. She asks as many questions as she gives answers to mine. She knows the history of the place, the story of the room, the myths of the hole in the wall and the story of the Battle of Dagworth.

We talk about how the wild dogs have decimated the sheep: one station down the road now runs 3000 after once having 20,000, all down to the dogs. Later when I photograph the turn-off to the old Landsborough Highway, four dog carcasses hang from the sign.

She warns me that the Bidvest bloke is on this way this morning and he's an ear chewer so if he turns up she'll have to give him some air time.

We talk about the guillotine window and her friendship with the late Richard Macoffin, whom she met when she ran the roadhouse up the hill, and she brings out a photo of the pub in the 1880s.

The food delivery bloke turns up so Pat's off out the back to accept the stuff and listen to the driver's stories. Before she goes she refills my water glass. While she's at it, can she pull me a schooner of lite to wash down the bacon and egg sanger from the roadhouse. I probably should have a champagne, get her to pass it to me through the window, but it's early and besides there's no bubbly by the glass. And anyway, a bottle in the morning should only be consumed in bed with your lover and two parts of my trifecta are a long way away.

The main bar has graffiti walls where, for a five-buck donation to the RFDS, today's pale descendants of the explorers can texta their names on the equivalent of a dig tree.

This pub's been a popular stopping off place for tourists and truckers for

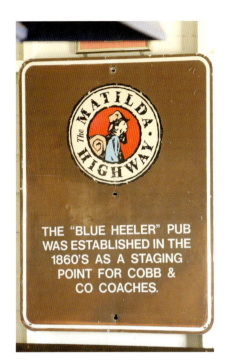

a damn long time. A bit later I catch up with Dave who used to bring road trains through here in the eighties. He's the same guy I quote in the bit about the Barringun Pub at the front of this book.

In the late-eighties the road out here was dirt, grey dirt; impenetrable dust when dry, impassable mud when wet. One time Dave and his mate came through from Winton. It'd been a hard slog and they needed a break. Dave headed for the phone box beside the pub and his mate turned on the tap and brought the hose around.

> My mate got the hose up to its highest pressure and got close to the phone box and started spraying the glass as hard as he could. I rang the boss back in Condo and shouted down the line, 'Mate it's absolutely pissing down here. I think we're marooned for a couple of days.' He said, ' No need to convince me! I can fucking hear it!' So we had the leave pass and stayed at the pub for a couple of days. When we got back the boss was real impressed how we'd cleaned all the mud of the truck!

Anyway, I stand at the window in the bar and look through to the dining room and then go through and look back. I'm the only one here, alone with the ghosts. The silence is perfect. The magpie outside is singing some sort of victory song. I try to imagine where Banjo Paterson was when he saw the champagne go through the window. Were the glasses poured or was it still bottled? If so, was it opened or did the shearers pop the corks?

I've read somewhere that Hoffmeister had his last drink at the Kynuna Hotel and I wonder where in the bar he sat, or did he stand? Was he suicidal or was he in good spirits? But these are the least of my wonderings.

Whilst at Dagworth Station, Paterson had been told the story of the woolshed fire and the death of 'Frenchy' Hoffmeister, and of the three troopers. He'd been to the Combo Waterhole and seen its beauty and its coolibah trees. He'd also met Jack Carter, a farm overseer, one evening at dinner. Bob Macpherson asked Carter what he'd been doing that day and Carter replied that he'd seen, 'a bagman waltzing matilda down along the river.' It was the first time Paterson had heard this phrase. Over three decades later in 'Golden Water' Paterson recalled:

> Miss MacPherson, afterwards wife of the financial magnate, J. M'Call MacCowan, used to play a little Scottish tune on a zither and I put words to the tune and called it, 'Waltzing Matilda'. Not a very great literary achievement, perhaps, but it has been sung in many parts of the world.

Banjo Paterson failed to mention that his contact with Christina Macpherson, Bob's sister, would spell the end of his engagement to Sarah Riley. But he now had his swagman and his squatter, his billabong and his coolibah trees. And he had his troopers, one two three, and of course he had his matilda ready to be waltzed.

Banjo Paterson never explained whether the death of Hoffmeister informed his image of the swagman or whether Bob Macpherson was the model for the 'squatter'. He never revealed if the three police who may indeed have killed Hoffmeister and covered it up through collusion with the other striking shearers, were the inspiration for his three troopers.

But sometimes it's better to have loose ends than a knot. Sometimes wondering and wandering are equally pleasant. I say 'Seeya' and 'Thanks' to Pat and head outside.

The magpie's been waiting as I've been forgetting and its wing brushes my ear and shoulder. I jam on my helmet and as it comes in for a second pass I head butt it. The bird squawks and retreats to its gum tree. I just hope it doesn't have mates in any coolibah tree beside the billabong up where I might end up camping tonight.

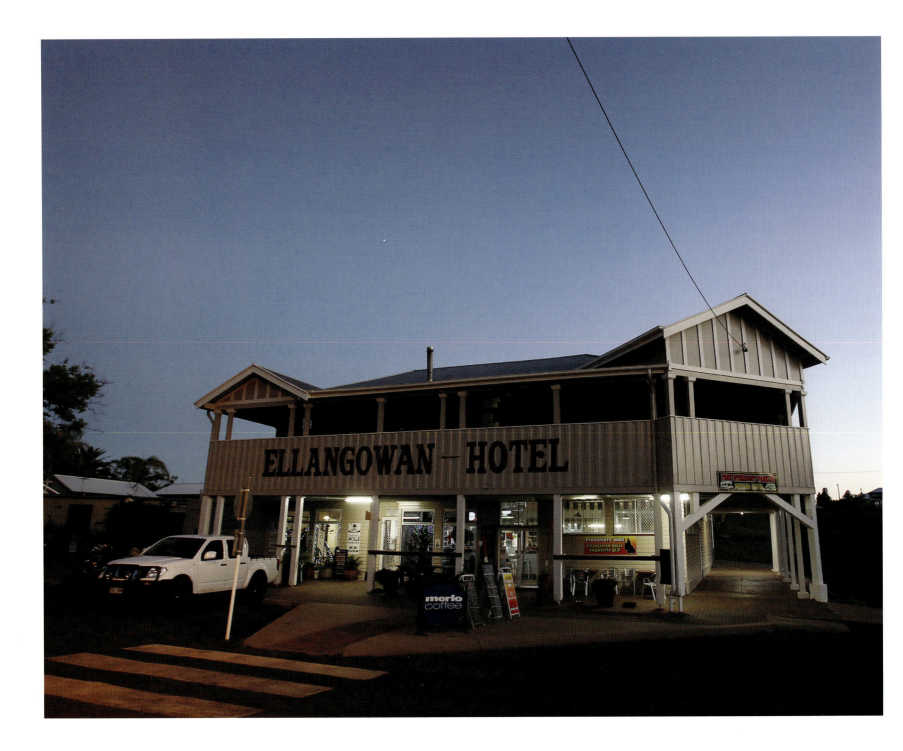

ELLANGOWAN HOTEL
AUGATHELLA, QUEENSLAND

Like a select few world-leading centres of arts and learning, Augathella in Queensland has had more than one name change in its history.

The Big Apple started out as New Amsterdam and then switched to New Orange before it became New York City. Walt Whitman wrote of New York:

> There is no place like it, no place with an atom of its glory, pride, and exultancy. It lays its hand upon a man's bowels; he grows drunk with ecstasy; he grows young and full of glory, he feels that he can never die.

In 330 AD Byzantium was renamed Constantinople and stayed that way for 1600 years before becoming Istanbul, the only city to sit astride two continents. Fatih Sultan Mehmet said of this city, once the second largest in the world, 'Istanbul is a magical seal which unites Europe and Asia since the ancient times. Without a doubt, Istanbul is certainly the most beautiful place of the world.'

When I grew up India had a place called, Bombay. Today it's Mumbai but before both it was first Mumba and then Boa Baia.

Meanwhile up in Queensland between Morven and Tambo, the tiny new township of Burenda soon had its name changed to Ellangowan before being gazetted in 1863 and adopting its current moniker of Augathella.

So what did some learned person have to say about the Aussie town in league with the bastion cities of taste, class, culture and intellectualism? Well in 1875 *The Darling Downs Gazette* gushed that this shearing town was:

> ...a disgrace to civilization...Burenda is the prolific source of crime, outrage, suicide, 'accidental poisonings', sudden deaths, delirium, and poetic flights of imagination committed to paper never surpassed out of bedlam, if ever equaled within its walls.

Oops! Can we get a second opinion?

The January year before *The Brisbane Courier* in its wrap of country New Year's celebrations advised its readers that big brother Charleville was not the place for a knees-up to bring in the New Year:

> Christmas at Charleville is kept neither very religiously as a festival nor very jollily as a holiday. Of public worship there was none, and public houses fared but little better...however, what was lacking in Charleville was amply compensated for at Burenda, where, I am credibly informed, not a single man was sober. In fact, nothing was wanting to make a Christian festival of the nineteenth century a frightful Saturnalia of pagan Rome.

Later in 1874 the Brisbane *Queenslander* noted, '(evidence of) a disgraceful state of things in the public-houses at Burenda; there is no place in the colony that more requires additional police protection...'

So it seemed the jury was in: Burenda was neither a seat of learning nor a temple of temperance and things were to get worse before they got better. When the town changed names the first time, the local sheep station kept the Burenda. When it changed the second time, the pub kept the Ellangowan and it was the Ellangowan Hotel which took a central role in what became known as the 'Burenda Tragedy'. *The Brisbane Courier* of 12 February 1874 set the scene:

> At Burenda township, ten miles from the station, a race programme... had been arranged for the 28th December; and a motley crew of shearers, washers, shepherds, &c., from the stations round had gathered (at the Ellangowan Pub) in anticipation of a 'big drunk... (and) up to three o'clock in the afternoon 'all hands and the cook' were deeply engaged in the more congenial pleasures o, 'lushing', 'scrapping', and 'gaffing'. [i.e. drinking, fighting, and gambling]

> *A move was made to the race-course by those who were able to move about 3 o'clock in the afternoon, and the (the races) ran off amid scenes of drunkenness and bestiality sickening in their details—a living disgrace to any civilised community of white men.*

The partying didn't stop when the horses did but kept going for days. A lot of the stuff they were drinking was, well, improvised, and one bloke later testified that

> *He took two nobblers of Cavanagh's grog early on the morning of the race day and remembered nothing more till the evening of the 31st, when he found himself in bed with his clothes on, in a back room at Cavanagh's public-house, and all his money gone.*

'Cavanagh's' was the Ellangowan, and once this bloke, Larkin, had woken, he and some mates had a 'final carouse' to celebrate the new year and then the next morning five of them decided to head out to Nive Station. They'd spent their remaining funds on some bottles of something, which may've been brandy, may've been rum, but which definitely contained tobacco. It wasn't a smart move. Three of the men died and Larkin only survived by slitting his puppy's throat and drinking the blood.

Neither survivor reached Nive but, guided by the barking of dogs, crawled into Burenda Woolshed where the staff immediately sent out search parties for the others. They found two bodies, three dead dogs and a dying man. Popular blame for the deaths was poured onto Michael Cavanagh at the Ellangowan Hotel, and the adulterated juices that he allegedly sold.

At the inquest and in the press, Cavanagh defended himself testifying that the liquor was genuine and sealed, 'either Hennessey's or Martell's' and blamed the 'Burenda Tragedy' on heavy swags, the heat and lack of water. The publican claimed the men were 'perfectly sober' when they left the township and he begged to have it known that, '(he had) never been charged with selling poisonous liquors, nor ha(d) any man's death been previously laid at (his) door.'

The fact that Michael Cavanagh survived any retribution and that his pub was not red steered has to be testament to the belief of the locals that he was innocent, or maybe just recognition of their pragmatism that this was the only pub for miles and bad grog was better than no grog at all.

Now a still existing pub with a story like that, in a town with an old reputation like that, and a nearby sheep station with such a history, would be more than enough to get my wheels into action. But it's not even close to the whole story of Augathella and its pub, and the other strands make the place an absolute magnet for a solivagant obsessed with history, pubs and myths and stories.

Because in contrast to Gundagai, Augathella is a town that can handle shit. Like the place itself, Augathella's place in the poetic pantheon has had a number of name changes. The song now mostly known as, 'Brisbane Ladies', has also gone by 'Augathella Station', 'Ladies of Brisbane', and 'Farewell to the Ladies of Brisbane'. The song's history is so long and convoluted that Ron Edwards, the greatest expert on Australian folklore, wrote a 53-page book about it. There's any number of versions of the words but what's certain is that the tune is from an old sea shanty, 'We'll Rant and We'll Roar' and that the chorus goes thus:

> *We'll rant and we'll roar like true Queensland drovers*
> *We'll rant and we'll roar as onward we push*
> *Until we return to the Augathella station*
> *Oh, it's flamin' dry goin' through the old Queensland bush.*

The most accepted Aussie lyrics were written by Saul Mendelsohn in 1891 and in the Augathella Park across the road from the pub, just in front of the giant meat ant, the council has constructed a display of the story of the town including the full 'Brisbane Ladies'. (I'm assuming no one needs me to explain that the 'ladies' were 'ladies of the night', 'working girls'.)

Now if Augathella were down south, and the city fathers more, er delicate, the fourth verse would've no doubt been sanitised, but up here, in this 'disgrace to civilisation', there's scant time for such concerns and it's printed in all its original glory:

> *Then on to Nanango, that hard-bitten township*
> *Where the out-of-work station-hands shit in the dust,*
> *Where the shearers get shorn by old Tim, the contractor*
> *Oh, I wouldn't go near there, but I flaming well must!*

I took the final verse to be an invitation not to be refused:

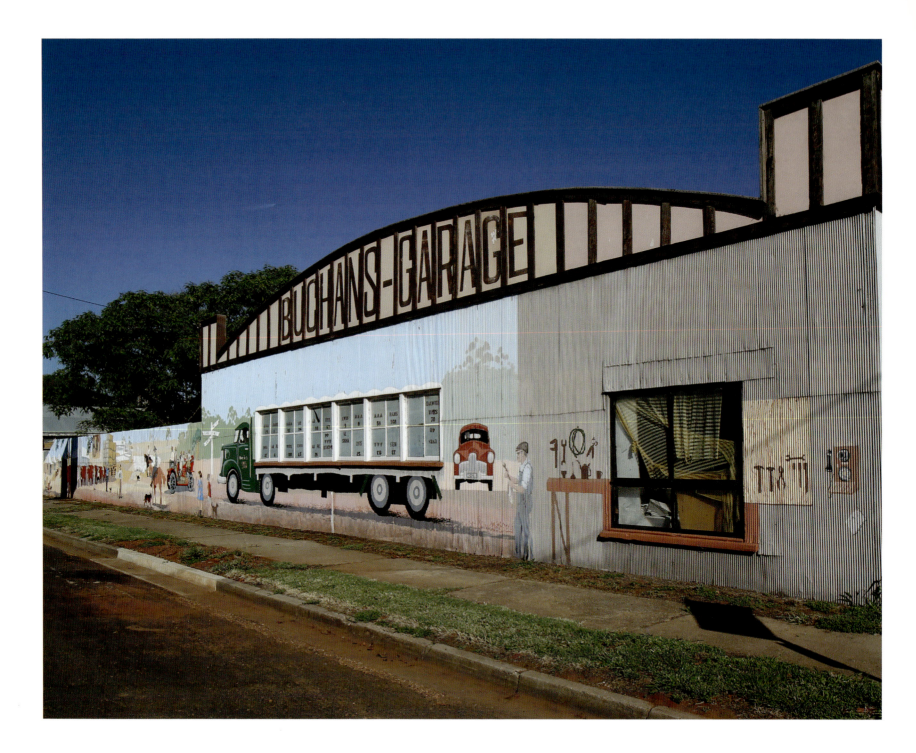

> *Then fill up your glasses, and drink to the lasses,*
> *We'll drink this town dry, then farewell to them all*
> *And when we've got back to the Augathella Station,*
> *We hope you'll come by there and pay us a call.*
> *So in early 2013 I headed out there to check out the pub, the racecourse, the old Burenda Woolshed and of course the current 'motley crew of shearers, washers, shepherds, &c.'*

Augathella is about a kay off the Landsborough Highway between Morven and Tambo and when the pub's quiet the town's quiet too. This late arvo it's all quiet. I get a room upstairs that opens onto the balcony, dump the riding gear and head back to the bar. The publican knows where the racecourse is but can't help with the sheep station. 'You really need to hang around in the morning and ask the Tree of Knowledge.'

Around every morning a bit after nine, a bunch of local blokes gathers on the seats downstairs to chat 'n' yarn, tell stories and swap memories and they'll know for sure the answers to anything I need to know. 'And if they don't, they'll sound very bloody convincing!'

So I head out for a wander. Check out the Warrego River which is nothing more than a string of greasy green waterholes, with mosquitoes bigger than packhorses, more persistent than a Jehovah Witness at the front door, and more annoying than a bloke who won't shout.

They reckon the Aboriginal name for this river translates as, 'river of sand' and here, less than 200 kilometres from its source at Mt Ka Ka Mundi to the north-east, its pools aren't fit for cattle, and to describe towns like Charleville, Cunnamulla and Fords Bridge as being 'downstream' would be to misleadingly infer some sort of flow. Oh yes, it sure is flamin' dry goin' through (this part of) the old Queensland bush.

I grab a parmy and a couple of beers for dinner and turn in early. A massive squadron of corellas signals the end of the day

Next morning after a brew on the balcony I head down for some early shots of the racecourse and then back to wait for the locals to turn up. This is cutting into the very DNA of Australian pubs, dancing within the double helix: locals and travellers getting together to share times and tales, of keeping up to date with news, exchanging gossip, and most of all, making each other laugh and chuckle.

Around 9.30 Joe turns up. He's an old shearer and shearing contractor who's lived his entire life in Augathella, started at the school when he was five and at the pub not too much after that. The first publican he can remember is Mary Cavanagh, probably Michael's daughter or maybe daughter-in-law, and how she had a disabled son, Colin, and how she managed it on her own after her husband died in the early fifties.

He remembers Mary selling out to the brewery and moving to Brisbane, but not liking the life there, and trying to buy the pub back but the brewery refusing. In 1959 Joe's mum took him to Brisbane for a while and they lived around the corner from Mary in Sandgate. He even remembers the street names, which I check later, and he's spot on.

Keith turns up and Joe does the introductions. Keith's a massive, obese bloke who eases himself down and joins the chat. Joe mentions I'm interested in Burenda (pronounced, 'Brenda' out here) and Keith tells me to hang around a bit and it'll be sorted. They remember the old blackboards on the side wall of the pub, where the weekend's footy teams would be listed each Thursday night of winter, and the cricket teams in summer. And they talk of how good the veges used to be when the Chinese down at Yo Yo Creek 'which always used to flow in them days,' had their market gardens.

Joe talks of one of the Chinese women who had a shop in the town but who had a cancer across the top of her nose.

> *No doctor could fix it, it was eating her flesh. So everyday she'd cover her face with this big wrap but at night would cover the cancer with raw meat and the cancer would eat this and not her face. I dunno how much meat it ate each night but I do know she lived for years like that. It really did save her.*

A ute cruises down past us and Keith butts in. 'That's Dan from Burenda. He'll be heading for the CRT. Go and catch him and he'll fix you up about that woolshed. We told you we'd sort it.'

I leave them to it and head down the street. Of course I can go have a look around. The original shed is long gone and there's not much at the new one now. Just close the gates and mind the horses. Dan gives me the directions and distances, which later prove correct to the metre, and I leave him to his business and head back to the Tree of Knowledge.

A couple of other blokes have turned up but time's moving and I have to get my arse into gear so I say my thanks and farewells and head east for the woolshed. It proves to be a beautiful building in a beautiful spot. The horses barely acknowledge me and the eloquence of the silence within begs, and

receives my reverence. The smell of the lanolin, the shards of light piercing through holes in the corrugated iron, the remnants of the last shear. The best woolsheds have the aura of cathedrals, of shrines, or temples, and this is one of the best.

Three years later I'm back at the Ellangowan at Augathella after a ride down from Isisford. Brett and Sharyon are now managing the place. They've made some changes. The old dining room's been turned into a cafe and it's now open from 8am. It's become the meeting place for tradies and mums after school drop-offs. There're pool comps and hookey, games and general fun.

Tonight's Sunday night—pool comp with a $200 first prize. I get eliminated in the first round and then the peaceful evening is shattered when the local lads turn up, fresh from a day of charity golf and uncharitable drinking. It's a loud crowd of young blokes and a couple of far more sensible young women. The boys all play for the Augathella Meat Ants, the local rugby league team, and they've all had a good day.

A couple start betting on the computerised horse racing while the others drink outside. There's some misunderstanding in the bar and a couple of them start wrestling and facing up. Brett closes the bar and orders them all out. The rumble continues for a bit on the footpath, the two women trying to separate the brawlers.

I think of those 142-year-old words of the *Brisbane Courier,* '"all hands and the cook" were deeply engaged in the more congenial pleasures of "lushing", "scrapping", and "gaffing" and realise one more time how little things change.

Next morning Brett tells me it's only the second bit of ugly that he's had in the nine months he's had the place and I tell him if that's as bad as it gets, he's on a pretty good wicket.

I go for a walk through the beautiful five-buck-a-night council camping ground to the levy bank, and the river of sand is just that. There's been good rains but there's scant evidence here, just a few dank, algae-covered pools and a brown snake waiting for frogs.

When I get back Joe's already turned up and we talk about the river. When he was shearing there was a regular flow. And some good fishing.

When we were shearing on the Warrego or any river really, we'd use our day off on Sunday to go fishing. Each day we were shearing the cook'd kill a sheep or sometimes two if we were a big group and we'd keep the heads. On the Friday or the Saturday we'd chuck the heads into the river, try to find a pool without any flow like. The fish would come and eat the meat out of the heads and they'd still be there on Sunday when we'd throw in our lines and whammo, we'd catch all we wanted in a couple of hours.

But if the river was flowing too fast, and this used to happen a bit back then, we'd tie the heads to a bit of string. We'd also use any carp we caught the week before. We'd cut them open, expose the flesh like, and then suspend them about a foot, maybe 18 inches above the water. The flies would swarm onto them and the maggots would keep falling off and into the water. You'd get there on the Sunday and you'd see a mass of fish just hanging around waiting for the grubs to fall. We'd chuck in our lines and have dinner on the first pull.

The rest of the Tree of Knowledge know Joe as, 'Mad Dog'. Everyone here has a nickname and as he's talking Heifer and Buffalo Bill turn up. Heifer is one solid unit. Probably in his late-fifties now, maybe sixties, he's a tank on legs, an ex-shearer who spent a long time working for Mad Dog. 'In the seventies and eighties there were over 20 shearers living in Augathella and we had some really good nights at this pub.'

One night back then secured Heifer's place forever in the folklore of this pub. It was a very busy night and the shearers were drinking upstairs when a stink broke out downstairs and the cops arrived. As they were trying to sort things out the blokes on the balcony leant over to see what was happening. Heifer, who was as full as the last bus, fell through the railing and landed on his back.

As he was laying there trying to work out if anything was broken one of the police shone a torch in his face and asked what was going on. 'Why the fuck are you askin' me? You know I just dropped in.'

The time eases past ten and Buffalo Bill is into the bar for his heartstarter as Joe tells me that big Keith died in his home last year. 'They had to break down part of a wall to get him out.'

A ute pulls up and the fella needs some advice on his chainsaw that won't start. Joe tells him to bring it around and he'll have a look but he's already pretty sure it's a fuel problem.

Kerry turns up with his blue heeler puppy, given to him by a breeder because it showed zero potential as a worker. I wonder whether he thought that'd give dog and master something in common from the start, but I keep

it unsaid. Kerry's honoured it with the name, 'shitfa' as in 'brains' and I hope that doesn't scar the pup for life.

Heifer tells me he's buggered from all the years shearing. 'Only cane cutting's harder on your body,' but that he's glad he cut out before harnesses came in. 'These young blokes who use harnesses are now all getting cancer from the rubbing on the breast. Same with women, it's their bras that cause all the breast cancer.'

The tales and the stories, the 'poetic flights of imagination' and the laughter meander on, flowing like the Warrego in its prime, but once again these blokes have outlasted me and I have to get moving.

I'd come in search of a 'disgrace to civilization', with a pub which was equally in 'a disgraceful state.' But I found no Saturnalia, no town where no man was sober. Instead I found a hotel which was the essence of a bush pub: the centre of the community where friends meet up to pass the time and to catch up on the news, where the youngsters can still 'rant and roar' and where any morning you can find a bunch of blokes who'll be only too ready to give you medical advice, social counselling, mechanical diagnosis or just entertainment with their absolutely true stories of times gone but not forgotten.

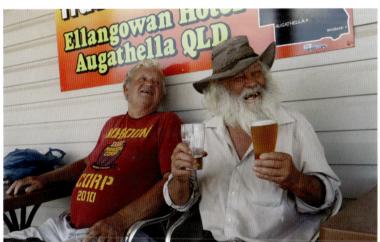

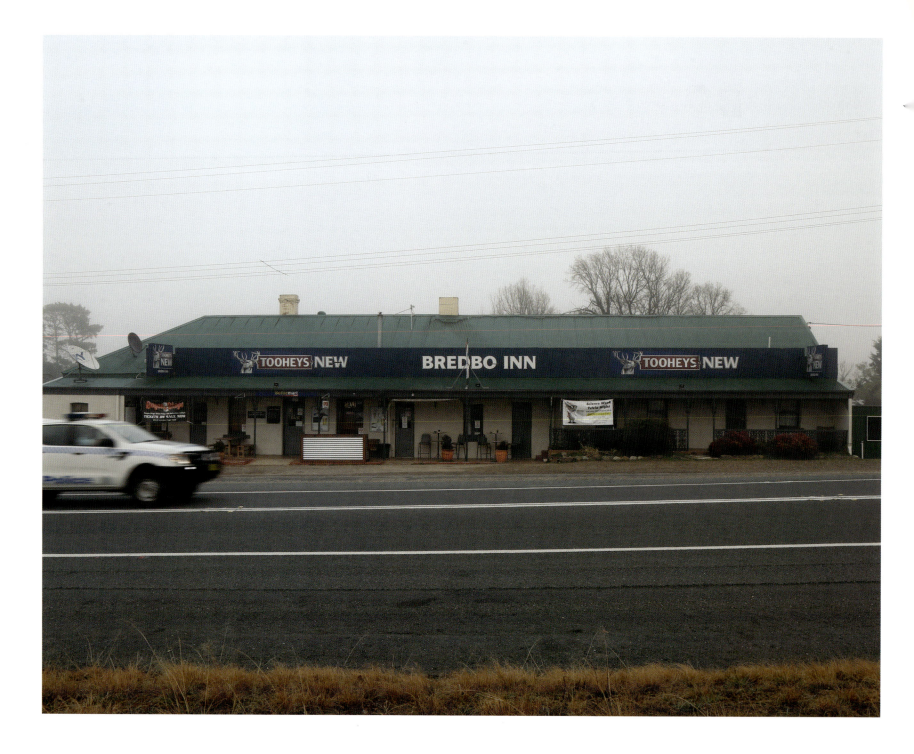

BREDBO HOTEL
BREDBO, NEW SOUTH WALES

When you head west from the Snowy River, out through Crackenback and then twist north to Khancoban before swinging west again down out of the Alps, you cross the Upper Murray, the aorta of Eastern Australia and you are in Victoria.

Here at the crossing bridge, the road morphs from the Alpine Way to the Murray Valley Highway. Follow it for seven kilometres then left at the T and you're on the outskirts of Corryong. The town is heralded by a silhouette of a bloke with a whip, on a horse.

Keep heading and on your right you'll find the Tourist Info Office beside a statue of a similar bloke on a horse, this time with the whip furled. Go into the office and you'll likely be given a map to the town cemetery where you can find the grave of a bloke who used to ride horses.

They're all the same person and his name was Jack Riley. The people in the town seem to honestly and earnestly believe that Jack Riley was the model for Banjo Paterson's Man from Snowy River and they have built the town's economy around the claim.

Bowen has its Big Mango, Coffs Harbour has its Big Banana, Grong Grong almost had its Big Neenish Tart (and still should!), Koonoomoo has its Big Strawberry and Ballina's got the Big Prawn. Corryong, instead, has its Big Myth.

Claiming to be the inspiration for The Man was a full-on growth industry and there were any number of riders and high plains drifters pretending they were Paterson's model. Prime Minister Billy Hughes recalled a campaign rally in Bombala New South Wales where he was introduced by the local member to, 'Banjo Paterson's man in the flesh.' In his memoirs, Hughes wrote:

> *I beckoned to my friends to gather round and presented each of them to 'The Man from Snowy River'. In less than no time they all insisted on shouting for him...(h)e not only looked the part but acted on it to perfection, drinking all that was offered to him.*

In the middle of the drinking, another bloke, Frank, whom Hughes knew turned up with a mate, 'a big man with a dark beard'. 'Let me,' said Frank, 'introduce you to Banjo Paterson's "Man from Snowy River".'

Billy Hughes demurred, pointing to the bloke he'd met a few minutes and more than a few drinks before, 'No, no you're wrong, Frank. This is the "Man from Snowy River".'

> *Frank's nominee...wasted no time in attempting to straighten things out by talk...and launched himself against the red-headed imposter... The two fought furiously...until a lucky swing caught (the original claimant) on the point of the chin.*

So claiming to be 'The Man' was so common that two blokes in the same bar on the south coast of New South Wales were milking drinks off it. Sheesh! They must've been more common that SP bookies who kept one to a pub!

Banjo Paterson always maintained 'The Man' was an amalgam of people he'd met and certainly not one specific person. In the late 1880s Banjo met Jack Riley out in the Snowy Mountains in the horseman's hut at Tom Groggin. Jack Riley was nothing like the 'stripling' mentioned in the poem but that didn't stop him joining the ranks of the great impersonators and claiming later that he was the true model for Paterson's 'Man'.

And in days long before the concept of 'fake news' and 'alternative facts', the town of Corryong, longtime home of Riley, climbed on board and embraced the myth as truth. Apart from Riley's physical stature being all wrong, there are many other issues that point to him not being the model and the biggest is a bloke called Charlie McKeahnie

Charlie Mac was born in 1868 near Queanbeyan and moved with his family to Adaminaby when he was five. He grew to be a formidable horseman and in 1891 Barcroft Henry Boake wrote a poem, published in *The*

Bulletin, that we can be certain is about Charlie. It details a wild chase made by Charlie Mac in 1885:

> *As through the tall tussocks rode young Charlie Mac.*
> *What cared he for mists at the dawning of day,*
> *What cared he that over the valley stern 'Jack',*
> *The Monarch of frost, held his pitiless sway?—*
> *A bold mountaineer born and bred was young Mac.*
> *A galloping son of a galloping sire—*

Charlie's exploits, expert horsemanship and riding ability were already well known throughout the Monaro, and Paterson, who spent more than a couple of nights at the Bredbo Inn, on the Monaro Plains about 60 miles south from Queanbeyan, would certainly have been aware of the stories.

Bill Refshauge is the pre-eminent expert on 'The Man' and in his book, *Searching for the Man from Snowy River* he examines the claims of Jack Riley, Charlie McKeahnie and a couple of others. He lists the criteria which any claimant must meet and he concludes, '(Charlie Mac) is the only candidate... (who) satisfies all the criteria. Therefore, of all those candidates, only he could reasonably be The Man.' (p 177)

But Paterson staying at the Bredbo Hotel is not its only link to this story. On 3 August 1895, aged just 27, Charlie McKeahnie died after a fall from his horse. In his book, Bill Refshauge quotes from an interview with Tom Goggin a Bredbo local:

> *McKeahnie was killed when his horse slipped in the frost one night...on the Little Bridge at Bredbo...just near Povey's store...(he) was treated by Dr Clifford...(he) had a bad cut, but there must have been an internal injury because Charlie McKeahnie died at the Bredbo Hotel two days later.(p 171)*

When I front up to the Bredbo pub, it's a misty, foggy afternoon. The roads are slippery for tyres let alone hooves. I park Super Ten around the back next to the original stables and head inside to be welcomed by a good fire, Lisa behind the bar and Ken, a local having a quiet one after work.

There's 240 people in the village of Bredbo, and 499 in the postcode according to Ken, and most belong to one of a handful of clans: the Poveys, the Bowmans and the Goggins. The Goggins used to own the pub, the Poveys ran the general store and the Bowmans were in charge of the railway station.

Ken's a Bowman and a long-time earth-moving contractor. He knows the country and its history. I ask him about a strange kiln-type ruin and a massive brick fireplace and chimney I passed on the way in, and he knows their stories, knows the contacts of the farmers who own the properties they're on, and of course has their numbers.

He asks what I'm doing in the town and when I tell him, he gets up and grabs a framed piece off the wall. It's a transcript copy of a letter written by a fella named Mal Lawrence, the great grandson of Albert Povey, one of the first of his clan to make Bredbo his home.

> *I thought it was time to put pen to paper and tell you a story my Grandfather VICTOR ALBERT POVEY 1886–1987 told me over 40 years ago...*
>
> *My Grandfather told me that BANJO PATERSON and my Great-Grandfather (k)new each other quite well...*
>
> *BANJO told my Great-Grandfather a young man called CHARLES LACHLEN (sic) MCKEAHNIE 1868–1895 was the inspiration for his poem.*

The folks down Corryong way have led the attack on the veracity of this letter but Ken reckons the truth is in the writing. He's a Bowman but his family has married Poveys and they don't bullshit. His quiet passion and conviction are pure oxygen.

Ken tells me that in the morning he'll take me down to the site of the old bridge where Charlie's horse slipped and tossed him, oh, and would I be interested in chatting with his Aunty Audrey? She's just gone 92 and Victor Povey was her father-in-law.

We agree to meet in the community hall. Ken's wife Louise has the keys and she'll show me the old photos on the wall while we wait for Audrey. Ken's had a long one so he bails and I chat with Lisa. This is their first pub, a change for Lisa from running a day care in western Sydney and for Steve after 26 years on the road as a Coke rep.

The tree change has worked well, although once again, neither was quite prepared for the hours, the long days and the long weeks without much time off.

There's some confusion and controversy over just where Charlie Mac collapsed, and Lisa explains how the two parts of the bar were originally one, how the wall at one end is new and how the fireplace in the pool room used to be part of the main bar. 'Charlie McKeahnie collapsed in the bar in front of the fireplace, which is now part in the pool room. That's where he died.'

The scene crystallises and it all works. There was a Charlie McKeahnie who was a master horseman, who chased a wild horse through the mountains, and about whom a poem was written. And this Charlie Mac did indeed fall from his horse just down the road and it's certain he died in the bar of the Bredbo Inn, now Bredbo Hotel, a place where Banjo Paterson definitely stayed several times.

I sleep well in room two, alleged to be Banjo's favourite, and Ken and Louise are at the community hall when I turn up in the morning.

Louise shows me through the old photos and the fine set of drawings of the extant old buildings, donated by an artist in town, and Ken nicks off to pick up Audrey. It's unusual for this wonderful woman to be chauffeured around town. She has a pair of electric mobility scooters which she usually pilots to the pub and the store.

'I have two,' she explains not long after turning up, 'in case I get a puncture in one. I would hate being stuck at home.'

For 75 years, from age nine until seven years ago when she was 84, Audrey rode a pushbike. And for the last 50 years, she only ever wore high heels when riding. 'I'm not tall and I like heels but I could never see the point of changing shoes when I got off the bike so I always rode in high heels.'

Louise chimes in, 'And she was known as the "hummingbird" because she always hummed loudly as she pedalled. We always knew when she was coming.'

When she was 84, Audrey had two falls from her bike and decided to stop riding and grab the electric carts.

She never heard her father-in-law talk about Banjo Paterson, which means he probably didn't because her recall of other things is all encompassing.

I remember we moved up to the railway station when I was four. My dad used to work on the railways and my sister was the attendant at the station. She was my older sister, she was 14 years older than me and we lived up there for 19 years.

It used to be really busy. There were lots of people catching the train up to Sydney or down to Cooma and then there was a mixed train that went down to Bombala. Steam trains, there was one every day, used to get here about six o'clock in the morning from Sydney. Then it would go down to Cooma.

It took all night to get to Sydney. You'd leave here about seven o'clock and get into Sydney at about 5.30 in the morning. I never went much, I just used to go to see my auntie.

And her memories of days at Bredbo Public School are lucid and vivid:

I never swam in the rivers but the school used to have picnics down on the sand beside the river, especially on Wattle Day. I couldn't swim but I kept asking Dad and one time Mr Quarmby, the teacher, was taking a big group down there and Dad allowed me to go.

I was with this girl who could swim and we walked in but when it got deep she swam away and I began to sink and I heard a girl call out to Mr Quarmby and he came in and pulled me out. I never asked to go again.

And she remembers how different discipline was back then:

One day a boy reported to the headmaster that other boys had been swearing and all the boys involved got four cuts of the cane from the headmaster. Mr Watson, the father of one of the boys, knew that the boy who did the dobbing lived up at Bumbalong and rode to school on his bicycle.

So he waited for him along the road and pulled him off his bike and took to him with his whip. The police were called but old Watson got off. We all reckoned that he got to the judge. He got away with it. You wouldn't get away with it today would you?

Audrey, a Bowman, married Kevin Povey in the Catholic church just south of the pub. He was a young soldier from up the road and when she was 28 went to Cooma for the birth of their first child. The baby girl arrived very early.

She was just two pounds four ounces. Maureen was born in May and I had to board in Cooma until she grew and I didn't bring her home until August. They had a blackout and as luck happened I was still in the

hospital and the sister was away having her tea. When all the lights went out I went in to check my baby and I took her out of the crib and cuddled her. Then I heard running footsteps outside and before she made it to my room I heard her say, 'I clean forgot about that baby in the crib.' If I hadn't been there I'm sure Maureen would've died.

We talk on about life in a country village in the Monaro 30, 40, 50, 60, 70 years ago and again I feel blessed that someone like Audrey, the daughter-in-law of the man who held one of the keys to the mystery of 'The Man' is sharing her experiences with me.

Ken and I leave Audrey and Louise to have a cuppa and we head down to the old bridge. There's not much evidence of its existence and Louise has been unable to find any photos of it but Ken explains where it was beside the new one. Charlie Mac fell just a short cooee from the pub.

We head back to the hall but Ken's gotta rattle his dags and get to work. He gives me a mud map to get to Bredbo Station where scenes from *The Sundowners* were shot in the 1950s. He's rung ahead and spoken to the owner and all's good, just be certain to shut the gates. I shake hands with Audrey and thank her for her time. Ken leads her down the ramp to his car and she asks if he could look at one of the tyres on her second scooter. It looked a bit flat this morning.

I fix Ken's mud map to my windscreen and head east. The skies have cleared, the grasses are bending in the breeze as I pull out from the Bredbo Hotel. Many pubs paint themselves as having brush with fame but the Bredbo Hotel, often the host to Banjo Paterson and the scene of the death of the likely model for his Man from Snowy River, has been painted with a very wide brush indeed.

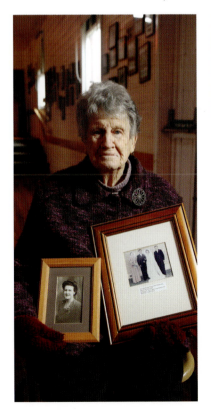

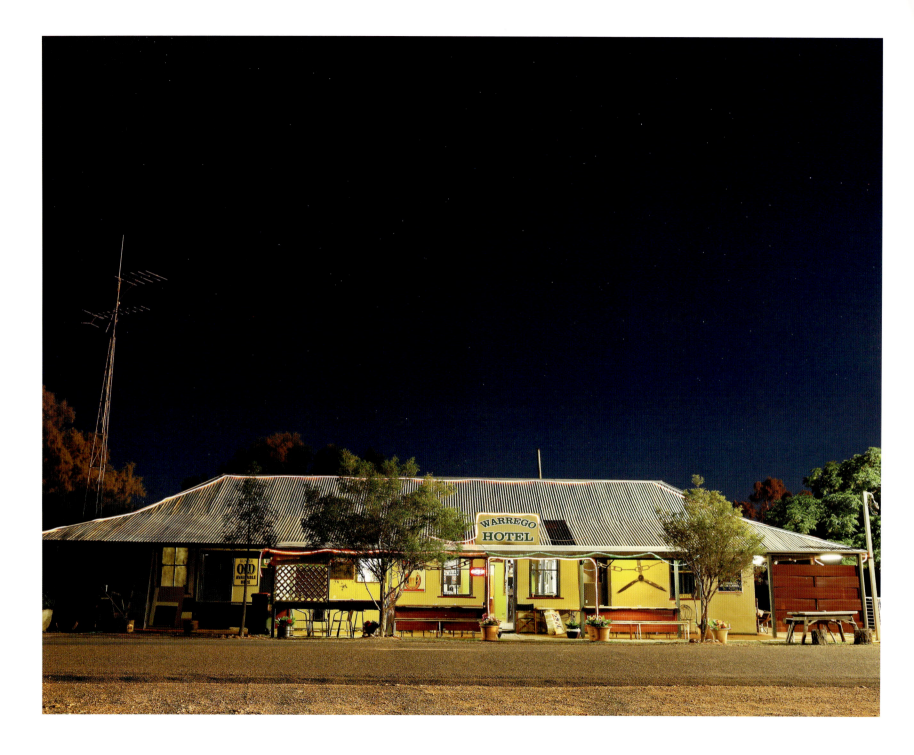

WARREGO HOTEL

FORDS BRIDGE, NEW SOUTH WALES

In the public bar of the Port o' Bourke Hotel, close beside the Darling River in Bourke, I catch up with Kat, who starts slowly but then I ask the question that gets most blokes, especially old shearers or stockmen out here going: 'Tell me about the biggest bastard you ever worked for?'

It's like opening lock gates on the river, and the tales torrent out until we've both had too many and I'm ready to head upstairs, and Kat's son Bryce has come by to take him home. Before he leaves he has some advice, 'Get yourself out to Fords Bridge if you're looking for a good pub. Henry Lawson was out there once.'

In the morning I head down to Diggers on the Darling for breakfast, like I always do when I'm up here, click into their wifi and find out Kat was right. In September 1892, Jules Archibald was worried about Lawson's health and lifestyle and put the 'unfortunate…deaf and shy and brooding' Lawson on the Western Mail at Redfern with a one-way ticket and a five-quid note.

Lawson didn't like the view from the train window, writing on his first day in Bourke that, 'the bush between here and Bathurst is horrible,' and his first mission on hitting town was finding digs. He got a room at the Great Western, a pro-union pub run by a gentleman by the name of John Lennon (truly!).

He called Bourke 'the metropolis of the Great Scrubs' and found it was, 'a much nicer town that I thought it would be,' but immediately something weird hit him, 'This is a queer place. The ladies shout. A big jolly-looking woman…marched into the bar this morning, and asked me to have a drink. This is a fact; so help me Moses!'

He didn't say if he took up the offer but he wasn't famous for refusing invitations to a drink. Lawson soon left the city with his mate Jim Gordon and they walked down the Darling, finding work on the floor at Toorale Woolshed where the shearing was in full tilt. Henry hated it. '(a) shearing-shed is not what city people picture it to be…it is perhaps the most degrading hell on the face of this earth.'

After just a couple of weeks, they struck out north-west for Fords Bridge on the Warrego.

You don't plough a field by turning it over in your mind, so I make myself a mud map, pin it to the windscreen, fill up with water and fuel, cross the Darling and then take the left off the Kidman Way.

The third stretch of dirt ends at the concrete bridge over the Warrego bywash, which is soon followed by another concrete span over the Warrego itself. The bridge's got no side barriers and when I arrive, Lawson's description on it, 'dusty gutter with a streak of water like dirty milk' is totally apt, despite ten centimetres of recent rain. The old Salmon Ford Hotel stood between these two watercourses and it was here that Lawson saw in the new year of 1893.

After the second bridge I'm in town, with a pretty reasonable home, surrounded by a two-metre Colorbond fence on my left, followed by a collapsed house, a livable place opposite the hall and then the pub on my right. When I get to the pub, Peter's outside having a durrie with his blue bitch, two-year-old Pepe, and Colin the mailman who comes by twice a week bringing all the food and beer supplies.

Pete's been here for a bit under seven years. He used to be a concreter in Queensland but bought this place because he wanted a home and a job. He's got three kids whom he hardly ever sees and a few grandkids, some of whom he's never laid eyes on.

He gives me the full town census. There's him who runs the pub, Barnsey who lives in the nearest place across the road and then there's the bloke in the Colorbond fortress. He doesn't speak to the other two. Every six weeks or so, opens the gate, drives out to Bourke for his supplies, comes back in the arvo, closes the gate for the next month and a half.

That's it! Oh, and Barnsey's not too keen on crowds so if a few people rock up this arvo, he'll probably stay at home.

I grab a stubby and pay five bucks. It's the same brand I was hit for 9 bucks 50 at a trendy Rocks pub back in Sydney a month ago. I tell Peter it's too cheap, that if he lifted the price by just 50 cents he'd see the difference by the end of the week. Pete draws on his fag, then fixes on me: 'And what would I do with a pocket full of 50-cent pieces?'

Later on a couple of locals pull up with a ute crammed with piggin' dogs and a quad on a trailer. Chris opens the lid of the trailer trunk and shows me maybe ten quality boar heads. They've had a productive day.

Kim and her husband Mark from a station up the Hungerford Road rock up with their daughter, soon followed by Ted and Beth from towards Wanaaring. Kim's the cook here on Friday and Saturday nights and she's soon in the kitchen keeping us all happy with feeds from a basic menu of schnitzels, steaks, bangers and mash and tonight's special of Mongolian beef.

Barnsey's feeling sociable and he walks in, pulls up his favourite pew outside. He talks of the old days, of catching roos for food, and one time of getting a red doe for some hungry hitchhikers. 'I caught this one and killed it then skun it and hung it up for them,' he tells me.

I ask him about 'skun' but everyone agrees that out here it's the past tense of 'skin' so we move on.

Other blokes from (sort of) nearby farms bowl up. They've all got lived-in faces, they've all got hands that've not spent much time in pockets. The chat ebbs and flows, sometimes it drips and sometimes it flows. After each story there's a quiet and a group inhale as the gist is digested, savoured. Tales are shared and swapped: stories of hardship and misadventure, of silliness and stupidity. All are self-effacing and entertaining.

Because out here men talk differently to men in towns and cities. Sit in a busy city bar and listen to blokes talking. Halfway through the first fella's contribution, the next bloke will already know what he's going to say and is waiting for his mate to finish. Then he'll only be a bit into his piece when mate number three will have formulated his response and will be ignoring the next bit until he gets a chance to talk. There's never silence. Oh, and you can eavesdrop a conversation between five blokes for an hour and you won't hear a single question asked. Just statement, contra statement, agreement, disagreement, next statement…

Out here it's different. Out here each contribution's culmination is marked by a pause, a pondering, before a response is offered, a question is posed, an observation contributed. In the backroom of my mind, Henry's observation that, 'I have…found that Bushmen are the biggest liars that ever the Lord created,' resonates but these aren't tales of bravado, more yarns of life. 'For a life along the Darling isn't like the life in town.'

I decide to stay two nights. Next morning Peter and I take our poisons together; Peter his rollie and I my coffee, as Pepe lies on the bitumen road in the rising sun. We talk about how the pub's the only mudbrick hotel in Australia and how some of the render's peeled off near the pool table and the rock-hard red dirt bricks are visible.

I spend the day walking around the town, checking out the cricket oval and the playground and the place where the old Salmon Ford Hotel was between the river and the bywash. Cattle roam the main street and maybe a dozen cars and utes come through. All the drivers but one nod or wave and over half of 'em pull in.

In the evening a few more locals come by but it's mostly just Peter and me and Pepe and in the background there's one bloke singing most of the songs on the jukebox.

'You like Slim Dusty, eh?' I ask.

'You should come back in September.'

I tell him I will.

Each year on the Saturday closest to the anniversary of Slim Dusty's passing on 19 September 2003, from eight in the morning 'til two the next

morning, specially brought in speakers shout out a continuous loop of every song Slim ever recorded.

There's a non-stop BBQ out back and a talent quest (of sorts) out front on the road. Over a couple of hundred people turn up, a lot sleeping in their vans, more swagging and camping on the grass opposite and a few just sleeping where they end up when the music dies.

When I get there mid-morning, there's already a few dozen partying hard and Slim can be heard from the Warrego bridge. Peter's brought in a temprite and is pulling draught beer with the help of a backpacker brought in from Bourke. There's raffles and pool comps and there's a whole lot of noise. Survivors of way too many B&S's pull up in piggin' trucks and utes. Every farm within cooee must be deserted as Landcruisers roll in full of families.

Pepe's nowhere to be seen—she's out back in a quiet place and around midnight she gives birth to half a dozen pups.

Around 9pm it begins to rain but no-one really cares. The roads in have only just been reopened after some good soaks and the only concern is whether we'll all get out but that's tomorrow's problem.

The party starts to thin as the folks with young kids begin to head out. The older people gather around the BBQ fire and swap laughs and lies whilst out front the youngsters are beginning to pair up. It must be a bit quieter too because around ten Barnsey walks in out of the rain and asks how it all went.

Before I go to turn in, I catch up with Peter who looks totally buggered. 'Bit different to the first time you were here.'

I nod.

'And I'm glad I didn't take your advice.'

I look up and put my eyebrows in their 'Huh?' formation.

'All them 50-cent pieces would've dragged me duds down by now!'

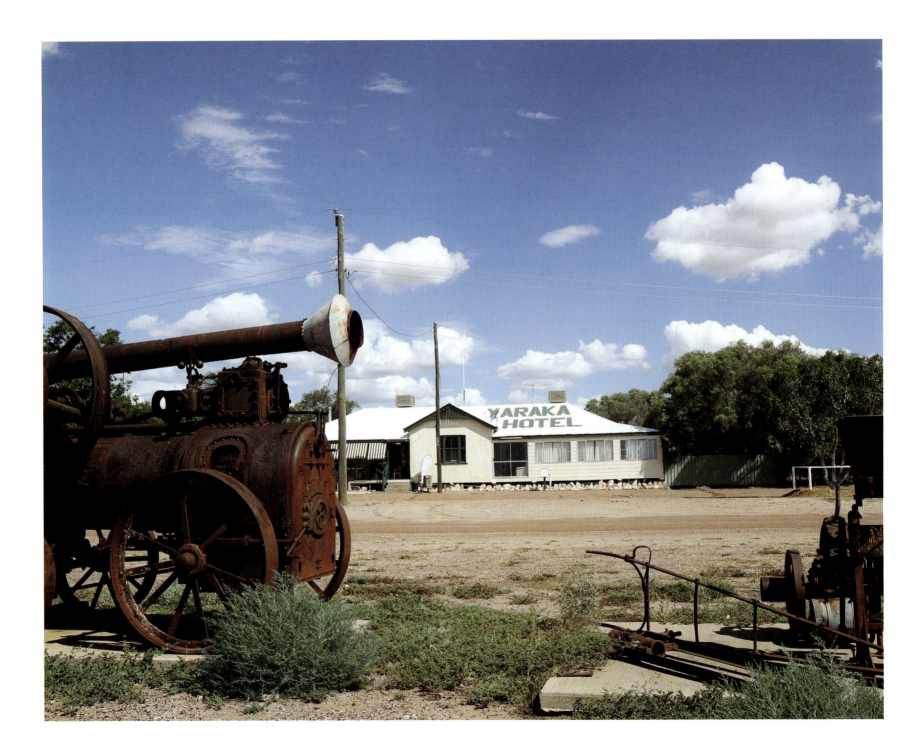

YARAKA HOTEL

YARAKA, QUEENSLAND

I'm in Barcaldine and ring Chris, the publican at the Yaraka Hotel. The rain's torrential and the police are saying both roads in are impassable for anything other than powerful 4WDs and that the bike won't make it through. I was hoping to be there in the morning, but there's no utes for hire in Barcy or Isisford or down at Blackall, so there's a problem.

'Stay where you are and I'll ring you back within the half hour.' I ask Noeline at the Railway for another lite and she's hardly handed it over when my phone rings:

> If you can get yourself to Isisford early tomorrow morning, I can get you a lift. Ken's the publican at the Golden West hotel and his son's been wanting to take a trip down here for a while and he's free tomorrow.

I leave the beer untouched and head for the door. It's a bit under two hours to Isisford: 80 kilometres straight west to Ilfracombe (no time for a whet at the Wellshot), then due south to the Golden West. And this day's only got about 90 minutes of daylight left in it.

A quick call to Ken to make sure the story's kosher and there's a room free and I'm outta there. The storm's coming in from the north-west, probably born back up in the tropics. In the late afternoon, light the clouds, and contrasts are stunningly threatening and I stop a coupla times to capture their beauty. Out to the west it's pissing axe handles and it's getting closer. I can't outrun it and the first drops, large, solid, noisy drops, hit my visor with 60 kilometres still to go. But it's still 28 degrees and I'm engulfed in a high pressure warm shower for the rest of the trip.

As I park the bike under the awning, a young fella comes out. 'You must be my hitchhiker for tomorra. I'm Byron, mate, Ken's son. Can I help you get sorted?'

I tell him all's good, that I'll dry off and see him inside.

There's a certain smile that people in a pub give you if you walk into their haven when it's seriously shit outside. I get it on the days of furnace heat and when I've come in from riding through snow. There's always a 'hello' or 'g'day' and *that* smile—eyes crinkle a bit at the corners and the mouth usually stays closed, but it's a smile of acknowledgement that you've come through a bit to get there. It's that smile and welcome that Ken gives me when I front the bar. 'So you made it, eh.'

'Yeah, just. Aquaplaning across causeways in the dark sure gets you focused.'

They ask how far back it's been coming down and how heavy and where was the water over the road. Rain talk's good talk.

Byron was born in Isisford but now lives with his wife and young son on the south coast of New South Wales. They're back for a month or so and Byron's been looking for an excuse to head down to Yaraka and Mt Slowcombe and I'm it. He wants to leave early in the morning in case it all goes pear shaped in the rain, so I tell him how grateful I am, that I'll be more sociable after some sleep, and take my kit back to my room.

'How'd ya sleep?'

I think of the poem that's brought me here and one of Banjo's most well-known but least attributed lines, 'Great sleep, mate, was 'as snug as a bug in a rug'.'

Most of the clouds have gone when we head south. The falls have been heavy but localised. Some of the red clay road is a bog and we take it carefully, in other places the track's only had a dust-settling sprinkle and Byron switches off the 4WD for long stretches. I get to thinking that Super Ten would've made it through.

We cross channels of the Barcoo a couple of times. Earlier rains had lifted the water to the bridge at one crossing and Byron hopes it won't rise too much before we come back.

I'd never heard of Mt Slowcombe or its views, and Byron hadn't heard about the reason I was so keen to make it to Yaraka. The tall mesa stands out

from the surrounding plains for a good half hour before, some 5 kilometres short of the town, we turn west and head to the steepest road for hundreds of kilometres. The view from the top is stunning in every direction. I head to the western side of the lookout and scan the view. I've stumbled across something for which I've been searching for years.

One of Paterson's most unforgettable couplets is from 'Clancy of the Overflow':

And he sees the vision splendid of the sunlit plains extended,
And at night the wondrous glory of the everlasting stars.

I've been blessed with many evenings under the 'everlasting stars', but I've been obsessed with finding such a vision of the 'sunlit plains', untainted by some human structure. Each time I think I've found it, some buggers've put in a road, or a shed, or a station or a fence or a powerline. But not this time.

I scan from left to right, from the foreground to the horizon, and there is nothing: Not a fence line, no poles or sheds; not a road or track. I head back to the ute for my cameras. We stay there for maybe an hour, probably more. Byron came for this bit and he sucks it all in. Rains in the previous weeks have greened the country and removed the harsh edge. It's a truly a wondrous sight and it's fitting that Byron's given me another piece of Banjo.

In 1893 Banjo Paterson wrote one of his most popular poems, 'The Bush Christening'. It begins:

On the outer Barcoo where the churches are few,
And men of religion are scanty,
On a road never cross'd 'cept by folk that are lost,
One Michael Magee had a shanty.

The remains of Michael Magee's wine shanty are around 70 kilometres west of the Yaraka Hotel and it's this poem, these lines, that've lured me to this pub in a town that proudly portrays itself as the end of the line.

The road curves around the end of a railway line and then past two yapping dogs in a yard and the Yaraka Hotel is on our right. We haven't seen another vehicle since we left Isisford and there's none in front of the pub.

A bloke who seems too well dressed for this part of the world comes down the steps to meet us. I guess he's Chris who sorted my lift, and he guesses I'm Colin and the chauffeur must be Byron.

There's one other person on the balcony and so Chris introduces us to Ian. If we're heading west, Ian could do with a lift out to his property. Turns out that the remains of Michael Magee's shanty are on Ian's farm and if we can give him a lift back to his homestead, he's doing nothing so he'll guide us out to the ruins and to a noteworthy grave nearby. He doesn't want us to join the ranks of 'folk that are lost'.

It's all too easy, but with the western sky full of moisture and the temperature already nearing 40 degrees, Chris reckons a storm will boil up in the arvo, so best get out there soon.

Ian piles into the back seat and we off. It's soon clear that Ian doesn't just occupy the land, he is within it. He points out waterholes and hills, tracks and trees; it's all interesting to him and it's all known. To our left is the Battle Hole Lagoon. It's near full so we detour in to check it out. In the 1870s Acting Sub Inspector Thomas Williams led a detachment of Native Police in a pursuit of a large group of Aboriginals.

'Many blacks' were cornered against this billabong and dived into the water to escape. The Native Police waited at the edge of the lagoon. As each Aboriginal came up for air, he was shot through the head. It was a massacre, one of many in these parts in those times. Williams was later suspended and then dismissed from the Force.

Ian's story changes the landscape. From a great place for a dip on a hot day, it becomes a place to be treated with reflection and reverence. Our voices are lowered, the conversation quiets down out of unspoken respect.

We then turn west, a pair of brolgas eyes us, chattering. The red sand gives way to the grey claypan. Two days ago this was underwater and we would've been snookered. It's spongey now, but passable. We follow Ian out past the grave of Richard Macoffin to the remains of Michael Magee's shanty.

There's not a lot to see. There's a cairn with a plaque surrounded with bits that visitors have found in the dust. As I'm photographing, Byron finds an old bottle neck with the stopper still attached and adds it to the collection.

Beside the cairn are the stone outlines of rooms, probably the bar and off to the side the poles from the horse yards. This most likely was a Cobb & Co stop on the crossroads of the Windorrah to Yaraka and the Budgerigar to Jedborough tracks.

There wouldn't have been a single visitor arrive who wasn't parched and thirsty, unless of course they'd let themselves into the barrels and bottles that many of the wagons would carry to outback pubs and shanties. Not much local business but good passing trade!

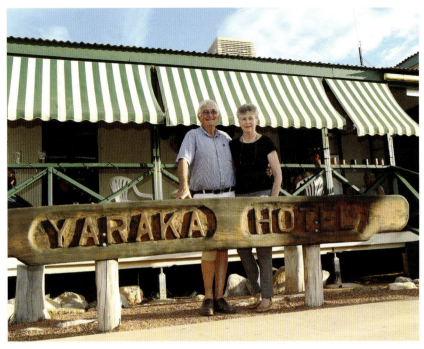

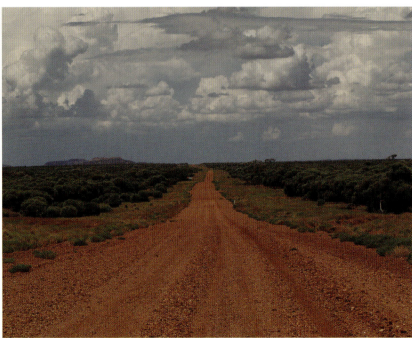

In 1991, 98 years after 'The Bush Christening' was published in *The Bulletin*, the town of Yaraka held a festival. Rough bench seats were made for the throng and an ecumenical baptism was held for five more-or-less local kids. The remnants of the benches are scattered near the cairn, and off to the edge a ragged tree-line alleges the existence of a creek.

This is harsh, hard land. When we're done we return to the grave of Richard Macoffin. Like a blind man in a dark room looking for a black cat that isn't there, Macoffin died in a sandstorm just 180 metres from the Barcoo's waters.

Thunder rolls in from the west. It's still far distant but we need to be moving. Ian leads us back to the main track where we part company. Ahead the sky is clear and we're pretty sure we're going to get out dry. The afternoon sun draws out every drop of the land's harsh beauty.

Back at the pub, Alan's standing at the rail having a yack to Chris. Bob lives down the street with his son and he's just on his way up to shut the dogs up that have been yapping for the last seven hours because their owners are away. I sure ain't going to hold him up so I tell him I'll catch him when he's put the dogs away.

In 2009 Alan was at the top of Mt Slowcombe driving around the country in his ute, looking for a place to live. Bob, the postie from Yaraka, happened to be up there admiring the view and they got talking. Bob knew a place for sale down in the town. Alan checked it out and bought it. So what does he like about it?

'It's the peace. The peace and the quiet. It's a very quiet town and I'm in the quietest corner.'

Before he quit working, 'I was a bit of everything. I'm not a qualified butcher but I'm as good as any and I grew cattle up near Ingham then I bought a station out near Torrens Creek and ran cattle there.'

Then he retired back to Charters Towers, his marriage broke up and with nothing to tie him down, he packed his ute and starting driving. It wasn't long until he met Bob on top of Mt Slowcombe and ended up owning his own patch in a town he likes. In his tie-dyed shirt, his anarchistic hat and flowing beard, Alan resembles an older Grateful Dead fan frozen in time.

A few lines from Victor Daley stir in the back of my brain:

> *His hat was shocking bad,*
> *He wore a faded tie,*
> *And yet, withal, he had*
> *A moist and shining eye.*

And though he's happy here living with one of his six children, and although cataracts in both eyes have put an end to his driving days, he's not rooted to the place. 'If I got the right price for my place now, I'd move on. Dunno where, I'd just move to somewhere else.'

It's getting a bit crowded for Alan, a bit noisy. There's almost half a dozen people in the pub by now and he excuses himself. Doug at the end of the deck tells me Alan's a decent bloke and I suggest to Doug, the local cop who's off-duty for the day, that for him a 'decent bloke' is one who's quiet and law-abiding.

'Well that'd mean everyone in the town and for a hundred miles around must be decent.'

Doug's just drained his glass so I ask if I can get him one but he passes.

> *If you're a country cop in Queensland, I think it might be the same in New South, if you're in a one-cop or two-cop town you have to always be under point zero five. If you're on duty you have to be zero point zero but even when you're off duty you have to be under oh five.*

Cops out here are never completely off duty. Crashes, fires, prangs can happen whenever and there's never the option of, 'I'll come out when I start my shift in the morning.'

'You have to be ready for the call 24/7. It's part of the job, part of the life.'

I bring him out a water and he gives it the sort of disdainful distasteful look that he must give some poor buggers when he arrests them.

Georgia is looking after the bar so Chris has time for a yarn. In the mid-eighties his wife Gerry was sent out to Yaraka school as the headmistress and for ten years they lived in the town. Their initial affection turned to a real love for the country out here. 'Once you cross the Barcoo,' says Chris, 'you always return.'

But Gerry was transferred to Beaudesert and a school with 750 kids, where she stayed until 2013 when they figured it was time to think retirement. Each year they'd holidayed up at Woodgate Beach near Fraser Island so they headed up there to check out the real estate, found a place that suited and then headed home to mull it over.

> *On the way home I said to Gerry, 'What are we doing? We've always had lots of space around us but we're about to buy a home for the rest of our lives that has a neighbour three metres from that side, three*

metres on the other side and one 30 metres behind us.' So we put it on hold for a bit but then, talk about timing, I got a call from Les Thomas who'd owned this pub for 26 years.

Les explained that he was 'over it', that the last 12 years running it on his own had been too much and he asked Chris if he remembered a conversation from years back when Chris'd said that if he ever felt like selling the pub, to give him first option.

We spoke for a while and I hung up and went back into the lounge and told Gerry that I'd just bought the pub at Yaraka. First of all she didn't believe it but when I convinced her, she was very happy and very supportive.

They moved into the old station master's house, right at the end of the old railway line, worked out a five-year plan to ramp up the services and the accommodation, rolled up their sleeves and got to work.

Meetings were held to discuss the best ways to turn Yaraka, the town and the pub, into a destination. Community space was turned over to free camping grounds and the entry fee to the small swimming pool was abolished. A string of regional councils joined together to develop 'The Outer Barcoo Way' as a tourist route from Blackall down to Yaraka. The final section should be sealed by late 2017 and this will bring vanners and mobile homes in massive numbers.

As we talk, the clouds way out to the west open up. It must be windy out there as the purple rain curtain is angled at almost 45 degrees. Chris looks up and his voice puts on a different hat.

That's heading the wrong way. Pity. We've had some good falls but we really need follow-up to get the Buffel grass and the Mitchell grass to really start shooting. Then we'll be in for a good season.

All very different to 2015 when Chris and Gerry arrived at the height of the last big dry, when grass was a dream and a memory, when red and grey dirt was the reality.

In 2015, not long after they took over, they had a call from Matthew Moloney, the priest from Longreach. Matthew was writing a dissertation on the effects of the drought on faith and on outback communities. He was in need of a quiet retreat to focus on this writing, did Chris know of anywhere?

For four days the next week, Father Moloney was quietly typing away in one of the accommodation rooms out the back of the Yaraka Hotel. In the serenity of this town, he composed a paper which he presented to a conference in tropical Bundaberg on the social effects of the harsh conditions out west.

A few months later, Gerry put through a call to the priest. As one of the very 'scanty men of religion', would he consider coming back to Yaraka for a baptism? Well of course he did and so 122 years after Banjo Paterson had penned, 'A Bush Christening' and centred it at a wine shanty on the banks of the Barcoo, Father Matthew Moloney from Longreach performed a similar ceremony up on top of Mt Slowcombe for the grand-daughter of the owners of another pub on the 'outer Barcoo'.

Gerry joins us for a bit but Byron is keen to watch the sunset from the mountain and Chris and Gerry are also headed up there in their courtesy bus with some more blow-ins. We meet up at the top and though the cloud's mostly disappeared to the south, the view is still spectacular.

As we head north back to Isisford, I realise I need to talk to Father Matthew Moloney. Next day I get hold of him. He tells me he spent two years heading up the diocese in Longreach and another two years in Blackall. He reckons the biggest challenge for men of religion out here, like for the rest of us, is distance.

In Longreach and Blackall, I'd do 40,000 kilometres a year driving around my area. There's less people but because of the isolation and the droughts, there is often a more urgent need for pastoral care.

To meet the challenges, the import of denominations subsides and the primacy of faith takes over.

In Longreach I was the only major minister of religion for nearly 12 months and so I was doing funerals for everyone. There was no distinction, there was no Catholic or Protestant, no Anglican or Uniting, I was the minister of the church. Out there people don't necessarily want the Catholic priest or the Anglican priest, they just want a priest and when I'd do a Christmas service I'd do it for the whole community.

But one year it became a bit competitive.

> In Muttaburra, the Anglican bishop had just been the day before I got there and they'd not gathered too many people, I think it was maybe seven. When I arrived to prepare for the Christmas mass they asked if we should have the mass in the church but I said, 'no'. Then they suggested the hall and again I said 'no', and I suggested we should have the mass out in front of the pub where the fete was going to be later. So we brought the seats to the front of the pub and I went into the bar and said, 'C'mon you people, bring your beers and come outside.' We got about 70 people out on the street in front of the Exchange hotel. We had people praying and celebrating and I was very happy with the turnout.

But that wasn't the best bit of the night, 'After we finished we set up the fete.' A nice community thing to do but I couldn't see where he was leading. 'And then I won the meat tray!'

Too funny! When we both stop laughing over his afternoon of renouncing Mammon then going home with the Gammon, I ask him about baptisms out in the bush.

> A farmer called me from a far western community out near Bedourie. They had three children and he asked if I could do a baptism the next Tuesday—this was Friday. I told him no we can't do it that quickly, there's some preparation to do and the father said, 'Ah well, don't worry.'
>
> I was a bit taken aback and I asked, is there a problem and he said they had come in from the far west and the wife was only due to have the baby on the Monday morning and they had to be heading back out west on the Wednesday so it needed to be Tuesday.
>
> When they told me this I of course changed all my thinking about the preparation and so we had the baptism. The baby co-operated and arrived on time and it was just the family. The eldest boy was in grade five or six and I gave him the book and he helped me go through the service.
>
> It was the most sacred and most special occasion for them but also for myself, sharing it with them, listening to the young boys talking of their love for their parents and their love for their new sister was one of the most sacred and faith filled experiences of my time out of my rural ministry.
>
> They all went home the next day in their truck. The power of their faith and the family love is something I'll always remember.

When I ask him what word most sums up his time in the outback, the priest barely hesitates. 'Inspiring. I find the people in the harsh country with their harsh reality to have spirits which are inspiring.'

I think back to Chris organising me a lift in, to Bryon who carted me for hundreds of kilometres, to Ian who gave up a morning to show us the shanty, to Doug who insisted we let him know when we got back safely. I think of everyone connected with the Yaraka Hotel and I need no explanation of 'inspiring spirit'.

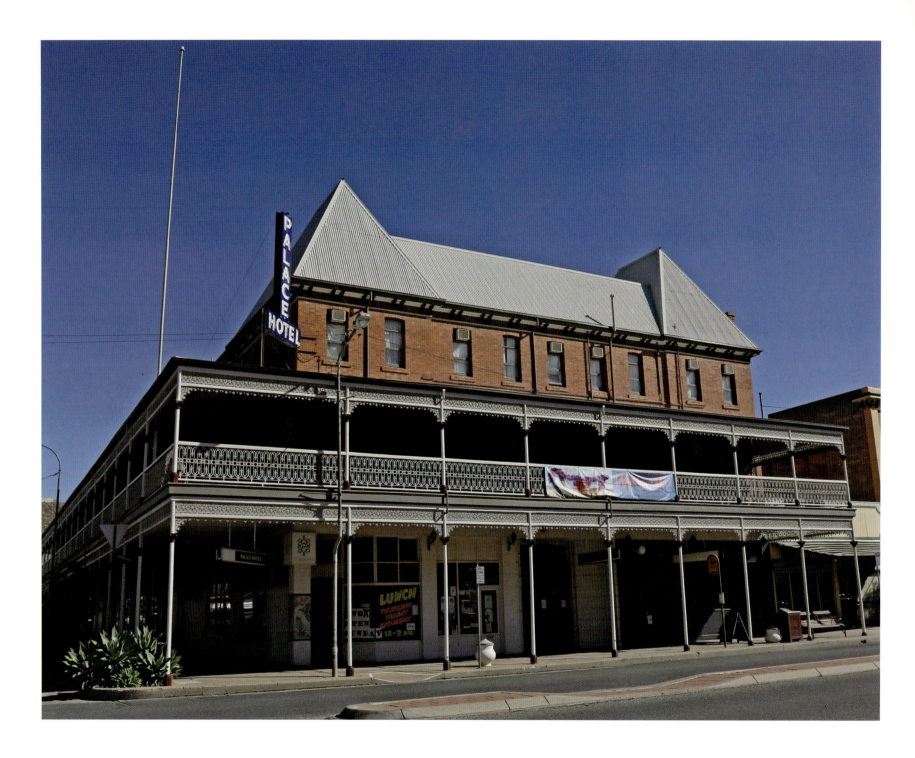

THE PALACE HOTEL

BROKEN HILL, NEW SOUTH WALES

On Saturday 19 March 1988 the punters of New South Wales headed to the polls to elect a new state government but way out west in Broken Hill, something far more important was on the cards: the twenty-fourth running of the St Pats Race Day.

Begun in 1965, this race meet was already an icon of the outback. It was a fundraiser for the local catholic schools and had grown into a week-long festival, also featuring a major volunteer-run charity night at the track with games like crown and anchor, unders and overs, and one to six.

These were the days of epic corruption down in Sydney. Barry Unsworth's Labor government had seen its Prisons Minister jailed for selling early prisoner releases, its chief justice in the clink for perverting the course of justice and a host of senior cops caught up in corruption charges and investigations. The Libs were led by Nick Greiner who promised to clean up the halls of power and to rescind the tough guns laws proposed by Unsworth as a response to the Hoddle Street massacre.

Meanwhile, on the Wednesday before the election around a dozen members of the New South Wales Gaming Squad secretly checked into Mario's Palace Hotel on Argent Street in Broken Hill.

Come Friday night and Paul Mullins was supervising one of the ten gaming tables at the charity do down at the track, just like he'd done each year for the past 'too many'. Paul was a real estate agent and was he nervous. All week there'd been strong whispers that the night was going to be raided and he knew that if he was arrested and convicted, he'd lose his licence to practise.

The committee had met mid-week and decided the night should go ahead. The local cops claimed they'd also heard rumours but nothing official. A bit after 9pm Paul was tapped from behind on the shoulder by a plainclothed D and the raid was on. Sitting in his office on Oxide Street, in 2016 Paul tells me about the bust.

There was no aggro, no disrespect. We weren't handcuffed. Just told we were under arrest for 'Conduct illegal game'. They got nine of us, all the blokes running the tables. They rang the local cops and told them to bring down some paddy wagons but (club president) Barrie (Collison) said there was no way he'd be getting into any wagon so they told him to drive himself up to the cop shop and they'd arrest him there. All very civilised.'

They were all finger-printed, height measured, mug shotted, charged and processed at the police station across from the Palace Hotel and allowed to go home.

Next morning news of the bust pushed coverage of Nick Greiner's election win onto the second page of the *Barrier Daily Truth*. If there was disgust at the arrests at this charity event there was total town outrage that police 'from away' had infiltrated the city and imposed out-of-town rules. Broken Hill had always looked after its own, always made its own rules, always enforced its own particular codes. It'd been that way since anyone could remember.

Way back in 1916 when hotels throughout New South Wales were mandated by law to close at 6pm, Broken Hill said 'get nicked' and all pubs continued to open until 11pm. A delegation of senior cops was sent from Sydney by Premier Joe Cahill in 1953 but returned to the Emerald City saying they were powerless out west to enforce the law. Broken Hill kept drinking any damn time it chose! A year later, no doubt partly due to the recalcitrance of Broken Hill, almost 40 years after being introduced strictly as a war measure, six o'clock closing was abolished in New South Wales.

Even more famous was the two-up game a couple of blocks up in Crystal Lane, which runs behind the Palace Hotel. 'The game' was run for decades and it hosted premiers, federal ministers, off-duty cops and pretty much every man who ever visited the Hill. But no women or anyone under 18.

Miners but no minors. These were the rules. Broken Hill rules and Broken Hill's rules ruled.

A silhouette of a bloke leaning on a pole was painted at the corner to mark the lane. It's still there. Right on the lane's curb was an unmarked door on which you'd knock and have an eye-level sliding hatch open, a voice would ask what you wanted and enquire whether you were over 18. If you passed, you'd walk to the next steel door and then past the cafe and into the game. The steel door also remains but, sadly, that with the sliding peak-hole has disappeared.

On the back wall hung a red curtain and Greg, who now owns the bakery on the site, reckons no-one ever really noticed the curtain or wondered why it was there. He lifts up a secret trap door in the floor just behind where the curtain used to hang, and I climb down the stone steps to the hidden cellar. If anyone can dig a secret emergency escape tunnel into an adjoining shop it's gotta be miners, but Greg reckons it was never used, never needed. There was never a bust, never any cops 'from away' causing grief.

The local cops knew all about 'the game'. If anyone caused trouble and was worse for wear from the bouncers, a call would be made, a paddy wagon with its back door open would arrive in the lane, the offender would be bundled in for a ride to the edge of town and a sobering walk back. Case closed.

But in 1984 a bloke who Greg *knows* was called 'Scott' had a blue with three other fellas. He knocked them all down, but they were the wrong people to brawl with.

> *The mafia from Mildura sent up a guy to sort Scott out but he went to the wrong house and beat up the wrong people. Scott fled town for a few years (but he's back now) and the cops said, 'That's enough' and closed down the game.*

A bloke in the pub at Silverton later tells me his name wasn't 'Scott', that his parents also had to leave town and that none of them has every returned. So many mirages out here!

So back to the end of the 1980s and Broken Hill is without its two-up and without its race night so mayor Peter Black heads to Sydney with a small posse arguing that two-up is so much part of the culture in the Hill that a special law should be made to allow it to be played.

'Blackie' confides to me that he'd missed the St Pats raid because a dinner had run late and he was driving to the gambling night with his guest when the bust went down. The guest in the car that night was the South Australian premier, John Bannon.

Both sides of politics united to support the *Gaming and Betting (Broken Hill) Amendment Act of 1992* with just one dissenting voice, old reliable Fred Nile.

The Act allows for two-up to be played one night a week at one venue and currently that venue is the same place the Gaming Squad hid out before the St Pats Raceday bust of 1988...the Palace Hotel, where the game's on every Friday from 9pm. The same time and day that the plain-clothed D, tapped Paul Mullins on the shoulder.

But it's not just the legal 'swy' that makes the Palace special, there a hell of a lot of other stuff too. Many interior scenes for *Priscilla Queen of the Desert* were filmed here and all the walls and most of the ceilings are painted with extraordinary murals. Priscilla memorabilia is everywhere. All the rooms are in top shape but the Priscilla Suite is the most over the top, amazing room you'll ever wake up in. From the mirror ball in its ante-room to the crazy chaise lounge in the bathroom to the bath itself to the pink robes to the golden fittings and tea set to the lamp stand to the massive bed to the tiger print air-con unit to EVERY SINGLE DETAIL, this is just, well, fabulous. If you're riding two-up or with your partner, splurge on this. It'll make memories!

The pub's restaurant is downstairs at the side. You can get dinner every day and lunch Thursday to Sunday but the bar snacks in the front bar are a better bet. Only go for the garlic arancini if you're on your own, wishing to ward off vampires, or your ride mate is sharing. The bar's open from 3pm Monday through Wednesday and from the noon other days. If you need an earlier drink the Barrier Social Democratic Club is right across the road.

The Palace is managed by Esther, one of the partners in a group of locals who rescued the pub in 2009 after it'd been closed for three years.

When I rock up to the Hill for a second time, most of the town is booked out. Turns out I've chanced upon the Festival of the Broken Heel, a high-camp crossing-dressing weekend-long celebration in the spirit of Queens of the Desert. The road beside the Palace is closed off for the party and music is LOUD!

The next day I head out to Silverton where, again by chance, there's the afterparty and I'm welcomed by the sight of a bloke in a pink frock and cowboy hat skipping rope in the beer garden. What's not to love?

That night I've been given special permission to camp out beside the sculptures in the Living Desert Reserve, ten kilometres out of town. The moon gives me just enough ambient light and the clouds keep away, and for five dark hours I get the effect of star trails as the earth rotates.

I get back to the Palace just after 7am and knuckles of people outside and in the lobby are just finishing up their party night. I step over them and head for a shower. A unique pub in a unique town, can't do much better than that!

ROYAL HOTEL
HILL END, NEW SOUTH WALES

For Henry Lawson, 1891 and '92 were some of the most productive and settled periods. In 1891 he took up an offer to work in-house for *Boomerang*, a workers' newspaper in Brisbane and was given a column, 'Country Crumbs', which featured pithy, sardonic paragraphs of near doggerel about the outback towns and stations, which he'd never visit.

He kept this position for a year, writing the column and also turning out some of his best work for other publications. 'Freedom on the Wallaby' was followed by 'On the Wallaby', 'When Your Pants Begin to Go' and 'When the Bush Begins to Speak'. But then his mates and the pubs called him back to Sydney and his work began to really show the conflict of his admiration—almost love—of the country, white, working man, and his hatred for the bush itself. He took brief trips out from Sydney but he was never content. He railed about the country:

I am back from up the country—very sorry that I went—

———

Further out may be the pleasant scenes of which our poets boast,
But I think the country's rather more inviting round the coast.
Anyway I'll stay at present at a boarding-house in town,
Drinking beer and lemon-squashes, taking baths a cooling down.
('Up the Country')

About the weather:

For the drought will go on drying while there's anything to dry,
Then it rains until you'd fancy it would bleach the sunny sky

About the flies:

Barren ridges, gullies, ridges! where the ever madd'ning flies—
Fiercer than the plagues of Egypt—swarm about your blighted eyes

And about the Indigenous residents of the bush:

Mick, the nigger, at the courthouse was remanded firm and fast,
Charged with popping at a sentry on the last of April last.
And he told the judge a story that we'd almost b'lieve was true—
If we didn't know the niggers in the region of Barcoo.

Meanwhile his sniping battle with Banjo Paterson turned into open warfare with his, 'The City Bushman (In answer to "Banjo" and otherwise)'.

It was pleasant up the country, City Bushman, where you went,
For you sought the greener patches and you travelled like a gent;

But there was one class on whom his angry sights were never trained: the white, outback struggler; the miner; the bullock; the shearer; the shepherd; the working man and woman. For Henry Lawson, the good working people of the bush were, if not the saving grace, definitely the major redeeming feature: in the end not enough to draw him away from the comforts of the coast but definitely worthy of memorialising in verse and prose.

No-one knows when Henry was in Hill End but it was either late '91 or early '92 and once there, he tramped six miles north across what he called, 'the Come-and-find-it Flats' to Tambaroora where he found a pub to his liking and a publican who more than compensated for the discomforts of the trip.

'Twas nearly night and raining fast, and all our things were damp,
We'd no tobacco and our legs were aching from the cramp;
We couldn't raise a cent, and so our lamp of hope was dim;
And thus we struck the shanty kept by 'Tambaroora Jim'.

In 1873 The Hargraves Hotel on the west of the main street had been purchased by James (Jim) Dagger and just holding on to such a place for almost two decades is proof that he must've been doing something right.

In the poem, 'Tambaroora Jim', Lawson goes on to tell how Jim spots them out in the rain, broke and soaking, and invites them in:

> *We sat beside the kitchen fire and nursed our tired knees,*
> *And blessed him when we heard the rain go rushing through the trees.*
> *He made us stay, although he knew we couldn't raise a bob,*
> *And tuckered us until we made some money on a job.*
> *And many times since we've filled our glasses to the brim,*
> *And drunk in many pubs the health of 'Tambaroora Jim'.*

Eventually Jim's charity to the hungry, the homeless and the thirsty brought about his downfall:

> *And this went on until he got a bailiff in his pub,*
> *Through helping chaps as couldn't raise the money for their grub.*
> *And so, one rainy evening, as the distant range grew dim,*
> *He humped his bluey from the Flats—did 'Tambaroora Jim'.*

When I pull up all's that left is the pub's old chimney and its well. There's been good rains and the place is covered in grass and roo poo. Down behind, the creek is flowing and a few fossickers, armed with flynets, metal detectors and picks are trying their luck. The fireplace seems still in reasonable nick and I sit down, rest against it and pull out a long neck of Hahn Lite that I picked up when checking in at the pub back at Hill End.

And I pull out my copy of Henry's complete works and read 'Tambaroora Jim', punctuating each of the nine stanzas with a swig. When I finish the final line, 'I want to have a glass or two with "Tambaroora Jim"', I raise the stubbie, toast the two of 'em and chug the remnants, trying to imagine the nights, and the hearts, that this fireplace must've warmed.

On the way back to town I stop off at the cemetery and search every tombstone. Once again there's way too many tiny graves of tiny babes and I find no resting place for Jim. When he humped his swag, he seemingly never returned.

Back at the Royal Hotel, at the edge of the verandah there's a chalk message telling what must be lies. I head inside to sort things out. 'What's the catch with the blackboard out the front?'

'No catch,' is Wendi's laughed response.

The sun cuts through the curtained window and hits a couple of beers from the round a group of locals is downing at the far end of the bar. I order another one for myself and take it out into the afternoon sun that's hitting the front of the pub, kick the boots off and kick back. Wendi comes by collecting glasses and with an eye on the bar, sits for a chat.

She and partner Stephen have had this place since 2012. They'd been in Alstonville up near Ballina, doing nicely, he a professional Bridge player and she a tennis coach, when they decided, bugger it, let's go run a pub. Wendi'd never pulled a beer but pretty soon they were in possession of the lease from National Parks to run the Royal Hotel here in Hill End. Stephen's away playing cards with his patron when I drop by and Wendi fills in all my blanks.

She tells me of the loyal locals and the weekends booked out by motorcycle riders, of her theory why every single fence in the town is falling down, and warns about the massive number of roos that come by in the evenings. She details the rooms with their electric blankets and ceiling fans and she tells me about the barrow in the beer garden full of firewood that, once alight, will warm the entire yard.

And that reminds her, if I'm interested in birds, the king parrots should be out back in the feeder about now. I arm up with a camera, head out the back and she's spot on. They're pretty tame too! I edge closer on my bum until he starts to look right at me with the right combination of awareness and fear.

Back in the bar we get back to the room and drinks charges which are all way below average and then we get onto the sign out front. It advertises Dinner, Bed and Breakfast for 50 bucks, and I ask her why. She'd prefer not to say, only that Stephen and she agreed on the policy, which effectively means the lodging is free.

After Wendi calls it a night and all the others have cleared out, I head out into the street. A storm bird sirens through the quiet and the mandatory dogs bark in the far off. The rest is silence. A single street light illuminates the pub. I check the back of the camera. The images, the colour, the light, eerily resembles the tones of Russell Drysdale's paintings of Hill End from the 1940s.

In the morning I head back into the dining room where the other riders have their maps spread out, covering their table beside the window, planning their day's adventure. Sorting out a route and maybe some rest points. The toaster spits out the toughened bread and the jug seems constantly on the boil. I tell them of Lawson's poem and the reason I'm here. I read it out aloud to them as they chomp into the cereal and toast. One rider asks me to repeat a verse and when I finish he nods.

'Seems like there's a tradition here of soft-hearted publicans'. His mate nods.

He'd say, 'I've gone for days myself without a bite or sup—
'Oh! I've been through the mill and know what 'tis to be hard-up.'
He might have made his fortune, but he wasn't in the swim,
For no one had a softer heart than 'Tambaroora Jim'.

PUB WITH NO BEER

TAYLORS ARM, NEW SOUTH WALES

If you ever want to win an easy beer, bet a mate that he can't name the only oceans that touch the Australian coast. It's an even easier bet if you're on the east coast where the answer will almost always include the Pacific.

There's the dreaded Pacific Highway and there's delicious Pacific oysters, so that water off Bondi or Byron has to be the Pacific, right? Nah, it's the Tasman, only the Southern and the Indian oceans wash our shores. Oh and I'll have a schooner of lite thanks!

I was mulling all this as I sat on the deck of The Pub with No Beer at Taylors Arm, midway between the two east coast state capitals linked by the Pacific Highway. The Pub With No Beer (let's call it, 'TPWNB' from here on), is inland from the highway south of Macksville, and if you have any pretensions about seeing the iconic hotels of this land, this is a pub you need to visit.

The sealed, 30-kilometre ride in from the Pac is a glorious, twisty respite from 'the slab'. If you've come from the south, take a left before the south Macksville Independent Fuel, and opposite Woolworths onto Boundary Street, and then another left onto Wallace, and follow the signs for Taylors Arm. This road soon joins the Taylors Arm water before leading you into the verdant beauty of the hinterland.

I park around the back (there's no undercover parking) and head into the bar to be welcomed by a young bloke who's obviously not a backpacker, and a 'G'day' from each of the other three drinkers in the bar. David's the son of the bosses and he soon sorts out my room and my drink and I retire to the west-facing verandah to soak up the last warming rays of the setting sun.

Pretty soon David's dad, Trevor, arrives and comes over for an intro and a chat. For no other reason than I am a new face in the place. We, of course, quickly move onto the claims of this pub and its stoush with a hotel up in Ingham, 2000 kilometres to the north, which claims to be the inspiration for the poem that inspired the song. Despite their battle, there's a few things all agree on.

In 1943 Dan Sheahan, a cane cutter, fronted up to his regular pub, The Day Dawn in Ingham tonguing for a beer only to be told by Gladys Harvey, who owned the place with her husband, that the American servicemen had drunk the place dry the previous night. Just like today, people who can't drink beer drink wine, and so Dan grabbed a vino and retired to a corner table, pulled out a sheet of paper and a pencil which he just happened to have, and wrote a lamentation. (If it'd been today he probably would've grabbed a Keno pencil and a coaster and the poem would've been much shorter!) Anyway, Sheahan titled the poem, which was published in 1944, 'A Pub Without Beer'.

It began:

It is lonely away from your kindred and all
In the bushland at night when the warrigals call,
It is sad by the sea where the wild breakers boom,
Or to look on a grave and contemplate doom,

And then got to the guts of the matter:

But there's nothing on earth half as lonely and drear
As to stand in the bar of a pub without beer

Another thing that's certain is that at some stage in the first half of the 1950s Slim Dusty's songwriter mate, Gordon Parsons, took a break and headed back to his hometown of Taylors Arm. The year isn't certain, Slim Dusty reckoned it was 1956 but others claim it had to've been at least three years before that. Whatever year it was, whilst he was back at the town where he'd spent a few years swinging an axe, Parsons hung out at the Taylors Arm hotel, and one afternoon a mate handed him a sheet of paper with Dan Sheahan's poem written on it.

Parsons liked the poem but realised it had to be changed a bit to become a song. According to Slim Dusty, 'he looked at the characters he knew from

the Taylors Arm Hotel' and got working, adapting the poem which became, 'The Pub with No Beer'.

The song began:

Oh it's lonesome away from your kindred and all,
By the campfire at night where the wild dingoes call,
But there's nothin' so lonesome, morbid or drear,
Than to stand in the bar of a pub with no beer.

A bloke at the bar chimes in that there was still beer rationing in the early 1950s and that when Parsons was at Taylors Arm, the pub was out of beer. I reckon this belongs in the slops tray of truth. It's just too bloody unlikely that Parsons was given the scrap of paper in a pub which just happened to be dry at the time. Neither Gordon Parsons nor Slim Dusty ever mentioned this and so it's little more than an attempt to claim the Taylors Arm Hotel was the inspiration for the song and the poem. It simply wasn't. But this is where it all gets a bit weird.

In his autobiography which, though it lacks dates seems to be in chronological order, Slim Dusty talks about a meeting with the Sheahan family in Ingham not long after the song was released. They told him about the poem and the story about its writing in the Day Dawn Hotel in Ingham. It was all news to Slim but he accepted their story, 'There is no disputing the fact that old Dan Sheahan, a cane farmer, wrote a poem called "A Pub Without Beer"...and that parts of it are very similar to the song.'

But then later, Slim Dusty, at the urging of his recording company, penned a sequel, 'The Answer to a Pub with No Beer'. The last line of the first verse went, 'So let me tell you the reason for the pub with no beer.'

And despite having met the family of the poem's author, despite being aware of the American Servicemen, the Day Dawn Hotel and the events in Ingham, Slim Dusty explained his version of why the pub had no beer:

Broken down on the track, cos he stripped out the gear
There's the old grey blitz wagon, the one with the beer
And the driver's near mad, standin' scratchin' his ear,
He knows just what they're thinkin', at the pub with no beer.

Up north, Dan Sheahan had written his own follow-up. Interestingly it uses the name of the song, not the poem, because Dan called it, 'How "The Pub with No Beer" Came to be Written'.

One day in the town at the time of the blitz—
So dry I was spitting out threepenny bits—
I went to the Pub and I called for a 'pot'
But found that the yankees had gobbled the lot.

So we're left with a few good songs and poems, some really good argument starters, a haze of interesting folk myths and one very good pub, The Pub with No Beer at Taylors Arm.

But we've been left with a bit more than that. Rock up in any bush pub and there's someone in the corner playing with a guitar, chances are they'll know a couple of the rewrites of this song. There must be hundreds—all funny and no doubt all a bit colourful. My two favourites are 'The Pub with no Dike', which begins:

I'll tell you a story, it happened to me,
A new pub had opened and the beer it flowed free,
I'd had several drinks and was full of mad talk,
Mother Nature came calling and I went for a walk.
There were blokes going out, there were blokes coming in,
And the racket they made was a Hell of a din,
I spoke to a swaggy we all know as Ike,
And he sadly told me 'The pub has no dike.'

And 'The Barmaid with Gonorrhoea':

It's a bastard away from a woman and all,
With a pain in the guts from a great lover's ball,
But there's nothing so lonesome, morbid or queer,
Than to knock off a barmaid who's got gonorrhoea.

We all owe Dan Sheahan and Gordon Parsons a massive debt!

Anyway, Trevor and his wife Tracey have leased the pub since 2014 this time around, after managing it for a while about a decade ago. They have a long connection to the place. Their family even donated to the hotel an old church that was on their property, and which has been relocated to the back of the pub and is now lined with beer cans.

After their first management of the pub they built up and then sold a stock feed business and bought a 100-acre cattle property just down the road. The cattle are grass fed and then finished with in-paddock grain mix, slaughtered down in Freddo and then brought back to the pub and served as everything from burgers to snags to T-bones in the restaurant. You can also buy shrink wrapped cuts to take home from the fridge in the back bar.

If you know the rudiments of ruminants, learned the evils of feedlots and are an advocate of short paddock-to-plate distances, this is just one of many reasons to come to Taylors Arm. The restaurant is open for lunch seven days and for dinner only on Fridays and Saturdays, though you can get delicious, massively topped pizzas on all other nights.

This is very much a family business with Trevor and Tracey helped in the bar by their two sons, Andrew and Brad, whom dad considers critical to the success of the pub. 'They both love working here, and the locals love having them behind the bar so it all makes for a happy place,' he tells me, and he's damn right!

On the wall at one end of the bar is an old-style bookmaker's odds board with, 'Who's Next' pinned to the top. This, Trevor explains is the 'book' on who's the next to be barred from the place and it's a pretty tight market at the top with 'Pawsey' favourite at odds of five to four on! I figure I need to speak with this thoroughbred!

Like every regular, Pawsey has his own stable so I hardly need my Garmin to find him in full flight, in his stall at the corner of the verandah. His raucous testaments to the goodness of this pub are echoed by the chorus of other nearby drinkers.

The only other guests this night are two young, hippie women in a clapped-out Volvo wagon who are squatting on the grass, and as the sun sets and Pawsey heads off to his 'mongrel kids', someone produces a guitar and it's passed around between locals and the Volvo dwellers, who all strum requests as others sing along. There is no seam, no line, no friction between locals, visitors, guests and staff; the sign on the wall claiming there's no strangers here just folks you haven't met, couldn't be more apposite!

The PWNB has a total of nine rooms with a combination of queen doubles, singles, twins, bunks and a dorm that sleeps 17. You'll pay 25 bucks per head. You can also throw a swag or tent pitch on the oval across the road for a fee (payable at the pub) of five bucks (including access to the pub's showers and toilets) to offset part of the maintenance.

The bathrooms are pristine and the pump-driven, gas-fired showers are fantastic. The rooms are clean and comfortable and with near zero traffic at night, I sleep well only to be woken at daybreak by a freaking lawnmower. What the??? Turns out it's Joe cutting the grass and then tending the garden of the Anzac Memorial across the road in readiness for the service the next morning, and feeling the goodness flow out of him as we chat, I decide to stay an extra night and then share the dawn service with the 30 residents of Taylors Arm.

In the crisp, cold dark of 25 April near 100 turn up to pay their respects. Young kids shine torches to help older folks navigate and read the service. It's touching, it's respectful and it's perfect. I make a resolution to spend each Anzac morning in a tiny village like this.

After the ceremony all head back to the pub, where the staff have been working since 4am to bang up a free breakfast of bacon and eggs and beans. David and Andrew are welcoming everyone with a nip of Bundy and milk. I realise that this is the sort of Australia for which so many lives were lost. Fair dinkum genuine people in a beautiful place, and I'm glad I stayed the extra.

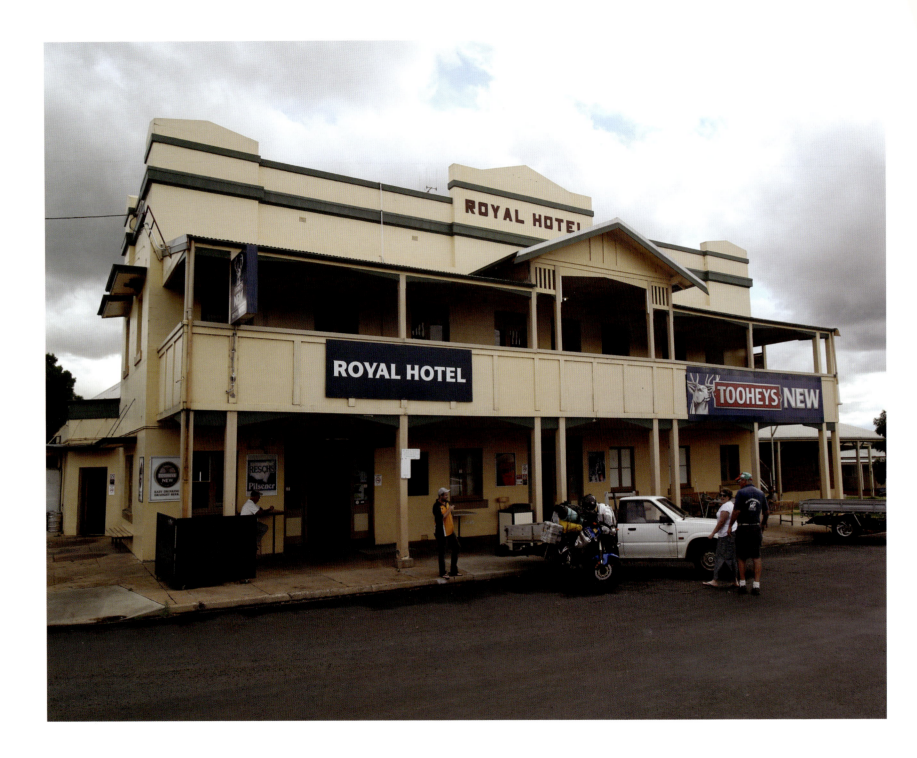

ROYAL HOTEL
YEOVAL, NEW SOUTH WALES

In the Banjo Paterson Bush Park, just up from the school at Yeoval, there's a massive sculpture of a bloke's head constructed in half a dozen pieces—a sort of busted bust. It's supposed to be of the British giant of the sculpture world, Henry Moore, and it was done by one of Moore's protégés, Drago Marin Cherina. Drago came to Australia in 1975 to do a study of Gough Whitlam and felt so at home that he organised to be naturalised in Gough's office.

A couple of things may've contributed to Drago's ease at settling in—obviously being mates with the PM would've helped, but he also didn't mind a drink, and he sure liked a punt. He may've been a reasonable sculptor, probably a decent drinker, but as a punter he was a shocker and soon ended up owing a bomb to the country's highest profile bookmaking family, the Waterhouses. Pretty soon this mob realised they had zilch chance of recovering any of the debt so they forced Drago into bankruptcy and confiscated his assets, including his sculpture of Henry Moore.

Alf Cantrell, a businessman in Yeoval, somehow heard about this and had an idea which he took to Robbie Waterhouse, and over three years they worked out a deal. See, Alf knew there's a law somewhere that if you donate a work of art to a public institution (like say a council or community), you receive a tax credit for the value of the donation. The Waterhouses found this appealing—they had a pile of metal they couldn't use and some taxation liabilities they could do without, so they had the work valued at a million bucks. In February 2010 they off-loaded Drago's work to the town of Yeoval and at the end of the financial year claimed a tax credit for $1,000,000. Neat eh? Much cleaner than that nasty Fine Cotton business, and even more lucrative!

Anyway, Alf Cantrell, the brains behind this acquisition, is not just still in Yeoval, he's the heart, the soul and most of the energy behind the Banjo Paterson Museum and he arrives there a couple of minutes after I turn up. I ask if he's a few minutes to give me. Glinting eyes sparkle over Alf's specs, he smiles and ushers me inside and out of the drizzle.

I don't see the weather again for two hours. I sit inside the museum entertained, enthralled, amused, informed, and more than a little educated. Alf knows the Banjo better than Earl Scruggs and the place is packed with rare and valuable documents, photos, books, historic pieces and manuscripts. Each piece has a story, but one especially catches his enthusiasm.

A few years ago a letter turned up on the international philately market. It carried three noteworthy 3d stamps known as Queen Victoria Loriettes. The letter had been in a 100-year-old collection in America but when the collector died, the collection was dispersed and a collector of Queen Victoria Loriettes on the north coast of New South Wales happened to buy the letter.

The Mulready envelope was only invented in 1840 and had still not gained total acceptance. Like most letters of the 1860s this letter was written on a sheet of paper around double A4 which was then carefully folded so as to leave one face blank. It was this face that then bore the address and the stamp, whilst the back was dabbed with wax to seal it closed. So it would've been impossible for any stamp collector to remove the three sought after Queen Victoria Loriettes without destroying the letter itself.

When the letter arrived in northern New South Wales, the collector realised something which had been irrelevant to the American: it had been written by Banjo Paterson's father to the Bank of Scotland, applying for finance to purchase property. The collector knew about the Yeoval Museum and rang Alf. Would he be interested in the letter.

Well you can imagine what I told him and over the course of a week we negotiated but we couldn't come to an agreement because he wanted too much so he put it on eBay advertising it as three 3d stamps QV Loriette for $3000.

But he'd listed it in the wrong part of eBay and a philatelist was interested.

So he rang me and said could I make him another offer, which I did, and eventually we got it. It's so valuable not for what I paid for it but for the fact that it's gone through so many hands and if just one owner had tried to remove the stamps from the letter, it would've been destroyed for good.

Alf and wife Sharyn drive buses to raise the funds to buy items like this; some can cost well over five grand and the entry fees cover the cost of utilities and insurance. Every item has its history and Alf knows every story. The drizzle's stopped when I head out to the bike. This has been a great stop and if Yeoval, Banjo's home for the first seven years of his life, has nothing else, then it's been worth the effort.

Then I pull up at the pub. There's a throng of folk on the tables out front and I nod as I head in. 'G'day mate. Bit wet for a bike eh? What'll you have?'

I've still a ways to go so I ask for a lite and park myself on a stool. The old bloke at the bar nods and asks where I've come from. As my beer arrives one of the men from outside comes in.

'You're gunna have to move your bike mate.'

I put the glass down and begin to head.

'The bloody South Sydney stickers on the windshield are makin' the place look untidy!' He laughs, everyone laughs, and I sit down.

The smiling fella behind the bar is Mark, 'Mark Isles, I'm the Commander-in-Chief.'

In 2014, Mark's mother-in-law, who'd owned the Royal for about seven years, decided she'd had enough but didn't want to risk selling the place to someone who'd not look after it. So Mark and his partner Marissa stepped up and took over as managers and, well, 'I'm lovin' it, absolutely lovin' it!'

And how're the locals accepting them? I swing to Jim at the bar. 'He's an arsehole, a total arsehole.'

More laughter from Mark and another group who've just come in from the smoking tables.

I leave the bar for a bit of a wander. On the back wall is a selection of portraits of people and on the side wall, a laminated plaque with a photo of the pub and a poem by bush poet, Bob Skelton from down Newcastle way. Bob tells me later that he stayed at the pub back in 2007. He was up doing some work with Alf and liked the pub and the town so much he wrote the poem.

The second last verse mentions, '"Cheryl the Feral", behind the bar,' so I call out to Mark, asking who she is. The place erupts. 'That's the mother-in-law!'

And the portraits? 'They started out as tributes to the more colourful characters who've passed away but then a few of the locals wanted to be added and so they had theirs done and it's just grown from there.'

They're the work of Phillipa, an artist based in Nimbin, but with a very good mate in town. When she comes to visit, she takes photos of the people interested and then paints the works back home on the north coast and sends them back.

Pretty much everyone at the pub this afternoon has a portrait on the wall. I ask the Commander what happens if anyone gets barred from the pub. 'Ah, we'd just put the painting in the naughty corner until they're allowed back in. But you'd be doing well to be barred from here.'

I head back to my pew next to Jim. Jim's 80: he started shearing when he was 14 and gave it away three years ago. Shore all over New South Wales, was the only life he knew.

I was glad the sling came in when it did. Added a few years to my career. My body's paying a bit for it now. I don't miss the work and I kept on for money reasons but I also thought I'd miss the life, y'now, the mates and friendships? But this is a good town and there's always a mate dropping in here.

Words said gently, softly and with a feeling cloaked in memories.

There's 13 rooms upstairs—each'll cost you 40 bucks a night. 'You can squeeze as many in as you like, the rate's the same.' And there's been up to 80 motorcycle riders camping and swagging for free on the grass out the back.

Banjo Paterson never returned to Yeoval after he left for his grandmother's place at Gladesville in Sydney, and his studies at Sydney Grammar School. If he'd come back and written a poem about this town it'd be the crowning treasure for Alf, and fascinating for the rest of us.

In its absence, I make do with Bob Skelton's poem, and before I head off I read the final verse once again:

So if you've got a thirst, or ya' feel one comin' on
There's a welcome mat at Yeoval, no matter where ya' from
You'll find the atmosphere so friendly, the characters you will love
At the dinky-di original, good old Yeoval Pub.

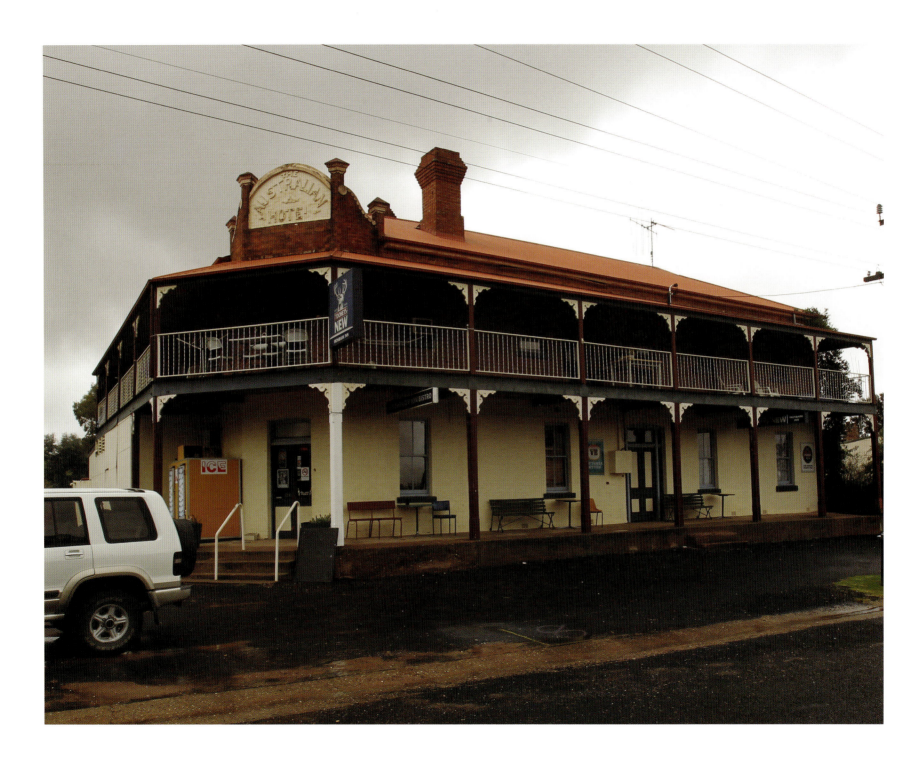

IRON BARK INN
STUART TOWN, NEW SOUTH WALES

There were a few things my dad didn't particularly like, amongst them swearing and the English. He'd found himself in trouble during the war when he back-chatted an English officer who responded, 'Do you know who I am?'

'If you hang around for a bit, I'll ask some of my mates. We should be able to find out for you', was my dad's reply. Things went a bit downhill after that.

But then in 1959, when I was just 8 and we were living in the 'satellite suburb' of Elizabeth in South Australia, surrounded by ten-pound Poms, Johnny Horton released a 45 record called, 'The Battle of New Orleans'. Dad bought it and gave me permission to sing the lyrics. I was over the moon. It was the first time in my childhood I was able to swear as I sang the opening verse at full blast:

> *In 1814 we took a little trip*
> *Along with Colonel Jackson down the mighty Mississipp*
> *We took a little bacon and we took a little beans*
> *And we caught the bloody British in the town of New Orleans*

I begged to do it at show and tell at Elizabeth Primary School and was given three cuts for swearing.

The next time I can remember hearing swearing at home was when we'd moved to Sydney and I must've been 15 or so and I heard my father reading some of Banjo Paterson's poetry. He read it with the type of gusto and infectious enthusiasm for which there is no antidote. There were many poems he liked but there was one line which he'd quote out of the blue: strangely the only line of swearing that Banjo ever wrote. He'd sprout it when the footy team was getting thrashed, or when the Aussies were thrashing the Poms at anything. It was his go-to line for any one-sided contest, his motif for a serious beating: 'Murder! Bloody murder!' yelled the man from Ironbark.

The poem's a beauty—a very funny account of a barber pretending to slit the throat of the Man from Ironbark—but it contains a maybe telling reversal of the city versus country theme that Paterson had included in so much of his work.

In poems like The Geebung Polo Club, Paterson portrayed the 'Cuff and Collar' crew from the city as aloof and out of touch and how the country boys brought them back to earth. From the comfort of his city legal offices (so despised by his burr, Henry Lawson), the Banjo portrayed the life of country as superior to that of the city, and hand in hand, he painted the people out bush as being a happier bunch. The Man from Ironbark stands this on its head.

Here we have a country bloke becoming the butt of a city prank. Down from the bush he decides to have a haircut and a shave but the barber figures it'd be fun to make him think his throat's been cut by running the back of a hot razor across it.

> *There were some gilded youths that sat along the barber's wall.*
> *Their eyes were dull, their heads were flat, they had no brains at all;*
> *To them the barber passed the wink, his dexter eyelid shut,*
> *'I'll make this bloomin' yokel think his bloomin' throat is cut.'*
> *And as he soaped and rubbed it in he made a rude remark:*
> *'I s'pose the flats is pretty green up there in Ironbark.'*

Andrew Barton Paterson was born at Narambla, north of Orange, in February 1864. Fifteen years later, gold was found just a further 60 kilometres north of Banjo's first home and the government pushed a railway line up to Wellington via this new find. The township of Ironbarks was created and a railway station was built. It was a pretty damn fine station too. The New South Wales Department of Environment and Heritage reckons it's 'one of the best examples of a third-class country station building on the New South Wales railway system.'

In 1889 the folks in Ironbarks decided to change the name of their town and probably either as reward for some pork barreling, or in the hope of

future favours, the place's political sycophants opted for renaming it Stuart Town after the recent premier of New South Wales.

Three years after the name change, the by now 28-year-old Paterson wrote his poem and published it first in Archibald's *Bulletin*. It was a hit and from then on the true believers in Stuart Town have held their cherished belief that theirs is the town of the poem. Well, most of them.

I come at the Ironbark Inn from the north, down the Burrendong Way from Mudgee. It's a good motorcycle route, winding and curving beside streams and valleys, past the old vacant church at the Dripstone turn, and then I slow and head into a farm gate to catch up with an old mate.

I first met Henry a few years back (neither of us can remember) when I passed him on the road as he drove his tractor back to his place. His sagging trailer all fencing wire and sheep dogs. We both pulled up and I got some shots as we chatted and he rolled a White Ox durrie, his beard all yellow from the previous million puffs.

This time I lucked in again and he was home. One of the dogs had died and been replaced with a black puppy who had a lot of training ahead of him. We yacked about how good the season was and I told Henry where I was headed. He sucked in, smiled and said, 'be careful they don't slit your throat.' We laughed and said our 'seeya's' and I headed back down his path and turned south.

The Ironbark Inn is one of those classic corner pubs with the door right at the apex of the two frontages. Rod's behind the taps. He looks up; recognises me despite the at least two-year absence. 'You wanna defrost first or get a drink?'

I go for the thaw, head to the fire, and begin shedding layers as the flames kick in. Over the fireplace is a painting by a local of the barbershop incident and the Man from Ironbark throwing his tanty.

Local workers flow in and we shuffle places at the hearth. They explain their theory that the secret of the fire's extraordinary heat is its tilted back wall, and of course the ironbark wood in the grate. In no time I slide from cold to toasty and, glass of merlot in hand, listen to Rodney do his best to dispel the myth of the Banjo connection.

His cynicism revolves around the plurality of the town's original name and the timing of the writing, but I get the feeling he's just being a bit contrary. But he sure knows the history of this place and takes me through the original, single-storey, wooden pub built by John Sloan and called The Carrington, which burnt down in 1904. It was replaced by a brick version and named The Australian.

Sixty years later the place had a new publican who tried to have the town's name changed to Ironbark but had no luck. So he did the next best thing and switched the pub's name to the Ironbark Inn, and that's what it is today. The blokes at the bar are discussing ferrets and the war on rabbits. It's all hobs v jills, sprites v gibs, feeding before hunting or after: important stuff. They all reckon Paterson's poem is about this place, the other options are too far from Sydney, too far for a bloke to go for a haircut! Besides, even back then it was just a train ride from here to the city.

Terry, a massive shearer, puts down his phone after saying that yes, he can get over on Monday to 'give 'em a haircut', and tells me the person I need to see is Ruth down at the Rural Transaction Centre. I nod. 'She's the reason I'm here for Thursday night.'

The Rural Transaction Centre is 50 metres down from the pub. It's open every Friday and Ruth Pope drops by each week for a chin wag and a toasted sandwich. She arrived here with husband Laurie in 1955, and although they're still not considered 'locals', Ruth's memories of the town are without equal; or almost without equal.

'Norma knows a lot more than I do, but she moved to Wellington last year. She had no right to do that.' Her eyes glint like embers in the core of a log.

For Ruth there's no doubt the painting in the pub is about a local fella. 'Bede Sloan (grandson of the builder of the original pub) always said it was supposed that it was either John Sloan or his father who was the Man from Ironbark.'

Ruth shares her stories of Ironbark, of the huge peaches that they grew and which were famous all across New South Wales, of the stores and shops that once filled both sides of the main street, and of her proudest achievement for the town, the huge reunion for the bicentenary in 1988.

I'd hoped to spend 30 minutes or so with her, but I took her advice and sampled a toastie of my own, and very quickly she'd given me two hours of her time. I thank this wonderful woman for her generosity and head back to get my gear from the pub.

It's just gone noon and already there's a few elbows on the bar. I check out their owners. Every face has some kind of bristles, not a clean chin amongst them. I say my farewells to Rod, and walk out of the Ironbark Inn convinced this has to be the right place:

And whether he's believed or no, there's one thing to remark,
That flowing beards are all the go way up in Ironbark.

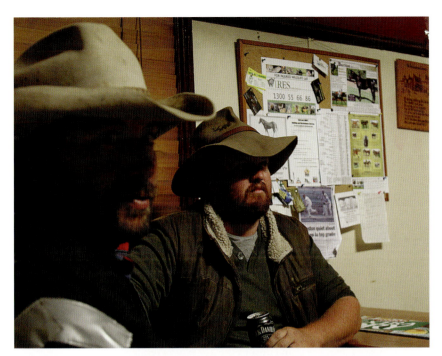
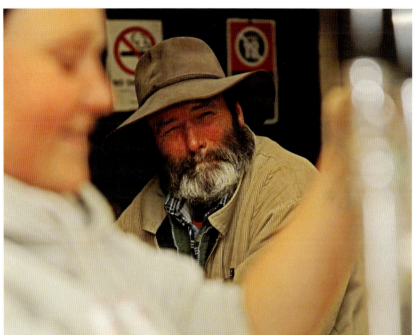

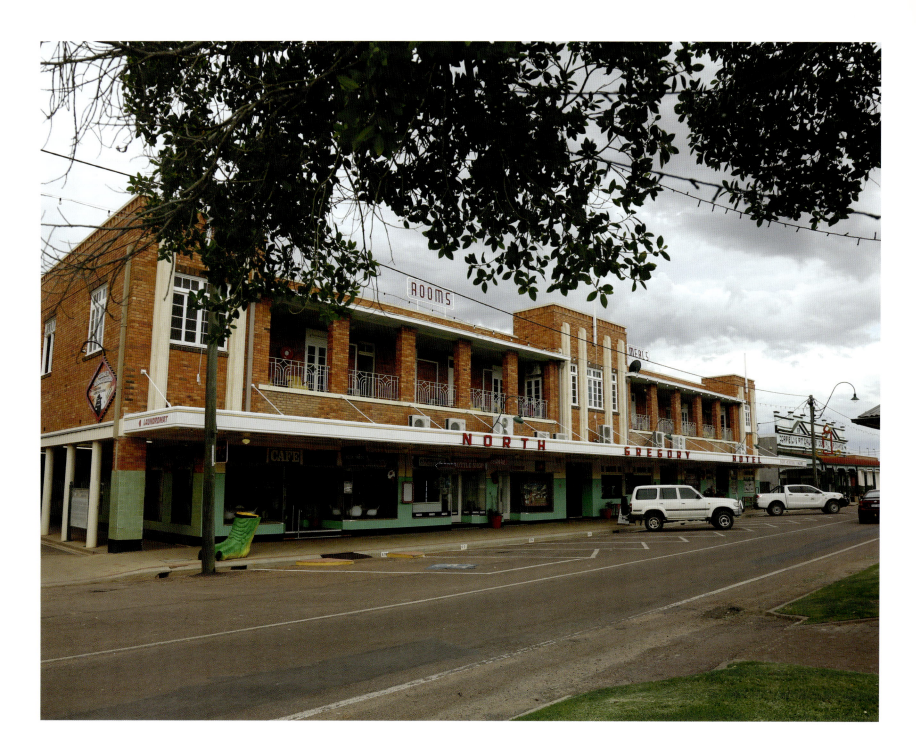

NORTH GREGORY HOTEL
WINTON, QUEENSLAND

Ah, tenacity! Some pubs have the tenacity of those extraordinary trees that you see growing on the rock faces of road cuttings. You know those steeply banked excavated walls where by rights nothing should grow, but there in the barren middle the wind, or a bird, has dropped a seed that's taken hold, somehow; somehow, the plant's survived if not flourished. As I ride I see these tough buggers and wonder at their stories. Some plants are simply tough and determined. They're also the right seeds in the right place at the right time, I guess. I call them 'hero trees' for their strength and determination and compare them with the groves of seedlings that are planted only to soon die on the edges of so many other highways.

These groves are part of the carbon offset programmes of high profile companies, who benefit from government assistance and offsets for their environmental pollution, according to the number of trees that are planted. Not 'survive to maturity', just 'planted'. So companies are contracted to plant totally inappropriate seedlings in unsuitable soils, and then ignore them as they shrivel and die, and the companies chuckle over their tax savings and send out media releases about their environmental responsibility.

But not my hero trees—they're so well suited to their home that setbacks of floods and droughts, furnace and frost are overcome as challenges rather than game enders.

There's a good few hero pubs like that: hotels that've survived more than the odd setback and challenge and have survived the adversities and prospered in the good times.

The Old Gregory in Winton is one of these tenacious, gritty and determined hotels that prove the right strain in the right environment is a recipe for survival. It was first built as a single storey in 1879, the second pub in the town, but was demolished in 1899 and rebuilt as a two-storey pub.

In 1916, with business a bit slack due to the war, this second version was torched but quickly rebuilt. Thirty years later with the country still suffering from World War II and a severe drought, the place went up in flames again. Far be it for me to suggest a pattern here.

Those three decades had been a mix of good and not so times for the North Gregory. In June 1942 an American Flying Fortress, on a break from action in PNG, took off from Darwin headed to Longreach. Nicknamed 'Swoose', the bomber was under the alleged control of Captain Kurtz (yep, same surname as Brando's character in *Apocalypse Now*!). Despite having a navigator and observer on board, according to the diary of one of the uniforms on board, they:

> ...got delightfully lost, could not find Cloncurry or Longreach—finally landed on a farm 40 miles SW of Winton at Carisbrook Farm owned by Mr. S.H. Taylor. Phone for car, gas, etc. & then played gin rummy on back porch with Martin Barnett till cars came about 7:30—to Winton—North Gregory Hotel stopped at 20 Mile for drink—to restaurant for bacon & eggs.

The crew all stayed at the pub that night and the bombing observer, a bloke named 'Johnson', stayed in room 6. His given names were Lyndon Baines and 21 years later, in November 1963 LBJ became President of the USA following the assassination of John F Kennedy. The room in which he slept is still known as the 'LBJ Suite'.

After the fire in 1946, the North Gregory wasn't immediately rebuilt, but in the early 1950s, with the town's population shrinking, the Council decided one way to reinvigorate the place was to rebuild the pub. The fourth incarnation was opened in 1955; a brick, art deco palace aimed at the upper end of the market. All rooms had ensuites, the tables in the ornate and stately dining room all had starched linen tablecloths. The press trumpeted that the rooms and the bars all had air conditioning. This was a class joint!

A massive part of the rationale behind the quarter-million quid rebuild was the pub's connection with Banjo Paterson and 'Waltzing Matilda'.

Back in 1895 as Banjo Paterson was living the life of an urban country squire, basking in the success of his book, *The Man from Snowy River and other Verses,* playing polo and riding with the Sydney Hunt club, his long-time fiancée, Sarah Riley, caught a steamer from Melbourne up to Rockhampton. From the coast, she travelled west to Winton and then out to Vindex, the property of some very wealthy friends of the family.

A month or so later, Sarah's good friend from Melbourne, Christina Macpherson, also caught the same steamer, the *Wodonga*, up to Rocky. From here she too headed west for Winton, but she then joined family friends at Dagworth Station.

Now, from here it's a bit murky but at some stage, Paterson journeyed north from Sydney, probably overland, and probably partly by train, and eventually joined his fiancée at Vindex. At some stage Banjo, Sarah and their hosts at Vindex hitched the horses to the sulkies and visited the Macphersons at Dagworth Station, which was next door.

We know that Bob Macpherson, who'd seen his woolshed torched the previous year by striking shearers, took Banjo on a ride out to the Combo waterhole, where Frenchy Hoffmeister had met his end. If Bob Macpherson had shot and killed the swagman here in retaliation for the loss of this woolshed and the 140 lambs within, he didn't fess up to Paterson.

Back at the homestead, the evenings were spent in refined pursuits. One evening the station overseer, Jack Carter, joined the group at table and he was asked what he'd seen that day. 'Not much, only a swagman waltzing matilda down by the river.' It was the first time Paterson'd heard this expression.

According to Bob Macpherson, quoted in Paul Terry's *Banjo*:

> *A few minutes later Banjo repeated the words, 'waltzing matilda' and became very animated. He reckoned he could write a poem about it. Everyone gathered around him and he wrote it then and there. Christina was a good musician and she set it to music the same night. A few days later we went to Winton. We called into the old Aryshire pub and we sang the song there.*

So according to Bob Macpherson, the words came first and then Christina Macpherson put them to music. Macpherson is the same gent who claimed that the day after his woolshed had been burnt to the ground and he'd lost 140 lambs, when he arrived at a billabong in search of the perpetrators, he, and his armed posse, found one of the prime suspects conveniently already dead by suicide. I think we can disregard both his recollections.

In a recently discovered letter, Christina Macpherson wrote:

> *We went in to Winton for a week or so & one day I played (from ear) a tune which I had heard played by a band at the Races in Warrnambool...Mr Patterson(sic) asked what it was—I could not tell him, & he then said he thought he could write some lines to it. He then and there wrote the first verse. We tried it and thought it went well, so he then wrote the other verses. I might add that in a short time everyone in the District was singing it.*

This tune was 'Bonnie Wood O' Craiglea'.

However it happened, and Christina's version is a whole lot more credible than brother Bob's, Andrew Barton Paterson and Christina Macpherson cooperated closely over a period of a few days and the song 'Waltzing Matilda' was conceived and born.

Just how closely they cooperated has never been fully explained but very soon Sarah Riley broke off the eight-year engagement, and Christina's brothers ordered Paterson off their property.

Bob Macpherson's claim about calling into the 'Ayrshire' pub is also probably rubbish. There's no record of any such hotel ever existing in Winton but Ayrshire Downs Station was midway between Dagworth and Winton and was often used as an overnight stop. Matthew Richardson in his valuable, *Once a Jolly Swagman: The Ballad of Waltzing Matilda* quotes a woman who was a child on Ayrshire Downs at the time who remembered Banjo Paterson reading 'Waltzing Matilda' to the children in the nursery there.

She goes on to recall hearing that 'a few days later it was sung at the North Gregory Hotel by Herbert Ramsey, whose family owned nearby Oondooroo station. Herbert Ramsey was the best singer in the district.'

Today in the art deco foyer of the North Gregory is a sign on the wall: This is *the* spot!

I sit down in the bar with Ben, who owns a share in the pub with his dad. I ask him how that sign can have any credibility. How can that over there be the spot for a performance in 1895, where that spot wasn't even built until 60 years later? It's all a bit like the slippery history up at Lees Hotel in Ingham.

For starters, this has always been the North Gregory. The pub on this site has never had another name and when the song was sung here, that's what its name was. Also, we've, and people before us, have done every bit of research we can to pinpoint where the piano would've been then. There's no real disputing that the song was sung here by Ramsey to entertain the Governor and if Ramsey stood a metre to the left or to the right, does it really matter?

I see his point completely. For some reason the performers took no selfies and their 'social media' consisted of being social, talking, singing, hanging out together; all that old-fashioned stuff.

So, there's no proof, just a billycan of evidence and it all points to here.

'Waltzing Matilda' almost died a death itself. By the start of the 19th century its popularity had begun to wane but then Billy Tea came to the rescue in 1903. They stumped up five quid to Paterson for the rights to use it as their jingle. The words were printed inside each box of tea leaves. New life was breathed in and the song took off. It became a hero song born in a hero pub and like my hero trees, it thrived in even the harshest climes.

There's no longer a piano in the room at the North Gregory but there's a pianola and yeah, there's a reel of Waltzing Matilda. When you come by, forget our modern antisocial media. Sit your mate down at the pianola, load up the reel, get him pedalling, lean on his shoulder with your hand that's not holding your beer and sing the words as they scroll up.

And forget the controversy over who was the first to sing 'Waltzing Matilda' at the North Gregory Hotel, just make bloody sure, you're the next!

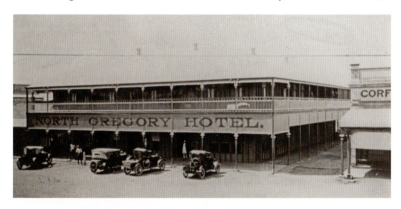

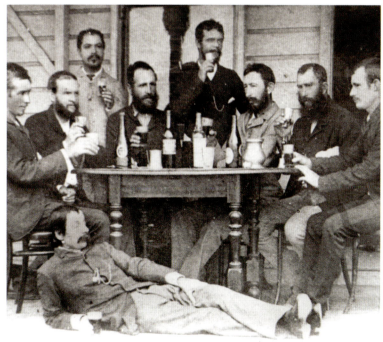

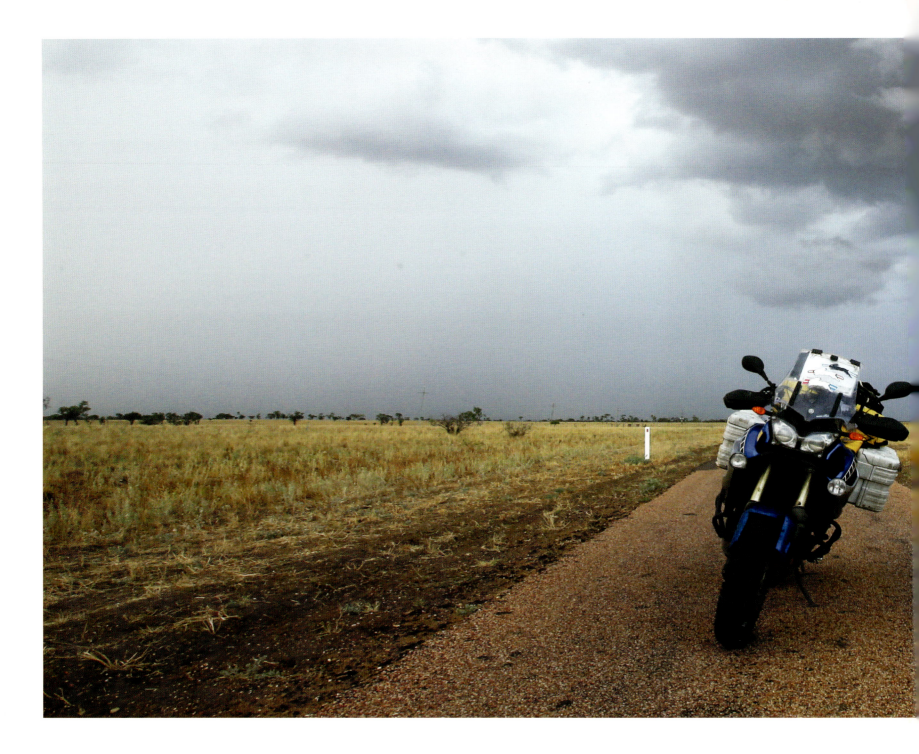

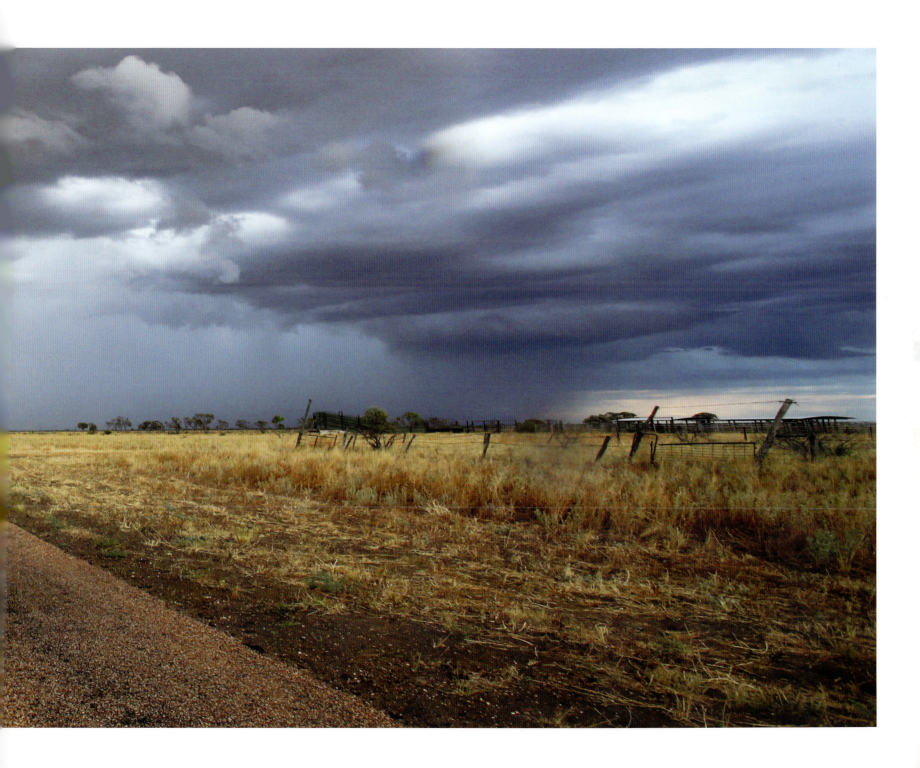

ACKNOWLEDGEMENTS

In 1965 my mother, Helen, allowed me, then aged 14, to hitchhike from Sydney to Perth and back in 10 days to settle a schoolboy bet. In so doing she sowed in me the seed of restlessness and love of the harsh heart which has remained vibrant within ever since.

Fifty years later my twins, Natalie and Jesse and my daughter-in-law, Lizzie gave me a book of bush stories for my birthday. They inscribed the front page with: 'We hope this inspires you to write some of the stories you tell from your travels.'

This book is dedicated to all four: my amazing mother, still inspiring at 90 years young, my wonderful two children and my son's wife, without whom this book (and the next) would never have even seemed possible.

IMAGE CREDITS

Page 12: Algernon Talmage, 'The Founding of Australia by Captain Arthur Phillip RN Sydney Cove, Jan 26th 1788', courtesy of State Library of New South Wales.
Page 54: IH Berner, 'Royal Hotel & Commercial Exchange, George Street, Sydney', courtesy of National Gallery of Australia.
Page 56: TSC Calvert, 'Attempted Assassination of HRH Duke of Edinburgh at Clontarf, NSW', courtesy of National Gallery of Australia.

First published in 2017 by New Holland Publishers
London • Sydney • Auckland

www.newhollandpublishers.co.nz

The Chandlery 50 Westminster Bridge Road London SE1 7QY United Kingdom
1/66 Gibbes Street Chatswood NSW 2067 Australia
5/39 Woodside Ave Northcote Auckland 0627 New Zealand

Copyright © 2017 in text & photography: Colin Whelan
Copyright © 2017 New Holland Publishers

All rights reserved. No part of this publication may be reproduced, stored in a retrieval system, or transmitted in any form or by any means, electronic, mechanical, photocopying, recording or otherwise, without the prior permission of the publishers and copyright holders.

A record of this book is held at the British Library and the National Library of Australia.

ISBN 9781742579597

Group Managing Director: Fiona Schultz
Publisher: Alan Whiticker
Editor: Liz Hardy
Designer: Catherine Meachen
Production Director: James Mills-Hicks
Printer: Hang Tai Printing Company Limited

10 9 8 7 6 5 4 3 2 1

Keep up with New Holland Publishers on Facebook
www.facebook.com/NewHollandPublishers